PHOTOGRAPH RESTORATION
AND ENHANCEMENT
USING ADOBE® PHOTOSHOP®

PHOTOGRAPH RESTORATION
AND ENHANCEMENT
USING ADOBE® PHOTOSHOP®

Vickie Ellen Wolper

MERCURY LEARNING AND INFORMATION
Dulles, Virginia
Boston, Massachusetts
New Delhi

Publisher: David Pallai

MERCURY LEARNING AND INFORMATION
22841 Quicksilver Drive
Dulles, VA 20166
info@merclearning.com
www.merclearning.com

1-800-758-3756

This book is printed on acid-free paper.

Vickie Ellen Wolper. *Photograph Restoration and Enhancement Using Adobe® Photoshop®.*
ISBN: 978-1-936420-39-1

The publisher recognizes and respects all marks used by companies, manufacturers, and developers as a means to distinguish their products. All brand names and product names mentioned in this book are trademarks or service marks of their respective companies. Any omission or misuse (of any kind) of service marks or trademarks, etc. is not an attempt to infringe on the property of others.

Library of Congress Control Number: 2012952665

131415321 Printed in the United States of America

Our titles are available for adoption, license, or bulk purchase by institutions, corporations, etc.

For additional information, please contact the Customer Service Dept. at 1-800-758-3756 (toll free).

This book is dedicated to my special friend,
the world traveler

CONTENTS

PREFACE

Taking pictures and looking at them later is fun but it can also be disappointing when they have become damaged, or lack polish because they contain red-eye or a washed out sky, etc. You may have always wanted to learn how to fix them and now you can. Rather than cover every element of Adobe™ Photoshop™, this book focuses exclusively on its restoration and enhancement features with an easy to follow format designed for novices and experienced users of Photoshop customized to be compatible with any version of the Adobe Create Suite™ software series.

Novices will learn to take command of Photoshop with opportunities to correct and enhance images with the ability to make informed decisions later in their own work, to restore and enhance their photographs using either basic or more advanced methods.

Experienced users will benefit from clarifications on challenging topics such as resolution and color management, as well as enjoy numerous tips and tricks using its tools in innovative applications that they most likely never thought of.

The book is divided into two sections. Part one teaches how to use Photoshop through projects that will continue to be repaired and enhanced throughout the remainder of the text. Part two provides a comprehensive exploration of how to repair and enhance photographs, as well as how to approach unique challenges such as working with paintings and photographing photographs for digitization. Through many hands on projects that include opportunities for you to use the images provided or substitute your own, you will build a diverse portfolio of works exemplifying a wealth of experience.

As you read this book, a variety of learning tools are included to further reinforce your learning:

Definitions: explanations of key photography, restoration, and color terms

Notes: clarifications and additional information about the content begin learned

Click Tips: Keyboard and execution short cuts to advance your skills and proficiency

On the DVD: Project files and figure examples to enhance your learning

Video clips: Demonstration videos of key processes that are best explained by watching

Congratulations on the purchase of this book. You have taken the first step to pursuing an engaging hobby or an exciting new career.

CREDITS

The following list of friends and patrons have generously given their permission to have their precious memories included in this book:

Anderson, Jr., Albert
Chapter 6: Figure 6.19
Chapter 13: Figure 13.26, Figure 13.28, Figure 13.29, Figure 13.30,
 Figure 13.31, Figure 13.32, Figure 13.33

Beamish, Susan
Chapter 12: Figure 12.6

Bohn, Meredith
Chapter 7: 7.26
Chapter 9: Figure 9.59, Figure 9.60

Casey, Michele Harris
Chapter 13: Figure 13.1, Figure 13.2, Figure 13.3
Part 2 Title Page Collage

Connarn, John
Chapter 4: Figure 4.8
Chapter 9: Figure 9.12

Duckoff, Richard
Chapter 1: Figure 1.15, Figure 1.16, Figure 1.17
Chapter 3: Figure 3.2, Figure 3.3
Chapter 7: Figure 7.12, Figure 7.13, Figure 7.14, Figure 7.15,
 Figure 7.16, Figure 7.17, Figure 7.18, Figure 7.19,
 Figure 7.22
Chapter 7: Title Page
Chapter 9: Figure 9.16, Figure 9.17, Figure 9.20, Figure 9.53
Chapter 11: Figure 11.28
Chapter 12: Figure 12.26, Figure 12.27

Fernandez, Lisa
Chapter 4: Figure 4.27, Figure 4.28

Hersey, Richard
Chapter 3: Figure 3.35
Chapter 6: Figure 6.18
Chapter 7: Figure 7.27
Chapter 9: Figure 9.19
Chapter 12: Figure 12.13, Figure 12.14, Figure 12.15, Figure 12.16,
 Figure 12.21, Figure 12.22, Figure 12.23, Figure 12.24,
 Figure 12.25
Part 2 Title Page Collage

Jenkins, John A.
Chapter 3: Figure 3.8
Chapter 9: Figure 9.21

Krupa, Michalena
Chapter 8: Figure 8.21, Figure 8.39, Figure 8.40, Figure 8.41,
 Figure 8.42
Chapter 11: Figure 11.23, Figure 11.24, Figure 11.25, Figure 11.26,
 Figure 11.27

Langelier, Wendy A.
Chapter 2: Figure 2.13
Part 1 Title Page Collage

Loiselle, Angela
Chapter 10: Figure 10.14, Figure 10.15, Figure 10.16, Figure 10.19,
 Figure 10.20, Figure 10.21
Chapter 11: Figure 11.29
Part 2 Title Page Collage

Martel, Eva
Chapter 2: Figure 2.14
Chapter 3: Figure 3.1

Medzela, Mary Ann
Chapter 8: Figure 8.28, Figure 8.29, Figure 8.30, Figure 8.31,
 Figure 8.33, Figure 8.34, Figure 8.36, Figure 8.37,
 Figure 8.38
Chapter 8 Title Page

Miller, David
Chapter 4: Figure 4.7
Chapter 8: Figure 8.1, Figure 8.2, Figure 8.3, Figure 8.4, Figure 8.5

Nadeau, Clémence
Chapter 2: Figure 2.5, Figure 2.6, Figure 2.17
Chapter 3: Figure 3.7, Figure 3.10, Figure 3.11, Figure 3.12, Figure 3.13,
 Figure 3.15, Figure 3.18, Figure 3.20, Figure 3.29,
 Figure 3.30, Figure 3.31
Chapter 5: Figure 5.15, Figure 5.20
Chapter 7: Figure 7.24, Figure 7.25
Chapter 8: Figure 8.9, Figure 8.10, Figure 8.13, Figure 8.14, Figure 8.15,
 Figure 8.43, Figure 8.44, Figure 8.45
Chapter 9: Figure 9.4, Figure 9.5, Figure 9.6, Figure 9.9, Figure 9.11,
 Figure 9.13, Figure 9.57
Chapter 10: Figure 10.9, Figure 10.10, Figure 10.11, Figure 10.12,
 Figure 10.13, Figure 10.16
Part 1 Title Page Collage
Part 2 Title Page Collage

Reed, Bobby L.
Chapter 12: Figure 12.17, Figure 12.18, Figure 12.19, Figure 12.20

Robblee, Bess L.
Chapter 4: Figure 4.21, Figure 4.22, Figure 4.23
Part 1 Title Page Collage

Smith, Shaunna
Chapter 10: Figure 10.22, Figure 10.23, Figure 10.24, Figure 10.25
Chapter 10 Title Page

Slater, Sandy
Chapter 13: Figure 13.4, Figure 13.5, Figure 13.6, Figure 13.7,
 Figure 13.8, Figure 13.9, Figure 13.10, Figure 13.11,
 Figure 13.12, Figure 13.13, Figure 13.14, Figure 13.15,
 Figure 13.16
Chapter 13 Title Page

Wolper, Barry F.
Chapter 2: Figure 2.12
Chapter 3: Figure 3.27, Figure 3.28
Chapter 4: Figure 4.30, Figure 4.31
Chapter 5: Figure 5.1, Figure 5.2, Figure 5.6, Figure 5.8, Figure 5.9,
 Figure 5.12, Figure 5.13, Figure 5.14, Figure 5.19, Figure 5.30
Chapter 6: Figure 6.2, Figure 6.8
Chapter 7: Figure 7.4, Figure 7.6, Figure 7.7, Figure 7.8, Figure 7.9
Chapter 9: Figure 9.27, Figure 9.28, Figure 9.29, Figure 9.30,
 Figure 9.31, Figure 9.42, Figure 9.43, Figure 9.44,
 Figure 9.45, Figure 9.51, Figure 9.61
Chapter 10: Figure 10.4, Figure 10.5, Figure 10.6, Figure 10.7,
 Figure 10.33, Figure 10.34, Figure 10.37, Figure 10.38,
 Figure 10.39
Chapter 11: Figure 11.1, Figure 11.7, Figure 11.9, Figure 11.12,
 Figure 11.13, Figure 11.45, Figure 11.46, Figure 11.47
Chapter 13: Figure 13.17, Figure 13.18, Figure 13.19, Figure 13.21,
 Figure 13.23, Figure 13.24, Figure 13.25
Part 1 Title Page Collage
Part 2 Title Page Collage
Chapter 4 Title Page
Chapter 5 Title Page

PART 1

PREPARING YOUR PHOTOGRAPHS FOR RESTORATION AND ENHANCEMENT

1

READYING AN IMAGE FOR ADOBE PHOTOSHOP

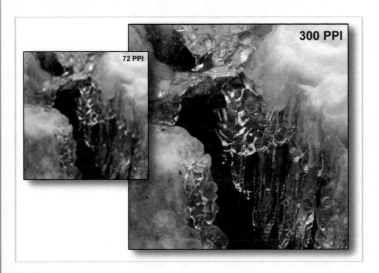

In This Chapter

- Explore the fundamentals of resolution
- Learn to assign scanner settings for high resolution output
- Be introduced to Bit Depth
- Prepare digital camera images for work in Adobe Photoshop©

Before opening images in Adobe Photoshop to begin their restoration or enhancement (referred to from now on in this book as simply Photoshop), this first chapter will examine their proper preparation including: scanning, downloading from a digital camera, assigning resolution, and saving formats.

1.1 Before We Begin

Perhaps you've got some old photos damaged by torn corners, holes, or water spots. Or perhaps you have some not-so-old color photos that were never properly stored, and their colors have faded or changed with age. Or more recently, you took some photographs with your digital camera of a special event, only to have the "guest of honor" blink, or turn away, just when you took the photo. Don't you hate that? Or maybe you have dozens of photographs that have red eye, are crooked, contain objects (or people) you wish weren't in them, and so on and so on and so on. You'd love to fix all these photos yourself, and you know it could be fun and rewarding doing it, but the thought of having to learn a huge program like Photoshop is intimidating to you. Even if it's not, you just don't have that kind of time. This book will get you there. Learning the essential features of Photoshop specific to our type of work, we will employ the images supplied (and use your own as well), to master many rewarding techniques in photograph restoration and enhancement, without extensive training in every aspect of Photoshop.

1.2 Clarifying Resolution

The visual quality or clarity of an image is determined by its resolution. Resolution can be one of the hardest concepts to grasp when learning to work with photographs digitally. To be successful in photograph restoration and enhancement, you do not have to know *everything* about resolution, or even ever fully understand it: you just need to learn how to work with two of its unique features. The first of those is what resolution your images need to start with in order to meet your quality expectations when they are printed. The other feature is an idiosyncrasy of resolution that arises when images

are merged together, that is critical to be aware of, so that you can avoid frustration and disappointment when you want to combine some yourself.

So...why are we starting our training with what was just referred to as "one of the hardest concepts to grasp"? The answer is simple. Before you even open your images in Photoshop, familiarity with these basics of resolution is a fundamental key contributor to your future success when working with digital images, whether they are scanned in, or downloaded from your digital camera. But, don't be concerned...you will learn what you need to know.

1.2.1 Pixelation: PPI and DPI

Figure 1.1 shows a small area of an image on a computer screen. This example allows you to clearly see that when photographs are converted to digital images, they are transformed into square blocks of color, called "pixels."

A copy of each figure shown in this chapter can be viewed on the companion DVD included with this book. *on the* **DVD**

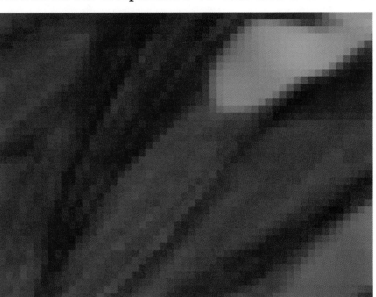

FIGURE 1.1 Pixelation.

PPI stands for "pixels per inch." When two photographs are of the same physical dimensions (e.g., 4″x 6″), if one of them has a smaller number of ppi than the other, it means that each pixel or square block of color within that image will be further apart than the same size photograph with more ppi. The more ppi (or more "square blocks of color" per inch) a digital image contains, the more flexible it will be when enlarged before the "squares" become so far apart from each other, that they begin to clearly be noticeable as individual blocks of color.

So if that's ppi, then what's DPI? Often mistakenly referred to as the same thing, DPI stands for "dots per inch," for printing purposes. The correct term for denoting the resolution of your photographs, and the phraseology that will be used in this book, is to refer to their ppi.

> **Definition**
>
> **DPI (dots per inch):** refers to the number of printing dots of ink per inch. A 1200 dpi printer will place 1200 minuscule droplets of ink within each square of the document being printed.

1.2.2 Choosing a Resolution Based on Your Final Output Needs

What's low, what's high, and what do you need? A 72 ppi digital image is often described as a low resolution image. The 72 square blocks of color per inch is great for online viewing, poor when used for print. 300 ppi (or 300 square blocks of color per inch) is typically referred to as a high resolution digital image. That statement is true, but is relative to the physical size of the image and the total number of pixels it is comprised of. When comparing two images of the same physical size, such as two 4″ × 6″ images where one has 72 ppi and the other

has 300 ppi, the image containing 72 ppi will have pixel dimensions of 288 pixels × 432 pixels (4″ × 72 = 288, 6″ × 72 = 432), and the 300 ppi image with the same physical size will have pixel dimensions of 1200 pixels × 1800 pixels (4″ × 300 = 1200, 6″ × 300 = 1800). The quality will be determined by its physical size relative to its total number of pixels for its width and height; more pixel density equals better quality. Many digital cameras produce images at 72 ppi but generate images with large physical dimensions which therefore still contain a high total pixel count, designed so that when they are printed smaller (the pixels compressed together) there will be a larger number per inch, relative to their adjusted physical size. A 72 ppi image, with physical dimensions of 16.667″ × 25″ is still a high resolution image because its pixel dimensions are 1200 × 1800. It has those dimensions so that it can be *converted* to a 300 ppi image (compress the pixels together, and result in a high quality 4″ × 6″ print, the conversion process of which you will learn how to do in Chapter Two). Mind boggling for sure, but for now, having learned that 300 ppi produces a high-quality end print, let's carry this concept further by exploring its application to cropping and enlarging your images.

1.2.2.1 *Resolution Considerations for Enlargements: the "Final Factor"*

Although we will learn the process of cropping using Photoshop in Chapter Five, let's look at cropping for now from a resolution standpoint. We will examine some original images, then cropped versions of them to further "clarify" resolution. The following two original spring ice photographs shown in Figure 1.2 both have the same physical dimensions of 4″ × 6″, however the image on the left is comprised of 72 ppi, and the one on the right contains 300 ppi.

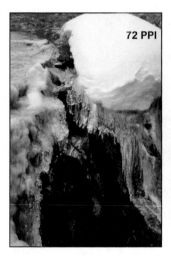
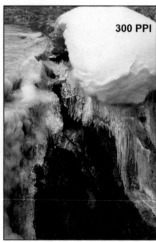

FIGURE 1.2 Same image at 72 ppi and 300 ppi.

When viewed at their original physical dimensions, even the low resolution version looks decent. Figure 1.3 illustrates when the problem becomes more noticeable. When cropped and enlarged, the low resolution image suffers dramatically in quality, as the "square boxes" of color become more evident, and the details, such as the icicles, become noticeably less defined.

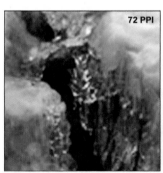
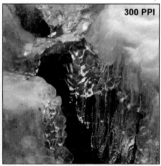

FIGURE 1.3 Cropped images.

Perhaps at some point you have tried to print a low resolution photo as a large print, and experienced this problem yourself. You may not have understood why it happened, or how it could have been resolved by using a higher resolution photograph to start with. Figure 1.3 also exemplifies the typical type of compromise in quality

when an original low resolution image with physical dimensions of 4″ × 6″, for example, is enlarged to a size such as 8″ × 12″, or even worse 12″ × 18″. The end result will most likely be disappointingly poor. So how can you get a high quality photo enlargement? What resolution would it need to be? 300 ppi or even larger than that? The answer lies in a little mathematical computation, referred to in this text as the "final factor." When an image is either scanned in or downloaded, it contains a certain number of pixels for its width and height, based on its assigned resolution. These pixel dimensions (or number of pixels) remain constant, even if either the physical dimensions or resolution of the image are changed later on. When the document size (physical dimensions) of an image is enlarged, the resolution is decreased (the boxes of color are spread out), or increased if the physical dimensions are changed to a smaller size (the boxes of color are condensed). Because these two factors are interconnected, if the resolution is changed instead to a higher number, the image's physical dimensions will decrease, or conversely, will increase if the resolution is lowered. All the while, the assigned original pixel dimensions for the width and height of the image never change. Perhaps just in learning this, you can guess what you need to do. You must start with a high enough resolution of your original to be able to enlarge it later to the size you want, and still end up with enough ppi to look good. How to know what resolution you need to start with will be covered later in this chapter when we discuss the principles of scanning. How to make the resolution/size adjustments to enlarge your image after you have determined the required pixel width and height and scanned your image using those calculations will be covered in Chapter Two once we are working in Photoshop. At this stage of your learning, understanding what pixelation is, and just knowing that you can avoid it by starting with a high enough resolution photograph, one with enough pixels per inch based on your "final factor" desires, is a great start. You

are on your way to a successful and fun experience in photograph restoration and enhancement.

1.2.3 Resolution Considerations When Combining Images Together

When you combine photographs or parts of photographs together as you will do later in this book, they should be the same resolution whenever possible: "apples with apples" so to speak. The following examples will help to understand why.

Both of the photographs shown in Figure 1.4, the snow scene, and the lake scene, have the same physical dimensions of 6″ × 4″. The lake scene photo's resolution however, is 300 ppi while the snow scene photo's is only 72 ppi.

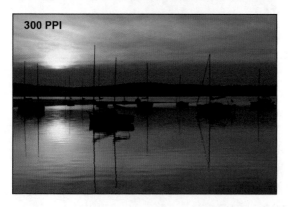

FIGURE 1.4 Snow scene 72 ppi image compared to lake scene 300 ppi image.

If the low resolution snow scene image is imported into the high resolution lake scene image, the pixels that are "spread out" in their original 72 ppi configuration are automatically compressed together to align pixel for pixel to the 300 ppi of the lake scene, making the imported image much smaller. A photograph imported into another photograph will always be converted to the destination resolution. Because we have already learned that the original assigned pixel width and height totals remain constant, the imported image will be automatically transformed as it needs to in order to do that, as shown in Figure 1.5. Even though it is still the original 6″ × 4″ photograph, the snow scene image becomes much smaller when added to the high resolution lake scene photograph.

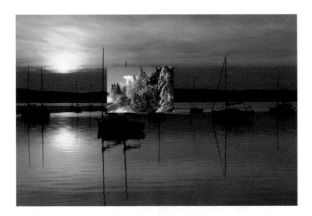

FIGURE 1.5 72 ppi imported into 300 ppi.

Conversely, when a high resolution image is imported into a low resolution image...can you guess the result? It will spread out as needed to once again align pixel for pixel with the lower ppi photograph it is brought into. Figure 1.6 illustrates this scenario. The "handles" we can see beyond the dimensions of the snow scene identify the outer edges of the 300 ppi lake scene photograph, representing how much larger the lake scene image has become than the snow scene it has been imported into.

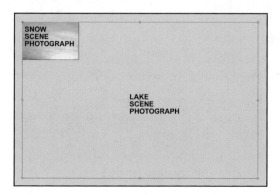

FIGURE 1.6 300 ppi imported into 72 ppi.

Let's carry this concept one step further. The *pixel* width and height (not physical dimensions) of the high resolution lake scene are 1800 px × 1200 px respectively. The *pixel* width and height (not physical dimensions) of the low resolution snow scene are 432 px × 288 px. This means that the lake scene photo can "fit" over 16 copies of the snow scene inside of it, as shown in Figure 1.7, even though both images' original physical dimensions were the same, 6″ × 4″.

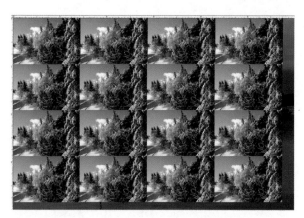

FIGURE 1.7 Multiple 72 ppi images in one 300 ppi image.

Undoubtedly, this can be a very difficult concept to understand. In actuality, you don't need to ever fully understand it, as long as you understand what will happen if you combine two photographs with different resolutions. Just remember "apples to apples"; if you

plan to import even a small piece of one photograph into another, be sure the photo to be imported is the same resolution as that of the destination image before you combine them. Once we start working in Photoshop, if you add part of one photograph into another and it suddenly appears disproportionately larger or smaller than you know it should, you will be able to recognize that the two photographs are most likely not the same resolution.

So what do you do if you have two different resolution photos and *need* to combine them together? Although not recommended, that can be done through a process known as resampling. We will examine resampling in depth as it pertains to cropping images in Chapter Five, and explore ways to minimize its ramifications when content from an image comprised of a different native resolution is required to enhance a photograph, in Chapter Ten. For now, with these two main features of resolution clarified, we are ready to learn how to prepare photographs to work with them in Photoshop by scanning them.

1.3 Scanning Basics

All medium and higher quality flat-bed scanners (the cover lifts, and you lay your photograph on the "bed" to be scanned) have the same basic features, with each brand scanner and its applicable scanning software defining the features perhaps a little different than the next one. Because of that, this section will focus on the critical ones that relate to scanning for importation into Photoshop, not the basic operation of your particular scanner, and will assume that one of the available scanning mode choices in its software is called either "Advanced," "Expert," or "Professional." That is the mode we will use, and when discussed in this chapter, it will be referred to as "professional." For your work in photograph restoration and enhancement, you will need to use some specific options this mode will have that the

rest of the scanning mode choices your scanner software may have available will not. Don't be intimidated; you will be a professional in no time.

1.4 The Three Expert Scanning Options You Need to Know

When using a scanner in its professional mode, a variety of settings come to life that were most likely not available when in its Auto type mode for general scanning. The four scanning modes shown in Figure 1.8 are those of an Epson Perfection V700 Photo scanner.

Let's take a look at the typical main components of the professional mode as shown in Figure 1.9.

Full Auto Mode

Home Mode

Office Mode

• Professional Mode

FIGURE 1.8 Epson scanning modes.

Document Type: If a scanner includes the capability to scan transparency, Document Type is the option to choose that alternative document type rather than the default option of Reflective for scanning prints.

Image Type: This menu provides the option to scan photos in color or grayscale and choose its bit depth.

Resolution: Using its menu, a predefined resolution can be selected or an alternative can be typed in that is not listed as an option.

Many scanners include basic color adjustment options such as Auto Exposure and Tone Correction as shown by the icons under the Adjustments category in Figure 1.9. There is no need to be tempted to try to "color correct" scans using features such as these if they are available within your scanner specific software, as you will soon be using Photoshop to do that. You will need to become familiar with three of the other available

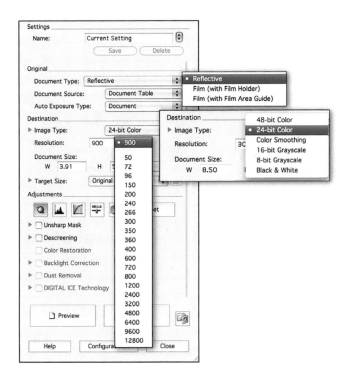

FIGURE 1.9 Typical professional mode scanning options.

features of a scanner's professional mode: how to crop the prescan to the actual size desired to scan at, how to choose the correct resolution to scan at, and what color depth, or bit depth to scan in.

Note

Although your scanner software may list its resolution settings as dpi, because Photoshop assigns resolution in ppi, all resolution calculations applied in this text will be in ppi. Additionally, when scanning black and white photographs, it is best to scan them in color, then convert the color to black and white within Photoshop. The process of converting color images to black and white will be discussed in detail in Chapter Nine.

1.4.1 Cropping an Area to Scan

Beginners often scan a larger area than they need to. The Prescan feature, available when using all flat

bed scanners in their professional mode, is designed to do a quick, low resolution scan. This allows us to define a dotted outline, referred to as a marquee selection, to delineate the specific area to scan at the chosen higher resolution instead of scanning the entire bed area of the scanner. If the photograph we want to scan is 4″ × 6″, for example, and we want all or only part of the image as the scan, after we apply the Prescan feature, the area to scan should be reduced from the full size of the scanning bed (8-1/2″ × 11″ for example) which will be chosen by default, down to only the outer dimensions of the desired final image area. We can adjust its dimensions by either typing them in an input area of the scanner software, or by grabbing and dragging the sides of the marquee selection to redefine its size if we want to scan the entire photograph, or smaller if only part of the image is desired, as shown in Figure 1.10. The dotted marquee selection perimeter defines the area of the prescan that will be scanned at the resolution chosen rather than the full bed area.

The 4″ × 6″ photo shown in Figure 1.10 was scanned at 300 ppi resulting in a high resolution copy of the same size. Most likely, if you already had a 4″ × 6″ copy of this photo, you would not be scanning it. You would probably be scanning it

FIGURE 1.10 Scanning area defined.

because you wanted to enlarge it. That's where our "final factor" comes in.

1.4.2 Choosing the Resolution to Scan At

If you have a 4″ × 6″ photo that you would like to enlarge, all you have to do is determine how many times larger you want the resulting print to be, then incorporate a little multiplication. If you would like to enlarge a 4″ × 6″ photograph to a 12″ × 18″ print, you want to make it three times larger: 4″ × 3 = 12″, 6″ × 3 = 18″. You have already learned that a high quality resolution is 300 ppi, therefore this 300 ppi must also be multiplied by three: 300 ppi × 3 = 900 ppi, meaning that you should scan the image at 900 ppi. The fact that you should scan it at 900 ppi is one of the reasons you need to work in the most professional mode of your scanner. When working in your scanner's professional mode, if it does not list the specific resolution you need as an option under in its resolution menu, an entry field to assign a specific resolution should be provided, or you should be able to highlight one of the existing ones listed, then change that number to the resolution needed such as 900 ppi, as shown in Figure 1.9.

Let's carry this concept further. The physical dimensions of the original photograph shown in Figure 1.11 are approximately 3″ × 2″ in size.

To enlarge just the girl sitting in the chair, a width and height for the original scan marquee selection area must be defined using the final factor based on the desired size of the resulting photo, which in this case was a 4″ × 6″ enlargement. A 1″ × 1.5″

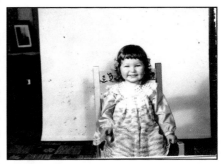

FIGURE 1.11 Original little girl.

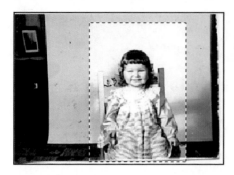

FIGURE 1.12 Prescan marquee selection of little girl.

area was defined in the prescan, as shown in Figure 1.12.

Using a multiplication factor of 4 (1″ × 4 = 4″, 1.5″ × 4 = 6″), the photograph needed to be scanned at 1200 ppi (300 ppi × 4) with the resulting high quality print shown in Figure 1.13.

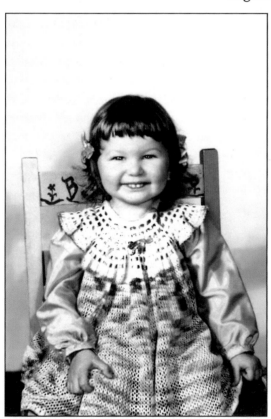

FIGURE 1.13 Enlargement of little girl.

1.4.3 Scanning Transparencies

The same multiplication factor we just learned to use when scanning prints, also applies when scanning film negatives and slides. The only difference lies in the fact that because the originals will usually be smaller, the required scanning resolutions will need to be higher, based on the final output size desired.

1.4.3.1 *Scanning a 4″ × 5″ Negative*

In order to be able to scan negatives, a scanner must be equipped with a transparency unit. How many different size film negatives can be scanned in addition to 35 mm negatives will depend on the model of the scanner. After loading the negative into the scanner's film holder that will be included with the scanner if it contains the transparency capability and choosing to scan transparency, the type of transparent film to scan (negatives or slides) must also be selected, as shown in Figure 1.14.

Figure 1.15 shows an old 4″ × 5″ film negative, with a 2″ × 2.5″ marquee selection defined in the prescan.

FIGURE 1.14 Selecting the film type.

To create a high quality 10″ × 8″ enlargement of just this defined area, the final factor was 4: 2.5″ × 4 = 10″, 2″ × 4 = 8″, 300 ppi × 4 = a required scanning resolution setting of 1200 ppi. A copy of the resulting high quality photograph is shown in Figure 1.16.

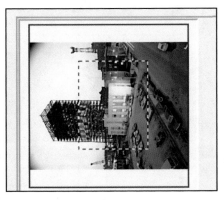

FIGURE 1.15 Hampshire Plaza building prescan selection.

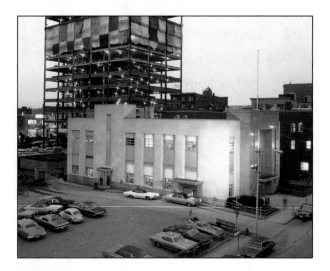

FIGURE 1.16 Hampshire Plaza 10″ × 8″.

Note

A common false assumption that many people make is that "over-scanning" (scanning higher than you need) will make the final enlargement even clearer. The image clarity is still limited to the output device (the printer), and choosing to have a higher scanning resolution than needed will only result in a larger, harder to manage file. Figure 1.17 shows an enlargement of the same prescan area of the film negative shown in Figure 1.15 scanned at 1200 ppi, resulting in an ending file size of 6.87 megabytes vs. one scanned at 2400 ppi, resulting in a file size four times larger: 27.5 megabytes. As we can see from the starburst detail of the construction lighting, quality improvements in the 27.5 M image are virtually impossible to be seen with the naked eye.

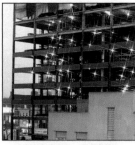
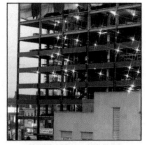

1200 PPI = 6.87 M **2400 PPI = 27.5 M**

FIGURE 1.17 Hampshire Plaza enlargement.

1.4.3.2 *Scanning 35 mm Negatives and Slides*

The Hampshire Plaza example used a $2'' \times 2.5''$ section of a $4'' \times 5''$ black and white negative. So what if you want to create an $8'' \times 10''$ print from an original as small as a 35 mm negative or slide? A common solution that you will hear is, "just scan it as high as your scanner will allow you to." We have just seen that file size and memory will become difficult to work with very quickly when working in large files. Instead of over scanning, the concept is still the same: the final factor multiplication rule we have already learned. The multiplication factor will simply need to be higher because the original is smaller. Figure 1.18 demonstrates this by showing a $1.0'' \times .8''$ marquee selection of a 35 mm color negative that when scanned at 3000 ppi generates the $10'' \times 8''$ enlargement at the 300 ppi final print quality desired.

COLOR
NEGATIVE:
1.0" x .8" MARQUEE
SELECTION SCANNED
AT 3000 (300 PPI X 10)
(1.0X10=10", .8X10=8")

RESULTING COLOR
ENLARGEMENT:
10" X 8"

FIGURE 1.18 Color negative to $10'' \times 8''$ enlargement.

1.5 An Introduction to Bit Depth

The third and final main consideration you need to know about when scanning photographs to work on in Photoshop, is something called "bit depth": not part of the mystery of resolution, but is an available setting in the professional mode of the scanner software and in Photoshop, and can seem when learning about it, to be somewhat of a mystery in itself.

1.5.1 8 Bits/Channel Versus 16 Bits/Channel Depth

As we have already learned, digital images are comprised of pixels. Bit depth refers to the number of "bits of color tones or values" used to produce the resulting color of each individual pixel of the image. The two most common bit depths are 8 bits/channel and 16 bits/channel. When referring to a grayscale digital image, 8 bit means that each pixel in the image contains 256 tones or shades of gray. When referring to an RGB color image, 8 bit means that each pixel will contain 256 color tones of each of the three colors it is comprised of: red, green, and blue, equaling a total of 16,777,216 bits of color information (256 red × 256 green × 256 blue), and is typically referred to as 24 bit color (8 bit × 3). 16 bit depth has 65,536 tones per pixel for grayscale, and three times that number for RGB color images. When scanning, 16 bit color is typically identified as 48 bit color (16 bit × 3 = 48 bit). By default, scanners will usually scan all images at 8 bit, which equates to 8 bit for a grayscale image, or 24 bit (8 × 3) for a color image. By changing the setting to 48 bit instead of 24 bit when working with color images, for example, the image will contain not millions of colors, but literally trillions. Although this might sound appealing, before deciding to plan to scan everything in 16 bit depth for grayscale or 48 bit for color, consider the resulting file size, the output device, and what you intend to *do* with the file

once it is opened in Photoshop. Because the image will contain more colors, a 16 bit depth grayscale or 48 bit depth color image will result in a substantially larger file that will be more difficult to work with. Additionally, because the output device (the printer) is limited by the number of colors it can print, it may not even have the capability to print the 16 bit grayscale or 48 bit color file. Furthermore, when working in Photoshop, some menu options will be grayed out because they are not designed to work with higher bit depth images.

> ### Note
>
> In Photoshop, if you scan a photograph at 48 bit color, and later decide you want to change it to 24 bit, you can do that with no negative ramifications. However, if an image is scanned at 24 bit color (or 8 bit grayscale), and later a bit depth of 48 bit (or 16 bit grayscale) is desired, the image should be rescanned at the higher desired bit depth rather than attempt to "fabricate" bit color in Photoshop.

At this point, are you wondering if there are *any* advantages to the higher bit depth? The answer to that question will lie in the type and severity of a particular photograph's color correction requirements. When applying color enhancement features in Photoshop, the additional color bits (or the additional tones that will produced at 16 bits/channel when working in grayscale) will provide more flexibility or "forgive-ability" in the editing process than the same image scanned at 8 bits/channel. Once we are working with color correction in Photoshop, we will compare and contrast an 8 bit grayscale image with the same image in 16 bit depth to better understand this concept. For most restoration and enhancement work, 8 bit grayscale and 24 bit color will be sufficient. You will be able to make "professional" decisions when scanning, resulting in prints and enlargements you will be proud to call your own as long as you remember the following:

- that bit depth and resolution are two very different parts of the puzzle

- that the most common bit depth is 8 bit which generates smaller, more manageable files

- that 8 bit is the one you will need for all the menu options in Photoshop to become available and for most printers to be able to output your photographs

- that between bit depth and resolution, the scanning setting you will be able to visibly see the most dramatic variation with (good or bad based on the selection) is resolution

1.6 Saving File Formats For Your Images

When saving a scan, although many scanners list other formats as well, the two most common image file format options (and the ones that will be discussed here) are TIFF (Tagged Image File Format: extension ".tif") and JPEG (Joint Photographic Experts Group: extension ".jpg").

1.6.1 TIFF File Format

When a file is saved in the TIFF format, the two most popular options to save the format into are to save with either no compression, or with something called: "LZW" (Lempel Ziv Walsh) compression. The LZW compression formula allows the image to be kept at the same original quality, but will be compressed to a smaller and more manageable file size (always a good decision). The TIFF format's LZW compression method is referred to as a "lossless" compression. What lossless means is that no matter how many times it is saved, no image data will ever be deleted.

1.6.2 JPEG File Format

In contrast to the TIFF file format, JPEG files are smaller (that's always good), however their method of

compression is "lossy." Every time the file is saved, a small amount of data is permanently removed from the file. A few saves will not necessarily be a problem but multiple saves while working with a photograph to restore or enhance it, could be. It is still a great, safe choice to save a scan in because we will be learning how to immediately convert a JPEG file to a PSD file (native Photoshop format ".psd") once it is opened in Photoshop which will stop the loss of data.

If you choose to save a scanned image as a JPEG, when prompted by your scanner software for the compression setting you want to apply, always choose the highest quality setting it provides.

When scanning, if files are saved as TIFFs instead of as JPEGs, once in Photoshop they can be left in that format, or converted to the native Photoshop file format of PSD to safely preserve the quality of all images from the time they are opened, and thereafter every time they are saved until the restorations and enhancements are complete. This best practice is the one we will use in our work.

1.7 Working With Images From Your Digital Camera

The resolution "final factor" and file saving formats we have just learned about for scanning are also applicable to images taken with a digital camera, and can be adjusted once the images have been downloaded, and then opened in Photoshop.

1.7.1 Downloading Your Digital Camera Images

In Photoshop, we will see how the same multiplication "final factor" that applies to scanning, also applies to downloaded digital images, based on the megapixels

that a camera can produce, and the quality setting chosen when the photograph was taken. For now, follow the instructions provided by the camera's manufacturer as to how to download your images, and be sure to download them to an easily accessible location on your hard drive for your work with them starting in Chapter Two using Photoshop.

> ## Definition
>
> **Megapixels:** "Mega" means "million" when referring to digital camera quality. A 12 megapixel (MP) camera will generate images consisting of 12 million pixels.

1.7.2 File Formats of Digital Cameras

Just as your scanner may have additional file format options besides the TIFF and JPEG formats, your digital camera may have multiple file formatting choices available with the most universal one being JPEG. JPEG is fine because as we have just learned, once in Photoshop, the first thing you will do is open the image and convert it to the PSD file format, preserving all of its data by transforming it from a "lossy" to a "lossless" file format: safe to work on throughout the numerous resaves required during its enhancement.

With a solid foundation in resolution, scanning, and downloading, we are ready to launch Photoshop.

Test Your Knowledge

1. Which file format is defined as "lossy"?

2. Using the final factor, what resolution should you scan a 2.5″ × 3.5″ photograph to enlarge it to a high resolution 5″ × 7″?

3. What do you need to remember about the resolution of two images you want to combine together?

4. What do you need to determine first before choosing a resolution to scan your photograph at?

5. What resolution should you scan a 4″ × 6″ photograph at if you would like to produce a high resolution 8″ × 12″ enlargement?

6. How many megapixels does a 8.2 MP digital camera have?

7. What is meant by a "lossless compression"?

8. What do the letters PPI stand for?

9. When scanning, what is the importance of a prescan?

10. A single pixel of an 8 bit grayscale image is comprised of how many color tones or shades?

Try It Yourself

Each chapter of this book will provide opportunities to reinforce your knowledge through practice exercises. Many times, a photograph that is worked on in some capacity during one chapter will be reworked in a later chapter. Before beginning the first exercise, create a folder on your computer, and assign the name "Photoshop practice" to begin saving your work in.

Project 1

Scan a vertical 4″ × 6″ color photograph of your choice, choosing the professional mode of your scanner.

1. Assign 24-bit color for the Image Type setting.

2. Crop an area in the prescan to 2″ × 2.5″.

3. Select the appropriate scanning resolution to result in a 8″ × 10″ enlargement at 300 ppi.

4. Save the file as: 8x10 color sample using the .jpg file format into your Photoshop practice folder.

 Project 2

Scan a 6″ × 4″ horizontal photograph (grayscale or color) of your choice.

1. Assign 8-bit grayscale for the Image Type setting.

2. Select the appropriate scanning resolution required to produce a high quality 18″ × 12″ enlargement.

3. Save the file as: 18 × 12 grayscale sample using the .jpg file format into your Photoshop practice folder.

2

AN INTRODUCTION TO WORKING IN PHOTOSHOP

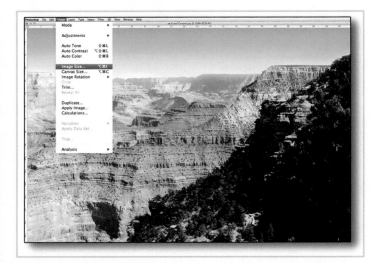

In This Chapter

- Explore a variety of ways to access files in Photoshop
- Learn to properly reassign image resolution
- Examine the key components of the Photoshop interface required for restoration and enhancement work
- Tailor key Photoshop operational preferences to your specific restoration and enhancement needs

Before we can start to work with any of its tools, we will need to learn how to open and save an image in Photoshop, convert its ppi, become familiar with the Photoshop interface, and learn to customize some of the Photoshop preferences applicable to restoration and enhancement.

2.1 Opening a File in Photoshop

To work in Photoshop, you must either create a new document from scratch, open an image saved on your computer, scroll through a menu to open an image you recently worked on, or open an image by finding it through Adobe Bridge©, (or through Mini Bridge, if your version of Photoshop includes it).

on the DVD A copy of each figure shown in this chapter can be viewed on the companion DVD included with this book.

2.1.1 Working in Photoshop CS6

This text is designed for Photoshop users of all versions of the Creative Suite© series. When a particular tool, menu item, dialog box, or technique we are learning has been modified in a newer version (such as changes and updates specific to CS6), both the new and former procedures will be discussed as they relate to our work.

2.1.2 File>Open Versus File>Open Recent Versus File>New

It is time to launch Photoshop on your computer. Once it is open, you will see its menu and tools displayed, ready for you to create or open a file to work on.

> **Note**
>
> If you are working in CS6, the interface opens using a black color theme by default. To unify the appearance of the interface across multiple versions of Photoshop, the samples used in this text were created using a lighter color theme interface, more comparable to the color theme applied to previous versions of the software. If you are working in CS6 and would like to change the default interface color theme to reflect the samples shown in this book, open the Preferences dialog box (**Edit>Preferences** in Windows, **Photoshop>Preferences** in Mac OS), and select its Interface category from the menu on the left. When the Color Theme buttons appear, four interface color schemes are available. Feel free to try them all. Choose and apply your favorite or select the one used in this text shown in Figure 2.1.

Preferences

General	Appearance		OK
Interface	Color Theme: ■■■□ **COLOR THEME CHOSEN**		Cancel
File Handling	Color Border		Prev
Performance			
Cursors	Standard Screen Mode: Default ⏷ Drop Shadow ⏷		Next
Transparency & Gamut	Full Screen with Menus: Default ⏷ Drop Shadow ⏷		
Units & Rulers	Full Screen: Black ⏷ None ⏷		
Guides, Grid & Slices			
Plug-Ins			

FIGURE 2.1 Assigning the light gray interface color theme in Photoshop CS6.

You are probably familiar with choosing the File menu from the main menu bar at the top of the working area, then scrolling down its menu and selecting New from using other software programs. Although Photoshop has the ability to create a new blank document using that same command, it is more commonly used as a photo-manipulation software, requiring you to open an existing photograph to restore or enhance.

If you have a photograph of your own that you scanned or downloaded that you would like to use, choose **DVD** **File>Open**, and locate the image. If you do not have one of your own yet, choose **File>Open**, and locate the Grand Canyon.jpg image provided on the accompanying DVD inside the Chapter 2 Files folder. Once it is open, notice that above the image it displays its name, a viewing percentage, and that it is a 24 bit RGB color image noted as "RGB/8," as shown in Figure 2.2.

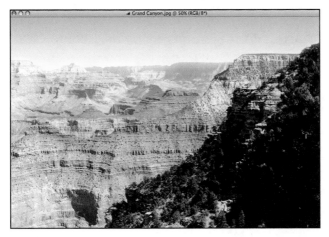
Grand Canyon.jpg @ 50% (RGB/8*)

FIGURE 2.2 Grand Canyon 24 bit color photograph at 50% identified as RGB/8.

> **Note**
>
> We learned in Chapter One that 8 bit RGB = 8 bit × 3, and that 8 bit Gray = 8 bit × 1. The area above the document window will always display what color mode and bit depth was assigned to the open image.

Let's close the file, but not exit/quit Photoshop. Now, from the File menu, let's choose Open Recent, and select the image we just opened instead of having to locate it as we did the first time. This menu option will display the last ten "most recently opened" files. Although by default, the **File>Open Recent** menu option will display the last ten files, this setting can be changed in the Preferences dialog box to list up to 30 of them, with the latest opened file at the top of the list. We will learn how to change this setting as well as some additional key Photoshop preferences later in this chapter.

Let's close this file one more time, so we can learn to locate and open it using Adobe Bridge.

2.1.3 Opening an Image by Using Adobe Bridge and Mini Bridge

When you installed Photoshop on your computer (CS2 and higher), a copy of the Adobe Bridge software (hereafter simply referred to as Bridge) was automatically installed as well (unless you did a custom installation and chose not to include it). You have just learned how to choose **File>Open** or **File>Open Recent** to locate a photo to work on wherever it is stored on your computer. Another option for locating an image saved on your computer is through this separate Adobe program. As you read this, you may be thinking, "I don't want to learn another program. I only want to learn the features of Photoshop I need for restoration and enhancement." Although Bridge has many useful features, it has three easy-to-learn ones that will improve your Photoshop efficiency in restoration and

enhancement, and are worth learning; referred to in this text as the "ABCs of Bridge." Let's check them out.

Choose File>Browse in Bridge from the menu bar at the top of the open window to launch this separate program. Once it is open, compare it to Figure 2.3, which identifies its "ABCs."

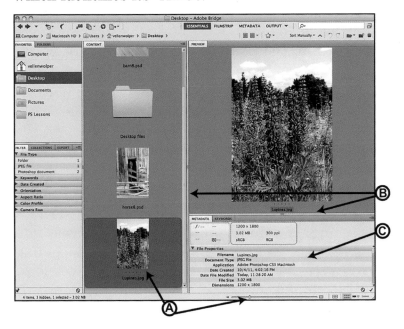

FIGURE 2.3 Bridge interface.

A. Its Content panel will display thumbnails of all the images and folders included in the folder selected from the default locations listed at the left side of the Bridge window. The size of the thumbnails displayed in this Content panel is controlled by the slider at the bottom right area of the Bridge window. As we drag this slider to the right, the folder icons, and any image previews that are displayed in the Content panel, become larger.

B. The two bars located at the left and bottom of the Preview panel on the right side of the Bridge window move independently when dragged, allowing us to enlarge the preview that displays when we select

one of the thumbnails from the Content panel. Depending how we adjust these two sides of the Preview panel relative to the Content panel, we will be able to view a sizable preview of an image before opening it. (Ever opened the wrong photograph because you were not sure which one it was?) Once we have selected a photo and viewed it in the Preview panel, we can open it either by double-clicking on its thumbnail in the Content area, or by Right/Control clicking on it in the Preview area and then choosing Open from the context-sensitive menu that appears. If Photoshop is already open, the selected image will immediately display in it. If it is not, selecting the image in Bridge will automatically launch Photoshop then open the image in it.

C. When an image has been selected, the File Properties category of the Bridge Metadata panel provides a potpourri of valuable information condensed into a small space with some of its highlights including the file type, date created, file size, pixel dimensions, physical dimensions, resolution, and bit depth. If you happen to have multiple copies of the same file at different resolutions, different bit depths, or created at different times, and are not sure which one you want to open by the names you gave them (such as version 1, version 2, etc.) , this valuable information can save you time and frustration by answering all of those questions with a single glance.

> **Note**
>
> Similar to Photoshop CS6, in Bridge CS6 the interface will open as a darker color theme by default which can be changed by selecting its Preferences (**Edit>Preferences** in Windows, and **Photoshop>Preferences** in Mac OS). Under its General category, four color themes are available to choose from (as shown in Figure 2.4) with the choice outlined in red that resembles the interface theme shown in Figure 2.3.

FIGURE 2.4 Selecting a color theme for Bridge in CS6.

2.1.3.1 *Mini Bridge in CS5*

Mini Bridge was added in CS5 to open a "miniature version of Bridge" within Photoshop. Although it does not include all of the features of the full version of Bridge, it can still be a handy method of quickly locating a file to work on. It can be accessed from the File menu by choosing Browse in Mini Bridge, or selected from the Application bar as shown in Figure 2.5.

FIGURE 2.5 Launching Mini Bridge in CS5 and accessing files.

2.1.3.2 *Mini Bridge in CS6*

In CS6, when Photoshop is launched, in the default Essentials workspace configuration, Mini Bridge is now automatically docked to the bottom of the document window, and displays as a horizontal panel by default. To access files using it, single-click on its tab to open it, double-click on its tab to close it. If it is detached from the document window, its appearance will be similar to the CS5 layout as shown in Figure 2.6.

MINI BRIDGE CS6

FIGURE 2.6 Launching Mini Bridge in CS6 and accessing files once it has been detached from the document window.

Now that you've mastered the ABCs of Bridge, and learned a little about its abbreviated version named Mini Bridge, open the Grand Canyon.jpg file or your own image this time by any of the methods you have been taught. Let's learn the first step of the restoration/enhancement process by saving a file in Photoshop.

A quick-and-easy keyboard shortcut to open an existing file in Photoshop is to press the Control/Command + "O" (the letter "O" for Open, not the zero key) on the keyboard, or add the Alt/Option key with it for a keyboard shortcut to launch Bridge.

2.2 Saving in Photoshop

Before working on an image in Photoshop, the first thing you should do is convert the image from its original saved format (such as .tif or .jpg) to the native Photoshop file format of .psd. Although not mandatory when working with .tif files, it will be easier when working with layers and channels, and because you have learned that you should convert .jpg files to .psd files for quality control, it is a great habit and best practice to simply start each project by opening the image, whatever file format it is in, and immediately saving it as a .psd before beginning to make any changes to it.

2.2.1 Saving a Before and After Version of Your Photograph

When saving an image you plan to work on for the first time, you should save the file twice: one with the file name plus the word "original," and one with the file name plus the word "restored" (when most of its work will be repair work) or "enhanced" (when most of its work will be to simply improve or enrich its appearance, such as its color or content). From a practical standpoint, once you begin working on the file, if you decide you want to start your project over again from the beginning, you will be able to do that. From an entertainment standpoint, it will be a great way to show off your talents to your friends and family by showing them a "before" and "after" version. It also adds to the fun of restoration and enhancement, and becomes a terrific confidence builder as you work on an image and periodically compare how much you have improved it.

2.2.2 Choosing the .psd File Format

As soon as you have opened your image, choose **File>Save As** to open the saving dialog box. Once it

is open, the original file format of the image will be prechosen by default under its Format category. Press and drag on the current file format name to select the Photoshop file format from the file formats provided under this menu. Among the file formats listed here, there are several with the word Photoshop as part of their name. Be sure to choose the one that says simply "Photoshop" as shown in Figure 2.7.

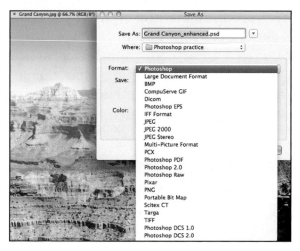

FIGURE 2.7 Saving in the Photoshop file format.

In the Save As dialog box, when choosing to save in the .psd file format, the specific Photoshop option you will want to select will always be the one at the very top of the Format menu.

Once you have selected Photoshop from this menu and named the file, locate where you want to save it on your computer then choose Save. Leave the rest of the available options that appear under the categories of Save and Color in this Save As dialog box at their default choices for now. We will cover some of these additional options as they relate to our restoration and enhancement learning in future chapters.

2.2.3 Saving Frequently When Working in Photoshop

In Photoshop CS6, an auto save feature has been added which allows you to choose how often it will automatically save the current open file for you in the File Handling category of the Preferences dialog box. (Preferences are discussed later in this chapter in detail, with this option detailed in Figure 2.20.) When working in Photoshop in *any* version, saving frequently by simply choosing Control/Command + S to avoid loosing your work in the event that Photoshop should lock up or crash, is an excellent habit to embrace in your work.

2.3 Converting Resolution to 300 ppi

Now that you have saved the copy of your image you are going to work on, let's learn how to correctly convert a 72 ppi image to a 300 ppi one. From the Image menu, scroll down and select Image Size as shown in Figure 2.8.

FIGURE 2.8 Selecting the Image Size dialog box.

When the Image Size dialog box opens, it will display the original resolution. Once you open this dialog box, if you see here that the image you have been using thus far is not 72 ppi (you may be working with a photo you scanned at a higher resolution, or using a photo from a digital camera that generates higher ppi images), save and close that file for now. Open the Grand Canyon. jpg file from the Chapter 2 Files folder if you have not already done so, and save it first as Grand Canyon_ original.psd, then as Grand Canyon_enhanced.psd into your Photoshop practice folder to walk through this next process.

As shown in Figure 2.9, the resolution of the newly saved Grand Canyon_enhanced.psd file is 72 ppi, however its physical dimensions (listed under the Document Size category) are width: 25″ × height: 16.667″. Let's check, then uncheck the Resample Image box. We can see that when it is *unchecked*, the pixel width and height dimensions at the *top* of this dialog box cannot be altered: that is what we want. With the Resample Image box unchecked, and Constrain Proportions *checked*, when

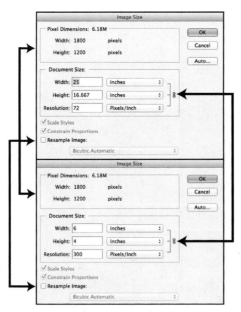

FIGURE 2.9 Increasing resolution.

the resolution of 72 ppi is highlighted and changed to 300 ppi, the document size (its physical dimensions) shrinks to 6″ × 4″.

Before we explore the opposite scenario, if you are working with a 72 ppi photograph downloaded from your own digital camera, its physical dimensions when viewed in this dialog box may be even larger than the Grand Canyon sample provided. If so, that's great. The starting size depends on the megapixels of the camera it was taken with: larger initial dimensions yield larger reduced dimensions when their resolution is increased from 72 ppi to 300 ppi.

Conversely, now let's examine how the "final factor" we learned about in Chapter One works when the ppi is reduced, which increases the physical dimensions of the image. Figure 2.10 compares the Image Size dialog box before and after changing the resolution of the little girl photograph from Chapter One. As we recall, the original scan selection was a 1″ × 1.5″ area, scanned at 1200 ppi (a multiplication factor of 4). Figure 2.10

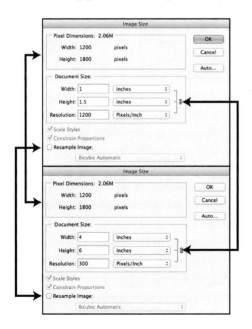

FIGURE 2.10 Decreasing resolution.

exemplifies that when the resolution was lowered, the physical dimensions were automatically increased. The result of the resolution reassignment yielded a 4″ × 6″ image at exactly 300 ppi. The critical component shown in both of these examples is that the Resample Image box *must* be unchecked, which keeps the total pixel dimensions the same: 6.18M, whether the resolution or physical dimensions are changed either up or down. Opening the Image Size dialog box with any image, and practicing changing its document size width and height, or its resolution to a higher or lower number, and observing how one affects the other (always being sure the Resample Image box is *not* checked), will help you to understand this concept even more.

2.4 Getting Comfortable With Photoshop

Once we have converted an image to the native .psd file format and adjusted its image size, it is important to learn a few key components of the Photoshop interface, learn to customize its workspace, and learn to set and reset some of its preferences related to the restoration and enhancement work we will do.

2.4.1 File Size

As shown in both Figures 2.9 and 2.10, the total pixel dimensions of an image determine its file size, with this number displayed at the very top of the Image Size dialog box. In addition to this location, any time an image is open in Photoshop, this same information is always displayed at the bottom left of the document window, in an area referred to as the status bar. In this location, the file size is shown twice with a slash between the two sizes. With the Grand Canyon_enhanced.psd file open, we can see that these two numbers echo the number that was displayed in the Image Size dialog box: Doc: 6.18M/6.18M.

To the right of these numbers is a small black arrow. If you press and hold on it, you can choose alternative information about the open file to display here instead of its document size

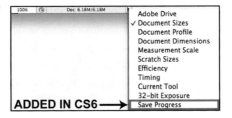

FIGURE 2.11 Status bar with document size and available status information options.

as shown in Figure 2.11. (The Save Progress option outlined in red is available only in CS6.)

For our work, we will keep the default option of Document Sizes selected at all times.

> **Note**
>
> The Document Sizes information listed in the status bar helps you keep track of file size as you work with an image. Initially, as shown with the Grand Canyon_enhanced.psd file, these two sizes will be identical. We will see the file sizes displayed here begin to change independently of each other with the number on the right reflecting the addition of layers and channels to an image, while the number on the left reflects what the file size will be if all layers are merged and all alpha channels are deleted.

2.4.2 Using the Options Bar

This tool accessory bar is displayed above the document window by default, but can be moved by pressing and holding on the tab located on its left side (if it is not showing, choose **Window>Options**). When any tool is chosen, this bar conveniently updates to display the current tool's customizable settings. Take a few minutes to click on a variety of the tools in the Tools panel, and watch the Options bar update to reflect the specific feature choices available for the tool selected. With the Brush tool chosen in the Tools panel, its settings become available in the Options bar as shown in Figure 2.12.

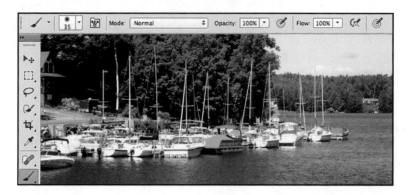

FIGURE 2.12 Options bar with Brush tool selected in the Tools panel.

2.4.3 Document Viewing Options

Working in Photoshop, you frequently need to magnify an area for precision corrections then to see the image either at a lesser magnification or small enough to view the entire image no matter how large it is (defined as the Fit on Screen view). Learning efficient ways to manipulate between different views of an image while working on it will improve both the time required to complete the project, as well as the quality of the result. With the Grand Canyon_enhanced.psd or any image open, let's learn how to view it using a variety of magnification methods and percentages.

2.4.3.1 *Toggling Between the Two Most Important Working Views of an Image in Photoshop*

The two most common ways we will want to view an image while working on it in Photoshop will be to view the photograph in the Fit on Screen view which displays the entire image as small as it needs to be to fit in the document window, and to magnify in to a specific area.

2.4.3.2 *Fit on Screen View*

When an image is opened in Photoshop, it defaults to opening at the Fit on Screen view. If you currently

have a photograph open, notice that this view displays the entire image proportionately within the document window area, regardless of how large or small its physical dimensions are. The top of the document window will display exactly what percent of the image you are viewing, which will be based on your monitor's size and resolution. This view is one of the most valuable ones we will use in our work as it will be extremely important to be able to compare how a correction we make in a particular area has affected the overall appearance of the photograph. When needed, the Fit on Screen view can be selected as a command under the View menu.

*An efficient way to return to the Fit on Screen view at any time while work-ing is to simply double-click on the Hand tool, located near the bottom of the Tools panel. (The Tools panel should be displayed by default, however if for any reason it accidentally disappears, choose **Window>Tools**.)*

2.4.3.3 *Increasing Magnification*

Professional restoration and enhancement work requires that you periodically enlarge the area you are working on for precision adjustments. There are a variety of ways to magnify in to work on a specific area of an image in Photoshop. One basic, straightforward way is to select the magnifying glass near the bottom of the Tools panel, named the Zoom tool. Depending on your version of Photoshop, you will be able to press and drag this tool upper left to lower right to create a marquee selection (a dotted outline like the one you saw in Figure 1.10 when learning about scanning) of the area you want to magnify in to, or simply press and hold the tool down in the area you want magnified, and have Photoshop "dynamically zoom" in until you let go of the tool. If you are not comfortable using the Zoom tool dynamically, you can also simply click on the page in the area you want to examine. Every time you click, your image will be magnified in by a preset increment until you reach the

size you want to view: up to 3200%. If you prefer, you can also choose the Zoom In command under the View menu to increase your view by the same preset increments.

Another way to zoom in is to type in a magnification percentage in the status bar area. As shown in Figure 2.11 to the left of the document size area, the current document magnification will be listed. This number can be highlighted and changed to any percentage view up to 3200%.

> **Note**
>
> When changing a view percentage in the status bar, after highlighting the number and the percent symbol, simply type the new number: the percent symbol will be added to the number automatically.

2.4.3.4 *Decreasing Magnification*

We have already learned how we can return to the Fit on Screen view. Sometimes, however, you may want to decrease your current magnification, without necessarily needing to return completely back to the Fit on Screen view. If you are using the Zoom tool, holding down the Alt/Option key will change the "plus sign" that displays on the tool to a "minus sign." Each time you click when the minus is displayed instead of the plus, the view will decrease by the same preset increments as it increased when clicked in its "plus" mode. Also, under the View menu, directly below the Zoom In command, is a Zoom Out command which when chosen will decrease the magnification by the same preset increments provided when engaging the Alt/Option key with the Zoom tool.

Additionally, when we select the Zoom tool in the Tools panel, two small magnifying glass icons appear in the Options bar: one of them with a plus sign on it, and one with a minus sign. These two tool options toggle: when we choose the Zoom tool *plus* icon in the Options bar to magnify in, we can alternatively click the Zoom tool *minus* icon to zoom out, and vice versa.

Another method to increase or decrease the current view using the same preset increments is to combine the Control/Command key with the "+" key on the keyboard to increase the view or zoom in, or combine it with the "-" key on the keyboard to zoom out.

2.4.3.5 *Moving Around Your Chosen Magnification*

While you are magnified in, you will oftentimes want to move around to other areas of your image at that same magnification percentage, rather than have to return to the Fit on Screen view, then magnify in again to another location. One way you can do that is the old standby method of the scroll bars. While these will work, using them can be awkward and time consuming. For a professional, there's a better way. Selecting the Hand tool, then pressing and dragging the mouse on the document in any direction when magnified in to any percentage higher than the Fit on Screen view, provides 360 degrees of directional flexibility.

Any time you are magnified in beyond the Fit on Screen view, you can temporarily convert your current tool into the Hand tool by simply pressing and holding down on the Spacebar without having to select the Hand tool in the Tools panel.

2.4.3.6 *Using the Navigator Panel*

Photoshop also contains a Navigator panel available under the Window menu, which provides both the convenience of multiple ways to magnify in or out of an image, and its own built in "hand tool" to easily move around the open photograph at the chosen magnification. The screen shot shown in Figure 2.13 details how this panel works. When its slider is dragged to the left or right, the view of the photograph decreases or increases with a red box identifying the chosen view of the image that is displayed in the document window. When we press inside this red box, a "hand" icon appears, allowing

us to drag it to move this same magnification percentage to another area of the image. The little "mountain peaks" to the left and right of its slider will decrease (left) or increase (right) the magnification percentage by the same preset increments that apply to the Zoom tool and the Zoom In, Zoom Out command options. At the bottom left of the Navigator panel is a percentage area identical to that located in the status bar area of the document window, which can be highlighted to alternatively type in a specific percentage to view. Perhaps your Navigator panel size does not look quite like the one shown in Figure 2.13. When your mouse is placed near an edge of the panel, double arrows appear allowing you to press and drag to enlarge or reduce the size of the panel to fit your needs.

FIGURE 2.13 Navigator panel.

Which zoom method is the best one to use? Which method of moving around a zoomed-in area is the best? The answers to these questions are a matter of personal preference. Excluding the scroll bars, as you continue to work in Photoshop, you will find which methods work the best for you.

2.4.4 Working With Panels and Customizing Your Workspace

In addition to the Options bar that provides settings specific to the tool selected, Photoshop contains an assortment of panels that provide the foundation of

its image editing power. Depending on the version of Photoshop you are using, some of its panels may be open automatically in its default workspace configuration, or will be tucked away and visible only as an icon in a row at the far right of the document window, until the panel's identification icon is clicked on. However they are displayed, they can also all be accessed under its Window menu. We will learn how to group together the panels we will use the most with restoration and enhancement, how to hide ones we will rarely use, how to save a custom workspace with your personal configuration of panels, and how to return the workspace back to its default appearance, if desired.

2.4.4.1 *Separating and Grouping Panels*

When you select the name or icon of a panel in Photoshop, it will most likely be part of a "dock."

Definition

Dock: A dock is a group of panels "nested" together, layered like folders, with one of them active, and the others in the group grayed out. A dock is a convenient feature. When you click on the name tab of one the panels in the group, it will toggle and become the active panel minimizing the room needed to display panels, which provides more working area for the user.

Three panels in Photoshop that you will use the most in restoration and enhancement work will be the Layers panel, the Channels panel, and the History panel. Locate the Layers panel. If you do not see it already open, choose **Window>Layers**. When it opens, typically, it will be part of a dock also containing the Channels and Paths panels. Our restoration and enhancement work will require both the Layers and Channels panels; we will not be using the Paths panel. To remove this panel from the dock, let's press and drag on its name tab to pull it away from the other two as shown in Figure 2.14.

FIGURE 2.14 Removing the Paths panel from the dock.

FIGURE 2.15 Adding the History panel to the Layers and Channels panels dock.

Once it is separated, click on its close button to hide it. Now locate the History panel. If it is not already visible on the right side of the document area, open it by choosing **Window>History**. When it opens, whether it is part of another dock or opens by itself, drag its name tab onto the top of the Layers and Channels panels' name tab until a blue border appears around the group. As soon as the blue appears, release the mouse. The History panel will now be part of the dock which includes the Layers and Channels panels, as illustrated in Figure 2.15.

2.4.4.2 *Saving Your Personal Workspace Configuration*

The Layers, Channels, and History panels will be the panels you will use the most for your professional restoration and enhancement work. You can keep this collection of panels open and choose to close/hide all the rest of the panels if you would like more document work area. Any time you hide a panel then show it

again, simply select its name from the Window menu. Following this same procedure, as you continue to gain experience in Photoshop, feel free to rearrange the configuration of any of its other docks to better fit your personal working style.

When you rearrange docks, the new configurations can be saved as a separate custom workspace that you can name and select to work from any time you want that special arrangement of panels. Let's create a custom workspace for the arrangement we just made for restoration and enhancement. From the Window menu, choose **Workspace>New Workspace**. In the dialog box that opens, type the name: "MY R AND E" (workspace names are not case sensitive), leaving the rest of the options blank (we will not need to save custom menu configurations or custom keyboard shortcuts) as shown in Figure 2.16.

Once you have done that, your personal workspace will be listed with the rest of the available options

FIGURE 2.16 Saving a custom workspace.

when you choose **Window>Workspace**. As you work, if you create more custom panel configurations while in your personal space, simply choose **Workspace>New Workspace**, pick out your saved space and choose to replace it when prompted. If you want to delete it, you must select a different workspace from the list to use first, then your custom workspace will be available when you choose **Window>Workspace>Delete Workspace.** Any time you want to return to the default panel configurations, depending on your version of Photoshop, select Essentials, or simply Default Workspace from the **Window>Workspace** menu option.

2.4.5 Using Guides and Rulers

When Photoshop opens, it does not display rulers by default. Rulers and guides will oftentimes be extremely helpful in your restoration and enhancement work. To use them, you must first choose **View>Rulers**. Rulers will then appear along the left and top edges of the document window. A variety of units of measurement are available with the default measurement system being inches. For our usage, we will not want to change that.

A document must be open to access rulers from the View menu, and rulers must be visible to be able to add guides to your work. Once you have made the rulers visible, placing the cursor inside one of them and then dragging across the document will bring in a light teal colored positioning guide. As you drag a guide from left to right across the image from the vertical ruler on the left side of the document window, a corresponding vertical line will appear inside the horizontal ruler above the image identifying its exact location. Correspondingly, if you press and drag down from inside the horizontal ruler located across the top of the document window, its location will be visible as a horizontal line within the vertical ruler on the left side of the document window. Figure 2.17 exemplifies a typical handy use of guides (the guides have been changed to red for demonstration purposes only). This client-supplied image was slightly crooked when it was originally scanned. Adding guides is one way to assist in the straightening of this image prior to beginning the work on its restoration.

When adding guides, it will be helpful to magnify in to a high enough percentage to clearly see the ruler increments to position the guides accurately. As you magnify in, the rulers enlarge along with the image for precision assignment.

FIGURE 2.17 Photograph with positioning guides added.

2.4.6 Undoing Your Actions

When working in other software programs, if you need to undo a step you have just done, choosing its **Edit>Undo** command usually allows you to do that. Although Photoshop includes the one step Undo command as well as a Step Backward command for multiple undoes under its Edit menu, it also provides a highly sophisticated History panel that not only allows you to revert back multiple steps, but also describes the steps, so you can select exactly how far back you want to revert to. If you have been following along in this chapter using either the Grand Canyon file or your own, when you access the History panel by clicking on its tab, or by choosing **Window>History**, it will show that the original file was opened, followed by some type of change in the image size dialog box. In Figure 2.18, the History panel in CS5 is shown on the left, with its new updated look in CS6 on the right.

FIGURE 2.18 History panel with the Grand Canyon image resolution changed in CS5 vs. CS6.

This panel will not list actions such as saves, reconfiguring docks, or creating custom workspaces, but will sequentially list each time content changes are made to the file through a tool or menu command. Although the History panel has two possible working modes, let's learn to work in its default, easy to follow Linear mode, which means that each new step (referred to as a "state") will be listed below the previous one, recording a default number of the last 20 states. After that point, the first state at the top of the list is deleted. However, you may soon find 20 states is not enough and you want to return to a state further back than the 20 saved by default. The number of history states can be changed to save up to 1,000 if you have enough RAM to hold all of them. The details of how to change the number will be discussed in the Preferences section of this chapter. For now, let's learn how to use its undo feature, by clicking on a previous step. With the Grand Canyon photo or your own photo still open, choose **Image>Image Size,** and change the resolution to anything you want, then choose OK to close the dialog box (not to worry, we'll be undoing this change). Refer to the History panel. It will now list "Image Size" a second time, below the listing identifying the first time you opened that dialog box. If you click instead in the text area of the "Open" state at the top of the History panel's list (*not* in the check box to the left of it), then reopen the Image Size dialog box, you will see that the file has reverted back to its original resolution before you changed it from 72 ppi to 300 ppi.

Notice in the History panel that the two states below the Open state are now still visible but are grayed out, and their description text has become italicized. A grayed state with italicized text indicates that we can select it to return to that stage of our work such as the first Image Size state (the one we changed from 72 ppi to 300 ppi). However, as soon as a change is made to a state we return to, all states below it disappear. To return the Grand Canyon image back to its 300 ppi resolution, click in the text area of the first Image Size listed in the History panel to reverse any changes you may have made the second time you opened the Image Size dialog box.

Note

To the left of the text area of a state (the description of the step) is a small check box that is used in conjunction with the History Brush (a tool we will never use in our work). To select a state to return to, always click on the text describing the activity you want to return to, which will activate that state and highlight it in color.

2.5 Setting and Resetting Preferences

Photoshop contains an extensive collection of operational preferences. Additionally, any time a tool or command setting is changed, Photoshop records that change as a new default for that specific tool/command.

Definition

Preferences: Options provided within a software that allow the user to customize a variety of its appearance and performance features.

2.5.1 Customizing a Few Photoshop Preferences

We have already learned that the Photoshop Preferences dialog box can be accessed by choosing **Edit>Preferences** in Windows, or **Photoshop>Preferences** in Mac OS to change the

interface color theme in CS6. We have also learned that the CS6 Auto Save recovery feature is customized in the Preferences dialog box. In addition to these, a few of its preferences that are available in all versions of Photoshop CS are particularly applicable to our restoration and enhancement work, and worth learning how to customize them. Let's open the Preferences dialog box now (**Edit>Preferences** in Windows and **Photoshop>Preferences** in Mac OS). When its dialog box opens, it contains an extensive list of categories, in which each one provides a number of features included within it that can be overwhelming and intimidating. In addition to the CS6 Auto Save recovery option, let's learn to customize four more features applicable to our work: Animated Zoom, Recent File List, Maximize PSD and PSB File Compatibility, and History States.

- Animated Zoom: If your version of Photoshop has this dynamic enlargement option that automates the zoom process when you hold down the Zoom tool, it will be listed under the General category. Here is where you can uncheck the feature if you are not comfortable using it as shown in Figure 2.19.

FIGURE 2.19 Enabling and disabling the Animated Zoom feature.

The Zoom tool will continue to work with this function unchecked, it just will no longer "power zoom" when you press and hold down on the tool.

- Automatically Save Recovery Information: The Auto Save feature in CS6 is designed to save a backup copy of your file by the frequency you

assign under the File Handling category, choosing to backup every 5, 10, 15, 30, or 60 minutes. In the event that Photoshop crashes, the backup temporary file will open when Photoshop is relaunched. This feature is activated by default, but can be unchecked to disable it, if desired. As we have learned, regardless of any auto save capability your version of Photoshop may or may not have, saving frequently is a great habit to learn, and best practice when working in Photoshop.

• Recent File List: This option is located under the File Handling category. You have already learned that the ten most recently opened files will be listed under the Open Recent option of the File menu: here is where that number can be changed to any number up to 30. It is not necessary to remember how high a number you can type in here, if you type a number higher than 30, a dialog box will tell you that the limit is 30, and automatically change whatever number you had entered down to 30 for you.

• Maximize PSD and PSB File Compatibility: This option is also located under the same File Handling category. Three choices are provided: Never, Always, and Ask. This preference assures that if your file is opened at some point using a previous version of Photoshop, or perhaps a different program altogether, that new features available in the version it was created in will display in the program opened, flattened without layers if needed, but will still display. Because you may never know down the road what you may want to do with files you are creating now, choosing its Always option is a safe recommendation. Both the Recent File List and Maximize PSD and PSB File Compatibility options, available in all versions of CS are shown in Figure 2.20, in addition to the Auto Save recovery option introduced earlier, which is available exclusively in CS6.

FIGURE 2.20 Choosing options for backwards compatibility, and recently opened files in the Preferences dialog box, and selecting the auto save schedule in CS6.

- History States: This setting is located under the Performance category (CS3 and higher, General category before then). You have just learned that the default number of linear states is set to 20 states. Although this number can be changed to any number up to 1,000 states, be aware that your computer must hold all those states in RAM. A great number to change this to which provides tons of flexibility without tons of memory use is to set this number to 200 states as shown in Figure 2.21.

FIGURE 2.21 Assigning the number of history states.

2.5.2 Resetting Photoshop Settings

In addition to the preferences we have just customized, when working in Photoshop any time a brush

or fill opacity, blending mode setting, etc. is changed, that setting becomes the new default the next time the same feature is chosen. It's a very handy feature for experienced users but oftentimes an extremely puzzling and frustrating one for beginners. It is a great habit when first learning Photoshop to start each session by returning these settings back to their defaults. Taking the time to do this before opening a project to work on will eliminate confusion and frustration when a tool does not perform as you expect it should because you did not realize that its factory default settings had been changed the last time you worked in Photoshop.

If you have been following along in this book, and have Photoshop currently open, choose first to exit/quit the program. Now before choosing to relaunch it, position (don't press yet) three fingers over the following keys on the keyboard first: Control+Alt+Shift if working in Windows, or Command+Option+Shift in Mac OS. Once you have your fingers over those keys, click to launch the program, then *immediately* press and hold those three keys down simultaneously until the message shown in Figure 2.22 appears while Photoshop is launching.

As soon as this message appears, you can let go of the three keys, and click "Yes" to finish the program launch. If you have done the process correctly, the delete message appears almost instantly after you click to launch the program. If it does not come up right away, you will need to let Photoshop finish launching, then exit/quit and try again. Don't get discouraged if it takes you a few tries to get the timing right. It will be well worth it when you do.

Once Photoshop opens after you have reset its preferences, you will notice that you no longer have anything

FIGURE 2.22 Deleting the Photoshop settings file.

listed under its **File>Open Recent** category, and that all your customized preferences of history states, and compatibility, etc. have reverted back to the defaults. A bit of a hassle to reset them again (think positive: you'll become a preferences setting pro in no time), but tool setting changes will also be reset, and in the learning stages that can be invaluable.

What about our "MY R AND E" custom workspace? That actually gets saved in a different spot in Photoshop, not with its settings preferences. Even though resetting the preferences will convert the current workspace back to the default, once Photoshop is relaunched, under **Window>Workspace**, MY R AND E will still be listed, and can be reselected.

Let's take a little time to practice what we have learned before moving on to mastering professional selection techniques in Chapter Three: a critical component of professional restorations and enhancements.

▉ Test Your Knowledge

1. What is the name of the dialog box used to convert resolution?

2. When converting resolution, the Resample option must be checked or unchecked to change the resolution while maintaining the original pixel dimensions?

3. Where is the status bar located in the document window?

4. Under what main menu can you choose to display rulers?

5. What three keys do you need to hold down at the same time to reset the Photoshop preferences?

6. When the resolution of an image is changed to a higher number, how does its physical dimensions change?

7. How do you remove a panel from an existing dock?

8. What is the name of the document view that will allow you to see your entire photograph, regardless of its size?

9. What are the steps required to save your personal custom workspace?

10. When preferences are reset back to their defaults are custom workspaces deleted?

Try It Yourself

Project 1

Open your 8 × 10 color sample.jpg file from Chapter One.

1. Open the **Image>Image** Size dialog box, and adjust your resolution being sure that the Resample box is unchecked.

2. When changed, your photograph should now have physical dimensions of 8″ × 10″ with a resolution of 300 ppi.

3. Save your file now as 8 × 10 color.psd.

Project 2

Open your 18 × 12 grayscale sample.jpg file from Chapter One.

1. Open the **Image>Image Size** dialog box, and adjust your resolution being sure that the Resample box is unchecked.

2. When changed, your photograph should now have physical dimensions of 18″ × 12″ with a resolution of 300 ppi.

3. Save your file now as 18 × 12 grayscale.psd.

Project 3

Open the photograph named House.jpg provided in the Chapter 2 Files folder.
In preparation for its restoration:

1. Save it twice: once as House_original.psd, and once as House_restored.psd.

2. With the restored version active, choose **Image>Image Size** and change its resolution from 1200 ppi to 300 ppi, being sure that the Resample box is unchecked.

3. Choose to display your rulers if they are not already visible (**View>Rulers**).

4. Drag in positioning guides to the top, left, and bottom sides of the photo.

5. Save the file into your Photoshop practice folder for future use.

Project 4

Open the photograph named White Dog.jpg provided in the Chapter 2 Files folder.
In preparation for its enhancement:

1. Save it twice: once as White Dog_original.psd, and once as White Dog_enhanced.psd.

2. With the enhanced version active, choose **Image>Image** Size and change its resolution from 72 ppi to 300 ppi, being sure that the Resample box is unchecked.

3. Save the file into your Photoshop practice folder for future use.

3 SELECTION

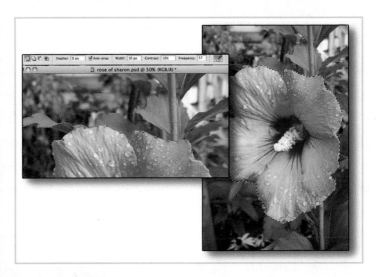

If a restoration or enhancement project requires a selection, the quality of the selection will ultimately define the quality of the resulting restoration. After an introduction to the selection process, this chapter will explore a variety of selection methods, with an emphasis on selection techniques that combine efficiency with accuracy.

3.1 The Importance of Selection

Professional photograph restorations and enhancements begin with professional selections. You have learned that digital images are comprised of pixels. Many times, not all the pixels in an image should be affected by your digital alterations. Although some of the tools in Photoshop allow you to directly alter the pixels you apply them to, much of your work will require you to isolate an area to affect. Because of this, before you can learn specific digital restoration and enhancement techniques, it is paramount to first master the craftsmanship of precision selection. When required, selections that accurately and efficiently include only the pixels you need to modify will define the quality of your resulting projects. The ones you will be proud to call your own.

3.2 The Principle of Selection

Definition

Selection: When working in Photoshop, a selection is an area isolated for alteration, identifiable by a boundary comprised of a moving dotted outline. Any content contained within this area will be affected by the change you make. The area outside the moving dotted outline will be protected.

A selection is used when a restoration or enhancement project requires improvement to only part of the image, not the photograph in its entirety. A variety of tools can be used, either singularly or integrated, to produce professional selections. We will explore the Marquee tools, the Lasso tools, and the Quick Selection and Magic Wand Selection tools. We will also learn how to tweak the accuracy of our selections using a variety of methods,

and how to save our selections for future refinement and application when needed.

The Chapter 3 Files folder on the accompanying DVD includes a variety of images, with each photograph chosen for its suitability for learning one or more of the selection tools or methods to be covered in this chapter. If a specific image from the supplied photographs is recommended when learning a particular tool, feel free to substitute your own image if you have one with characteristics that echo the image being used in the specific exercise.

3.3 Understanding the Anti-alias Option

When using most of the selection tools in Photoshop, the Anti-alias option will be available and turned on (checked) by default in the Options bar as shown in Figure 3.1.

FIGURE 3.1 Anti-alias checked in the Options bar.

A copy of each figure shown in this chapter can be viewed on the companion DVD included with this book. **DVD**

Definition

Anti-alias: An option available in Photoshop that will generate "softening" transition pixels along the edges of a selection, eliminating the grid appearance inherent in any digital image without blurring or compromising its accuracy.

We learned in Chapter One that a digital image is comprised of pixels: squares of color, arranged in a "grid" type fashion. Unless you create a rectangular, square, or single-row/single-column selection of pixels that will "follow" this grid by design, the edges of all other selections must conform to the nearest grid edge. Figure 3.2 exemplifies this problem. In the original photograph, a red rectangle indicates the general area from which the enlarged selection below it was made. With the anti-alias feature turned off, the "roundness" of the tire in the enlarged selection is restricted by the pixel grid, resulting in an unattractive choppy edge.

ANTI-ALIAS OFF

FIGURE 3.2 Sample with the anti-alias option turned off.

Figure 3.3 shows the same enlargement of the tire area with the anti-alias feature turned on. Fortunately

the anti-alias option is turned on by default. After reviewing this example, you will most likely never want to uncheck it, and most importantly now that you understand what it does, if it ever accidentally gets turned off, you will be able to diagnose the problem.

ANTI-ALIAS ON

FIGURE 3.3 Sample with the anti-alias option turned on.

3.4 Marquee Selections

If you have reset the preferences for Photoshop, the Tools panel will be displayed at the left side of the document window. However, if it is not visible now, or at any time, choose to either reset your workspace, or select **Window>Tools** to display it. At the very top of this panel is the Move tool which we will learn to use in Chapter Four. Right below this tool are the Marquee tools. "Tools," because if you press and hold the mouse down on whichever one is currently displayed, you will see in the extended menu that appears, your chosen tool is actually part of a group of four Marquee tools. The visible one you pressed on will be shown with a small black square to the left of it with three other Marquee tools available to choose from by holding the mouse down and scrolling over to highlight the one

FIGURE 3.4 Marquee tools.

you want to use instead, as shown in Figure 3.4. When tools are grouped together in this fashion, the nonvisible ones are defined as "nested" with the active tool in the group.

> **Note**
>
> A small black triangle in the lower right corner of any tool visible in the Tool's panel signifies that it is part of a group containing at least one additional tool or variation of the active tool.

3.4.1 Rectangular Marquee Tool

on the DVD As its name implies, the Rectangular Marquee tool draws rectangular or square selections. To learn to create a selection using this tool, begin by opening any photograph provided in the Chapter 3 Files folder, or one of your own. Once it is open, let's select the Rectangular Marquee tool from the Marquee tool group. Once it is selected, let's press and drag diagonally down across the image. The selection will be created starting with its upper left corner by default, and will be completed when we release the mouse; its size and shape determined by the length and direction of our drag.

> **Note**
>
> In CS6, a small information box will appear to the right of your marquee tool anytime you draw or transform a selection, dynamically updating to reflect the size the selection will be if the mouse is released at that time. The location and visibility of this box in relation to the selection can be changed under the Interface category of the Preferences by choosing an alternative from the Show Transformation Values pop-up menu.

Under the Edit menu, let's select the Fill command. In the dialog box that opens, let's choose Black from the Use pop-up menu, leaving the rest of the options at their default settings as shown in Figure 3.5. Then click OK to complete the fill. To eliminate the moving dotted

outline around our filled area, we can click anywhere outside the selection, or choose **Select>Deselect**.

FIGURE 3.5 Rectangular marquee selection filled.

A quick and easy way to deselect a selection is to hold down the Control/ Command key while pressing the letter "D" (D for Deselect) key on the keyboard.

This simple exercise demonstrated the creation of a rectangular selection, as well as the rationale behind selection. Only the area enclosed within the drawn selection was affected by the change; the command to fill using black. We have learned the value of the History panel. Let's use it now to return to the opening state of our image and to disregard the selection and fill that we just made.

3.4.1.1 *Additional Rectangular Marquee Tool Options*

To create a square selection instead of a rectangular one, we need to simply hold down the Shift key as we draw to constrain our selection to an equal sided one as it enlarges. To keep our square proportional, the mouse must be released *before* the Shift key when we have finished drawing the size that we want. To draw from the center outward instead of upper left to lower right, press the Alt/Option key down before beginning to draw, and keep it held down until the shape has been completed. To draw a square starting from the center (yes, it is as you may have guessed), hold down *both* the Shift and the Alt/Option keys at the same time when pressing and dragging on the photograph.

3.4.2 Elliptical Marquee Tool

Nested with the Rectangular Marquee tool is the Elliptical Marquee tool. This tool functions the exact same way as its counterpart. It draws upper left to lower right by default while adding the Shift key to draw perfect circles, adding the Alt/Option key to draw from the center, and combining the Shift and Alt/Option keys to draw a perfect circle from its center outward. However, unlike the Rectangular Marquee tool, when choosing the Elliptical Marquee tool, Anti-alias will be prechosen in the Options bar, and as illustrated in Figure 3.3, is usually best practice. However, if you ever did *not* want it applied to a selection, it must be unchecked *prior* to drawing. Because each tool's setting change becomes its new default, after unchecking Anti-alias in the Options bar, it will not be reapplied until the option is rechecked before the tool is used the next time, or until the preferences are reset.

3.4.3 Single-Row, Single-Column Marquee tools

Just as their names imply, these tools select only a single row or column of pixels depending which one

you choose. To use either one of these tools, select the tool from the Marquee tools group, then single-click on the page. Although these tools can be handy for specific selection needs, they are not commonly applicable to restoration and enhancement work.

3.5 Improving an Existing Selection

Because you have learned that your goal should always be to create the most accurate selection possible, before being introduced to the rest of the selection tools and methods you will use in your work, let's learn how to improve an existing selection. Without having to redraw it, any selection can be refined by adding to or deleting from its content, transforming it, feathering it, contracting or expanding from its perimeter to eliminate the unwanted appearance of a "border" around it, or improved using the Quick Mask Mode.

3.5.1 Using the Add To Selection, Subtract From Selection, and Intersect With Selection Options to Improve a Selection

When experimenting with the Marquee tools, you probably discovered that as soon as you started to draw a new selection, or tried to reshape the one you had just drawn, that the selection disappeared even without having chosen **Select>Deselect,** or Control/ Command+D. To add to any active selection (identifiable by its moving dotted outline), click on the Add to selection icon in the Options bar first, then draw again on the photo. This icon, identified by two boxes "merged" together as illustrated in Figure 3.6, becomes available in the Options bar when a selection tool is chosen.

When using the Add to selection option, the active selection tool will display a small "plus" sign to the right of its icon, indicating that you will be adding to your existing selection when you draw with it. Let's

FIGURE 3.6 Add to selection, Subtract from selection, Intersect with selection icons.

draw a box using the Rectangular Marquee tool, and while it still has its moving dotted outline, click the Add to selection icon in the Options bar. Now when we begin to draw again, we will be adding to, rather than replacing, the existing selection.

Deleting from a selection will follow the same procedure. With our selection still active, let's click on the icon directly to the right of the Add to selection icon in the Options bar, appropriately named Subtract from selection (also illustrated in Figure 3.6). The Rectangular Marquee tool now displays a small "minus" sign next to it. When we draw another rectangle that covers part of the first one, the original selection remains active with the newly drawn area that overlaps deleted from it.

To the right of the Subtract from selection option in the Options bar is the Intersect with selection alternative. As illustrated by its icon, also shown in Figure 3.6, if this option is activated when a selection already exists, the icon will display a small "x" next to it, signifying that when a second selection is drawn that *overlaps* the active one, *both* original selections will be replaced by a single new one comprised of only the area where the two original selections overlapped. Feel free before continuing to try this option as well to better understand its possibilities.

With any selection active, if the Shift key is held down when you begin to draw again, it will temporarily engage the Add to selection feature without having to stop and select it in the Options bar. The "plus" sign will be added to the right of the tool while the Shift key is held down, and the Add to selection button will become automatically depressed in the Options bar without having to click on it. Alternatively, holding down the Alt/Option key

instead of the Shift key will temporarily convert the current selection tool to the Subtract from selection mode when drawing without the need to select it first from the Options bar. And as you may have guessed, the Intersect with selection option can also be temporarily accessed by holding down both the Shift and the Alt/Option keys simultaneously while drawing without having to choose its icon from the Options bar.

3.5.2 Transforming a Selection

Any selection can be resized using traditional bounding box handles. With one active, choosing **Select>Transform Selection** will add eight transformation handles around it; one in each corner and center of its sides. Pressing and dragging on a center handle will enlarge or shrink the side you have selected, while grabbing a corner handle and dragging it diagonally in or out will affect both the height and width of the selection. If you hold down the Shift key as you drag a corner handle, the sides of the selection will increase or decrease proportionately. If you hold down the Control/Command key as you drag a corner, that corner will move independently of the other three corners for additional customization. To complete a selection transformation, click the check mark that appears in the Options bar when this command has been selected. Figure 3.7 exemplifies customizing an active Rectangular Marquee selection by first choosing the **Select>Transform Selection** command, then holding down the Control/Command key and dragging each corner bounding box handle individually as needed.

Anytime the check mark appears in the Options bar to complete a task, instead of clicking on it, the task can alternatively be completed by pressing the Enter/Return key.

The image used shown in Figure 3.7 is the same one you saved as House_restored.psd in Project 3 of the Chapter Two "Try It Yourself" exercises if you would like to practice this now.

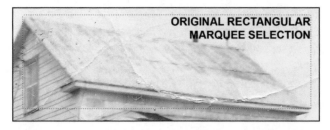

FIGURE 3.7 Customizing the Select>Transform Selection command.

③⑤③ Feathering a Selection

Definition

> **Feather:** An option available in Photoshop which transitions selection edges to transparency by blurring them, based on a pixel radius setting.

Unlike the anti-alias feature which eliminates the choppy perimeter of a selection by adding transitional pixels that soften its edges while maintaining the selection's original size and detail, feathering also creates the visual effect of a soft edge but does so based on a user-assigned "fade rate" which blurs its edges to transparency.

Figure 3.8 compares a selection with anti-alias only applied, to one with the anti-alias option on, *plus* a feather radius of two pixels. When examining the edges of the two selections, the image on the left has sharp crisp edges without a choppy appearance, while the feathered one on the right, even with a very small radius assigned, additionally displays a less-defined edge due to the blur created by the feather.

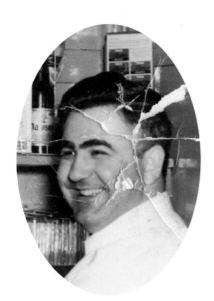 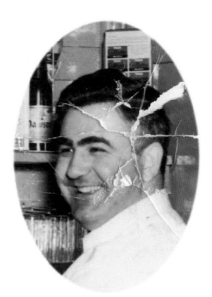

ANTI-ALIAS ONLY **ANTI-ALIAS WITH FEATHER**

FIGURE 3.8 Anti-alias applied vs. anti-alias and feather applied.

When any one of the Marquee or Lasso tools is selected, the Options bar provides an entry field that allows you to type in a feather amount in pixels. If assigned here, it must be assigned prior to creating the selection, but then will automatically be applied any time the same tool is selected after that, until its current setting is deleted in the Options bar, or the preferences are reset. Rather than pre-assigning a feather before creating a selection, one can always be applied to any active selection, regardless of how it was created, by using the Feather Selection dialog box. With any selection active at any time, choose **Select>Modify>Feather** to assign

a feather radius of pixels to it. When assigned here, the default setting of 0 px in the Options bar will not change, which you may find easier as not all selections should have a feather applied to them.

> **Note**
>
> Assigning a feather radius is relative to the resolution of the image it is applied to. A low resolution image, such as one with 72 ppi, will need a much lower number feather value assigned to achieve the same final blurred appearance that an image with 300 ppi will require.

3.5.4 Contracting or Expanding a Selection

Sometimes a "would be perfect" selection may contain a thin unwanted "border" around it comprised of the colors that abut the selected area as shown in Figure 3.9.

While an original selection is still active, this border can easily be avoided by choosing **Select>Modify>Contract** (if you are selecting a specific shape), or conversely **Select>Modify>Expand** (if you are selecting the area surrounding a specific shape), then assigning a pixel amount to uniformly slightly decrease or increase its perimeter. Setting a pixel value such as 1 to 3 pixels will be just enough to eliminate the "outline" effect without affecting the content of the selection itself. Although this can be helpful with many selections, especially if they were not created as accurately as they should have been, it is particularly

FIGURE 3.9 Unwanted border around a selection.

valuable when creating a

selection that will be placed against an area that will be significantly lighter or darker than the selection itself.

3.5.5 Improving a Selection Using the Quick Mask Mode

The Quick Mask Mode allows you to improve any existing selection by "painting" it using a brush size appropriate to the task, even as small as a 1 pixel brush to adjust a selection border pixel by pixel, if needed.

Let's practice what we have learned thus far. Using the Quick Mask Mode, we will improve the selection we **DVD** will make. Begin by opening the Miner.jpg file shown in Figure 3.10, provided in the Chapter 3 Files folder. As you have learned, save the image first as Miner_original.psd, then as a working copy named Miner_restored.psd into your Photoshop practice folder. In addition to needing some other repairs, the rest of this photograph would look better lightened a little, except for the mining car. To be able to do that, the mining car must be isolated as a selection.

Begin by selecting the mining car in your Miner_restored.psd file using the Rectangular Marquee tool. After choosing the tool in the Tools panel, starting in its upper left corner, drag diagonally down to the lower right corner of the mining car. Even though the car is not a perfect rectangular shape, draw one to enclose it as shown in Figure 3.11.

Now let's choose **Select>Transform Selection** to adjust the sides of the selection as

FIGURE 3.10 Original Miner.jpg photograph.

FIGURE 3.11 Rectangular selection of the Miner_restored.psd photograph.

needed, but not click the check mark or press Enter/Return to complete the transformation just yet.

The next step is to refine the selection further by customizing the existing transformation. With the transformation handles still active, let's hold the Control/Command key down and move the lower right corner selection handle up to the edge of the car, adjusting any other corners the same way as shown in Figure 3.12. Then complete the transformation using the check mark in the Options bar, or by pressing the Enter/Return key.

With this selection still active, we are ready now to learn how to use the Quick Mask Mode to refine the shape of this selection. The Quick Mask icon is located

FIGURE 3.12 Rectangular selection of the Miner_restored.psd photograph with a custom transformation applied.

at the very bottom of the Tools panel; the square with a circle inside.

> **Note**
>
> In CS6, an additional icon is located below the Quick Mask icon which allows you to toggle the amount of interface content you want to view, providing three screen mode choices, with the complete interface environment chosen by default. Anytime you choose intentionally or accidentally to display its Full Screen Mode which eliminates all tool and panel accessibility, pressing the Escape key will revert it back to the standard full interface access mode.

Because we have an active selection, when we single-click on the Quick Mask icon, the rest of the image becomes covered in red, except for the mining car selected area. To refine our selection, a paintbrush is used to add to, or delete from, the protected red area of the mask. The regular Paintbrush tool is the eighth tool down from the top of the Tools panel, and is grouped with a variety of other brush tools. When the paintbrush is active, an appropriate brush size and hardness are assigned in the Options bar, by single-clicking on the arrow next to the brush size icon currently displayed in it. The size brush needed will depend on the current magnification: the higher the magnification, the smaller the brush size that should be used for accuracy. After selecting the brush size, the brush hardness is assigned. Assigning a Hardness of 20% or less, produces a softer selection edge, which provides a little "fudge factor" in the accuracy of the selection. When using a paintbrush in conjunction with the Quick Mask Mode, its Mode category should be kept on Normal and its Opacity and Flow settings both kept at 100% as shown in Figure 3.13.

The Quick Mask Mode is controlled by the default foreground and background colors of black and white, the respective squares that are located just above it in the Tools panel. If these boxes happen to be a different color when the Quick Mask Mode is selected, they will be

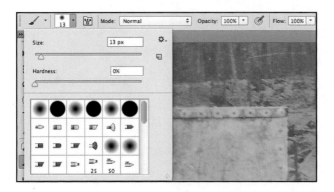

FIGURE 3.13 Brush settings when using the Quick Mask Mode.

converted to black and white automatically. Let's paint around the outside edge of the lower right corner of the car to round the selection off and line it up with the edge of the car. In the Tools panel, if black is in front, as you paint you will be reducing the size of the selected area. When the selected area needs to be increased instead, single-click on the double arrow above the color squares to toggle the white square to the front. Now with white in the foreground when painting, areas can be *added to* the mining car selection as needed.

The color of the mask defaults to red at 50%. You may find that by changing this setting to a lower number such as 20%, you will be better able to identify what you need to add to or delete from your selection. To lesson the opaqueness of the masking color, double-click on its icon, then highlight and change its opacity setting as desired in the Quick Mask Options dialog box that opens. In this dialog box, you can also single-click on its color square to choose a new masking color as shown in Figure 3.14.

It will be helpful at times to single-click on the Quick Mask icon to temporarily turn it off so that you can see how the selection has improved, then single-click again to return to refining the selection. When done, the selection with the Quick Mask Mode turned on should resemble Figure 3.15 (in this example, the default opacity of the mask has been left at 50% for demonstration purposes. If the masking color opacity is

FIGURE 3.14 Selecting the opacity and color of the mask.

reduced to 20%, for example, more of the protected area will be visible through the mask).

When satisfied with your selection, apply a small feather of 2 pixels by choosing **Select>Modify> Feather**, then leave it active. We will use it to learn how to save a selection into an alpha channel for future use.

FIGURE 3.15 Rectangular selection of Miner_restored. psd photograph refined using the Quick Mask Mode.

Demonstrating the Quick Mask Mode

This book includes seven video demonstrations of tools and techniques you will use in your restoration and enhancement work. When a tool or process may be more easily understood by watching it, a demonstration video clip has been provided on the accompanying DVD included with this book in the folder titled "Video Demonstrations." One of the video clips is named "*Using The Quick Mask Mode For Refining A Selection.*" Feel free to take a few minutes to watch it now to further understand how to use the Quick Mask Mode, or at any time for a "quick refresher."

3.6 Using Alpha Channels to Save Selections

Although creating this selection was fairly simple, many times selections will be complex and time-intensive. Oh, no...what if you were making an intricate selection, were almost done, and had to stop and exit Photoshop because of another commitment? (Unfortunately, we all know that life gets in the way of having fun sometimes.) Even if you had saved the file, but had not saved the active selection before closing it, you would need to start the selection over from the beginning the next time you opened Photoshop. That's when the ability to save an existing selection into an alpha channel becomes so valuable.

3.6.1 Saving a Selection into an Alpha Channel

Saving a selection into an alpha channel begins with an active selection. With the mining car selection still active, let's choose **Select>Save Selection**. In the Save Selection dialog box, the name of the open document will be listed at the top under the Document category of the Destination section. Below that, we will want to be sure that New is chosen in the Channel category. In

the Name category, a
name can be assigned
to the channel if
desired, such as
"mining car" (channel
names are not case
sensitive) as shown in
Figure 3.16.

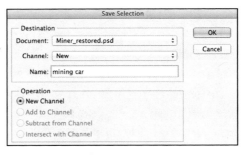

FIGURE 3.16 Save Selection dialog box.

Note

Although a specific name can be assigned in the Save Selection dialog box, if left blank, Photoshop will assign a name by default with the first one named "Alpha 1." Because an image can have multiple selections each saved into its own alpha channel, each channel's name will default to "Alpha 1," "Alpha 2," etc., if the file has multiple selections saved within the same file that are not specifically named.

Once a selection has been saved, it can be deselected. When the file is then saved, the channel will automatically be saved with it. When working with the Miner_restored. psd file, if you choose the Save As command instead of Save, in the dialog box that opens you will see that a check mark will be visible next to Alpha Channels under the Save category. Always keeping this option checked when applicable assures that any channels created with a file will be retained with it. Now by using either the Save or Save As command, let's save and close our Miner_restored.psd file for now which will save the mining car alpha channel with it.

3.6.2 Reactivating a Selection

Reopen your Miner_restored.psd file. To reactivate a selection at any time to continue to create it, improve it, or use it, choose **Select>Load Selection**. When the Load Selection dialog box opens, choose the name of the channel to activate from the Channel category,

then click OK. The selection will become active again. When changes are made to an alpha channel, such as further refining it, it must be updated by choosing the **Select>Save Selection** command again. Choose this command now, whether you have made any changes to the selection since the previous save or not. In the Save Selection dialog box this time, once the specific name of the channel you want to update is selected from the Channel category pop-up menu, the Replace Channel radio button can be chosen under the Operation section to update its channel to reflect any changes as shown in Figure 3.17.

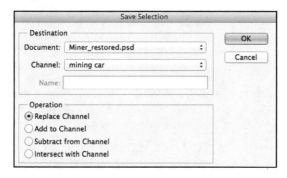

FIGURE 3.17 Replacing an existing channel using the Save Selection dialog box.

3.6.3 Channels Panel Basics

When selections have been saved into channels, they can be viewed in the Channels panel. We learned in Chapter Two how to dock the History panel with

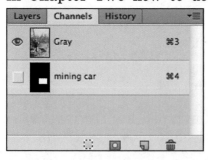

FIGURE 3.18 Channels panel with the mining car alpha channel.

the Layers and Channels panels. Click on the tab of the Channels panel to make it active. (If needed, reset your workspace, or choose **Window>Channels.**) Here you will see the selection you saved as shown in Figure 3.18.

Because this Miner_ restored.psd file is a grayscale image, it contains only one default channel (Gray) in addition to the alpha channel created. When working with a RGB image, the Channels panel will contain four channels by default: a full color composite channel and three additional channels

FIGURE 3.19 Channels panel of an RGB image with one alpha channel.

(a red, green, and blue channel, with any additional alpha channels you have created listed below these), as shown in Figure 3.19.

The icons at the bottom of the Channels panel allow you to load, save, create, and delete alpha channels respectively. You may find the Save Selection and Load Selection menu options under the Select menu easier and more straightforward than accessing them through the Channels panel. When first learning, this panel can be very confusing, especially if you click on one of its channels, or "eye" icons. If you do by accident, click on the "Gray" channel if you are working in grayscale, or on the "RGB" composite channel if you are working in full color, and be sure that each of the regular channels have the "eye" icon visible (click in the area where it should be to make it visible, if needed), and any eye icons of your alpha channels are turned off, as shown in Figure 3.19.

3.6.3.1 *Deleting a Channel*

After reading the last section, you may be wondering "why open the Channels panel at all?" What you will need to access this panel for will be to delete a specific channel you do not want or need anymore. To delete a channel, press and drag the alpha channel from its current location

in the Channels panel until it is over the Delete current channel icon (trash can). When the trash can becomes highlighted, release the mouse. Alternatively, you can select the channel to remove, and then click the Delete current channel icon. You will be asked if you want to delete the selected channel, and will need to click the "Yes" button to complete the deletion. A third option is to simply Right/Control click the channel and select Delete Channel from the context-sensitive menu that appears. When deleting channels, be sure to *never* delete the main channels of the file; only any *extra* alpha channels that have been added to it.

When a file has one or more alpha channels saved with it, its file size increases. If you look now at the file size in the status bar displayed at the lower left of the document window area, now the two numbers with the slash between them are no longer the same. The larger number on the right reflects the file size with the saved channel and the number on the left represents the file size without the channel as shown in Figure 3.20.

FIGURE 3.20 Miner_restored.psd file size with saved alpha channel.

If you are sure you have an alpha channel that you will never need to use its selection again, deleting it will help to keep your file size down.

③⑦ Lasso, Polygon Lasso, and Magnetic Lasso Tools

Now that we have learned how to improve an existing selection and save it, let's close the Miner_restored.

psd file for now, saving the changes if prompted. Let's move on to learning the rest of the selection methods, beginning with the Lasso tools. Directly below the Marquee tools in the Tools panel are three Lasso tools grouped together; the regular Lasso tool, the Polygon Lasso tool, and the Magnetic Lasso tool. In contrast to the Marquee tools, these tools create either curved or hard-edged free-form selections.

3.7.1 Lasso Tool

Working like a pencil on a piece of paper, when you press and drag with this tool, you can trace around the shape you want to select. However, unlike a pencil, accuracy using solely this Lasso tool can be difficult, making it ideal for quick general selections when precision is not required and great for adding to or deleting from a selection originally created using another selection method. When drawing with this tool, if you release the mouse before returning to your original starting point, the selection will automatically be completed with the moving dotted outline returning to the beginning using the shortest distance.

3.7.2 Polygon Lasso Tool

The Polygon Lasso Tool will draw freeform straight-sided selections. To use this tool, single-click with the mouse anywhere along the edge of the area you want to isolate to start creating the selection, then *release* the mouse. After the initial click, do not hold the mouse down, simply move it to the next "turning point" or "corner" of the area you want to select then single-click again. You will notice that your movement will be shown as a little "piece of string" that follows the tool. This step is repeated with each change in direction that you need to make as you trace.

This process is illustrated in Figure 3.21. (In CS6, a small black arrow is provided to indicate the drawing

FIGURE 3.21 Illustration of how to use the Polygon Lasso tool.

point of the Polygon Lasso, instead of the tip of the Lasso itself.) The red arrow suggests a starting point, with the red line denoting the selection being drawn by the Polygon Lasso tool. The directional arrows indicate each time the mouse will need to be clicked to change the orientation of the tool.

Feel free to try this on a photograph of your own containing straight edges, or use the Polygon practice. jpg file provided in the Chapter 3 Files folder.

TIP *Holding the Shift key down when using the Polygon Lasso tool will restrict its directional movement to 45° increments.*

When you have finished tracing around the area you want to select and are back to your starting point, a small circle icon should appear, indicating that when you single-click, you will close the shape to complete your selection. If at any time you are using the Polygon Lasso tool and upon returning to your starting point, the

"circle" icon does not appear, simply double-click instead. What double-clicking will do is enclose the selection automatically by returning to the first point you added from wherever you click. You can also double-click anytime you simply want to start over, and need the "piece of string" to stop following your mouse. A completed Polygon Lasso selection of the sky in the Polygon practice.jpg file is shown in Figure 3.22.

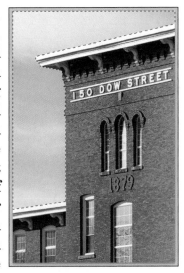

FIGURE 3.22 Completed polygon selection of the sky area.

3.7.2.1 Combining the Polygon Lasso Tool With the Regular Lasso Tool

Within the same selection, you can easily toggle between the Polygon Lasso tool and the regular Lasso tool. Let's learn how.

The photograph titled Covered bridge.jpg provided in the Chapter 3 Files folder has great color and values throughout the image except for the bridge's entrance, and the stone support beneath the bridge, as shown in Figure 3.23.

on the DVD

Because the rest of the photograph looks great, these areas should be enhanced independently of the rest of the photograph which requires them to be isolated with individual selections. The entrance area provides a great opportunity to learn how to combine the Polygon Lasso tool with the regular Lasso tool. As you have learned, save the file first as Covered bridge_original.psd, then save a working copy named Covered bridge_enhanced.psd into your Photoshop practice folder. Let's begin by enlarging the entrance area of the bridge to trace it. Once it is enlarged, let's single-click anywhere along

FIGURE 3.23 Bridge entrance and stone support areas identified that require isolation by a selection.

its perimeter, such as just above the guardrail with the Polygon Lasso tool to start. Then continue to single-click as we move around the perimeter of the opening. When we reach the area where the foliage requires a freeform selection instead of a straight edge, let's press and hold down the Alt/Option key and drag on the photo. The Polygon Lasso tool will be temporarily converted into the regular Lasso tool and allow us to freeform drag to draw, until the Alt/Option key is released, and then it reverts back to its original hard-edged style.

Note

While using the regular Lasso tool, when you press and hold down the Alt/Option key, it will be temporarily converted to the Polygon Lasso tool, allowing you to click to create straight segments, until you release the Alt/Option key. Then it will convert it back to its original freeform design to continue to trace your freeform shape.

A sample of the completed entrance selection is shown in Figure 3.24. When viewing this sample, notice that the regular Lasso tool was integrated to trace

around the foliage in the lower left area of the bridge opening. Let's apply a small feather of 2 pixels to our selection by choosing **Select>Modify>Feather**, then save this selection into an alpha channel, and then save and close this file for now. We will learn how to lighten this area in Chapter Nine.

FIGURE 3.24 Selection of the bridge entrance created by combining the Polygon Lasso tool with the regular Lasso tool.

To add to a Polygon Lasso tool selection requiring the freeform properties of the regular Lasso tool, you can continue to use the Polygon Lasso tool by pressing the Shift key once to engage the Add to selection option, and then holding the Alt/Option key down as you add to the selection. Conversely, to engage the regular Lasso tool to subtract an area while still using the Polygon Lasso tool, click once with the Alt/Option key and the mouse to activate the Subtract from selection mode, then release them both. Then press and hold the Alt/Option key a second time to temporarily engage the subtract option in combination with the regular Lasso tool until you release the Alt/Option key.

Demonstrating the Polygon Lasso Tool and Toggling It with the Lasso Tool

Sometimes learning to use the Polygon Lasso tool, and how to toggle its use with the regular Lasso tool, can be frustrating and confusing. Included in the book's "Video Demonstrations" folder, is a video clip titled "*Using the Polygon Lasso Tool And Saving Selections*" which demonstrates how to use the Polygon Lasso tool to create a selection, how to incorporate the Alt/Option key to temporarily convert it to the regular Lasso tool when needed, and also demonstrates the saving of selections into alpha channels using the same Covered bridge.jpg file used in this section.

3.7.3 Magnetic Lasso Tool

The third tool in the Lasso group is the Magnetic Lasso tool, the tool identified by a polygon lasso with a magnet on it. This tool is appropriately named, as it will try to "cling" to the edge you are selecting and follow it, whether it contains hard edges, or freeform curves, even if you are not real proficient at tracing. The resulting selection will be easier to create, and oftentimes, more accurate than selections created with any of the tools you have learned thus far. However, it will not be the perfect tool for every selection. Its drawback is that it is controlled by edge contrast. When it can detect a strong enough contrast between the area you are trying to select versus the area you do not want included in your selection, it can be awesome. The degree of accuracy the tool can produce is controlled by three customizable settings that become active in the Options bar when the tool is chosen: Width, Contrast, and Frequency.

The Width setting determines how close the mouse must be to the edge you want to select with the default distance being 10 pixels. When using this tool, as you guide it along the edge of the area you are selecting

and as you move away from its edge, you will see its "string" try to still cling and follow the edge until you have moved the mouse too many pixels away from it.

The Contrast setting defines how strong a contrast is needed for the tool to identify an edge to follow. The contrast option uses a percent scale from 1% to 100% with a default setting of 10%. A low number, such as the default setting of 10%, is usually good (lower percent means lower contrast is needed between the desired selection and the surrounding pixels), and is definitely a great place to start.

The Frequency setting determines how often "contact points," which recognize surface changes, are added as you trace your selection. When using this tool, if the default frequency setting of 57 does not allow your "piece of string" to recognize the surface changes accurately enough (skips over edges due to an insufficient number of contact points), this setting can be raised to a higher number; the higher the number, the more frequently added points. As you can see in Figure 3.25, the default settings of Width 10 pixels, Contrast 10%, and Frequency 57 work well to detect the edges of this flower, even though its surrounding area contains multiple colors and values.

FIGURE 3.25 Magnetic Lasso flower selection.

To understand how these settings work, the Rose of Sharon.jpg image used to create the selection shown in Figure 3.25 has been included in the Chapter 3 Files folder.

To begin tracing around the petals of the flower in this photograph, single-click anywhere along the outer

edge of one of the flower's petals. Once you have done that, do *not* press down on the mouse, but simply begin slowly moving and guiding it along the outer edge of the flower. As the mouse is moved around its perimeter, the Magnetic Lasso tool will automatically insert contact points along the flower's edge. If when tracing, the tool does not place a point where you can see that it will need to have one, click the mouse to add one as you go, then release it and return to simply guiding it along the desired selection path. If a point is added where you know is incorrect, stop and immediately press the Backspace/Delete key to remove that point, then continue to guide the mouse along the path. When you have finished defining points around the flower and are back to your beginning point, you will see the same small circle icon that you have learned indicates that when you click you will close the selection.

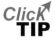

Click TIP

Any time you are using the Magnetic Lasso tool, you will have more success if you magnify in first; large enough to easily watch as its contact points are being added around your selection, making it easier to insert additional points, as well as delete incorrect points as you drag around the shape you are tracing.

Compare your completed selection with Figure 3.26. If yours is close, but not exact, remember that any time you have a selection created by one selection method, any other selection tool or method can be integrated to add or delete from it. Feel free to now incorporate the regular Lasso tool to tweak the accuracy of your active selection, or refine it using the Quick Mask Mode.

FIGURE 3.26 Completed flower selection.

If you would like to try this selection method on one of your own images, remember that this selection method works best for photographs containing high contrast between your desired selection and the area around it. When using this tool on you own image, you may need to experiment with its Width, Contrast, and Frequency settings in the Options bar, as needed, to improve its sensitivity and edge detection capability.

3.7.4 Quick Selection Tool

Added in CS3, the Quick Selection tool uses a paintbrush to "paint" a selection based on color and edge detection, using a prechosen brush size. Like the Quick Mask Mode, this tool is one of many that you will use in your work, that utilize a paintbrush to execute their function. Let's open a different image provided in the Chapter 3 Files folder named Egyptian columns.jpg to learn how to select with this tool. As you have learned, save the file first as Egyptian Columns_original.psd, then as a working copy, named Egyptian Columns_ enhanced.psd into your Photoshop practice folder.

The Quick Selection tool is located directly below the Lasso tools group, and is nested with the Magic Wand tool. When we select it, we can see in the Options bar that three icons appear at the far left; a New selection icon, as well as an Add to selection and Subtract from selection option. The keyboard shortcuts that we have already learned of using the Shift key to add, and Alt/ Option key to delete from a selection, can be substituted for choosing the corresponding option in the Options bar. To the right of these icons, the Sample All Layers option is not applicable, as this file has only one layer (we will learn about sampling multiple layers in Chapter Four). The Auto Enhance option to the right of it will help to improve the smoothness of the edges of our selections (similar to the anti-alias feature), and should always be checked as shown in Figure 3.27.

FIGURE 3.27 Quick Selection tool options.

After selecting the tool in the Tools panel, we will need to select a brush size relative to the selection task by single-clicking on the arrow to the right of the brush size icon in the Options bar. Notice in the extended menu that opens, we can choose to not only assign a size and hardness for the brush when using one with the Quick Selection tool, but also customize the brush's spacing and design. When using the Quick Selection tool, assigning a brush size relative to the desired selection task, then leaving the rest of the settings at their default assignments will work fine. This photograph could be improved by isolating the columns to adjust their values separately from its sky. Starting with the default brush size of 30 px, let's press and hold the mouse down as we *slowly* drag *inside*

the columns, starting at the lower right corner, and dragging up towards the upper left corner. When we release the mouse, the Add to selection option becomes active automatically, ready for us to continue creating our selection. With little effort, the columns become completely selected. If the sky became selected as well, simply deselect your selection and begin again, or engage the Subtract from option and drag

FIGURE 3.28 Columns selected using the Quick Selection tool.

over the part that should be removed from the selection. When all of the columns have been selected, the small area of sky between the two columns at the top left will need to be removed from the selection, by switching to a smaller brush and using its Subtract from option to delete it from the selection. Your completed selection should resemble Figure 3.28.

When you are satisfied with your selection, save this selection into an alpha channel, then save and close the file to reopen it for color correction later in Chapter Nine. This selection will not require a feather, as in this instance, it will be important to maintain the definitive edge between the columns and the sky, and with the Auto Enhance option checked, the selection edges will automatically be smoothed and softened. Although this selection tool can be fast and relatively accurate, it will still not be the perfect tool by itself for every type of selection.

3.7.5 Magic Wand Tool

This tool, grouped with the Quick Selection tool, is controlled by color range. When the tool is chosen in the Tools panel, a default Tolerance value of 32 is prechosen in the Options bar, with its Anti-alias and Contiguous options also pre-assigned (like the Quick Selection tool, the Magic Wand tool also contains a Sample All Layers option we will learn about in Chapter Four). In CS6, an additional pop-up menu is available to select the accuracy of the point you want to define for the selection, and if working in this version, keeping it at the default setting of Point Sample will work great. As we have already learned, we will always want the Anti-alias option on, and in most cases when using the Magic Wand, the Contiguous option as well. What the Contiguous option will do is assure that the Magic Wand will look for similar colors *only* next to each other (such as in a sky), rather than everywhere the color appears in the photograph, such as additionally found in someone's coat, car, etc., *as well as* the sky.

> ### Definition
>
> **Tolerance:** Magic Wand Tolerance is a color sensitivity setting assigned in the Options bar to define the accuracy of the selection. The lower the range value setting, the more similar in color the pixels must be to be included in the selection with a default setting of 32. This setting refers to the range of colors and tones beyond the initial pixel color clicked on which will be included in the selection.

on the **DVD** To understand how this tool works, and how it compares to the Quick Selection tool, open the photograph provided in the Chapter 3 Files folder named April 1942.jpg, saving it first as April 1942_original.psd, then as a working copy named April 1942_restored.psd into your Photoshop practice folder. When attempting to select just the man's coat, first using the Quick Selection tool as shown in Figure 3.29, the coat's buttons and the man's hands become selected as well.

Although we have learned how these items can later be removed from the selection, deselect that selection, and instead select the same coat this time using the Magic Wand tool. With its default settings applied in the Options bar, single-click the Magic Wand tool approximately in the center of the man's coat, but not on one of its buttons. Figure 3.30 shows how much of the coat was selected with one click of the mouse, Sample Size set to Point Sample, Tolerance set to 32 pixels, with the Anti-alias and Contiguous options also checked.

Because of the color of the coat material versus the color of the coat's buttons and the man's hands, only the coat material becomes almost exclusively selected. To further understand how this tool works, deselect this selection first, then select

FIGURE 3.29 Selecting the coat using the Quick Selection tool.

FIGURE 3.30 Coat selected using the Magic Wand tool.

different areas of the coat (lighter versus darker areas of the material, for example), and notice how the coat becomes more and less selected based on the particular pixel color you click on. It will also be helpful to deselect the current selection, then change the Tolerance setting to a lower number, and click on the coat again, to observe how setting a lower number (more limited color variation) affects the sensitivity and accuracy of the coat selection. When you are done experimenting with the Magic Wand tool on this photograph, deselect any active selections, then close the file and do not save any changes if prompted, we will reopen and repair this photograph and restore its tones in later chapters.

3.8 Getting the Most Efficient as Well as the Most Accurate Selections

We have learned to create selections using a variety of selection methods, how to combine them, add to and

delete from them, transform, contract, expand, and feather them, and save them into channels for future use. Because you will be anxious to get to the "fun" part of your restoration and enhancement projects, you will always want to begin with the best selections possible, using the quickest as well as the most accurate method. In addition to becoming comfortable with all of the selection techniques available, and how you can integrate them together as needed, learning when to select everything *except* what you want, and how you can feather, smooth, and contract or expand a selection all in one dialog box, will combine accuracy with efficiency, streamlining the selection process.

3.8.1 Using the Select>Inverse Command

Sometimes the most efficient method of selecting the area you need in a photograph may be to select what you *don't* want included in the selection, and then choose the **Select>Inverse** command to select the opposite of

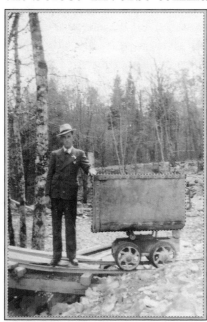

what you currently have selected or what you really want included in the selection instead.

Earlier in this chapter, you saved a photograph with an alpha channel named Miner_restored. psd. Let's reopen that file now, and load its selection using the **Select>Load Selection** command. Once the selection is active, the mining car only will have the moving dotted outline, indicating that it is selected. To adjust all the values in this

FIGURE 3.31 Inverse command applied to the mining car selection.

image *except* for those of the mining car, let's now choose **Select>Inverse**. The resulting selection will include the *rest* of the image except for the mining car. It may at first seem like nothing has changed, however when we study the perimeter of the photograph, we can see that the moving dotted outline surrounds it as shown in Figure 3.31.

To further understand this concept, let's choose **Edit>Fill>Use: Black**. Once we have done that, everything turns black except the mining car. Because we will want to keep this selection without the fill, we will instead want to now back up one state in the History panel to undo this temporary black fill. Before we save and close this photograph to work with it again at a later time, its channel should first be updated with the inversed selection. Let's choose **Select>Save Selection**, choose the mining car channel, choose Replace Channel under its Operation section, and then save and close this file for now.

3.8.2 Using the Refine Edge Dialog Box

Introduced first in CS3, and updated in CS5, the Refine Edge dialog box can be accessed from the Options bar when any selection is active, or by choosing **Select>Refine Edge**. Although some of its options are specifically designed to improve the accuracy when creating difficult selections such as strands of human hair and dog fur, this dialog box can expedite the refinement process of any selection with its ability to apply further smoothing of selection edges, add a feather, or contract or expand its edges to eliminate an unwanted "border," all in one dialog box. This dialog box also provides the additional advantage of being able to watch your applied settings immediately update in its image area against a contrasting background as they are assigned, without having to close it to view their affect. Let's take another look at the Rose of Sharon. jpg selection shown in Figure 3.9. With the same

FIGURE 3.32 Refine Edge dialog box options applied to the Rose of Sharon.jpg.

flower selection active, this time Figure 3.32 shows the selection improved through the Refine Edge dialog box. Feel free to reopen this file or one of your own, and make a selection of the flower (or a selection of an area in your own photograph which abuts a distinctly darker or lighter background), this time using any selection method or combination of methods you have learned. Once you have made your best selection, before opening the Refine Edge dialog box, it will be helpful to magnify in to an edge of the selection first. With the active selection enlarged, click the Refine Edge button in the Options bar, or choose **Select>Refine Edge** to enter its dialog box. Under its View Mode category, when you single-click on the arrow provided next to the View thumbnail, a background can be chosen from a list of options to best view the affects of your settings as they are applied to your selection. If you are practicing with the Rose of Sharon.jpg photograph, it will most likely not be until you select the On White option that you will

be able to identify the "border" problem in your flower selection. (If using your own photograph, test it against a variety of view options, then select the most effective view mode based on the colors in your selection.)

Under its Adjust Edge category, its four categories can be further customized to fine-tune your selection.

3.8.2.1 Smooth

This setting will apply a smoothing effect similar to that of the anti-alias feature, with the ability to apply a value from 0 to 100. While anti-alias will have been applied to your original selection by default, if a Shift Edge setting is applied to your selection through this dialog box, you may see the "grid" appearance return once the original border is altered, that this Smooth option will correct. This option, therefore, is most commonly applied *after* a Shift Edge setting has been assigned if needed.

3.8.2.2 Feather

We have learned that a feather value can be set prior to creating a selection, or applied to any active selection using the **Select>Modify>Feather** dialog box. If you want to apply one to a selection, by adding it here instead you will be able to clearly and immediately see its affect on your selection, making it easier to determine exactly how much of a feather you need to assign.

3.8.2.3 Contrast

This setting increases the contrast of the edges of the selection helping to sharpen them.

3.8.2.4 Shift Edge

This setting adjusts the edge of the selection by contracting it (negative percentage), or expanding it (positive percentage). As shown in Figure 3.32, a negative percentage of −38% was applied to this selection to

completely eliminate the unattractive "border" around it. If you try this yourself, you will notice it is after this contraction is applied, that the edges of the selection may develop the choppy grid edge. If this occurs, assigning a small Smooth setting will correct this being sure to assign the lowest value possible that still eliminates the rough edges. A value of 7 was applied to the selection shown in Figure 3.32. Your settings may vary slightly, depending on the accuracy of your original selection.

> **Note**
>
> Because the edge adjustment available through the Shift Edge option of the Refine Edge dialog box is designed to provide the minimal edge shift required to eliminate the "border" appearance of a selection, its adjustment range capability is limited. When a more significant selection border shift is desired, more flexibility can be achieved by assigning it through the **Select>Modify>Contract/Expand** dialog boxes instead.

3.8.2.5 *Output*

Under its Output category, this dialog box setting will default to the Output To: Selection option, allowing the selection to remain active with its updated improvements, once the Refine Edge dialog box has been exited. When using the Refine Edge dialog box in your own work, you will want to keep it at the Output to: Selection option for now until we have explored its layer output options in Chapter Four.

on the DVD The Refine Radius tool added in CS5, helps select thin, feathery edges such as strands of human hair or dog fur; ones in which accuracy can be more difficult to achieve using the traditional selection methods we have learned in this chapter. Let's learn how this tool can help select human hair by opening the Tourist.jpg file provided in the Chapter 3 Files folder, then saving it as Tourist.psd into your Photoshop practice folder.

Note

The selection we will be refining in this photograph will be used in Chapter Ten. If you are working in a version of Photoshop prior to CS5, your Refine Edge dialog box will not contain the tool used in this exercise. Therefore, a copy of this file with a completed selection already tweaked using the Refine Edge dialog box and saved into an alpha channel has also been provided in the Chapter 10 Files folder if needed.

We will begin by making an accurate selection of the woman's head and shoulders using any selection method, with the bottom edge of our selection determined by the guide provided. When selecting around the subject's hair, we can see that it contains many protruding strands of individual hairs. It will not be necessary to attempt to select these individual strands of hair around the perimeter of her head, as this is the selection area we will "refine" through the Refine Edge dialog box.

With our completed selection active, let's choose to access the Refine Edge dialog box by either selecting it in the Options bar, or by choosing **Select>Refine Edge.** Once we have done that, let's choose the Overlay option for the View Mode which will convert our selection to the familiar masking appearance of the Quick Mask Mode.

If you did not remember to zoom in to work on the subject's hair area prior to entering the Refine Edge dialog box, while it is open, you can access the Zoom tool provided within its dialog box. Although you will not be able to also use the Zoom tool or Navigator panel, you can still use the keyboard shortcut (Control/Command + Spacebar to magnify in and Control/Command + Spacebar + Alt/Option to magnify out) and/or use the Control/Command key combined with the Plus/Minus keys to adjust your view as needed.

In the Options bar, let's choose a brush size that appears comparable to the circle shown in Figure 3.33 based on our view. Let's also assign a Contrast setting of 10%. For its output, let's select Output to: Selection. With its cross hair centered over the edge of the hair, slowly drag around the circumference of the hair area only

using the Refine Radius tool to more accurately select the subject's hair as shown in Figure 3.33.

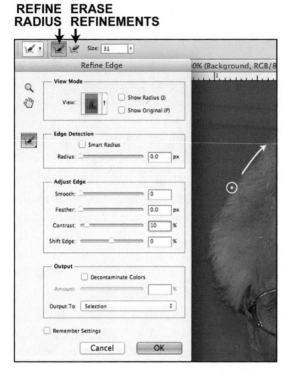

FIGURE 3.33 Using the Refine Edge dialog box to select human hair.

In the Options bar, the Erase Refinements tool can be alternatively chosen as needed while tracing the outer edge of the hair to erase a section of the selection to retrace it without having to start over. Once the selection is complete, click OK to exit this dialog box, save this selection into an alpha channel named "refine edge selection," then save and close this file for now.

3.8.3 Favorite Selection Method

At this stage of learning, oftentimes users start to become comfortable with a specific selection method, and eventually use it exclusively for all their selections. While it is natural to prefer one method over another, every selection presents a unique challenge. It will be

important to take a few minutes *before* you begin to create *every selection* you need, to evaluate the specific needs of each one, to be sure you are always maximizing the efficiency and accuracy of your selections, providing more time to enjoy the restoration and enhancement phase of your work. Now, with a wealth of selection knowledge, and some selections saved into channels, test your knowledge, and reinforce your learning by completing a few projects provided in the last section of this chapter before moving on to mastering the use of layers in Photoshop.

Test Your Knowledge

1. What selection tool is controlled by a Tolerance setting?

2. Why does a rectangular marquee selection not require the Anti-alias option to still look good?

3. To add to an existing selection, what key on the keyboard can you hold down, instead of choosing the Add to selection option in the Options bar?

4. What command will allow you to select everything *except* what you currently have selected?

5. How can you soften the edges of a selection by blurring them?

6. How can you save a selection for future use?

7. The Magnetic Lasso tool is controlled by three settings: Width, Contrast, and _____?

8. What dialog box allows you to reactivate a saved selection?

9. How many channels does a RGB image have by default?

10. When a second rectangular selection is drawn that overlaps an existing one, and both original

selections become replaced by a single new one comprised of only the area where the two original selections overlapped, which option was selected in the Options bar?

Try It Yourself

Project 1

Open your photograph named Covered bridge_enhanced. psd from your Photoshop practice folder.
To further prepare this image for color correction in Chapter Nine:

1. Enlarge the photograph so that the stone support beneath the bridge dominates the viewing area of your screen.

2. Using the Polygon Lasso tool in combination with the regular Lasso tool, trace this area as shown in Figure 3.34, and also demonstrated in the video clip titled *"Using The Polygon Lasso Tool And Saving Selections."*

FIGURE 3.34 Stone support selection created using the Lasso tools.

3. Apply a small feather of 2 pixels by choosing **Select>Modify>Feather** or through the Refine Edge dialog box, save this selection into its own

separate alpha channel, then save and close the file for now.

Project 2

Open the photograph named Restaurant kitchen.jpg *on the* **DVD** provided in the Chapter 3 Files folder.
In preparation for its restoration:

1. Save it twice, once as Restaurant kitchen_original. psd, then as a working copy named Restaurant kitchen_restored.psd into your Photoshop practice folder.

2. With the restored version active, notice that in addition to its damaged areas, except for its floor area, the rest of this black and white photograph could be significantly improved by increasing its contrast.

3. Because the floor is more uniform in its color, the easiest way to adjust the contrast in the entire image except for its floor will be to select the floor, then use the **Select>Inverse** command to select the rest of the photograph instead.

4. Use any selection method or combination of methods you have learned to select the floor, then refine your selection as needed. When completed, your floor selection should resemble Figure 3.35.

5. Once you are satisfied with your selection, choose **Select>Inverse** to select everything except the floor.

6. Apply a small feather such as 2 pixels to this selection by choosing **Select>Modify>Feather**, or through the Refine Edge dialog box.

7. Save this selection into an alpha channel named "kitchen."

8. Save the file into your Photoshop practice folder. We will use this file with its alpha channel in conjunction with our learning in future chapters.

FIGURE 3.35 Restaurant Kitchen_restored.psd with floor selected.

Project 3

Open the photograph named Rushmore.jpg provided in the Chapter 3 Files folder.

1. This image needs color correction and its sky is washed out. Because these will be two separate corrections, the sky must be isolated from the rest of the image.

2. As you have learned, save the file first as Rushmore_original.psd, then as a working copy named Rushmore_enhanced.psd into your Photoshop practice folder.

3. Use any selection method or combination of methods to accurately select just the sky area.

4. Apply a small feather of 2 pixels using either method you have learned.

5. It will be helpful with this selection to expand it. Choose **Select>Modify>Expand**, and assign a value of 2 pixels.

6. Save this selection into an alpha channel, then save and close the file.

Project 4

Take a look through some of your own photographs. Choose one which has an area or two (except for its sky; we will work with skies in Chapter Eleven) that is distinctly lighter or darker than it should be, such as the example of the covered bridge.
In preparation for its color correction:

1. Begin by checking its image size, and adjusting its ppi as you have learned.

2. Once you have done that, also following our learning, save it once with its name plus "_original.psd," and the one you will enhance with "_enhanced.psd."

3. Select the area(s) using whichever selection method or combination of methods needed, with emphasis on speed and accuracy, based on its color and design requirements.

4. Save the selection(s) into alpha channel(s). If you have two rather than one, you will have more flexibility later when correcting the image if each selection is separately saved into its own alpha channel.

5. As we have learned, when required, a feather can be applied anytime a selection is active. Choose to assign it later, if needed. For now, save the photograph into your Photoshop practice folder, then close the file.

4

WORKING IN LAYERS

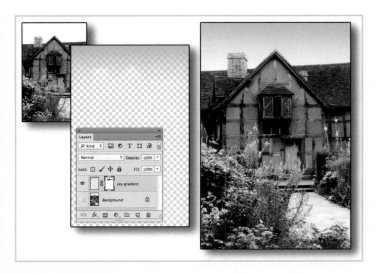

In This Chapter

- Examine the Layers panel's options and icons
- Add layers using a variety of methods
- Learn to link and group layers
- Incorporate additional pixel selection options available only in multilayered files

All professional restoration and enhancement projects benefit by utilizing layers in their execution. Following an introduction to the Layers panel, we will learn to embrace them in our work through an in-depth exploration of their creation, manipulation, organization, and more.

4.1 The Importance of Using Layers

Layers are invaluable when working in photograph restoration and enhancement. A few of the many advantages of using layers include the ability to separate content onto individual layers, show/hide/lock isolated content as needed, store image data borrowed from one area to use in another location, duplicate a layer to create a "working layer" allowing you to maintain the integrity of the original, assemble an image that was scanned in pieces because it was too large to fit on the flatbed of your scanner in its entirety, and so much more. In Chapter Three, you learned how to create professional selections. It is time now to advance your learning to the next level of professionalism through the exploration and implementation of the use of layers in photograph restoration and enhancement work. This chapter will introduce you to the Layers panel, with a focus on the critical role layers will play in the execution of your restoration and enhancement projects.

4.2 The Basics of Layers

> **Definition**
>
> **Layer:** When working in Photoshop, a layer is a pixel manipulation container whose physical dimensions equal those of the original image. Layers are stacked one above the other resembling sheets of tracing paper. Any area of a layer that does not contain image pixels is transparent, with its transparency identified by a checkerboard pattern.

4.2.1 Understanding the Background Layer

on the DVD Let's start by opening any image of your own, or the Mexico.jpg photograph provided in the Chapter 4 Files folder, then click on the tab of the Layers panel to make

FIGURE 4.1 Default Background layer when an image is opened in Photoshop.

it the active panel in the dock. If your personal workspace is active, the Layers panel will be in a dock with the Channels and History panels as shown in Figure 4.1. If not, choose **Window>Workspace>Reset MY R AND E** to open up the configuration of panels we created in Chapter Two, then make the Layers panel active. As shown in Figure 4.1, when *any* image is opened in Photoshop, it will open by default with one layer.

A copy of each figure shown in this chapter can be *on the* **DVD** viewed on the companion DVD included with this book.

You may not have noticed this before, as our learning in the preceding chapters has focused on other aspects of the photograph restoration and enhancement process. This one layer is prenamed "Background" and italicized, and contains a small "lock" icon indicating that the layer will allow alteration of its pixel content, however its movement will be locked in place.

Note

Every image opened in Photoshop exists on a Background layer by default, with the ability to add any number of additional regular layers, limited only by your computer's available RAM.

Let's examine the Layers panel closer. In addition to the lock icon and its italicized "Background" name, notice that many of its options are currently grayed out. Only three are presently accessible in CS5: Create a new fill or adjustment layer, Create a new group, and Create a new layer, with the Add Layer Mask option additionally available in CS6 as shown in Figure 4.2.

Because all of the rest of the icons in the Layers panel require a layer to become active rather than simply the Background layer, they are grayed out until a layer is added to the file. Each of the options that are currently active with only a Background layer are also available when multiple layers exist, and will therefore be detailed later in this chapter. When the Layers panel menu is opened with only a Background layer in the file (click on the small icon of lines at the top right of the panel), notice that most of the options here are also grayed out, except for the ones shown in Figure 4.3.

Let's take a closer look at the options that are currently available here. The New Layer and New Group options are the same as those using the corresponding active icons at the bottom of the Layers panel shown in Figure 4.2. We will discuss the Duplicate Layer option later in this chapter. We will learn about Smart Objects in Chapter Nine, however, we will not be utilizing the animation options available in Photoshop. We will not want to select the Close, or Close Tab Group, as that will either hide the current active panel of the dock (Layers) or close the entire dock.

New Layer... ⇧⌘N
Duplicate Layer...
Delete Layer
Delete Hidden Layers

New Group...
New Group from Layers...

Lock All Layers in Group...

Convert to Smart Object
Edit Contents

Layer Properties...
Blending Options...
Edit Adjustment...

Create Clipping Mask ⌥⌘G

Link Layers
Select Linked Layers

Merge Down ⌘E
Merge Visible ⇧⌘E
Flatten Image

Animation Options ▶
Panel Options...

Close
Close Tab Group

FIGURE 4.3 Layers panel menu options with only a Background layer.

4.2.1.1 *Panel Options*

The Panel Options feature of the Layers panel menu can be a handy one. What this option will do is open a dialog box allowing you to select an alternative thumbnail size for the layers in the Layers panel as shown in Figure 4.4.

For our work, we will want to leave the

FIGURE 4.4 Layers panel options.

rest of the options in this dialog box at their default settings, however you may want to experiment by selecting a larger layer thumbnail option to see if enlarged thumbnails in the Layers panel work better for you.

If you Right/Control click on a layer thumbnail, or anywhere in the Layers panel below the Background layer (but above the row of icons at the bottom of the panel), you can select a different layer thumbnail size from the context-sensitive menu that appears.

Note

Assigning a panel option other than the smallest thumbnail size is a customization that will be reverted back to the default smallest thumbnail option when the preferences are reset.

4.3 Working With a Multilayered File

To begin learning about layers, let's get comfortable moving around the Layers panel by opening a file with some regular layers already added to it, to explore layer visibility, layer order, and to move layer content.

In the Chapter 4 Files folder, open the Rye Beach Layers Sample.psd file. In its Layers panel, you will see its Background layer, plus three additional layers named "grass," "harbor," and "sky," as shown in Figure 4.5.

4.3.1 Layer Visibility

A layer's visibility can be turned off or on by single-clicking on the "eye" icon to the left of the layer, including the default Background layer. You can also press and drag up or down through multiple layer eye icons to turn them off/on as you pass through their location in the Layers panel. Once you have experimented with this feature on your own, let's turn off the sky layer. Notice that when that layer is off, another sky becomes visible,

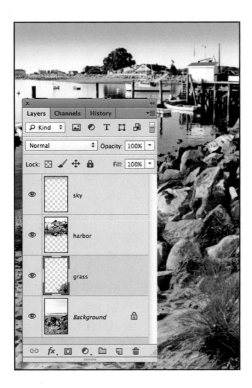

FIGURE 4.5 Multilayered Rye Beach file.

which is not as bright blue; the sky in the harbor layer. If we now also hide the harbor layer, we can see a third sky; one that will become visible only when both the sky and harbor layers are turned off, which is the sky in the Background layer photograph.

Note

If a file has *only* a default Background layer, you will not be able to turn its visibility off. As soon as at least one *additional* layer has been added to the file, the eye icon will allow you to hide any of its layers, including its Background layer.

If you have the Alt/Option key held down when you single-click on an eye in the Layers panel, it will remain visible, while all other layers will become hidden. Conversely, holding the Alt/Option key down when you click again on the same eye icon will keep this layer visible, and return the visibility of the rest of the layers as well.

4.3.2 Layer Order

Let's take a look at the position or stacking order of the layers in the Rye Beach Layers Sample.psd file. The default Background layer is at the bottom, with the grass layer on top of it, the harbor layer on top of that, with the sky layer at the top of the order. The stacking order of layers in any Photoshop file can be changed, except for the locked Background layer.

To change the order of the layers, press and drag on a layer in the Layers panel that you want to move. As you drag it to a new location, you will see a copy of the layer you have selected move with you (the selected layer will also still be visible in its original location at this point), and a small closed hand icon will appear, indicating that you are dragging the layer. When you have reached the location in the stacking order that you want to move the selected layer to, a black line will appear, indicating that that is where the layer will be moved to when you release the mouse. Let's press and drag the sky layer below the harbor layer as shown in Figure 4.6.

Once we release the mouse, the bright blue sky is no longer visible, as it is now hidden beneath the duller blue sky of the harbor layer.

It will be beneficial to now practice moving this file's layers up and down through the stacking order to get more comfortable with this process. You will notice that you cannot drag a layer below the Background layer,

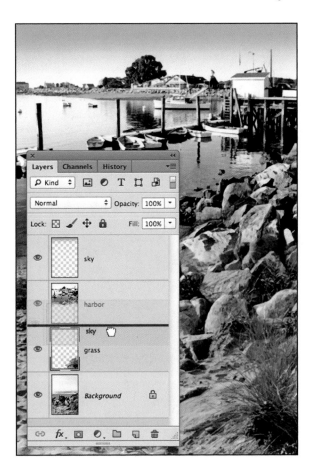

FIGURE 4.6 Changing the stacking order of layers.

nor can you move the Background layer up, but can adjust the stacking order of all of the rest of the layers in the file.

Note

When practicing, if you move the harbor layer below the grass layer, you will not see any image change in the document window. If a layer has *transparency* in an area where a layer with pixels located in that same area exists *below* it, the pixel content of the layer underneath will still be visible, even if it is lower in the stacking order of layers.

4.4 Moving Layer Content

Layer content is moved using the Move tool. The Move tool is the first tool located at the top of the Tools panel, the four-arrow icon. When it is selected, its features become active in the Options bar as shown in Figure 4.7.

FIGURE 4.7 Move tool options in the Options bar.

Note

In CS6, when the Move tool is chosen, the Options bar additionally contains 3-D move icons which will not be used in our work.

Notice by default, the options of Auto-Select, and the Show Transform Controls are not currently active. Before we learn about these Move tool features in the Options bar, leave them unchecked for now, and click on any one of the layers (except the locked Background layer) in the Layers panel of the Rye Beach Layers Sample.psd file. With the layer selected, press and drag anywhere on the image using the Move tool. The Move tool works like a "selection" tool in other graphic programs. Notice that even though it does not visibly show any "selection handles" right now, it allows you to freely move the selected layer content around the image canvas... even off the canvas if you choose to drag it out there.

So... can you guess what the Auto-Select option will allow you to do? This feature will allow you to place the Move tool over the area in the document where the layer you want to move is located, and drag it, without having

to first choose it in the Layers panel. It will be chosen automatically for you because of the location that you click on. If this file contained any groups (we will learn to create them later in this chapter), you could choose Group versus Layer from its pop-up menu for which of the two you wanted to select. With the Show Transform Controls option turned on... there they are: selection handles. When using the Auto-Select feature, they help identify the particular layer content you want to select. In Chapter Five, we will also explore their use for scaling and other layer transformations as well. With a file such as this sample, the Auto-Select feature works great. However, when a file has many layers, it may become more difficult to select the specific layer you want using the Auto-Select option. Once you have experimented with both methods of layer selection in your own work, you will be able to decide which layer selection method you prefer. The row of icons directly to the right of the Show Transform Controls checkbox are for aligning layers which we will learn about later in this chapter.

Want the best of both worlds? If you know that a layer's content is not hidden under other layers and is easily accessible, yet you want to leave the Auto-Select option off for the majority of your layers work, press and hold down the Control/Command key when clicking in the image area where the layer is you want to move. Although the Auto-Select feature will not appear to become active in the Options bar, when you drag on the document, you will be pleasantly surprised. Your layer will be selected and will move without having to first activate it in the Layers panel.

4.4.1 Moving Selections Versus Moving Layers

Two very common frustrations occur in the learning process when first working with layers: choosing the wrong tool based on what you want to move and trying to move a pixel selection (moving dotted outline) with the Move tool when you have the wrong layer selected. Let's examine both of these scenarios to help you avoid these frustrations in your own work.

4.4.1.1 *Wrong Tool Error*

Figure 4.8 is an illustration of the process of moving a selection versus moving a layer (the icons have been intentionally enlarged and are not to scale in this example).

When you want to move an active *selection* (moving dotted outline) to another location on the same layer, you must have any *selection* tool chosen *first*. When you do, and you click *inside* of an existing selection, the cursor will change to an arrow with a small selection box next to it indicating that when you drag you will be moving the *active selection*. When a layer is selected with the *Move* tool chosen, the cursor displays an arrow with a miniature Move tool next to it, indicating that when you drag you will be moving the *content* on the layer.

4.4.1.2 *Empty Selection Error*

The second common error that can occur with a multi-layered file is attempting to move an active

ICON WHEN MOVING
A SELECTION WITH
ANY SELECTION TOOL

ICON WHEN MOVING
A SELECTED LAYER
WITH THE MOVE TOOL

FIGURE 4.8 Moving a selection versus moving a layer.

FIGURE 4.9 Attempting to move a selection with the wrong layer active.

selection with the Move tool when the wrong layer is active. When this happens, the error message shown in Figure 4.9 will appear.

Here the moving dotted outline is in an area of the Background layer, however, the currently selected layer in the Layers panel is the sky layer. As we can see, the sky layer contains no pixels in the area selected. When the Move tool is chosen and dragged *inside* the selection, the warning message "Could not move the selection because the selected area is empty." appears.

4.5 Adding Layers to Your File

A layer can be added to a file by choosing to create a new blank layer, bringing in content from another photograph, converting a selection to a layer, duplicating

an existing layer (including the default Background layer), and by converting a Background layer to a regular layer.

4.5.1 New Layer Command

So far, we have only seen and worked with layers that already contained pixels. In your restoration and enhancement work, there will be times you will want to incorporate your skills as an artist on a separate "editable (and 'delete-able,' if needed) blank canvas" so to speak. We will be learning techniques such as adding highlight spots in eyes, creating gradients for skies, etc. all of which should be created on their own layer.

There are multiple ways to add a new blank layer to a file. Earlier in this chapter we learned about some icons at the bottom of the Layers panel, one of which allows you to create a new layer as shown in Figure 4.2. If your mouse is held over the small folded page icon at the bottom of the Layers panel, the tooltip "Create a new layer" appears. When you single-click on this icon, a new layer will be added in the Layers panel.

Note

When a layer is added to a file through any method, it will always be added above the current selected layer. If no layer is currently selected when a new layer is added, it will be added at the top of the stacking order by default.

In addition to using the Create a new layer icon, a new blank layer can be added to an image by selecting the New Layer command from the Layers panel menu (introduced earlier and shown in Figure 4.3), or by choosing the **New>Layer** command from the Layer menu. When a new layer is added using one of these two commands, a dialog box will be automatically generated for assigning certain properties to the layer at the time of its creation as shown in Figure 4.10.

The two options within this dialog box that are applicable to our work are the ability to name the layer when creating

FIGURE 4.10 New Layer dialog box.

it, and to assign a lower percentage of opacity to the new layer if you do not want it to be 100%. However, both of these options can also be assigned or changed at any time right within the Layers panel, which we will be learning how to do later in this chapter.

What's right for you? Once you have learned how to rename a layer and change its opacity within the Layers panel, whether you add a layer using its Create a new layer icon, or use one of the commands, will be your personal preference.

4.5.2 Adding a Layer Through Importation

Whether an entire photograph or just a selected area of one is added to another image, the new content will automatically be added to the destination image on its own layer. You will use this feature often in your work to improve a photograph by borrowing content from another file. Although content can be copied and pasted into Photoshop through the Edit menu and clipboard, it is easier and more common to drag and drop the content between files using the Move tool.

Note

Under the Edit menu, in addition to the Paste command, there are also three additional pasting options (Paste in Place, Paste Into, and Paste Outside) under a general category of Paste Special, which provide more ways to paste clipboard content into a file. However, in addition to the convenience of the drag and drop feature, when you drag and drop files instead of pasting them they do not use the clipboard which will save on memory use.

DVD
on the

Let's practice this now. We will begin by reopening the Rye Beach Layers Sample.psd file if it is not still open. With it open, also open the River.jpg file provided in the Chapter 4 Files folder, and save it first as River_original.psd, then as a working copy named River_enhanced.psd into your Photoshop practice folder. Now let's choose to display the two photographs side-by-side to easily drag and drop from one into the other by choosing the 2-up Vertical icon from the Arrange Documents menu located in the Application bar in CS5, or by selecting it from the **Window>Arrange** submenu in CS6 as shown in Figure 4.11.

CHOOSING 2 UP: CS5 CHOOSING 2 UP: CS6

FIGURE 4.11 Arranging documents to drag and drop between them.

Alternatively, working in either version, files can be detached from the dock by choosing **Window>Arrange>Float in Window** or **Window>Arrange>Float All in Windows**.

Once both photographs are visible simultaneously, let's click on the Rye Beach Layers Sample.psd image to make it active, then select its sky layer in the Layers panel. Once the layer is active, let's use the Move tool to drag it into the River_enhanced.psd photograph.

> ### Note
>
> These two images contain the same resolution of 300 ppi allowing for seamless integration when they are combined. We will not work with images containing resolution conflicts until Chapter Ten.

When importing the sky layer into the river photograph, even though it will appear as we drag that it is being moved/deleted from the original image, as soon as we release the mouse on the river image, we can see that only a copy of the Rye beach sky layer is moved to the new file. When using the drag and drop feature to add either a layer or a selection from one image to another, you do not have to drag the entire image into the new file. As soon as an outline of the perimeter of the layer or selection begins to appear in the destination file (Mac OS) *or* you see a small icon of an arrow with a plus sign in a square (Windows), you can release the mouse as shown in Figure 4.12.

FIGURE 4.12 Dragging a layer or a selection into another photograph.

However, if you release the mouse before at least a partial outline or a plus sign appears in the destination file, you will have accidentally moved the content from its original location in the source file. In that instance, it is best to return to the source file, and select its history state prior to dragging the file content, then try it again. With the sky successfully dragged into the River_enhanced.psd file, the Rye Beach Layer Sample. psd file can be closed, and not saved, if prompted. In the River_enhanced.psd photograph, the imported sky layer can now be positioned to align with the top and center of the Background layer using the Move tool to match the sample shown in Figure 4.13.

FIGURE 4.13 New sky added to River_enhanced.psd photograph.

When it does, save and close this file for now. We will use it again to learn about changing the opacity of a layer, later in this chapter.

TIP *When images are tabbed together in the document window, in addition to the Arrange Documents pop-up menu (CS5),* **Window>Arrange** *(CS6), or the* **Window>Arrange>Float** *commands to separate them from the dock for drag and drop convenience, you can alternatively Right/Control click on the name of the image in the dock that you want to separate and choose Move to New Window from the context-sensitive menu that appears, or simply press and drag the image's tab to separate it from the dock.*

4.5.3 Converting a Selection to a Layer

You will frequently restore images by "borrowing" content within an image to repair another area of the same photograph, such as siding on a building, an arm, shoe, etc. Although we will work extensively with this repair technique in later chapters, let's get a sneak peak at how this feature works by learning how to use the Layer via Copy command.

Let's open the Brick building.psd file provided in the Chapter 4 Files folder. As we can see, some of the bricks on the side of the building are discolored while others have been replaced, resulting in an unattractive "patchwork" appearance. We will practice repairing a small section of the wall to introduce the power of the Layer via Copy command.

This file contains a small selection of some of its bricks already saved into an alpha channel for this exercise. Let's first activate the saved selection using the **Select>Load Selection** command, and choose the "brick repair" channel in the Load Selection dialog box. Once we have done that, the selection will become active as shown in Figure 4.14.

This area must be enlarged to be able to accurately match up the brickwork. Let's magnify in now to the

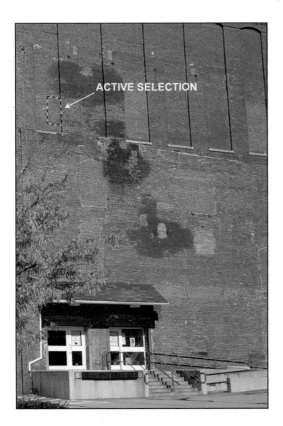

FIGURE 4.14 Brick building with loaded selection.

active selection area, shown in Figure 4.15, leaving visible area above the selected area in our magnification, as that will be where the repair will be made.

Now let's choose the **Layer>New>Layer via Copy** command, or with any *selection* tool active (not the Move tool), Right/Control click and choose Layer via Copy from the context-sensitive menu that appears. Once we have done that, we can see that a new layer has now been added in the Layers panel, above the Background layer. With this new layer selected, the Move tool can now be used to carefully drag the layer content up to cover the discolored bricks just above it, as shown in Figure 4.16.

Although this selection covers these bricks perfectly, oftentimes a repair layer will need multiple

FIGURE 4.15 Magnification of bridge selection.

FIGURE 4.16 Brick repair sample.

transformations such as scaling, rotation, and distortion to properly cover an area and seamlessly match its surrounding image content which we will learn how to do in Chapter Seven. For now, optionally choose to save the changes if you would like, then close this photograph. Let's move on to learning how to duplicate an existing layer.

4.5.4 Duplicating a Layer

The Duplicate Layer command can be used to duplicate any layer, whether it is a regular layer or a Background layer, and is particularly useful in restoration work. Let's open any photograph of your own to learn how to duplicate its Background layer, or the Cat.jpg file provided in the Chapter 4 Files folder. Once you have opened the photograph, you will notice in the Layers panel, that its single Background layer will be preselected by default. Whether you are duplicating a Background layer, or any layer added to a file, the

layer you want to duplicate must be selected first. When learning to create a new blank layer, we saw under the Layers panel menu that Duplicate Layer was one of the available options that we did not discuss at that time. With the Background layer selected in the Cat.jpg photograph, we can select the Duplicate Layer command from the Layers panel menu, choose **Layer>Duplicate Layer**, Right/Control click on the layer and choose Duplicate Layer from the context-sensitive menu that appears, or simply drag the Background layer down on top of the Create a new layer icon at the bottom of the Layers panel. When using this last method, the "none" symbol (circle with a slash) will appear as you drag the layer down: don't give up... it will convert to the "hand" and create a copy of the layer, once you reach the Create a new layer icon. A duplicated layer, whether it is a copy of a Background layer or a regular layer, will have the same name as the original layer selected with the word "copy" added after it by default as shown in Figure 4.17. Once you have done that, save the file for your personal future reference, or choose to close it without saving when prompted.

FIGURE 4.17 Duplicating a Background layer.

With any regular layer (not a Background layer) selected in the Layers panel, if you press and hold down the Alt/Option key first before you drag the layer up or down in the Layers panel and keep it held down as you drag, an icon of two overlapping arrows will appear: a black arrow with a white arrow partially visible behind it. This icon indicates that you are duplicating the selected layer. As you move the layer up or down within the Layers panel, the black line that appears between the layers as you drag will indicate where the new copy of the layer will be added when you release the mouse.

4.5.5 Converting a Background Layer to a Regular Layer

Some commands and features of Photoshop that we will use in our restoration and enhancement work, only apply to regular layers, and will not work on Background layers. Not to worry, when needed, a Background layer can be converted to a regular layer. To convert one, choose **Layer>New>Layer from Background**, Right/Control click on the Background layer and choose Layer from Background from the context-sensitive menu that appears, or simply double-click on the Background layer. When the command is chosen through any one of these methods, the same dialog box shown in Figure 4.10 opens with the former Background layer given the new default layer name of Layer 0.

Note

Once the default Background layer of a file has been converted to a regular layer, *any* layer in the file can be converted to the Background layer. When a regular layer is selected instead of a Background layer, the Layer menu command of Layer from Background toggles to Background from Layer. If a regular layer is converted to a Background layer, it becomes automatically moved to the bottom of the stacking order in the Layers panel, and becomes locked and renamed Background and italicized. If it contains transparency before it is converted, its transparent areas will become filled with the current background color in the Tools panel.

4.6 Managing Layers

Now that we have learned how to create and duplicate layers, let's learn to manage layers by naming them, and exploring the four lock options available in the Layers panel.

4.6.1 Naming Layers

We have learned that when layers are created using the New Layer command, a dialog box appears allowing us to name the layer. We have also learned that when a Background layer is converted to a regular layer, its default new name of Layer 0 can be highlighted in the New Layer dialog box and customized. At any time, any layer in the Layers panel can be renamed by double-clicking directly on its name: not on its thumbnail, and not on the colored area of the layer to the right of its name. When this is done, its original name becomes highlighted, with the ability to customize it. Feel free to reopen your Brick building_restored.psd file to try this now, by changing its default name of Layer 1 to "brick selection" as shown in Figure 4.18 (layer names are not case sensitive).

FIGURE 4.18 Renaming a layer.

> ### Note
>
> If you do not click *exactly on* a layer's name to change it, the Layer Style dialog box will open instead. As you will see if it opens, this dialog box is for special effects such as drop shadows and bevels, and will not be part of our learning. If it opens accidentally, simply click OK or Cancel to close it, and then try double-clicking again directly on the layer's name to customize it.

4.6.2 Locking Layers

Four lock options shown in Figure 4.19: Lock transparent pixels, Lock image pixels, Lock position, or Lock all can be applied to a layer, and are assigned by single-clicking on the desired lock option(s) when a layer is selected. These options toggle on and off; to release a selected lock option, single-click again on the same icon.

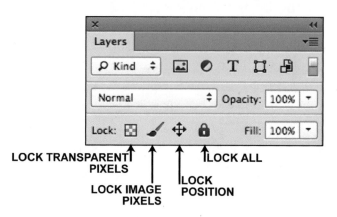

FIGURE 4.19 Lock icons in the Layers panel.

on the DVD Let's explore the lock options of the Layers panel by opening the Fish with plants.psd file provided in the Chapter 4 Files folder which contains a layer of duplicated content for us to work with. Let's begin by turning its Background layer off, then select the fish layer to better understand the specific effect each lock option has on a selected layer.

4.6.2.1 *Lock Transparent Pixels*

Let's choose the Lock transparent pixels icon first. When it is active, image pixels can be manipulated, however the transparent area will be protected. Let's choose **Edit>Fill>Use: Black**, as shown in Figure 4.20, only the fish pixels turn black, the transparent area is protected. Now let's click again on the Lock transparent pixels icon to turn it off, and back up in the History panel to the state prior to filling it with black.

TRANSPARENT PIXELS ARE LOCKED

FIGURE 4.20 Locking transparent pixels on a layer.

4.6.2.2 *Lock Image Pixels*

Now let's select the second icon, the Lock image pixels option. When this icon is selected, the content on the layer can be moved, however, neither its pixels nor its transparent area can be altered. When we select this lock option, and again choose **Edit>Fill>Use: Black,** the message "Could not fill because the layer is locked." appears. Now let's click again on this icon to unlock it, and then click the Lock position icon instead.

4.6.2.3 *Lock Position Versus Lock All*

The Lock position option allows the layer's content to be altered, both its existing pixels as well as its transparent

area, but will *not* allow the content's position to be moved. Let's choose **Edit>Fill>Use: Black,** the entire layer becomes filled. However, when we return to the previous state in the History panel, and drag the Move tool on the layer instead, the message "Could not complete your request because the layer is locked" (CS5) or "Could not use the Move tool because the layer is locked" (CS6) appears. If desired, this option can be applied *in addition to* the selection of *either* the Lock transparent pixels, *or* the Lock image pixels option. This is the same lock option that is applied to a Background layer by default: its pixels can be manipulated, its position cannot.

The Lock all option prevents *both* the manipulation of the layer's pixels, *and* its movement. If we back up in the History panel one more time, and click the Lock all icon, when we now try to either fill *or* move the fish, a warning message appears that the layer cannot be filled, or moved because it is locked. When you are done working with this file, close it, and do not save the changes, if prompted.

4.7 Multiselecting, Linking, Grouping, and Filtering Layers

In our layers work in this chapter thus far, we have always selected a layer, and when we later chose to select a new layer, the previous layer became deselected automatically. Layers can also be multiselected, whether they are contiguous or noncontiguous. Once layers are multiselected, they can be linked to move and transform together, or added to groups for manipulation and organization. Let's learn to multiselect, link, and group layers using a practice file provided in the Chapter 4 Files folder.

4.7.1 Multiselecting Layers

Let's open the Horse and buggy.psd file. Although this photograph needs a lot of work, in its Layers panel,

we can see that this file has a Background layer, and already has three additional layers created, which cover some of the damage to the house roof area of the photograph (feel free to peak at the original roof beneath them). To select multiple adjacent layers in the Layers panel, select one layer, then press and hold the Shift key down as you click on the next contiguous layer: the new layer will be added to your selection. To select noncontiguous layers, such as the Background and roof 3 layers only, click one of them first, then press and hold the Control/Command key down as you click on the particular nonsequential layer or layers you want to add to your selection.

If you have several contiguous layers that you would like to select, click to select the first one, then Shift-click on the last one: all of the layers in between will become selected as well.

Click
TIP

4.7.2 Linking Layers

When layers are multiselected, their content moves and scales together. This relationship can be maintained after they have been deselected, if the layers are linked. Let's link the three roof layers together. Click on the roof 1 layer, then Shift-click and select roof 3. Once you have selected all three of the layers, single-click on the Link layers icon (chain link) at the lower left of the Layers panel as shown in Figure 4.21.

When any one layer is selected and moved now, we can see that the other two layers move with it. Let's select just the roof 1 layer, then single-click again on the Link layers icon at the bottom left of the Layers panel. Notice that this layer is now no longer linked with the other two layers. When a layer or layers are selected, single-clicking on the Link layers icon toggles the linkage on and off.

FIGURE 4.21 Linked layers.

Note

In addition to using the Link layers icon in the Layers panel, alternatively, multiple selected layers can be linked by choosing the Link Layers command from the Layer menu, the Layers panel menu, or when you Right/Control click on one of the selected layers and choose Link Layers from the context-sensitive menu that appears. When linked layers are selected, the Link Layers command alternatively toggles to the Unlink Layers command when chosen under the Layer menu, the Layers panel menu, or when you Right/Control click on one of the selected layers, Unlink Layers will become available from the context-sensitive menu that appears.

4.7.3 Grouping Layers

When layers are part of a group, the group can also be moved and scaled together just as linked layers can. So... what's different about layer groups? Layer groups additionally provide the convenience of collapsible folders for organization when a file contains multiple layers, helping to reduce the space they require in the Layers panel, and allow for individual layer manipulation while still being part of a group. Let's create a layer group using the roof layers, instead of linking them. We will first need to select each layer individually or collectively and click on the Link layers icon to unlink them, if they are still currently linked. With the layers unlinked, we can now multiselect the three roof layers, then choose New Group from Layers from the Layers panel menu, or **Layer>New>Group from Layers**. In the dialog box that opens, the default name of Group 1 can be renamed here, or at any time after its creation in the Layers panel by double-clicking on its name. While still in this dialog box, let's choose to name the group "roof repair" (group names are not case sensitive). Once we click OK, a folder icon appears with an arrow to the left of the group name, that when clicked displays the layers included in the "roof repair" group. When the arrow is in the down position, the layers included in the group are identified as such by indentation as shown in Figure 4.22.

> **Note**
>
> Once a layer group has been created, anytime its group folder is selected above the lock icons of the Layers panel, a pop-up menu which assigns a layer "blending mode" will automatically be converted from its Normal mode to the Pass Through mode as shown in Figure 4.22. Although an alternative blending mode can be selected from this pop-up menu, we will always leave it at the default Pass Through mode when working with groups.

FIGURE 4.22 Contents of a layer group.

When exploring the Layers panel, we learned that the icon that appears as a folder at the bottom of the Layers panel was the Create a new group icon, and that the Layers panel menu also contained an option of New Group. Additionally, this command is available by choosing **Layer>New>Group**. When chosen from any one of these locations, a new empty group folder is added to the Layers panel above the currently selected layer. To add layers to a group created in this manner, simply press and drag the layer up into the folder (except a Background layer). When a black line appears, indicating that you have "reached" the group folder, release the mouse. The layer will be identified as part of the group by the same indentation shown in Figure 4.22.

When multiple layers exist within a group, they can be dragged up or down to adjust their stacking order within the group, as well as the group itself

can be moved in the stacking order within the Layers panel as needed, except below the Background layer. Additionally, just as layers can be duplicated, if a group is selected instead of an individual layer, either from the Layer menu, Layers panel menu, or when you Right/Control click on an existing group, the duplicate command toggles from Duplicate Layer to Duplicate Group. As you have probably guessed by now, if you also drag a group folder down to highlight the Create a new group icon at the bottom of the Layers panel, the group will be duplicated.

When a group is selected, you can choose to transform or hide all of its layers as a unit. If you need to manipulate the pixels of a specific layer within the group, you can edit it without having to remove it from its group. Simply click the down arrow of the group, then select the specific layer you want to show, hide, or work on. Let's try that now. Click on the arrow to the left of the group folder to open the group. Now let's select the roof 2 layer, and then use the Move tool to drag it within the document. Notice that even though it is still part of the group, it moves independently of the rest of the layers within the group. Now let's select the group folder, then use the Move tool to drag anywhere within the document. The group moves with the roof 2 layer's new location also moving correspondingly.

4.7.3.1 Removing Layers From a Group Versus Deleting the Group

To remove a layer from a group, press and drag it above its group folder. When the black line appears, release the mouse, the layer will be detached from the group, identified as such by no longer being indented. Figure 4.23 exemplifies moving the roof 2 layer within the roof repair group, and the roof 3 layer removed from the group if you would like to try this yourself now.

It is more typical that you will want to "detach" layers from a group when a group configuration may

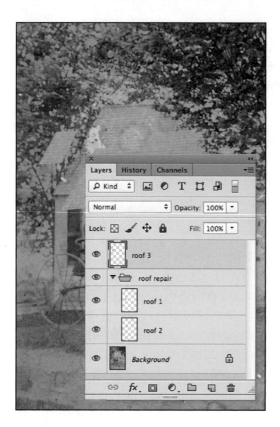

FIGURE 4.23 Moving a layer within a group, and removing a layer from a group.

no longer be needed, rather than want to throw away the group as well as all of the layers contained within it. If a group is selected, and the delete option is chosen by either clicking the Delete layer icon at the bottom of the Layers panel, choosing **Layer>Delete>Group** from the Layer menu, Delete Group from the Layers panel menu, or when you Right/Control click on a group and choose Delete Group from the context-sensitive menu that appears, a confirmation dialog box appears as shown in Figure 4.24.

Be *very careful* in this dialog box. Oftentimes in dialog boxes, the preselected option is the one you want, however in this case, if you inadvertently press Enter/Return without reading the dialog box in its entirety first, the group will be thrown away...with all of its layers as well. Yes, you can back up to the previous history

FIGURE 4.24 Deleting a layer group.

state to recover its layers, but why backtrack when you don't have to? Choosing the Group Only option deletes the group folder only, and returns its contents back to regular layers in the same hierarchy in the layers panel as they were in within their group.

4.7.4 Filtering Layers

In CS6, in addition to the ability to group layers together, then collapse the group folder for more "working space" in the Layers panel, a row of icons have been added above its blending mode and opacity options. These icons provide the ability to temporarily hide some of the layers in a file by filtering them based on categories of types of layers or features applied to them. The pop-up menu at the left allows you to choose a general category of types of layers you want to filter, with additional more specific options to the right of the menu, once a general category has been selected. Because these are *layer* filters, they will be grayed out when a file is opened that only contains a Background layer. When working with a multilayered file, theses filter options can be made accessible by clicking the Turn layer filtering on/off icon provided at the far right this area of the Layers panel. Because our files will not contain *several* layers, or a wide variety of *types* of layers, we will always keep the default filter visibility of Kind chosen, or single-click the Turn layer filtering on/ off icon to toggle it off to hide its accessibility altogether.

Let's close the Horse and Buggy.psd file now, and choose to not save the changes when prompted.

4.8 Aligning Layers

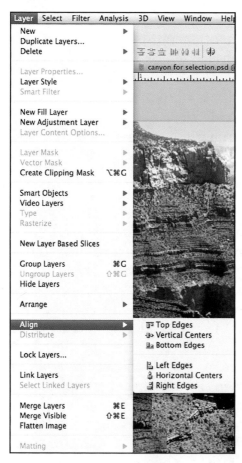

FIGURE 4.25 Options for aligning layers.

When multiple layers are selected, they can be aligned by choosing one or more of the alignment options available in the Options bar when the Move tool is chosen, or when any tool is active, by choosing **Layer>Align>** then choosing the particular layer alignment option desired as shown in Figure 4.25.

When bringing in content from another photograph such as a sky, this attribute can assure that the imported layer is aligned exactly with the top and sides of the destination image. Earlier in this chapter,

we added the sky layer of the Rye Beach Layers Sample. psd to the River_enhanced.psd file which required us to align the destination layer with the top and center of the River_enhanced.psd photograph. Wouldn't it be nice to not have to guess? Enter the alignment icons. Let's try them out.

Let's open the Cactus.jpg and the Sky gradient.psd files provided in the Chapter 4 Files folder. Using one of the arrange document methods we have learned, let's place the two files side by side so that we can easily drag and drop between them. As we can see, the cactus photograph is an awesome one except that its sky is washed out. Notice also that the Sky gradient. psd file has a layer named "sky" above its white Background layer. Let's drag this sky layer into the Cactus.jpg file, not worrying where it is released (to appreciate the power of this alignment feature, it will be more impressive to release it way off to the right or left, or low on the destination image). Now, with *both* layers selected in the Cactus.jpg file, let's apply the alignment options of Align top edges and Align horizontal centers either by using the icons available in the Options bar when the Move tool is active, or by using the **Layer>Align** command as illustrated in Figure 4.26.

Let's choose to save the cactus file now to be able to refer back to it at any time as a refresher. You will notice when you choose the Save command, that the Save As dialog box opens instead with the file extension of .psd applied. Because JPEG files cannot have layers, they are automatically converted in the Save As dialog box to the native Photoshop file format.

4.9 Merging Layers

Just as channels add memory to a file, so do layers. Therefore, if layers can be *safely* merged, the file size

SKY LAYER ADDED TO CACTUS.JPG FILE

ALIGN TOP EDGES AND ALIGN HORIZONTAL CENTERS APPLIED

FIGURE 4.26 Aligning layers using the Options bar icons.

will be reduced. Safely, because once two or more layers are merged, they can no longer be independently moved or manipulated in any manner.

Definition

Merge: When working in Photoshop, to merge layers is to fuse them together with three available unification options: Merge Layers, Merge Visible, and Merge Down.

4.9.1 Merge Down Command Versus the Merge Layers Command

Let's open the Multi-layered couple.psd file now in the Chapter 4 Files folder to explore the Merge Down and Merge Layers options. This photograph's original physical dimensions were too large to be scanned using a standard size 8.5″ × 11″ scanner bed, requiring it to

be scanned in four sections, and then pieced together. Notice its current size in the status bar with its layers: Doc: 13.2M/25.6M (CS5), and 13.2M/36.7M (CS6), with the second number reflecting the file size with its current layers. It is large and memory-intensive. These four sections were imported into a single Background layer file, then adjusted as needed to align them seamlessly, and color-adjusted so that together they appear as if this file was comprised of a single photograph (feel free to turn each layer off and on individually to examine their contents and how they overlap). Before proceeding to restore a composite image such as this one, its layers should be fused into one.

Let's select any layer except the Background layer. Under the Layer menu, or conveniently also available from the Layers panel menu or when you Right/Control click on any layer for the context-sensitive menu, are the Merge Down and Merge Visible options as shown in Figure 4.27.

Now with only the "lower left" layer selected, let's choose the Merge Down command by any one of the three methods you have just learned. Notice after you do

FIGURE 4.27 Merge options when a regular layer is selected.

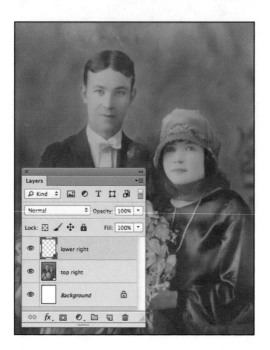

FIGURE 4.28 Layers merged and stacking order adjusted.

that, the "lower left" layer disappears, with its content becoming part of the "top left" layer. Notice also, that our file size has dropped from 25.6M to 21.6M (CS5), or from 36.7M to 28.7M (CS6) by merging just one layer.

Let's now select the "top left" layer, then Control/ Command click to add the "top right" layer. When two layers are selected, the Merge Down option changes to Merge Layers. If you select this command now, an unwanted surprise emerges. Because the "top left" layer has moved up to merge with the "top right" layer, now a dark area located on the "top right" layer becomes visible, that was previously covered by the "lower right" layer. When we now drag the "lower right" layer *above* the "top right" layer, the dark area is once again hidden as shown in Figure 4.28.

> ### Note
>
> When layers are merged, the composite layer inherits the name of the destination layer, and should be renamed after the merge to accurately identify its added content.

Feel free to back up in the History panel, and repeat this exercise, or experiment by merging different layers, or a different sequence of merging layers, then close the file and do not save the changes when prompted.

4.9.2 Deleting Layers Versus Flattening or the Merge Visible Command

In addition to the merge commands you have just learned, layers can also be reduced by deleting them, or merged using the Merge Visible or Flatten commands. If a layer needs to be deleted because it was created accidentally, or as a copy to repair that didn't work as hoped, the selected layer can be removed from the Layers panel by single-clicking on the Delete layer icon, choosing **Delete>Layer** from the Layer menu or from the Layers panel menu, or Right/Control clicking on the layer and choosing Delete Layer from the context-sensitive menu that appears. When this command is chosen using any one of these methods, a dialog box will appear, requiring you to confirm that you want to delete the layer. When you click OK, the layer, along with any content it may contain, is deleted from the Layers panel.

If you know that you want to delete a layer or layer group, and prefer to not have the confirmation dialog box appear, click and drag the layer or group folder down onto the Delete layer icon until the "hand" appears and it becomes highlighted. When you release the mouse, the layer or layer group and any layers it contained, will be deleted automatically.

Definition

Flatten: When working in Photoshop, when this option is selected, all layers contained in the file become merged with its Background layer. When a file is flattened, it size is reduced, with any regular layers for individual editing no longer available.

4.9.2.1 *Save As a Copy Alternative to Flattening*

We all make mistakes. We all change our minds. When working in Photoshop, sometimes we don't even see something we want to change until we take a fresh look at a project the following day. A layer should be merged or a file flattened, only if you are *sure* that you no longer need to edit it, and even then, only if needed. By default, when a .psd file is saved, all layers within the file are automatically saved with it. As an alternative, in the Save As dialog box, by choosing the As a Copy option, and deselecting the Layers option, a flattened *copy* of the file will be saved, leaving the flexibility of the original file with all its layers intact, as shown in Figure 4.29.

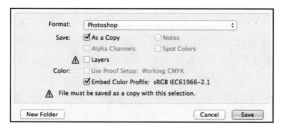

FIGURE 4.29 Choosing the Save: As a Copy option in the Save As dialog box.

4.9.2.2 *Merge Visible Option*

The Merge Visible command will allow you to selectively merge layers by turning off the visibility of the ones you do not want merged *before* choosing this command. If all layers are visible when this command is selected, it will merge all of the regular layers with the Background layer, just as the Flatten command does.

4.10 Additional Pixel Selection Options When Using Layers

The Sample All Layers option when using either the Quick Selection or Magic Wand tools, the Layer Mask

feature, or when using the Refine Edge dialog box, its options to output as a layer, a layer mask, or a layer with a layer mask, are all additional pixel selection features only available when a file contains multiple layers.

4.10.1 Sample All Layers

To understand the Sample All Layers option, in the Chapter 4 Files folder, let's open the photograph named Gondola with layer.psd. When we select the gondola layer with the Sample All Layers option on, then use either the Quick Selection tool or Magic Wand tool to make a selection, the selection affects both layers, not exclusively the gondola layer. Figure 4.30 illustrates a selection of

FIGURE 4.30 Using the Magic Wand tool with the Sample All Layers option checked, and the Contiguous option unchecked.

one of the black areas of the gondola layer using the Magic Wand tool, with the Contiguous option unchecked, but with the Sample All Layers option checked.

4.10.2 Layer Mask

In Chapter Three, you learned to create a selection, then tweak its accuracy using the Quick Mask Mode. At that time, we learned that you could then save this selection into an alpha channel for future use. Another way to improve the accuracy of a selection by painting is to use a Layer Mask. Let's open a file to create and manipulate a Layer Mask. Close the Gondola with layer. psd file, and now open the Single gondola.jpg file instead, and save it first as Two gondolas_original.psd, then as a working copy named Two gondolas_enhanced.psd into your Photoshop practice folder. Let's begin by creating a rough selection around the gondola using a tool such as the Lasso, then moving it to its own layer by applying the Layer via Copy command. When we now hide the Background layer, only the copied gondola is visible, and therefore easier to work with. A layer mask can be added to a selected layer by single-clicking the Add layer mask icon at the bottom of the Layers panel, as shown in Figure 4.31.

FIGURE 4.31 Using a layer mask to refine a selection.

Once the mask is active (click on its icon if necessary to highlight it as shown in Figure 4.31), with the default colors chosen in the Tools panel and black as the foreground color, when the Brush tool is chosen with its Opacity setting at

100%, paint around the outside of the gondola to hide the excess around it. When black is the foreground color in the Tools panel, the masking area is increased (excess around the layer content is hidden, *not* removed), when white is toggled to become the foreground color, as you paint, layer content that was hidden will become exposed. A layer mask can either be saved with the file, allowing it to continue to be tweaked/refined at any time, or when satisfied with a layer's visible content and it is no longer needed, applied by choosing **Layer>Layer Mask>Apply** to remove the mask and make any changes made to its layer content permanent.

> **Note**
>
> Any time you want to edit a Layer Mask after it has been created, it must always be selected first (single-click its icon next to its layer in the Layers panel) for the foreground and background colors when painting to show/hide it rather than paint over it. Additionally, when a mask layer is selected, under the Layer menu in addition to the **Layer>Layer Mask>Apply** option is a Delete option. This will delete the mask, and all your work on it, returning the layer to its original state before the mask was added.

When you are satisfied with the visible content of your gondola layer, apply its layer mask, do not choose to delete it. Turn the Background layer back on, then reselect the copied gondola layer, and move the gondola to appear to be another boat next to the one in the original image, similar to the Gondola with layer.psd file we previously worked with, then save and close this file for now.

4.10.3 Additional Output Options Available in the Refine Edge Dialog Box

Now that you have learned about creating layers and layer masks, CS5 and higher versions of the Refine Edge dialog box include a variety of output options

FIGURE **4.32** Additional output options when using the Refine Edge dialog box.

in addition to outputting as a selection, three of which are applicable to our work: choosing to output as a layer mask, as a new layer, or as a new layer with a layer mask as shown in Figure 4.32.

Feel free to now open any photograph, make a selection, and then experiment with these additional output options in the Refine Edge dialog box, if they are available in your version of Photoshop.

4.11 Layer Transparency, Adjustment Layers, and Layer Effects

Transparency, Adjustment layers, and special effects can be applied to layers. Of these three features, we will explore layer transparency now, with Adjustment Layers explored in depth in Chapter Nine, as they will be applicable to our learning at that time. A variety of other special effects such as drop shadows, and bevels can be applied to layers, as well. (When learning to rename a layer, you learned that if you do not double-click directly on its name, the Layer Style dialog box opens instead.) These effects are not typically used in restoration and enhancement work, and will not be covered in this book.

Adding transparency to a layer can be a handy tool in both restoration and enhancement work, referred to

FIGURE **4.33** Assigning layer opacity with the Normal mode chosen.

in Photoshop as layer opacity. When a layer is selected, its opacity can be reduced, allowing partial visibility of the layer content beneath it, based on the percentage of visibility reduction assigned.

The opacity of a selected layer is assigned by typing in a percent less than the default of 100%, in the Opacity percent window at the top right of the Layers panel, or by pressing on the arrow to the right of this area, and using the slider to visually adjust the percentage, as shown in Figure 4.33.

Note

To the left of the Opacity slider is a pop-up menu (also identified in Figure 4.33) of blending modes which adjust the appearance of a layer's colors relative to the layer below it based on the mode chosen. We learned earlier in this chapter that when groups are created, the default Normal mode changes to Pass Through. In our work, we will *always* want to keep the default settings of Normal for layers and Pass Through for groups. Additionally, directly below the Opacity slider is a Fill slider, which also allows you to assign a lower percentage. Although its results will appear confusingly similar to an opacity change, this option works in conjunction with layer styles which we will not be using in our work, and should be kept at 100%.

Because we will use transparency frequently in our work, let's learn the basics of changing layer opacity for now. Let's reopen the River_enhanced.psd file we worked on earlier in this chapter, when we learned to drag a sky layer into it from the Rye Beach Layers Sample.psd. Notice that the lower right area of the shore is dark, with the tree detail in the foreground totally obscured. With the *Background* layer selected (not the sky layer), draw a selection using the regular lasso that *resembles* the example shown in Figure 4.34 (it is not necessary to attempt to replicate it exactly in this exercise).

With this selection active, assign a feather radius of 5 pixels, then use the Layer via Copy command to add a layer above the Background layer of this area of the photograph. With this new layer selected, lower the percentage of its opacity to 25%, and then use the Move tool to press and drag it down and position it over the dark area in the lower right area of the hill to add a

FIGURE 4.34 Selecting the layer opacity source area.

suggestion of color and texture here as shown in Figure 4.35, then save and close this file.

This exercise improved an area of tones in a photograph by covering it with layer content at a lower opacity. Later in our work, we will learn several additional ways to improve tones. For now, with a strong foundation in the use of layers for our restoration and enhancement work, let's move forward to working with transformation in Chapter Five.

FIGURE 4.35 Layer opacity reduced.

▉ Test Your Knowledge

1. What command converts a selection to a layer?

2. What is a Background layer?

3. Where will a new layer always be added in the stacking order of the Layers panel?

4. How can you easily display two photographs at the same time to drag and drop between them?

5. How do you turn off a layer's visibility?

6. What can you use a layer mask for?

7. What is the difference between linking layers vs. creating a layer group?

8. What does the Lock transparent pixels Layers panel lock option do?

9. What tool is used to drag pixel content from one image into another?

10. What does flattening a Photoshop file do to its layers?

▇ Try It Yourself

▇ Project 1

Open your Restaurant Kitchen_restored.psd that you created an alpha channel of its floor and saved as one of your projects in Chapter Three.
To continue to prepare this image for its restoration:

1. Even though in Chapter Three, we saved an original version as well as our working version, let's choose to duplicate the Background layer of our working copy to be able to monitor our restoration progress with a single-click (and easily start over if we need to).

2. Rename this layer "Background Copy".

3. Choose the Lock position layer lock option to lock the position of this duplicated layer while maintaining the ability to alter its pixels.

4. Hide the original Background layer.

5. Save and close this file for future work.

▇ Project 2

on the DVD Open the photograph named Fish with plants.psd provided in the Chapter 4 Files folder that we used earlier in this chapter when exploring the layer lock options. Save it now first as Fish with plants_original. psd, then as a working copy named Fish with plants_ enhanced.psd into your Photoshop practice folder.

1. Select and duplicate its fish layer.

2. Choose the Lock position option to lock the original fish layer.

3. Drag the fish layer copy below the original fish layer.

4. Rename this copied layer "transparent fish".

5. Use the Move tool to move this fish to appear slightly above the original fish.

6. With the transparent fish layer selected, lower the opacity of the layer to 70%. Your photograph should now resemble Figure 4.36.

FIGURE 4.36 Duplicated layer with reduced opacity.

7. Save this file now into your Photoshop practice folder, then close the file.

Project 3

Open the photographs named House with flowers.jpg and Sky gradient.psd provided in the Chapter 4 Files folder. Notice that the sky in the House with flowers. jpg file is washed out. Let's add a new sky, using a layer mask.

1. Save this file first as House with flowers_original. psd, then as a working copy named House with flowers_enhanced.psd into your Photoshop practice folder.

2. Position these two files side by side using one of the arrange methods you have learned.

3. Drag the sky gradient layer into the house photograph, then close the Sky gradient.psd file and do not save any changes if prompted.

4. Select both layers, then use the align options to align the sky gradient layer to the top and horizontal center of the house photograph.

5. Now with only the sky gradient layer selected, click the Layer Mask icon in the Layers panel to add a layer mask to it.

6. With the layer mask active, and black as the foreground color, using an appropriate size brush, paint

FIGURE 4.37 Layer mask added to sky gradient layer.

away the part of the gradient which covers the house (magnifying in as needed for accuracy), or when white is the foreground color in the Tools panel, add some of the sky gradient back in as needed. When done, with the Background layer hidden, your sky gradient layer should resemble the sample shown in Figure 4.37.

7. When you are satisfied with the customization of this layer, choose to apply (not delete) the layer mask.

8. Save this file now into your Photoshop practice folder, then close the file.

Project 4

Take a look through some of your own photographs. Choose one with an object or person in it that you would like to select (the source file), and one to add this source content into (the destination file). It will not be important in this exercise whether the size of the source content is proportional to the destination file, only that the two files, whether scanned or downloaded, are both the same resolution.

1. Save the destination file into your Photoshop practice folder with an appropriate name indicating that it contains the imported source content.

2. Make a selection in the source file of the content you want to add to your destination file.

3. Drag the content from your source file into your destination file.

4. Rename the new layer added in the destination file with a new identifiable name.

5. Add a layer mask if desired to tweak the accuracy of your selection, then choose to apply the mask if used.

6. Save and close this file for now. We will apply transformations as needed to it in Chapter Five.

5 TRANSFORMATION ESSENTIALS

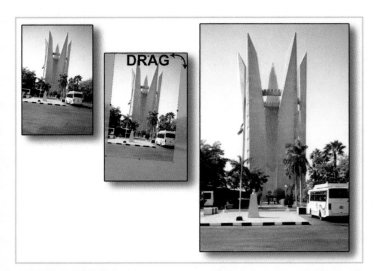

Restoration and enhancement projects often require pixel transformations such as crops, rotations, and distortions. We will be examining these types of transformations, applying them to entire images as well as to individual layers, focusing on their role in the process of restoration and enhancement.

5.1 An Introduction to Pixel Transformation for Photograph Restoration and Enhancement

In Chapter Four, we learned how to import layer content. However, in each case, our content was precreated and intentionally designed to fit its destination location. Many times in your own work, you will need to scale, rotate, and/or distort layer content to have it improve a photograph, as desired. When needed, transformations can be applied to layers of a file, or the entire image including redefining its canvas. If cropping a photograph is desired, there are a variety of options to consider in order for the resulting crop to meet your quality expectations. All of these scenarios involve varying degrees of image shape reconstruction, or transformation, which will significantly broaden the repair possibilities and enhancement capabilities of your future work.

on the **DVD** A copy of each figure shown in this chapter can be viewed on the companion DVD included with this book.

5.2 Transforming Pixels Versus Transforming a Selection

In Chapter Three, we learned that if a selection is active, we can transform it without having to recreate it by choosing **Select>Transform Selection**. When this command is chosen, we learned that selection handles appear that we can manipulate individually to reshape the selection, then click the check mark in the Options bar (or press the Enter/Return key) to commit our selection transformation. In this chapter, we will be transforming pixels, not selections. However, the format of selection handles and clicking to commit pixel transformations will replicate our learning of selection transformations previously mastered.

5.3 Cropping Fundamentals

We will begin our learning in pixel transformation by exploring the fundamentals of cropping. This practice is often applied to photographs to enhance their appearance, and will be explored in depth from an aesthetic perspective in Chapter Eleven. At this time, we will be introduced to the mechanics of cropping and its role in other pixel transformations.

Definition

Cropping: Removing part of an image. While often used in conjunction with other tools and procedures in photograph enhancement, it is commonly employed to improve the artistic appeal of a photograph by removing part of it, so that the remaining content will be more visually interesting to the viewer.

Let's begin by opening a file provided in the Chapter **DVD** 5 Files folder named Crop practice.jpg. With this file active, when we open the Image Size dialog box, as we can see by its size and resolution shown in Figure 5.1, this photograph is from a digital camera: notice its low resolution. With large dimensions, it is designed to have either its size or its resolution reassigned.

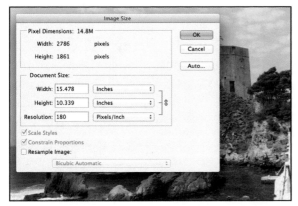

FIGURE 5.1 Original file.

Now if you reassign its physical dimensions to 6″ × 4″ (with the Resample Image box unchecked as you have previously learned), you will see its resolution increase, but also that its original dimensions were proportionately larger: programmed by design to allow its dimensions to be resized to a smaller standard print size automatically without the need to crop as shown in Figure 5.2.

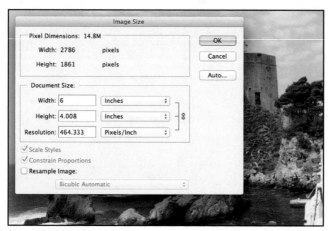

FIGURE 5.2 Physical dimensions reassigned to 6″ x 4″.

Rather than keep this change, click the Cancel button to exit this dialog box. Let's create a vertical cropped version of this photograph instead. An image can be cropped using either the Crop tool or the Rectangular Marquee tool. Let's begin by exploring the crop options available when using the Crop tool. The Crop tool icon is uniquely identifiable in the Tools panel by two opposite right angles with a diagonal line connecting their corners. Its exact location in the Tools panel, and whether it is separate

FIGURE 5.3 Choosing the Crop tool in the Tools panel.

or is grouped with any other tools, will vary depending on the particular version of Photoshop you are using. In CS6, it is the fifth tool down from the top of the Tools panel and is part of a group that includes two Slice tools which are used in web design, and a Perspective Crop tool as shown in Figure 5.3.

> ### Note
>
> In CS6, the Crop tool's operation has been significantly redesigned. To accommodate multiple versions of its operation, when applicable, operational features will be explained separately for CS5 (and all previous versions) versus CS6, with CS6 assigned to work in its "Classic" mode. If you are working in CS6, in the Options bar when the Crop tool is chosen, press and hold its Additional crop tool options icon and select Use Classic Mode from its menu as shown in Figure 5.4.

When the tool is chosen, the Options bar correspondingly provides entry fields for assigning a specific width, height, and resolution for the crop (width and height in CS6) with all fields left blank by default as shown in Figure 5.5.

CLICK HERE TO SELECT THE CLASSIC MODE IN CS6

FIGURE 5.4 Using the Crop tool in CS6 Classic Mode.

OPTIONS BAR CS5

OPTIONS BAR CS6

FIGURE 5.5 Default Options bar when the Crop tool is selected.

With these fields left blank in the Options bar, press and drag across the photograph upper left to lower right to create a vertical crop that resembles the sample provided in Figure 5.6. (When experimenting with this tool, it will

OPTIONS BAR WITH ACTIVE CROP CS5

OPTIONS BAR WITH ACTIVE CROP CS6

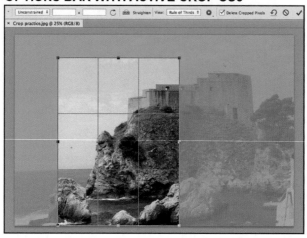

FIGURE 5.6 Options bar features when a crop is active.

not be necessary to match the sample provided exactly.) After the Crop tool has been dragged, the Options bar features update to assist in determining the final crop. The Crop Guide Overlay Options (renamed View in CS6) pop-up menu allows you to display your proposed crop with a Rule of Thirds grid by default, a standard grid, or no grid, or in CS6, choose from a variety of additional overlay grids. Its Shield feature, active by default, allows you to choose a color and opacity percentage to partially hide the area around your proposed crop, to help visualize how the image will appear after the crop has been completed. In CS6, its assignment is located with the Use Classic Mode option, as shown in Figure 5.4. At this stage, you can press and drag within the rectangular crop area (except on its center point) to move the crop around the image, or grab a corner or side handle to reshape the crop preview.

By default, when a crop is completed, the excess image content is deleted. In CS5, if the Background layer has first been converted to a layer, the option Hide will be active in the Options bar, allowing the actual visibility within the

defined crop area to be adjusted later on by pressing and dragging on the photograph using the Move tool. In CS6, the option is provided without first converting the file to a layer by unchecking the Delete Cropped Pixels button in the Options bar, which will convert the Background layer to a regular layer automatically for you. When you are satisfied with the area you have defined for your crop, click the check mark in the Options bar to complete the cropping process. The circle with a slash cancels the crop process, and exits the active crop window, and in CS6, the curved arrow additionally offers the opportunity to remain in the active crop mode, but start the cropping process over.

When a crop preview has been defined, the crop can alternatively be completed by Right/Control clicking on the image, and choosing Crop from the context-sensitive menu that appears, or by pressing the Enter/Return key.

Click
TIP

Note

When in the crop preview mode, if you move the mouse outside a center handle of the preview rectangle, the arrow will change to a *curved* 90° double arrow, indicating that you can press and drag left or right to rotate the area you want used for the resulting image. When the crop is completed, the resulting photograph will be cropped with its orientation adjusted to reflect the position you defined in the preview, as shown in Figure 5.7.

When the crop is completed, the image is resized, however, its final document size when viewed in the Image Size dialog box will most likely not reflect a standard print size because the dimensions in the Options bar were left blank when the crop area was drawn. Let's back up in the History panel to the state before the crop was assigned, and redo it with dimensions entered into the Width and Height fields before drawing an area to crop.

With the Crop tool chosen, let's type in a value of width: 4″ and a height of 6″ with no resolution assigned in the Options bar (in CS6, Size & Resolution must be

FIGURE 5.7 Resulting image when crop preview is rotated.

selected from the Unconstrained pop-up menu first, for the entry fields for this option to appear in the Crop Image Size & Resolution dialog box that opens) as shown in Figure 5.8.

Click **TIP** *Any time dimensions have been typed into the Width and Height fields of the Options bar when the Crop tool is chosen, if you would like to reverse the dimensions entered, click on the icon of two opposite arrows located between the fields in CS5, or the single curved arrow to the right of the fields in CS6. As soon as you do that, a width of 4˝ and height of 6˝ for example, will become a width of 6˝ and height of 4˝ respectively.*

CROP WITH NO RESOLUTION ASSIGNED CS5

CROP WITH NO RESOLUTION ASSIGNED CS6

FIGURE 5.8 Assigning a width and height for a crop, with resolution not defined.

Now press and drag a rectangle diagonally from the top to the bottom of the image, or reposition the one provided when working in CS6. You will notice that compared to using the Crop tool when no values were entered, as you drag, the tool is constrained to maintain the ratio you have assigned. When you complete the crop and open the Image Size dialog box, you will see that the resolution of the image has changed, but the dimensions will reflect the width and height as entered before the crop was drawn. Why and how did the resolution change? When a width and height are assigned but no *resolution* value is assigned, the resulting crop will be the size

ORIGINAL DIMENSIONS: WIDTH 15.478" X HEIGHT 10.339"
ORIGINAL RESOLUTION: 180

LARGE AREA CROP **SMALL AREA CROP**

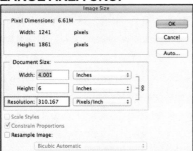

FIGURE 5.9 Resulting resolutions based on the size of the defined crops.

defined, however its resolution will be relative to the size of the area chosen for the crop. Let's take a look at Figure 5.9. In this illustration, the height of the larger crop area is the full height of the image. Therefore, the resulting crop shrinks the original photograph height from 10.339″ to 6″ causing the pixels to be condensed together, raising the resolution to 310.167 ppi. In the smaller crop, the assigned height of 6″ which is more than half the total height of the original image is only using a small area of the image to define that height (approximately one-fourth of its total height), causing its pixels to be spread out, and its resolution (and therefore its quality) to drop to 84.333 ppi.

> **Note**
>
> In CS5, once a width and height setting have been entered in the Options bar when the Crop tool is selected, it will apply to all future crops until the preferences are reset, the fields are highlighted and their content deleted, or by simply single-clicking on the Clear button located to the right of the entry fields. In CS6, click the curved arrow icon in the Options bar to reset the Crop tool back to the default setting of Unconstrained. To cancel a crop altogether, click on its circle with a slash.

5.4 Understanding Resampling

So... what do you do if you want to enlarge a small area using a crop, but still want the resolution of the resulting image to be high? You are not alone: Photoshop has addressed this need through its ability to resample. In all of our work thus far, we have learned to always maintain the pixel dimensions of the image in the Image Size dialog box by being sure that the Resample box was unchecked. As you have learned, when it is unchecked, changes made in this dialog box will affect the physical dimensions or resolution of the image, however the pixel dimensions will remain constant.

Definition

Resampling: Changing the pixel dimensions of an image through one of five interpolation or "conversion" methods: Nearest Neighbor, Bilinear, Bicubic, Bicubic Smoother, or Bicubic Sharper in CS5, with an additional sixth interpolation method added in CS6 named Bicubic Automatic. When an image is resampled down, pixels are deleted. Conversely, when an image is resampled up, pixels are added. Once a resampling method has been selected, Photoshop will calculate how to add or delete pixels as needed to conform to the pixel dimensions entered. Each of the available interpolation options completes this task using a different calculation method with Bicubic Smoother recommended for enlarging an image, Bicubic Sharper recommended when one needs to be reduced, with Bicubic, the default method in CS5, being a median alternative between Bicubic Smoother and Bicubic Sharper. Bicubic Automatic, the default method in CS6, assigns the most appropriate interpolation method based on whether the crop enlarges or reduces the image.

Because pixel data is added or deleted when an image is resampled, the process should be avoided when possible. When minimal adjustments are made to the pixel dimensions of an image through resampling, especially if the recommended method of interpolation is applied, image quality will not be compromised. However, when significant size or resolution adjustments are made, the resulting clarity and image quality may suffer. We will explore scenarios in which it may be advantageous to assign the resample option in the Image Size dialog box, in Chapter Ten. In this chapter, our learning will focus on applying resampling when cropping using the Crop tool.

5.4.1 Applying Resampling When Cropping

Let's close the Crop practice.jpg file now and not save the changes. We will explore resampling when cropping, by using a different image. Let's open the image named Ephesus.jpg this time, provided in the Chapter 5 Files folder. With this photograph open, in the Image Size dialog box, we can see that this image has a width of 12.8″, a height of 17.067″, and a resolution of 180 ppi. We'll crop

FIGURE 5.10 Assigning an Image Interpolation method for resampling under the General category of the Preferences dialog box.

this photograph to a 10″ × 8″ enlargement with a resolution of 300 ppi, which focuses on its ruins. To resample when cropping an image when the Crop tool is selected, the desired resolution is assigned *in addition to* its dimensions. However, when the Crop tool is chosen, there is no menu provided in the Options bar to choose the interpolation method that will be applied when the image is resampled. If a resolution is assigned when cropping, causing the image to be resampled, the interpolation method that will be used will be whichever one has previously been defined in the General category of the Preferences dialog box. When this dialog box is opened, the default interpolation method will be preselected, with the additional interpolation methods available from its pop-up menu, as shown in Figure 5.10.

With the default interpolation method selected and the Crop tool chosen, let's assign a width of 10″ a height of 8″, *plus* a resolution of 300 ppi either in the Options bar directly in CS5, or in its Crop Image Size & Resolution dialog box that opens when Size & Resolution is selected from the Unconstrained pop-up menu in the Options bar of CS6 as shown in Figure 5.11.

CS5

| | Width: 10 in | ⇄ Height: 8 in | Resolution: 300 | pixels/inch ⬍ |

CS6

Crop Image Size & Resolution
Source: Custom ⬍
Width: 10 Inches ⬍
Height: 8 Inches ⬍
Resolution: 300 Pixels/Inch ⬍
☐ Save as Crop Preset

OK Cancel

FIGURE 5.11 Assigning a width, height, and resolution for a crop.

We can see that the Ephesus.jpg file has three guides already in place to help us create the crop (if they are not visible, be sure to make them visible by choosing **View>Show>Guides**). Let's press and drag diagonally from the intersection of the vertical and horizontal guides on the left, down to the vertical guide on the right as shown in Figure 5.12, or drag a corner handle and reposition the crop to confine to the guides provided (CS6).

FIGURE 5.12 Preview for 10″x 8″ crop at 300 resolution.

Once the crop is completed, when the Image Size dialog box is now opened, the new size of the image is exactly 10″ × 8″ with a resolution of 300 ppi. Because of the original physical dimensions of the photograph and the new size defined, if these dimensions are instead assigned for a crop *without* a resolution value assigned (no resampling), the resulting resolution is lowered, as you can see when comparing the two scenarios shown in Figure 5.13.

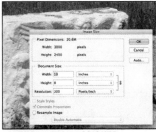

300 RESOLUTION ASSIGNED

NO RESOLUTION ASSIGNED

FIGURE 5.13 Image Size dialog boxes comparing a crop with resampling versus a crop with no resampling.

5.5 Cropping Using the Rectangular Marquee Tool

An alternative to cropping using the Crop tool is to draw a rectangular selection, then apply the Crop command. Feel free to return to the opening state of the Ephesus.jpg file to try cropping using the Rectangular Marquee tool instead. When the Rectangular Marquee tool is selected, the Options bar will display Normal in its Style pop-up menu by default, with two additional options available: Fixed Ratio and Fixed Size as shown in Figure 5.14.

FIGURE 5.14 Crop options when the Rectangular Marquee tool is selected.

If either Fixed Ratio or Fixed Size is selected from the Style pop-up menu, the Width and Height fields to the right of this menu will become active to assign crop dimensions. After you have typed them in, when you click on the image, you will be able to adjust your crop area as desired (when typing in a size, be sure that the "px" unit of measure is replaced by "in," if applicable when Fixed Size is selected). With the moving dotted outline defining your desired crop area, the crop is completed by choosing the Crop command under the Image menu, then deselecting the selection after the crop has been applied. The resulting image will be cropped to the size you defined, with its original resolution in tact. Taking time to experiment by practicing a variety of crops using both the Fixed Ratio and Fixed Size cropping options will help to better understand this alternate cropping method. When practicing, notice that when values are typed in the Fixed Ratio or Fixed Size fields in the Options bar, a "two opposite arrows" icon becomes active between the width and height fields, allowing you to easily reverse the values in these fields. When

you are done practicing, close the Ephesus.jpg file and choose to not save the changes, if prompted.

> **Note**
>
> To later use the Rectangular Marquee tool to create a regular selection, if either the Fixed Ratio or Fixed Size style is the active style in the Options bar when the tool is chosen, the tool will be constrained to reflect the crop values previously typed into its width and height fields. If you attempt to highlight and delete them, a dialog box will warn you that they cannot be left empty. You must reset the preferences back to the default settings, or simply reselect the Normal mode from the Style pop-up menu to return the tool to its default operation.

5.5.1 Cropping a File With Multiple Layers Versus Cropping Layer Content

When a file has multiple layers with *any* layer chosen and when the crop tool or crop command is applied, the entire image is cropped to the defined area. Any empty layers that no longer contain image pixels will still be listed in the Layers panel, and should be deleted. Oftentimes, this transformation is applied accidentally. What if you do not want to crop the entire image, you only want to crop the pixel content of a particular layer? To do this, select the specific layer to crop, then draw a rectangular marquee selection around the content you want to *keep*. The deletion of the unwanted content on that layer will be completed by choosing the **Select>Inverse** command to select all remaining pixels to remove on the selected layer only, then pressing the Backspace/Delete key to delete them.

5.6 Transforming an Image

Image rotation and canvas area redefinition are both image transformations that will often be required in your future restoration and enhancement work.

5.6.1 Straightening an Image

In this chapter, we will explore the process of straightening a crooked image, either because it was not placed exactly parallel to the side of the scanner bed when it was scanned, or was simply taken by a tilted camera (we've all been there). We will learn more advanced techniques for correcting perspective distortion, later in Chapter Eleven. In Chapter Two, you applied guides to a slightly crooked photograph then saved it into your Photoshop practice folder as House_restored.psd. Photographs should always be straightened before they are restored. Let's reopen this house image now to learn how to straighten it using three different methods: through the Options bar when using the Crop tool (CS6 only), through the Options bar when using the Ruler tool (CS5 and CS6), and when using the Ruler tool combined with the Rotate Canvas dialog box (all versions).

5.6.1.1 *Using the Crop Tool Option (CS6) to Straighten a Photograph*

Before we begin, if the guides that were added in Chapter Two are showing, choose to hide them (**View>Show>**then uncheck **Guides**). When the Crop tool is chosen, a miniature ruler icon appears in the Options bar. Let's click on this ruler icon to make it active, then simply drag it along the bottom of the image area of the photograph, as illustrated in red in Figure 5.15. (This edge is easier to see than the top edge of the photograph, as well as this photograph's image area is actually slightly taller on its left side than its right side. Because of this, if we use the top as our guide, the sides will not straighten correctly.) Once we have done that, we need to simply complete the transformation by clicking the check mark in the Options bar, or by pressing Enter/Return. When the guides are again made visible, they confirm whether

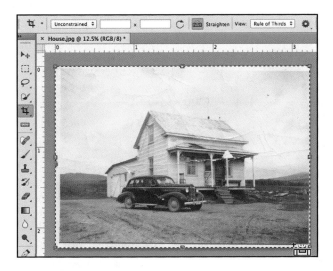

FIGURE 5.15 Applying the Crop tool straighten feature in CS6.

an accurate line was drawn, following the bottom edge of the image. If it was, voila! Proof that the image has been quickly and easily straightened.

5.6.1.2 Using the Ruler Tool Straighten Option (CS5 and CS6) to Straighten a Photograph

Now let's back up in the History panel to the opening state. This time, again with the guides hidden, let's select the Ruler tool which is available from the group that opens when we press and hold on the Eyedropper tool located just below the Crop tool as shown in Figure 5.16.

With the Ruler tool chosen, let's draw a line that again echoes the bottom edge of the House_restored. psd photograph. As soon as we release the mouse, a button labeled Straighten Layer (CS6, or Straighten in CS5) becomes active in the Options bar.

When we single-click on this button,

FIGURE 5.16 Choosing the Ruler tool in the Tools panel.

the image is straightened, defined by the line we drew as the straight edge, and confirmed when the guides are again made visible.

> **Note**
>
> When this feature is applied in CS6, the Background layer becomes converted to a regular layer with the excess area transparent. In CS5, the image becomes both straightened and cropped (the two states will be visible in the History panel). Additionally, when using this straightening option in either CS6 or CS5, if you do not draw a line that is perfectly parallel with the edge of a photograph when using the Ruler tool, you can adjust its angle before applying the straightening option. When you place the mouse over the end point of the line, an arrow with a ruler icon appears that you can either grab and drag as needed, or click the Clear button in the Options bar to start over.

5.6.1.3 Using the Ruler Tool Combined With the Arbitrary Dialog Box to Straighten a Photograph

Now let's back up in the History panel one more time to the opening state, once again choosing to hide the guides. Using the Ruler tool, let's drag it along the bottom edge of the photograph, just as we did in the previous method. However, once we have done that, in all versions of Photoshop, the Options bar will display the degree of the rotation of the line that was drawn, such as "A: -0.5,°" shown in Figure 5.17.

FIGURE 5.17 Options bar displaying the angle of a line drawn with the Ruler tool.

Now under the Image menu, when the Image Rotation command is selected (or in some versions: Rotate Canvas), its submenu provides options to rotate the image 180°, 90° clockwise or counterclockwise, flip the image horizontally or vertically, as well as an Arbitrary option. When the Arbitrary option is chosen, in the Rotate Canvas dialog box that opens, an accurate angle

rotation will be listed based on the line which was drawn first, as shown in Figure 5.18.

Once we click OK to complete the canvas rotation, the photograph will be straight.

FIGURE 5.18 Assigning a canvas rotation in the Rotate Canvas dialog box.

Note

In addition to photographs placed on a scanner bed crooked, all of the straightening techniques we have learned will work on a photograph taken with a tilted camera. Instead of dragging the edge of the photograph, simply drag along the edge of content that you know should be straight *within* the photograph. Additionally, when the Crop tool is selected, and the mouse is moved to a corner selection handle, the image can be dragged to straighten it, reposition it, resize it, and crop it in one step as shown in Figure 5.19.

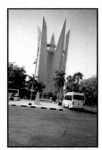

FIGURE 5.19 Straightening a photograph taken with a tilted camera.

5.6.2 Cropping Canvas

Our house_restored.psd image is now straight, however in this method, because the image has been rotated, some of its canvas is now visible.

> **Definition**
>
> **Canvas:** An image in Photoshop exists on top of a background surface equal to its dimensions by default, referred to as its canvas. While usually hidden by the image, when an image is rotated, its canvas does not rotate along with it: allowing parts of it to become visible, displayed in the current background color chosen in the Tools panel at the time the rotation was applied.

Let's eliminate the photograph's border as well as any visible canvas by cropping. Using either the Crop

tool with *no* width, height, or resolution assigned, or by using the Rectangular Marquee tool, crop the image to the edge of the straightened image area as shown in Figure 5.20. Save and close the file for now to continue its restoration later.

FIGURE 5.20 Rotated and cropped photograph.

5.6.3 Adding Canvas to an Image

When learning to straighten an image, we discovered that an image always contains a canvas beneath it that equals the image size. Sometimes in your work, you will need to add to an existing image beyond its current dimensions. In order to be able to do that, the canvas area must be increased. In this chapter, we will apply a basic canvas extension to learn the process. In Chapter Eleven, we will explore additional applications of this technique.

Let's open the Train.jpg file provided in the Chapter $_{\frac{\partial}{\partial}}$**DVD** 5 Files folder, and save it first as Train_original.psd, $_{\frac{c}{c}}$ then as a working copy named Train_enhanced.psd into your Photoshop practice folder. When this image opens, we can see that the top of the front car of the train is so close to the top edge of the photograph that it would inevitably be cut off if the photo was printed and framed as is. This photograph can be improved by adding more sky above the train, then recropping the train back to its original dimensions. However, in order to add sky area to this image, its canvas area must first be increased.

Let's choose **Image>Canvas Size** to open the Canvas Size dialog box. When it opens, it may at first glance appear to replicate the Image Size dialog box. However, let's learn about its options in detail by examining Figure 5.21.

The Current Size information of the Canvas Size dialog box is the same as the Document Size information in the Image Size dialog box, except that in the Canvas Size dialog box it cannot be edited. What *can* be

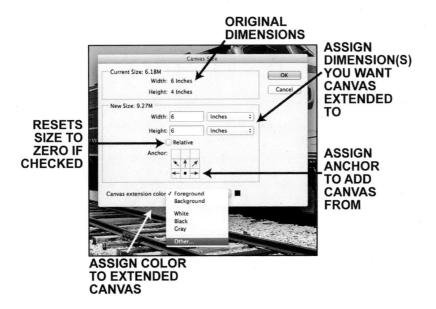

FIGURE 5.21 Canvas Size dialog box.

edited (and must be to increase the canvas area of the image) are the New Size fields. If the Relative box is unchecked, the original dimensions can be highlighted and reassigned. If this box is checked, the two fields begin with a value of zero, allowing you to assign the new size "relative" to the original dimensions. (The end result is the same and which method works better for you will be simply a matter of preference.) Once a new size for one or both of the dimensions is entered, the desired location to add the new canvas area is defined by clicking in the appropriate box to place the "anchor" direction to expand the canvas from. Lastly, the desired color for the new canvas area is selected.

Are we ready? Let's add some more sky area to this photograph. How much canvas do we need to add? It is always helpful to add a little more than you actually expect you will need, and then crop away the excess. With the Relative box unchecked, let's change the Height field from 4″ to 6″. We will need to assign the Anchor option so that our extended canvas will be added *above* the train by clicking on the bottom center anchor square. The arrows will automatically update to visually illustrate how the canvas will be extended. Lastly, to add the color of the new canvas, we choose the Other option from the Canvas extension color pop-up menu. The

SELECTING A CANVAS COLOR CLOSE TO THE TOP OF THE PHOTOGRAPH

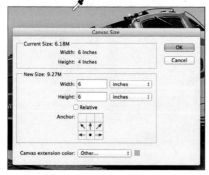

FIGURE 5.22 Setting options in the Canvas Size dialog box.

Color Picker that we were introduced to in Chapter Three opens, however, instead of choosing a color inside of it, when we move the mouse outside of the picker, an eyedropper appears that we can choose a color for the canvas. Let's click as close as possible to the top edge of the sky in the existing photograph to select a color to use to extend the canvas, as illustrated in Figure 5.22.

When we click OK to exit this dialog box, the image is updated with the new additional canvas area. To complete our canvas training for now, let's recrop the image back to 6″ × 4″. With the Crop tool chosen, let's assign a width of 6″, a height of 4″, and a resolution of 300 ppi. Press and drag diagonally from the left edge of the photograph above the train to the lower right edge of the photograph, then adjust the crop preview as you like, with a *suggested* preview shown in Figure 5.23.

FIGURE 5.23 Crop preview of the train photograph with added canvas.

Once the crop is completed, the color in some areas of the newly added sky may not perfectly match the original: not to worry…learning how to match color when enhancing a photograph, will be part of our future learning. Let's save and close this file for now.

5.7 Transforming Layer Content

Oftentimes your future restoration and enhancement work will require the transformation of one or more layers of a multilayered file, through scaling, rotation,

and/or distortion, instead of applying those types of transformations to the *entire* image.

5.7.1 Scaling Layer Content

Let's begin our exploration of layer transformation by learning to correctly scale content when a couple of images are combined.

on the **DVD** Let's open the Shore.jpg photograph provided in the Chapter 5 Files folder. Once it is open, save it first as Shore_original.psd, then as a working copy named Shore_enhanced.psd into your Photoshop practice folder. Although we will not be working with this same file again in later chapters, it will be fun to show others your work, and you will be able to return to this file to review its layer transformations as a refresher if needed later on. Before we add content to this photograph that will be scaled, notice under the Edit menu that the commands of Free Transform and Transform are both grayed out, indicating that they are currently unavailable.

Now let's open the Gull.psd file, and then arrange the two files side by side for convenience. Using the Move tool, let's drag the contents of the Gull.psd file into the Shore_enhanced.psd file, then close the Gull.psd file and do not save the changes if prompted. Whoa!... One huge bird... no problem: let's learn how to scale him (or her?) down to a size proportional to the rest of the Shore_enhanced.psd photograph's content.

FIGURE 5.24 Layer transform commands.

With the seagull layer selected in the Layers panel, when we choose the Edit menu now, both the Free Transform and Transform commands are available for selection: these commands are only applicable to layers. Notice that unlike the

Free Transform command, the Transform command contains a submenu of transformation options as shown in Figure 5.24.

Let's choose **Edit>Transform>Scale**. Once we have done that, a bounding box with eight handles appears around the perimeter of the seagull image. To scale this image proportionately, grab any corner handle, and drag it diagonally towards the center of the image while holding down the Shift key. You must hold the Shift key down the *entire* time, and release the mouse *before* the Shift key when done to constrain the proportions of the layer content as it is being scaled. Once you are satisfied with the size, you can drag inside your transformation (except on its center point) to move its location as desired then click the check mark in the Options bar (or press the Enter/Return key) to complete the transformation. Alternatively, you can scale the layer and complete the transformation, then press and drag it to its desired location using the Move tool.

As we learned in Chapter Four, when the Move tool is chosen, and Show Transform Controls is checked, bounding box handles appear around the selected layer's content every time the Move tool is chosen. An alternative to scaling layer content by choosing **Edit>Transform>Scale** is to have the Show Transform Controls option checked in the Options bar first, then press and drag any corner bounding box handle while holding the Shift key to resize the layer content as desired, then complete the transformation by clicking the check mark in the Options bar, or by pressing the Enter/Return key.

How much should you scale the content, and where should it be placed? As long as it is placed on top of the matching color area of the water in the shore photo, use your artist's eye and have fun: the sample shown in Figure 5.25 is just a suggested size and location.

FIGURE 5.25 Scaled layer content.

5.8 Rotating Layer Content

To manually rotate content on a layer, when the Rotate command is chosen (**Edit>Transform>Rotate**), press and drag to visually rotate the layer content as desired, then click the check mark (or press the Enter/ Return key) to apply the transformation. Or drag outside a corner when the curved arrow appears, if you have the Show Transform Controls option active in the Options bar. Before continuing, feel free to experiment with manually rotating this layer content.

If you have experimented by applying any manual rotations, click back in the History panel to the state where the original scaling transformation was completed. As shown in Figure 5.23, in addition to the Rotate command, when **Edit>Transform** is chosen, we can see that there are additional rotation options

available from its submenu: Rotate 180°, Rotate 90° clockwise, Rotate 90° counterclockwise, Flip Horizontal, and Flip Vertical.

We have learned that layer content can easily be duplicated by holding down the Alt/Option key, while dragging the layer content in the document using the Move tool. Let's do that now, to duplicate the seagull. Once a copy has been made, let's scale the new seagull down or up a little as you have learned, then move it to appear either closer or further away than the original. Now, let's choose **Edit>Transform>Flip Horizontal**. Your results will vary, but should *generally* resemble the sample shown in Figure 5.26.

FIGURE 5.26 Rotated, moved, and scaled layer content.

> **Note**
>
> When you select a layer transform command from the Edit menu, the Options bar provides applicable entry fields to assign a specific transformation value, such as to rotate a layer 45°. When assigning a rotation, positive values rotate the layer content clockwise, while negative values rotate it counterclockwise as shown in Figure 5.27. The pivot point of the rotation is determined by the reference point, the highlighted square in the Reference point location icon at the far left of the Options bar. While visually making your adjustments may work best for you, assigning transformation values within the Options bar may also be helpful at times. If layer content is transformed by entering values into any of these fields, the transformation is also completed by clicking the check mark in the Options bar, or by pressing the Enter/Return key.

FIGURE 5.27 Options bar transform entry fields.

5.8.1 Distorting Layer Content

Although the Skew, Perspective, and Warp commands that are also located under the Transform submenu will not be applicable to our work, we will oftentimes utilize the Distort command. This command allows the individual transformation of each corner handle of layer content as needed, and is invaluable in restoration and enhancement work. Let's learn how to use this command by completing a basic distort transformation.

Let's open the Distortion.jpg photograph provided in the Chapter 5 Files folder. Its guides indicate that the photographer was not standing directly in front of the sign when the photograph was shot as shown in Figure 5.28.

By using the Distort command, we can fix that. The Distort command is also located with the Scale and Rotate commands by choosing **Edit>Transform> Distort**. However, when we try to choose this command

FIGURE 5.28 Photograph with distortion.

now, notice that it is grayed out, because as you have learned, all of the **Edit>Transform** commands apply only to layers. Once we convert the Background layer to a regular layer, the command becomes available. When we now choose **Edit>Transform>Distort**, each corner selection handle can be manipulated independently. Using the guides to assist in its straightening, with the mouse, drag the left corner handles of the image one at a time until the image is aligned with the guides. As you straighten the sign, notice that oftentimes you need to *return* to a corner's selection handle and readjust it, once you have manipulated another one of its handles. Once the image is straightened, its corners now protrude beyond the canvas as shown in Figure 5.29. Notice also in the sample, that we must reduce the view of the document enough to be able to extend the transformation handles as needed beyond the canvas, until the sign is straight.

When you are satisfied with your adjustments, click the check mark (or press the Enter/Return key) to apply the transformation. Because the Distort command requires a layer, as soon as we now choose to flatten the image in the Layers panel, the excess image area beyond the canvas is automatically removed. Although this Distortion.jpg project introduced the basic concept of the Distort command, it is commonly used in conjunction with the Layer via Copy command for repair work, which we will learn to do in Chapter Seven.

FIGURE 5.29 Distortion handles extended to straighten the sign.

*When using the **Edit>Transform** commands, if you apply one, and want to add another different transform command as well, you can return to the **Edit>Transform** command and select to add the additional transformation option without having to click the check mark to complete the previous command first. Alternatively, when one transform command has been selected, before completing the transformation you can Right/Control click to add a different command from the context-sensitive menu that appears.*

5.8.2 Using the Free Transform Command

The Free Transform command can provide multiple types of transformations. While the **Edit>Transform** options of Scale, Rotate, and Distort are straightforward, you may prefer to use this multifaceted alternative. When the Free Transform command is chosen from the Edit menu, bounding box handles appear around the layer content, ready for your transformation. Scaling is achieved by dragging a corner, with the Shift key added to constrain the scaling. When the mouse hovers outside a corner of the transform bounding box, a curved double arrow icon appears to rotate the layer. To distort, drag a corner handle of the bounding box while holding down the Control/Command key. To practice with this

command, click in the History panel back to the state where the Background layer of the Distortion.jpg file was converted to a regular layer, and experiment with this transform command alternative to decide which method of layer transformation works best for you. When you are done practicing, close the file, and do not save the changes when prompted.

> ### Note
>
> When applying a distortion by using the Show Transform Controls feature in the Options bar, the Control/Command key must be held down when dragging a corner selection handle, just as it is required when the command is applied using the **Edit>Free Transform** command.

Test Your Knowledge

1. In addition to the Crop tool, what other tool can be used to create a crop in Photoshop?

2. What is the name of the background surface that an image exists on top of that is equal to the dimensions of the photograph?

3. What does resampling do?

4. What is the purpose of the Anchor setting in the Canvas Size dialog box?

5. What is the default image conversion method for resampling in Photoshop CS6?

6. Which tool provides the choices of Fixed Ratio and Fixed Size in the Options bar when it is chosen?

7. Which layer transform command allows you to move each bounding box handle individually as needed?

8. Where can you type in a specific rotation for a layer, such as 45°?

9. When the Move tool is selected, what option can you choose in the Options bar to automatically show

bounding box handles around layer content for transformation purposes?

10. When in the Canvas Size dialog box, what must you assign in addition to the New Size, Relative, and Anchor options?

 Try It Yourself

Project 1

on the **DVD** Open the photograph named Colosseum.jpg provided in the Chapter 5 Files folder. This photograph was not placed on the scanner bed properly, and needs to be straightened.

1. Save it twice: once as Colosseum_original.psd, then as a working copy named Colosseum_enhanced.psd.

2. Straighten the photograph using any one of the methods you have available in your version of Photoshop.

3. Crop the image (if applicable), maximizing the image area as shown in the right sample of Figure 5.30.

GUIDES ADDED STRAIGHTENED AND CROPPED

FIGURE 5.30 Guides added, and image straightened and cropped.

4. When you are satisfied with your work, save and close the file.

Project 2

Open the Church.jpg file provided in the Chapter 5 Files folder. Notice that the crosses at the top of the church are almost cut off. This photograph can be improved by adding canvas area to the top of the photograph.

1. Save it twice: once as Church_original.psd, then as a working copy named Church_enhanced.psd into your Photoshop practice folder.

2. Choose **Image>Canvas Size**.

3. In the Canvas Size dialog box, change the Height to 5 inches, adjusting the Anchor option to add the new area to the top of the image, with a sampled background color to the right of the center cross of the main building (because of the clouds in the sky, the color here will most likely be white).

4. Choose the Crop tool and assign a width of 6 inches, a height of 4 inches, and a resolution of 300 ppi.

5. Draw a crop that adds sky to the image while removing the shadow on the lower left as shown in Figure 5.31.

6. Save and close the file for now. In Chapter Ten, we will learn how to cover its extended canvas area with content to further match the original sky.

Project 3

Open your composite image from your Photoshop practice folder of two of your own images combined together, created as Project 4 in the last chapter.

1. Apply transform commands such as scaling, rotation, etc. as need to the imported layer, so that its content appears proportional in the destination file.

FIGURE 5.31 Crop preview of photograph with added canvas.

2. Add more content to your composite image, by importing selections from additional photographs if desired being sure that all files are the same resolution, continuing to scale, rotate, or distort the imported layers to blend the added content into the original image as realistically as possible.

3. Save and close this file.

Project 4

Select any photograph of your own, either scanned or downloaded from a digital camera.

1. Create a 4″ × 6″ (or 6″ × 4″) crop with no resolution assigned in the Options bar.

2. Open the Image Size dialog box and note the resulting resolution compared to that of your original image.

3. Save this image with the extension: my crop_no resolution.

4. Return in the History panel to the opening state.

5. Create a new crop with the same dimensions assigned, but with a resolution of 300 ppi assigned as well.

6. Save this modified version with the extension: my crop_300.

7. Arrange to display the two images side by side.

8. Magnify in as needed to study the details in the two images. Note which version yielded a higher quality image, and delete the poorer quality cropped image.

6

PAINTING AND PRINTING

In This Chapter

- Examine sizes, settings, and uses of the Brush tool
- Employ the Eyedropper tool independently and in conjunction with the Brush tool and Color Picker
- Master color management
- Learn tips and techniques for proofing and printing photographs

Many of the tools we will learn in the second half of this book will utilize brushes for their application. Additionally, for our prints to fulfill our color expectations, our workflow must be color managed from start to finish. After exploring the Brush tool, the Eyedropper tool, and the Color Picker, we will learn to assign the appropriate color and print settings required to effectively color manage our future restoration and enhancement projects.

6.1 Painting Fundamentals

In previous chapters, some of the tools we learned required us to assign a brush size and hardness, select and sometimes reverse the default foreground and background colors, and access the Color Picker dialog box. Because that was not the focus of our learning at the time, when settings were applied, minimal explanation was given regarding the specifics of the settings chosen. Many of the photograph restoration and enhancement tools and techniques we will be learning in future chapters will *also* require the assignment of custom painting settings when implemented. Additionally, sometimes color enhancements and accent details can be effectively and conveniently applied to a photograph by choosing a brush, setting, and color, and simply painting them directly onto the image. Exploring these painting settings in depth now, will empower us to maximize their effectiveness when our future projects require their application.

6.2 Assigning Brush Sizes and Settings

Let's learn to assign brush sizes and settings by exploring their application when the regular Brush tool is chosen. Although a variety of tools and techniques used in Photoshop require brushes to execute their functions, their brush options are similar, and oftentimes identical to those provided when the regular Brush tool is selected.

When we press and hold on the Brush tool to view its extended menu, we can see that although it is the active tool by default, it is part of a group of tools, as shown in Figure 6.1 (how many additional

FIGURE 6.1 Choosing the Brush tool.

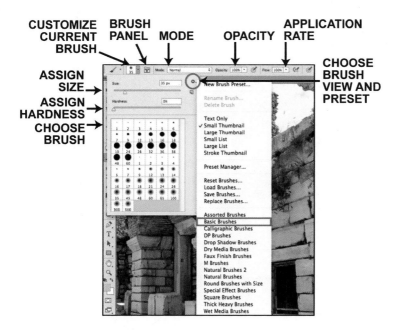

FIGURE 6.2 Brush tool Options bar settings.

tools are available in this group will depend on your version of Photoshop).

A copy of each figure shown in this chapter can be viewed on the companion DVD included with this book. **DVD**

As soon as the Brush tool is selected, its options become active in the Options bar. In our work, some of its options should be kept at their default settings, while others will require customization based on their application. Let's take a look at the settings detailed in Figure 6.2.

6.2.1 Choosing a Brush Type and Size

When the preferences are at their default settings, the size of the Brush tool when it is selected in the Tools panel will have a diameter of 13 pixels, with a hardness of 0%. When the arrow to the right of this size is clicked, the Options bar expands downward to provide Size and Hardness sliders to customize the brush chosen: when this same arrow is clicked a second time, the menu toggles and closes. As shown, when this extended

menu is open, a variety of types of brushes are available that are all part of the default brush set. Additionally, when the small icon/arrow to the right of the size slider is clicked, the viewing style of the brush presets can be changed, as well as a variety of other brush presets can be selected to display additionally, or in place of, the current default brush preset. As detailed in Figure 6.2, let's select the Basic Brushes preset. The style and sizes of these brushes will be most applicable to the type of work we will do, and will allow our brush selections to display more uniformly across multiple versions of Photoshop. When this selection of brushes is chosen from the list of available brushes, a dialog box will open asking if we want to append or replace the current brushes: we will choose OK to replace them. Once active, notice that the brush tip icons represent a variety of sizes, and two styles: hard and soft. When any brush with the "feathered" outline is chosen, the hardness setting defaults to zero. The small "container of brushes" icon directly to the right of the current brush option will toggle to display the Brush panel which allows you to further customize your brushes, as well as create ones from scratch. Feel free to experiment with the panel, however, all of our work will require only the Basic Brushes preset.

> **Note**
>
> While this book will always display brushes at the default view of Small Thumbnail, you may prefer to choose an alternative method of displaying the brushes, such as Small List, or Stroke Thumbnail from the menu that opens when you click the icon/arrow to the right of the Size slider.

6.2.2 Choosing Brush Settings

When the Brush tool is active, the Mode category in the Options bar refers to the assigned blending mode.

For our type of work, its pop-up menu must *always* display Normal for all brushes to perform as needed. To the right of the Mode category, the Opacity, Flow, and Airbrush options assign what percent of application, and in what manner a brush will apply the chosen color. By default, the opacity and flow options are set to 100%, and the airbrush option is off. While opacity defines the amount of color applied with each click of the mouse, flow defines the rate of that application, with the airbrush option allowing the color to continue to "spray" until the mouse is released. For our purposes, when assigning brush options, we will oftentimes assign a lower opacity, but will always keep the flow of the brush set to the default application of 100%, and the airbrush setting off.

6.2.3 Defining Cursor Display Preferences

Even though we can choose the Brush tool and assign options for it, we cannot see its cursor, or use it, until we have a file open.

Let's open the Brush and color sample.jpg file provided in the Chapter 6 Files folder. Once it is open, with **DVD** the Brush tool chosen, when the mouse is moved over the image, a circle should display representing the current brush size chosen. This display view is popular because it allows users to know before they apply the tool, whether they have chosen the appropriate brush size for the task. This is the default painting cursor which can be changed by choosing the Cursors category of the Preferences dialog box as shown in Figure 6.3.

FIGURE 6.3 Defining cursor preferences.

As an alternative to the Normal Brush Tip painting cursor, the Precise cursor displays crosshairs indicating the exact center of the brush tip. In the Cursors category of the Preferences dialog box, we can see that all other tools which display their specific icon when chosen, can also be alternatively displayed using the precise cursor by selecting the Precise option provided here.

Is the brush width cursor not showing when the Brush tool is selected even with the option selected in the Cursors category of the Preferences dialog box? Is your Caps Lock key on? Rather than assigning this option in the Preferences dialog box which will apply it every time a brush is chosen, when the Normal Brush Tip cursor is set as the Painting Cursor preference, applying the Caps Lock key on the keyboard will temporarily switch to the Precise mode, providing crosshairs for accuracy, and will switch back to the normal display when the Caps Lock key is disengaged. In addition to working with brushes, the caps lock toggle feature will engage the precise cursor when working with any tool in the Tools panel that typically displays its icon when using it.

Note

When the normal brush tip cursor is chosen, you have learned that its width will be shown on your screen relative to the magnification you are viewing your image at. A small brush such as one with a width of only 3 pixels, for example, may still display only as crosshairs until you are magnified in large enough to display its regular brush tip cursor.

When adding color using a brush, best practice is to always create a new layer to paint on rather than painting directly on top of an image. On its own layer, it can be manipulated through addition, deletion, its layer opacity lowered, etc., without permanently disfiguring the original file. Let's begin to develop this habit

FIGURE 6.4 Brush size, opacity, and hardness practice.

by applying it in our practice work. Creating individual layers for each brush application, with black as the foreground color in the Tools panel, let's practice a few different brush size, opacity, and hardness settings as shown in Figure 6.4.

When assigning the opacity of a brush, an alternative to typing in a percentage, such as 30%, is to press the "3" key on the keyboard. Pressing any number key from 1 through 0 in the main keyboard or in the numeric keypad will represent percentages of opacity, with the number "1" equaling 10%, and "0" equaling 100%.

6.3 Choosing and Applying Colors

In addition to the default colors in the Tools panel, foreground and background colors can be defined by sampling color within an image using the Eyedropper tool, or through the Color Picker.

6.3.1 Using the Eyedropper Tool

Depending on your version of Photoshop, the Eyedropper tool's specific location in the Tools panel will vary, but it is very distinctive and easy to identify as the icon replicates an ink bottle eyedropper.

> **Note**
>
> In your version of Photoshop, the Eyedropper tool may also be grouped with a Color Sampler tool or a 3D Material Eyedropper tool. Both of these tools contain an additional icon to the left of their eyedropper, our work will always utilize only the regular Eyedropper tool, which contains no additional icons next to its eyedropper icon.

When the Eyedropper tool is selected, the Options bar will default to the Sample Size setting of: Point Sample. Although additional average larger sampling options are available from its pop-up menu, we will always keep it at the default setting. When applied it samples only the color of the exact pixel we click on. In CS5 and higher, you will additionally be able to choose to sample from more than just the current layer, and if you have turned on the Enable OpenGL Drawing feature under the Performance category of the Preferences dialog box, you will also be able to select to show or hide its Sampling Ring, which compares the new sample color with the current one, each time you click the tool.

Let's experiment with this tool by using it to sample new foreground and background colors. With the Brush

and color sample. jpg file still open, delete all the layers added, or revert in the History panel to the opening state with only its original Background layer. Magnify in to the purple flowers in the photograph, and click the Eyedropper tool on the various shades of purple in the cluster of flowers. Notice as you do that, the foreground color continues to update each time you sample a new shade of purple.

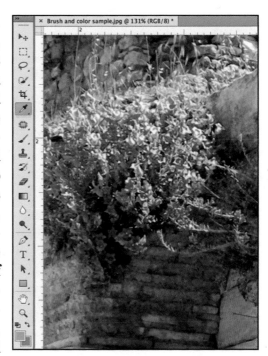

FIGURE 6.5 Selecting foreground and background colors using the Eyedropper tool.

Although by default, when sampling an image using the Eyedropper tool, the new color will always replace the existing foreground color in the Tools panel, when the Alt/Option key is held down while using the tool, the sampled color will replace the current background color in the Tools panel instead. In the magnification shown in Figure 6.5, the foreground color in the Tools panel reflects the sampling of one of the purple colors in the flowers on the left, with the background color selected by using the Eyedropper tool with the Alt/Option key held down while sampling the flowers on the right.

6.3.2 Using the Color Picker

We were briefly introduced to the Color Picker for selecting an alternative to the default red masking color when painting a selection in the Quick Mask Mode, and

for assigning a canvas extension color when in the Canvas Size dialog box.

When selecting a color to extend the canvas area of the train photograph, we learned that when the Color Picker dialog box opened, as soon as the mouse was moved out to the image, an eyedropper appeared allowing us to select a color within the photograph. When the eyedropper was clicked, the "new" box in the Color Picker reflected the color selected, and became the color used to extend the canvas.

You may have discovered another way to access this dialog box accidentally: any time you single-click on either the foreground or background color in the Tools panel with *any* tool chosen, the Color Picker opens. When the Color Picker is accessed by single-clicking on either the foreground or background color, if the eye dropper is clicked outside the picker anywhere in the open image, the selected color appears as the "new" color in the Color Picker, and will replace the current foreground or background color, whichever one you had originally clicked on, once you exit the dialog box.

Alternatively, a color can also be chosen by using the color slider and color field options located within the Color Picker itself, as shown in Figure 6.6.

A color is selected by first dragging the slider up or down the color bar located in the middle of the Color Picker dialog box, then clicking an option for the color in the light to dark color field provided on the left. The selected color will display in the new box, with the previous color shown in the current box below it. The new color will also be numerically represented by the values located in the R, G, and B fields below it. For the Color Picker to display

FIGURE 6.6 Selecting a color in the Color Picker.

in the default configuration shown in Figure 6.6, be sure that the H is chosen for the color model, and that Only Web Colors is *not* checked. All other categories of this dialog box will not be applicable to our work.

6.4 Painting With the Brush Tool

Before learning some color management and printing tips, let's close the Brush and color sample.jpg file now, and not save the changes. We will use a different photograph to practice our new knowledge of choosing brushes and colors to enhance it through painting. We will improve the color of some burnt grass, by selecting a color within the photograph, then using it to paint over its grass, which will be *one way* its appearance can be improved.

Let's open the Stonehenge.jpg file provided in the Chapter 6 Files folder. In addition to its areas of burnt grass, this photograph needs color adjustment to the stones. Save the file first as Stonehenge_original.psd, then as a working copy named Stonehenge_enhanced. psd into your Photoshop practice folder. We will work with its grass for now, but will improve its stones in Chapter Nine. Let's use the Eyedropper tool to select a color to paint with. As shown in Figure 6.7, a rich green color was found in the lower left grass area. Alternatively, if you single-click on the current foreground color and access the Color Picker, in the RGB section to the right of the color slider, the values of R: 126, G: 139, and B: 72 can be typed in, which will produce the same color shown in the sample.

Following best practice, let's create a new layer before beginning to paint. Once the layer has been created and is active, let's choose the Brush tool. We will be lightly painting over *only* the burnt out areas of the grass. You have learned that a brush size is relative to your current magnification. Choose the largest size brush possible, which still provides the degree of accuracy required, that

FIGURE 6.7 Selecting a foreground color to paint with.

can be adjusted larger or smaller as needed. We will want a hardness of zero so that the edges of the brush strokes will blend back naturally into the unpainted areas. In the Options bar, keeping the Mode at Normal, let's assign an Opacity of 20% with the Flow kept at 100%, and the Airbrush setting off. It will be important to apply the strokes horizontally, to follow the general appearance of the rest of the grass, and to not apply color over the same area repeatedly. Even though the opacity is assigned at 20%, the next time the brush is passed over the same area, the opacity will actually then become 40%, etc., and begin to hide the texture of the grass. By using the Brush tool on its own layer, we will be able to delete the layer and start again, or lower the opacity of the layer if it seems too dark. We can continue to create more new layers to

FIGURE 6.8 Stonehenge_enhanced.psd file with the Brush tool applied to the grass as needed.

paint on, and test the final look by turning the layer (or layers) on and off to access the improvement with the painted areas, versus the original image, with the enhanced image resembling Figure 6.8.

Any time you are using the Brush tool, you can select a new color to paint with by holding down the Alt/Option key to temporarily access the Eyedropper tool to click and choose a new color within the image. As soon as the mouse is released, the Eyedropper tool will automatically revert back to the Brush tool and its current settings to continue painting with the new color.

Once you are satisfied with your painted grass, save and close this file for now. This project introduced the Brush and Eyedropper tools which we will use in future chapters. Before beginning our restoration work in Chapter Seven, let's learn about color management and some tips on printing our work to maximize its quality and affordability.

6.5 Color Management

All of the components in the digital imaging process: scanners, digital cameras, monitors, and printers have ICC (International Color Consortium) color profiles attached to them which define how they handle colors. Color management is the name given to the process of literally "managing the color profiles" between those devices, so that the colors in your printed photograph will match the colors as they appear on your monitor. You may have already experienced this in a positive or negative manner: you printed a photograph, and the colors in the hard copy matched your monitor screen, or perhaps more likely, printed a photograph and were totally discouraged at how different it looked from the image as it displayed on your monitor. Welcome to the world of color management. By choosing the correct working color space, properly handling profile mismatches when they occur, and choosing the most appropriate settings in your printer's Print Settings dialog box, we will learn to get consistently great color prints by design, not by accident, through color management.

> **Note**
>
> These color management settings assume that you will be printing your photographs in-house. If you will instead be having your printing outsourced, contact your service provider, and assign the color profile specifications according to their recommendations.

6.5.1 Calibrating Your Monitor

To maximize the effectiveness of your color management, your monitor should be calibrated. Let's learn how to color manage our files first, just in case your monitor is already calibrated properly. If after you have learned how to color manage your files and the colors in your prints still do not satisfactorily match their corresponding colors on your monitor screen, calibration may be affecting your results. At that point, a variety of third party calibration utility software are available, if one is needed.

6.5.2 Understanding the RGB Versus CMYK Color Working Spaces

Because we will need to assign a color space in the Color Settings dialog box, it will be important to be sure that we have a solid understanding of the difference between the RGB and the CMYK color spaces first. The letters CMYK denote the four inks: Cyan, Magenta, Yellow, and Black referred to as process colors that are used to create all colors and continuous tones in commercial offset printing. When a photograph will later be used in this manner, it is typically saved in this color space. The RGB color space on the other hand, with its letters referring to Red, Green, and Blue, is used by digital cameras, monitors, and scanners, and is *converted* automatically for you by your home inkjet printer to CMYK when printing. Even if your printer has ink cartridges that are named "Cyan" or "Magenta," for example, all files should

be kept in the RGB mode which they will be by default whether they were scanned in or downloaded from a digital camera. Because of this, we will always be working in the RGB color space throughout this book.

6.5.3 Assigning Color Settings

Let's open up the Color Settings dialog box and review its default settings. To access this dialog box, we do not have to have a file open. With Photoshop open but no image open, let's choose **Edit>Color Settings**. Once we have done that, the dialog box shown in Figure 6.9 opens.

The Settings pop-up menu defaults to the North America General Purpose 2 color setting. With this setting chosen, under the Working Spaces section of this dialog box, the sRGB IEC61966-2.1 (hereafter referred to as sRGB) color space is the default RGB choice. When you roll your mouse over this menu option, the Description category at the bottom of the dialog box updates to provide details about the selected working space. The words "its limited color gamut" indicate that it is not the best choice for our work.

FIGURE 6.9 The North America General Purpose 2 default working space.

When we press and hold on the Settings category and instead select North America Prepress 2, just as a description of the sRGB space displayed in the Description area when we rolled over it, this time the Adobe RGB (1998) space description reads: "provides a fairly large gamut (range) of RGB colors." This is the color space we will want to use for our work from now on, as shown in Figure 6.10.

Note

In Chapter Two, we learned how to customize a workspace: our personal arrangement of panels and docks. Although similar in its phraseology, working spaces in the Color Settings dialog box refer specifically to the assignment of color profiles for color management, and have no relevance to panel configurations.

FIGURE 6.10 Choosing the Adobe RGB (1998) working space.

6.5.4 Color Management Policies

With the Adobe RGB (1998) working space chosen, while still in the Color Settings dialog box in the Color Management Policies section, we need to define how we want files handled that have profiles which are not the same as our working space of Adobe RGB (1998), as well as ones that have no profile attached to them at all.

6.5.4.1 *Profile Mismatches*

Notice that by default, as soon as we choose the North America Prepress 2 setting, under the RGB category of the Color Management Policies section, in addition to the Preserve Embedded Profiles being selected, all of the mismatch scenarios also become automatically checked to ask us what to do, if a mismatch of some kind exists when opening a file. As shown in Figure 6.11, we will choose Convert to Working RGB, and still keep all the profile mismatching options checked that we want to be asked first: this will always alert us to a profile mismatch or missing profile (an image that has no embedded profile). Alternatively, if you prefer, you can keep the other two options checked, but choose to *uncheck* the Ask When Opening Profile Mismatches, so that Photoshop will automatically convert any file with a profile other than Adobe RGB (1998) to this defined space when opening it without asking.

When you choose to open an image that has a color profile that is not the same as your defined working space, if you checked to be alerted and asked how to handle it, an Embedded Profile Mismatch dialog box will open, and ask how to handle the profile discrepancy. To view this dialog box with the color management settings set as shown in Figure 6.11, let's

FIGURE 6.11 Assigning a color management policy.

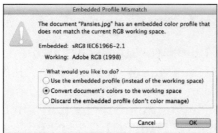

FIGURE 6.12 Converting a profile mismatch to the working space.

open the Pansies.jpg file provided in the Chapter 6 Files folder. Because we chose Convert to Working RGB for our color management policy, before the image will open, if you did not *uncheck* the Ask When Opening Profile Mismatches color management option, a dialog box will open automatically asking how to handle the profile mismatch, but will have the radio button preselected to Convert document's colors to the working space as shown in Figure 6.12. Anytime this dialog box opens, we will always keep this setting, and click OK to apply it.

Note

Although most digital cameras use the sRGB color space, some of them provide the option to alternatively assign the Adobe RGB (1998) color space. In consulting your manual, you can search for information on "Color Mode" or "Color Space" and assign Adobe RGB (1998) to further synchronize your color management if applicable.

6.5.4.2 *Handling Missing Profiles*

If you are working with images that you have scanned or have taken with your digital camera, they will automatically have embedded profiles attached to them. Because we have chosen under our color management policies to Ask When Opening when working with images

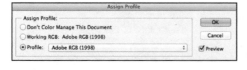

FIGURE 6.13 Assigning a profile when an image does not already have one embedded.

with missing profiles, if someone gives you a file with no color space assigned to it, when you attempt to open it, you will receive the

message that it does not have an embedded profile. If that should occur, choose to open the file, then assign the Adobe RGB (1998) profile by choosing **Edit>Assign Profile**, then selecting it from the Profile pop-up menu in the Assign Profile dialog box as shown in Figure 6.13.

6.6 Assigning the Proper Color Management Print Settings

Now that we have assigned our working space of Adobe RGB (1998) to our Pansies.jpg file, let's learn how to complete the color management process by assigning the proper settings in the Photoshop Print Settings dialog box. Let's first choose to save this file as Pansies_color managed.psd, then select **File>Print**. (Because we will not be enhancing or restoring this image, we will save this one copy with its descriptive name for reference purposes only.) Once the Photoshop Print Settings dialog box is open, it will require some specific color management customization, as shown in Figure 6.14.

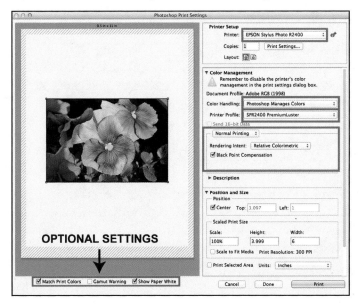

FIGURE 6.14 Choosing settings in the Photoshop Print Settings dialog box.

If you have more than one printer, begin by selecting the specific one you plan to use for your restoration and enhancement work in its Printer Setup section. Once you have done that, in the Color Handling section, Printer Manages Colors will be chosen by default. This *must* be changed to Photoshop Manages Colors from its pop-up menu. Once chosen, the Printer Profile pop-up menu will become active: check its pop-up menu to be sure the profile displayed is the one that best describes the paper being used as well as the printer (if applicable), and select a more appropriate profile from the list if necessary. Choose a rendering intent from the Rendering Intent pop-up menu, typically selecting either Relative Colorimetric or Perceptual. Let's select Relative Colorimetric, however, at times depending on the colors in your photograph, you may want to apply the Perceptual method instead. (We will be learning how to save on printing costs when doing test prints later in this chapter.)

> **Definition**
>
> **Rendering Intent:** When colors in the color space of a destination device are out of the range of the color gamut of the source device, a "conversion method" defined as the "rendering intent" must be assigned for how the destination device will handle the out of gamut colors. There are four rendering intent conversion methods available: Perceptual, Saturation, Relative Colorimetric, and Absolute Colorimetric, with Relative Colorimetric being the default conversion method in Photoshop.

The Black Point Compensation option should be checked to assure that dark shadows will print as close to the original as possible. The three options below the preview area: Match Print Colors, Gamut Warning, and Show Paper White are all simply convenience options which provide previews of the final appearance of the print, therefore, whether selected or not, they will not affect the actual printing of your file. Feel free to turn

each one on and off, and observe the respective changes they display in the preview window of the Pansies_color managed.psd file, to better understand what these options display, then choose to check or uncheck one or more of them as desired.

6.6.1 Turning the Printer's Color Management Off

We must make one more very important setting assignment for all of our hard work to "render" the results we expect. Every color printer comes with its own built-in method of handling color space. This *must* be turned off, so that it will not conflict with the color management settings we have defined through our choice of Photoshop Manages Colors as shown in Figure 6.15. To locate this setting to disengage it, while still in this initial print dialog box, begin by clicking the Print Settings button in the Printer Setup section. Once you have done that, you will enter the printer settings dialog box specific to your printer: exactly where the color management setting will

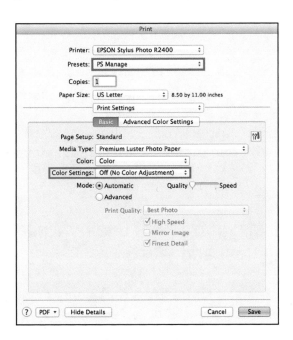

FIGURE 6.15 Turning off the printer's specific color management feature.

be for your particular printer will depend on the manufacturer and model. While it will typically be under a category such as Color Settings or Color Options, you may need to consult your printer's manual.

> **Note**
>
> Although the settings detailed in the print dialog box figures shown in this section represent those of an Epson Stylus Photo 2400, the options will be the same for all printers, except for selecting your specific printer profile from the Printer Profile pop-up menu, and the location of where to turn off your printer's internal color management feature within its specific Print Settings dialog box.

Once you have found the location to turn off the color management feature of your printer, you can save this as its own selectable printing option preset by choosing the Save As option under your printer's Presets pop-up menu. That way, if you use the same printer for other work, you can select your default printing preset, and only select your specific preset with your printer's color management off when printing from Photoshop, as shown by the custom preset that has been created named "PS Manage" displayed in Figure 6.15.

Now, with all of our Photoshop color management options on, and our printer's color management option off, let's click the Print button, and enjoy the rewards of our newly learned professional color management skills.

6.7 Ten Tips to Maximize Print Quality While Minimizing Cost and Waste

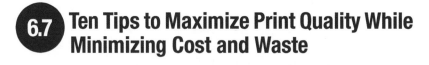

Let's face it: all inkjet printer inks and papers are expensive, with archival products being even more so. When printing test or final prints, you will want to max-

imize the output quality, while minimizing your cost and waste. The following ten tips will help.

> **Note**
>
> Any of the printing paper saver tips noted in this section that require the reinsertion of a sheet of paper will work with all inkjet printers except ones which include a Gloss Optimizer as one of their ink cartridges. Additionally, some of the printing tips may require the image's orientation on the page to be the opposite of your actual print. When needed, choose **Image>Image Rotation>Rotate 90° CW (or Rotate 90° CCW)** prior to opening the print dialog box, then print your proof, and click back in the History panel to the state prior to your orientation change when done.

1. Print using only the archival papers and inks recommended by the printer's manufacturer.

 Many photo papers available on the market today, state that they are "universal" and may even specifically state that they are compatible with your printer. However, to maximize the quality and longevity of your prints, if there are specific archival papers recommended for your printer by its manufacturer, you should use them. Even if you are just doing a "test run" using a lower quality paper, it could be wasting paper and ink, by not properly displaying the true colors of the file.

2. Saving paper by turning off the Center Image option. Under the Position category of the print dialog box, the Center Image option is preselected by default. By unchecking it, but still keeping the Bounding Box option checked (if applicable) as shown in Figure 6.16, if the photograph is small enough, the image preview can be dragged from the default center position, to the top half of the preview window. To be sure you are placing it within the margin restrictions of your printer, once the Center Image box is unchecked, rather than simply dragging it, if you

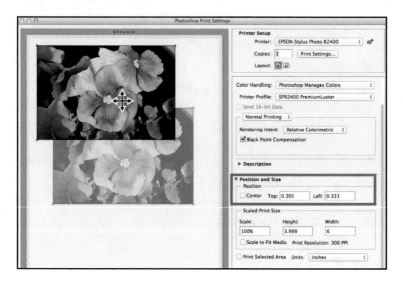

FIGURE 6.16 Turning off the Center Image feature.

prefer, you can define the distance from the edge of the page you want to move the location of the print on the paper by typing in specific values into the Top and Left fields provided. The next time you need to print and also do not require an entire sheet of paper, you can flip this paper 180°, then reinsert it into the printer again to use its other half: sort of like getting "two for one."

3. Scaling up to fit the page size for proofing.
 If your print is smaller than the full sheet of paper, you can adjust the orientation/layout of the page (if applicable), then under the Scaled Print Size section of the print dialog box, check the Scale to Fit Media box, to print an enlarged version of the file if you need help discerning details in severely damaged areas as shown in Figure 6.17. The new print resolution will be lower, and will be precalculated for you, however for proofing purposes it will not significantly affect the quality of the test print.

4. Scaling down to fit the page size for proofing.
 Following the same scenario, if your final print will be larger than your printer is capable of producing,

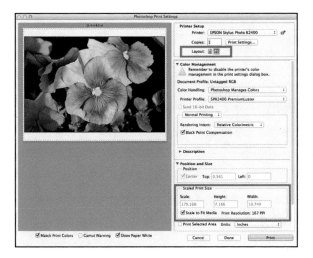

FIGURE 6.17 Using the Scale to Fit Media feature.

requiring you to outsource its printing, you can proof it by having the same Scale to Fit Media box checked, to proportionately reduce the file size to be able to print and proof the oversized print in it entirety.

5. Previewing a section of an oversized print at 100%.
 If you will be outsourcing a large print, you may want to check the quality of the print, or a specific area of the print at 100% of its size and resolution, instead of, or in addition to, the Scale to Fit Media option. As shown in Figure 6.18, if Center Image is unchecked, and Scale to Fit Media is unchecked, with the Bounding Box option on, you can press and drag the image around the preview window to select the area you want to print. Although this photograph is 18″ × 12″: even though only a small area of the photograph will be visible when printed, the selected area will print at 100%.

6. Printing a selected area.
 In all versions of Photoshop except CS5, regardless of the size of the photograph, if a selection is made prior to entering the print dialog box, the Print Selected Area option is available, allowing you to print only a preselected area, instead of the entire print.

FIGURE 6.18 Printing a section of an oversized print at 100%.

7. Standardizing a print size without distorting or cropping it.
Perhaps you have a print that is not a conventional frame size, but you would like it to fit in one, without having to crop it, or custom frame it. With the photograph open, choose the **Image>Canvas Size** dialog box, and assign the dimensions of the standard frame size, then choose to fill the surrounding area with a color sampled from the photograph. In Figure 6.19, the original print size was 8″ × 6″, with the canvas dimensions changed in the Canvas Size dialog box to 10″ × 8", with the canvas extension color sampled from the photograph as shown.

8. Using a 4″ × 6″ print template.
The Chapter 6 Files folder contains a file named 4 × 6 template.psd. This template was created in the Adobe RGB (1998) color space with a resolution of 300 ppi. Most photo inkjet printers allow for either borderless prints, or minimal margins of ¼″ on all sides. When this file is opened, you will see that it contains guides for placing three 4″ × 6″ prints on the same page. By opening one, two, or three of your own 4″ × 6″ photographs then dragging them onto this template using the Move tool and rotating them as

FIGURE 6.19 Standardizing a print size by extending its canvas.

FIGURE 6.20 Using the 4″ × 6″ template for printing.

needed, you will be able to print three photographs on one sheet of paper as shown in Figure 6.20. When using this template, once you click the Print button in the Photoshop Print dialog box, the warning message in Figure 6.21 may appear. If your printer allows minimal margins, even though this message appears, there will be no clipping.

9. Using a 5″ × 7″ template.

Additionally, included in the Chapter 6 Files folder is a template that was also created in the Adobe RGB (1998) color space with a resolution of 300 ppi for printing two of the same, or two different 5″ × 7″ prints.

10. Testing layer content.

Only visible layers print. If you have one or more layers of content that you want to test, and know that you do not need to print the entire image, you can turn off the layers you are satisfied with, then in the print dialog box, using the same steps shown in Figure 6.16,

FIGURE 6.21 Printable area warning dialog box.

save paper by only printing the questionable area. Next time, flip the paper 180°, and test another layer or layers as needed.

With a fundamental knowledge in using many of the tools and menus of Photoshop, we are now ready to adapt these skills to new tools and techniques used for repairing damaged photographs beginning in Chapter Seven.

Test Your Knowledge

1. When using the Brush tool, what key can you press and hold down on the keyboard to temporarily access the Eyedropper tool?

2. What is the name of the default RGB working space (abbreviated name), when the North America General Purpose 2 color setting is selected?

3. What is meant by the term "Rendering Intent"?

4. What key can you press on the keyboard to *temporarily* access the Precise cursor when using the Brush tool?

5. What causes a color profile mismatch?

6. What are some of the advantages of creating a new layer to paint on when using the Brush tool?

7. What do the letters CMYK stand for?

8. What is the name of the RGB color space that "provides a fairly large gamut of RGB colors," which works well for photographs?

9. When using color management, which Color Handling option should you select from its pop-up menu?

10. What does the default painting cursor look like?

Try It Yourself

Project 1

Open one, two, or three of your own photographs.

1. When opening each image, confirm that it will be converted to the working space: Adobe RGB (1998), if you have chosen to be asked when a profile mismatch occurs.

2. Resize or crop each one to a 4″ × 6″ image size (vertical or horizontal).

3. Open the 4x6 template.psd file.

4. Choose to arrange the documents to conveniently access all of them, then use the Move tool to drag each photo into the template and position it within the guides provided as shown in Figure 6.20. (If you are using one photograph to create three copies of it, once it has been added to the template file one time, Alt/Option drag the photograph to the next two guide areas.)

5. Be sure your print dialog box is set to color manage your printing, and that your specific printer's color management is turned off, then print the template page.

Project 2

Open the Add canvas.jpg file provided in the Chapter 6 Files folder. *on the* **DVD**

1. Click OK to convert the document's colors to the working space of Adobe RGB (1998) when prompted (unless you have chosen to have this converted without asking).

2. Open the Canvas Size dialog box.

3. Assign a new size of 10″ × 8″.

4. For the Canvas extension color, choose Other, then use the eyedropper to select any color you would like from the photograph, or type in the values of R: 143, G: 172, and B: 208 in the Color Picker, as shown in Figure 6.22.

FIGURE 6.22 Canvas extended to convert photograph to a standard 10″ × 8″ frame size.

5. Save and print the photograph, if desired.

Project 3

Open your Covered Bridge_enhanced.psd file previously saved into your Photoshop practice folder.

1. Click OK to convert the document's colors to the working space of Adobe RGB (1998) when prompted (unless you have chosen to have this converted without asking).

2. Add a layer to the file, then select the Brush tool, and assign a Hardness of 0% and an Opacity setting of 20%.

3. Select a brown color from the side of the bridge, or use the Color Picker and type in the values of R: 67, G: 53, and B: 37.

4. Soften the "metallic" appearance of the guardrails, by gently painting over them with the brown color

selected, using a brush size applicable to your view. Your photograph when completed should resemble Figure 6.23.

FIGURE 6.23 Covered Bridge_enhanced.psd file with guardrails painted.

5. Save and close this file for now, we will work with it again in Chapter Nine.

Project 4

Open any photograph of your own, either scanned or downloaded from a digital camera that could use some type of simple painting enhancement such as grass color or tinting rails.

1. Choose to convert the document to the Adobe RGB (1998) working space, if prompted.

2. Add a layer to the file, then select the Brush tool, and assign a Hardness of 0% and an Opacity setting of 20%.

3. Use the Eyedropper tool to select a color to paint with.

4. If you have multiple areas you would like to improve, use separate layers for each color enhancement.

5. Choose to print your photograph, being sure to have Photoshop manage the color, and confirm that your printer will *not* be managing the color.

PART 2

RESTORING AND ENHANCING YOUR PHOTOGRAPHS

7 REPAIRING TEARS, FOLDS, AND HOLES

Most restoration projects require both surface repairs and color correction to varying degrees, in order to return the photographs back to their original grandeur. In this chapter, we will begin learning to repair surface damage through the art of cloning. The Clone Stamp tool and the Patch tool will be employed individually, and in concert to repair tears, folds, and missing image content. We will also advance our experience with the Layer via Copy command to include its application to restoration challenges that can be difficult to repair using traditional cloning tools. When using this command, we will be additionally introduced to how the Eraser tool is used in the restoration and enhancement process.

7.1 Starting a Restoration

Sometimes restoration projects require only surface repairs, sometimes only color correction, but usually, at least to some degree, they necessitate the incorporation of both. Commonly, a photograph that appears initially to require only color correction, once scanned and opened in Photoshop, shows surface damage that may not be visible in the original, but would definitely be visible if the photograph was enlarged. Because of that, which type of repair should be done first: color correction or surface correction? Although we will learn the repair process first, it is often a matter of personal preference. Sometimes restorers prefer to correct the color in a photograph first, then "tidy" it up with damage repairs, while others remove the flaws first, then "polish" the repair with color correction. Oftentimes, the sequence decision is made simply based on the degree of work the particular project requires in each of these restoration categories. Because most restorations require both surface damage and color corrections, some of the projects we will work with in this chapter will be saved and reopened in Chapter Nine to adjust their tonal quality as well.

7.2 Repairing Through Cloning

Repairing tears, folds, and holes in Photoshop is done through cloning, by using a variety of methods and tools, oftentimes combined together to perfectly reconstruct a damaged area of a photograph. The type and severity of a damaged area determines the tool or tools and methods required to repair it. We will begin our learning of cloning with the Clone Stamp tool, and then combine it with the Patch tool and the Layer via Copy command for the types of restoration projects covered in this chapter.

> **Clone:** To clone is to make an identical copy of something. When working in Photoshop, to clone an area of a photograph is to copy its content to reuse it to cover another area of either the same, or a different photograph.

7.3 Using the Clone Stamp Tool

The Clone Stamp tool is a powerful tool used in restoration to cover damage, as well as used for enhancement by adding to, or removing by covering, content in a photograph. In this chapter, we will focus on its repair capabilities. As we will learn, as powerful as it is, the Clone Stamp tool is often used in conjunction with other repair tools, to maximize the quality of the resulting restorations. Let's begin our repair work in this chapter by first mastering the Clone Stamp tool as a standalone repair tool.

7.3.1 Clone Stamp Tool Basic Operation

The Clone Stamp tool is located directly below the Brush tool in the Tools panel. It's "rubber stamp" icon is very distinctive, however when we press on the small triangle located in its lower right corner, we can see from the extended menu that opens, that it is part of a group which also contains the Pattern Stamp tool. We will *never* use the Pattern Stamp tool in our work, and it can appear confusingly similar to the Clone Stamp tool, except that in addition to its rubber stamp icon, it also contains a small checkered pattern to the left of it, as shown in Figure 7.1.

FIGURE 7.1 Selecting the Clone Stamp tool in the Tools panel.

on the DVD A copy of each figure shown in this chapter can be viewed on the companion DVD included with this book.

Once the Clone Stamp tool is selected, the Options bar updates to reflect its features. As we can see, many of them echo those of the Brush tool, with a few important additions, detailed in Figure 7.2. Before learning how these specific options affect the use of the Clone Stamp tool, let's first learn its basic operation.

FIGURE 7.2 Options bar when the Clone Stamp tool is chosen.

on the DVD Let's open the Big Ben.jpg photograph provided in the Chapter 7 Files folder. As we can see when it opens, this photograph has some minor damage to it: folds, tears, spots, and a missing corner. To continue to reinforce good work habits, save it first as Big Ben_original.psd, then as a working copy named Big Ben_restored.psd into your Photoshop practice folder.

The Clone Stamp tool works its magic by borrowing a "good" area of the same or a different photograph to

FIGURE 7.3 Warning message to define the source point for cloning.

paint over a "bad" area. Because the Clone Stamp tool borrows content to paint with, if it is simply clicked on an image without having first been assigned what to use, one of the following messages shown in Figure 7.3 will immediately display.

So, now that we know we must define a source

point, where shall we begin? Let's start by learning to repair the torn area on the right, just above the tree branches. Before choosing a brush, we will want to magnify in so that we will be able to clearly see the effects of our work. Now let's choose a soft brush (Hardness setting of 0%), comparable in size to the sample shown in Figure 7.4, and leave all other features in the Options bar at their default settings for now.

FIGURE 7.4 Repairing an area using the Clone Stamp tool.

Alt/Option single-click in the white area just above the torn section of the photograph to define the image content you want to borrow as the source for your repair, and then release the mouse. With this source area defined, now make a couple of clicks with the mouse over the torn section: you should see it begin to disappear... or accidentally start to "reappear" in another area.

7.3.2 Understanding the Aligned Sample Method

The Aligned option, which is checked by default in the Options bar, determines where the source point will be: the content you plan to borrow for your repair. Once you have clicked and created your original source point, you have also determined a specific distance your

source point will be from the Clone Stamp tool. As you press and drag with your mouse, the source (watch the crosshairs as you move the mouse) is following it by the distance you predefined: which if you are not careful, can "reproduce" the very detail you are trying to eliminate. This problem will happen more commonly if you sample an area as your source, then press and drag with the mouse as if you were painting, without frequently redefining a new source. So...how can this be avoided? The most effective repair cloning is achieved when a source as close to the destination (in color, detail, etc.) is sampled, then clicked to "apply" the detail, then sampled again, and applied again, each time Alt/Option clicking to resample a new accurate match close to the destination to be covered.

When the Aligned option is *unchecked*, once you have determined a source point, each time you click with the mouse, the Clone Stamp tool source will start at that same original point, no matter where you click on the image. It will still follow you, the normal action of the tool, however each time you click the mouse, its "source" will once again *begin* where you defined the original source content, until you Alt/Option click and define a new source point. This source method is particularly valuable for repairing large areas of similar heavily damaged content, such as a sky, which may contain only a small area of usable repair content. For this type of damage, you will want to keep reusing the same "good" content to repair with, which will be easier with the Aligned option unchecked.

Although not required in our current project, let's uncheck the Aligned option now, and practice repairing this same torn area using the nonaligned method. Let's back up in the History panel to before the first practice repair was done, then Alt/Option click to sample an area once, similar to the source point shown by the crosshairs in Figure 7.4 (slightly above the damaged area), then make several single-clicks starting on the left side of the tear, moving slowly towards the

right with each click, switching to a smaller brush as you near the branch of the tree. With each click of the mouse, notice the starting point of the source content: no matter where your mouse is in this exercise, each time you begin to clone, the cloning content that you are borrowing, begins at the same original source location you defined. Complete the rest of this area of the photograph damage now, with the Aligned option either checked or unchecked, then save and keep the file open.

7.3.3 Assigning Opacity

Just as you learned that you can assign a lower opacity to a brush when painting with color, you can assign a lower opacity when painting with the Clone Stamp tool as well. Rather than keeping the Opacity setting at 100%, it is oftentimes helpful to select a slightly lower setting such as 80% instead: by lowering the opacity just a little, it provides a little fudge factor in your accuracy. Sometimes, depending on what the Clone Stamp tool is being used for, you will want to reduce its opacity to as low as 25%. However, most of the time, toggling between a setting of 100% and 80% will work well for the types of repairs we will be doing in this chapter.

7.3.4 Choosing the Layer to Sample From and the Ignore Adjustment Layers Options

As shown in Figure 7.2, the Sample option in the Options bar provides three layer choices to sample content from, with the default option being the Current Layer, which we have been using.

Instead of cloning directly on the actual image, you can clone above it by creating a new layer and choosing Sample All Layers or Current & Below for the Sample option in the Options bar. You will be able to sample any area of the Big Ben photograph, but your cloning results will be on a separate layer and you can lower its opacity or delete it if needed. You can merge it down later once you perfect it.

As we learned in Chapter Four, adjustment layers are used for color correction, and will be incorporated into our tonal repair and enhancement projects in Chapter Nine. However, once we begin to employ them, if you choose to sample from more than just the current layer when cloning, single-click the Ignore Adjustment Layers icon to prevent any added adjustment layers from interfering with your repair work.

7.3.5 Working With the Clone Source Panel

The Clone Source panel was added in CS3, with an important addition added in CS4. It can be toggled open and closed by single-clicking on its icon in the Options bar when the Clone Stamp tool is active as shown in Figure 7.2, or opened by choosing **Window>Clone Source.** One of the features of this panel is the ability to save up to five clone source areas to reuse. Source 1 is created by default, which is the only one we will use in our work in this book, as we will be constantly needing to define new sources, and will not be reusing old ones. However, to try this in your own work, when you want to add a new source, yet keep the old source to return to, simply click the next rubber stamp icon in the row, then choose your source area, and begin to clone. When you re-click on the first rubber stamp in the group, your previous source area will be "reloaded" and ready to use. These "saved" clone sources, however, are only saved while the file is open, and will be lost once the file is closed. Whether you decide to use multiple saved clone sources in your own work or not will be your personal working preference. However, both the Rotate feature and the Show Overlay option when coupled with the Clipped option, will oftentimes come in handy, and be ones you will want to employ as needed, as you will see in our upcoming work.

7.3.5.1 Using the Show Overlay and Clipped Options When Cloning

In CS4 and higher, the Clone Source panel includes both the Show Overlay option, *and* the Clipped option. If your version contains this Clipped option, let's turn on both the Show Overlay and the Clipped options now, keep the Opacity setting for the Show Overlay at 100%, and keep the blending mode at Normal, as shown in Figure 7.5 (this example also illustrates the addition of a second saved source point selected in the panel, with its "X" and "Y" coordinates listed in the Clone Source Offset category of the panel).

FIGURE 7.5 Clone Source panel with key features identified.

Let's work on the tower area of the Big Ben photograph to understand how, when combined together, the Show Overlay and Clipped options can be used to help target the area where you want to apply your clone source. Magnify in to the tower area to the left of the area you just repaired. Notice when you enlarge the image, that fold marks exist across the entire photograph, even though they are not as obvious as the tear we just repaired, they detract from the image, and would definitely show up if the image was enlarged, as shown in Figure 7.6.

With a brush size comparable to the one shown in Figure 7.6, the Aligned option checked in the Options bar, and the Opacity setting assigned to 80%, let's Alt/Option click to define the source to repair with, directly below the damaged area as shown. If you have the ability to turn on both the Show Overlay and Clipped options in

DEFINED SOURCE

FIGURE 7.6 Enlarged area of the tower with visible damage and clone source defined.

your version of Photoshop, with them on, when you now carefully move the mouse up and over the area to repair, you will be able to tell when you have aligned it perfectly prior to clicking and releasing it by the "preview" that will display within the brush width cursor display. When it appears to be "gone" (meaning you are exactly over the area you want to cover) in the preview clip, click once or twice with the mouse to complete the repair.

> **Note**
>
> Although the Show Overlay coupled with the Clipped option helps to align a clone source with its destination area, whether you have these convenient features in your version of Photoshop or not, with a little practice, you will master how to place your source "right on" the area to be repaired, and will soon become an expert at aligning your clone sources with their destination repair areas.

When both the Show Overlay and Clipped Clone Source panel options are on, if you hold down the Alt/Option key after using the Clone Stamp tool to define the source content, and before you click to add it to the destination area, you can temporarily hide the repair source preview, if desired. As soon as you release the Alt/Option key, the preview will become visible again.

Following this same process, repair the rest of the fold damage on the tower area, except for the detail at the bottom right and left just outside of the clock face (we will use the Flip vertical feature of the Clone Source panel for those). Once you have done this, your tower restoration should resemble the sample shown in Figure 7.7.

DO NOT REPAIR THESE AREAS YET

FIGURE 7.7 Tower repair except for the corner clock face details.

7.3.5.2 *Using the Rotate Source Feature*

The two damaged bottom corners of the clock face that have not been repaired yet require inverted source content from its top corners to match correctly. In the Clone Source panel, single-click on the Flip vertical icon first, then choose a brush size that is *just* large enough to encompass the top left corner design around the clock face. Set the Opacity to 100% (100% opacity, because with this type of damage you will want to be able to repair it with a single-click), Alt/Option click to define it as the source, and then move your mouse down to the lower left corner. When your source is directly over your destination, single-click to repair the corner, as shown in Figure 7.8.

Let's use these same steps now to repair the opposite side of the clock face. When done, we will need to be sure to click again on the Flip vertical option to toggle it off, or choose Reset Transform from the Clone Source pan-

FIGURE 7.8 Enlargement of the clone source and destination using the Flip vertical option.

el menu (the Clone Stamp tool will continue to clone at whatever rotation setting has been assigned until a new rotation value is defined). To complete the rest of the restoration of this photograph, assign an appropriate size brush based on your view, select the Aligned option and an Opacity setting of 80% in the Options bar, then carefully repair the sky to the left of the tower, the torn corner at the top left, and cover the many small blue flaws in the sky which will be visible when you are magnified in.

When using the Clone Stamp tool for small color imperfections (such as the blue spots in the sky of the Big Ben photograph) repairing them can sometimes just create "new" spots of a different color. To minimize this affect, magnify in, and place your chosen brush (with a Hardness setting of 0%) directly over the spot first to "measure" the size needed, then adjust its size, and continue to recheck it over the flaw, until it is just slightly *larger than the damaged area. Now when you Alt/Option click and sample your repair content next to this spot, then place the mouse directly over it and single-click, your repair will blend in with the surrounding color content perfectly.*

BIG BEN ORIGINAL

BIG BEN REPAIRED

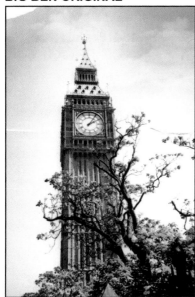 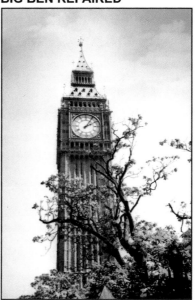

FIGURE 7.9 Before and after versions of the Big Ben photograph.

Once you are done, save and close this file. Or, before you do that, if you would like, reopen your Big Ben_ original.psd file, arrange your documents to view them simultaneously, and then sit back and admire your first restoration masterpiece, as shown in Figure 7.9.

> **Note**
>
> If your edition of Photoshop does not include any version of the Clone Source panel, and you were not able to flip the source content around the clock as detailed in this exercise, the same repair can be made by using the Layer via Copy feature introduced in Chapter Four, which will be explored in depth later in this chapter.

7.4 Using the Patch Tool

With a basic knowledge of the Clone Stamp tool, let's learn to use the Patch tool, and advance our skills through a more challenging restoration project.

Let's open the Fire truck.jpg file provided in the Chapter 7 Files folder. Save it first as Fire truck_original.psd, then as a working copy named Fire truck_restored.psd into your Photoshop practice folder. At first glance, it may appear that our expertise with the Clone Stamp tool, although time-intensive, could repair this entire photograph. However, for professional results which is what we will always want, and although the Clone Stamp tool will be able to repair the majority of this photograph's damage, it will not be the most effective tool, nor achieve the best results for some of its blemishes.

As shown in Figure 7.10, the Patch tool is located just above the Brush tool in the Tools panel, and is grouped

with some additional repair tools in its extended menu, however the actual shape of its patch icon will depend on your version of Photoshop.

FIGURE 7.10 Choosing the Patch tool in the Tools panel.

Once it is selected, its options become active in the Options bar.

As we can see in Figure 7.11, some familiar features are available with some new ones specific to the Patch tool.

Notice first of all, the Use Pattern option, and its accompanying pop-up menu in the Options bar that is currently grayed out: this patch feature is not applicable to our work, and will not be covered in this book. To understand the rest of its features, we need a basic knowledge of how the Patch tool works. In its default Normal mode, the Patch tool uses texture, lighting, and

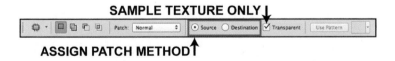

FIGURE 7.11 Options bar when the Patch tool is selected.

shading by default, or texture only when its Transparent option is chosen, to perform its repair magic on an active selection. The selection the Patch tool will use can be made by drawing with the tool itself, or by creating a selection using any selection tool first, then while its moving dotted outline is still active, switching to the Patch tool.

7.4.1 Understanding the Source Versus Destination Patch Tool Usage Methods

The Patch tool defaults to its Normal mode and Source method when the tool is chosen. When this method is chosen, you select the damaged area you want to repair first, then drag this selection with the mouse and release it on top of the repair/patch content you want to use. Once the mouse is released, the original damaged area is replaced with the content you chose to repair it with. Because the Patch tool uses a selection, to deselect a patch area after using it, choose **Select>Deselect,** or Control/Command +D, or simply make a new selection.

When using the Destination method, the opposite scenario takes place: the clone or repair content is selected first, then dragged with the mouse and placed on top of the damaged area: when the mouse is released, the damaged area is repaired using the content selected.

*Because any selection tool can be used to draw a patch, any options for a regular selection can be applied to a patch selection before dragging it with the Patch tool, to improve its accuracy and final appearance, such as moving its location using any selection tool, choosing **Select>Transform Selection,** or choosing **Select> Modify>Feather**.*

Click TIP

Let's explore how to use each of the Patch tool's repair methods on the same area of this photograph just below its snow bank, as shown in Figure 7.12.

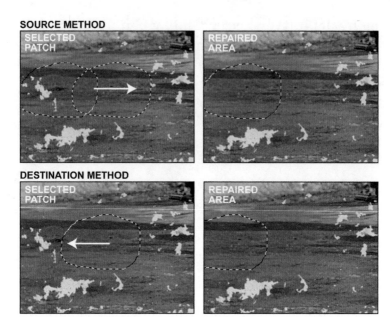

FIGURE 7.12 Repairing with the Patch tool.

7.4.1.1 *Using the Source Method*

Let's begin by making a selection around the damaged area shown in the top left screen shot in Figure 7.12 by drawing it with the Patch tool itself, or any applicable selection tool. Once we have done that, with the Patch tool chosen, the Patch mode set to Normal, and the default Source method selected in the Options bar, let's carefully drag it over to the right of the damaged area to the "good" section of the ground, keeping it aligned with the dark pattern in the soil. As we drag it, the original area will "update" showing us a preview of the resulting repair to help with this alignment. When the mouse is released, the repair selection will "jump" back to the damaged area and cover it with the content we chose. If you are working in CS6, an alternative to the Normal mode is to select the Content-Aware mode from the Patch mode pop-up menu, which is applied in the same manner as the Source method we have just learned. When chosen, an Adaptation pop-up menu in

the Options bar provides five "pattern mixing settings" ranging from Very Loose to Very Strict with its Medium setting pre-chosen by default that can be assigned to help improve the realism of the patch. If you have this mode available to you, feel free to back up in the History panel now and apply it to the same ground damage you learned to repair with the Normal mode Source method, and then apply a variety of the Adaptation settings to the selected patch to compare how each setting affects the quality of the resulting repair.

7.4.1.2 *Using the Destination Method*

Now let's back up in the History panel, and redo the same repair using the Destination method. As also shown in Figure 7.12, this time let's make a selection around a "good" area to use for the repair, using either the Patch tool, or an applicable selection tool. Once we have done that, with the Patch tool in its Normal mode and its Destination option chosen, we can drag this area to the left to cover the damaged area, being careful to drag it so that the pattern (dark edge) of the soil in your clone source aligns with the pattern (dark edge) of the soil in the destination, then release the mouse.

Once you are familiar with how the Patch tool works using each of its repair alternatives, whether you choose the Normal mode Source or Destination method, or the Content-Aware mode (if applicable) for how it will clone, will depend on your working preference, but will sometimes be determined by the specific repair you need to make. To maximize the potential of this tool in your restoration work, it will be important to experiment with all of its methods, to clearly understand how they differ in their application and in their results.

> **Note**
>
> Just as the Clone Stamp tool sometimes requires its repair source to be aligned with its destination area such as we saw when repairing the fold damage in the Big Ben photograph, if a definitive edge is part of a damaged area you plan to fix using the Patch tool (for example the dark area of the soil shown in Figure 7.12), its repair content must contain corresponding detail that will align with the surrounding content of the destination area when moved into place.

7.4.2 Combining the Patch Tool With the Clone Stamp Tool

When the Patch tool was added to Photoshop, it solved a problem that can sometimes occur when using the Clone Stamp tool. In repairing areas such as grass, or ones like the textured area near the bottom center of the fire truck photograph, the cloned area may begin to take on a fake appearance, no matter how careful you clone, or what size brush you use, resulting in what is referred to in this book as a "clone stamp pattern." Figure 7.13 shows an exaggerated version of this problem to help explain it: the photograph's damage has been removed, but the resulting repair does not look realistic.

FIGURE 7.13 Clone stamp pattern created when using the Clone Stamp tool.

FIGURE 7.14 Repairing a large area of a different color using the Patch tool.

The Patch tool by itself will also sometimes not provide perfect results. Figure 7.14 illus-

trates using the Patch tool by itself applied in its Normal mode to repair an area similar to the area repaired using solely the Clone Stamp tool in Figure 7.13. Because of the nature of how the Patch tool works, if there is a large area of distinctively different color in its destination location, it may "mix" with it, and therefore not be able to hide the damage perfectly.

To solve both of these scenarios, the two tools can be combined together by using the Clone Stamp tool first, then "refining" its appearance with some Patch tool texture added on top: let's try it. Magnify in to the same area of your Fire truck_restored.psd file, as the view shown in Figure 7.13 (the ground area just below the name "Hose 3" on the side of the truck). Using the Clone Stamp tool with the Aligned option unchecked, and an appropriately sized brush with an Opacity setting of 80% assigned, let's begin by covering approximately the same amount of damaged area as that shown in Figure 7.13.

Now let's add some texture on top using the Patch tool. With the Patch tool selected, in the Options bar, choose Normal from the Patch mode pop-up menu, Destination for the method, and check to add the Transparent option (for this type of application, all we need is its

texture feature). Draw a circular shape using the Patch tool, or any selection tool, to select some of the "good" area to the right of the repaired area as shown in Figure 7.15.

Be sure to add a small feather radius of

FIGURE 7.15 Selecting a patch area to remove the clone stamp pattern.

2 pixels to soften the outer edge of the selection before moving it. Once the feather has been added, use the Patch tool to drag the patch over to cover some of the clone stamp pattern, then repeat the steps as needed to remove the rest of the clone stamp pattern.

Note

Although you could drag the same patch selection to another spot to "reuse" it, when using the Patch tool for any repetitive repairs, be sure to choose a *variety* of sources, not the same one, to avoid creating another new clone stamp pattern to replace the one you are trying to cover.

ideo

Demonstrating the Clone Stamp and Patch Tools and Combining Them

To assist in perfecting your skills in the art of professional cloning using the Clone Stamp and Patch tools, included in the book's "Video Demonstrations" folder, is a video clip titled: *"Using The Clone Stamp Tool, The Patch Tool And Combining Them"*. Feel free to stop and watch it now, or at any time as a refresher.

7.4.3 Additional Cloning Tools

As shown in Figure 7.10, the Patch tool is grouped with two healing tools. As you have learned when exploring the Clone Stamp tool versus the Patch tool, each tool has its unique advantages. The Healing Brush tool and Spot Healing Brush tool both work and provide results similar to the Clone Stamp and Patch tools, but are most effective on smaller blemishes, and will therefore be part of our learning in Chapter Eight. In this chapter, let's move on to a repair technique that can be applied to damage of any size, and one that is particularly helpful for replacing missing content that would be difficult, and in some cases impossible, when using either the Clone Stamp or Patch tools: repairing using the Layer via Copy command.

7.5 Repairing Using the Layer via Copy Command

When working on restoring this photograph, it will make no difference for many of its flaws, whether they are repaired using the Clone Stamp tool or the Patch tool, and one method will surely become your "personal favorite" over the other when a repair can be quickly and successfully achieved using either one. As you have also experienced, for some types of damage, they are most effective when combined together. With a little practice, you will know which tool or tools you need to use to repair a particular type of damage. However, even with the help of the Show Overlay and Clipped features of the Clone Source panel, photograph damage such as siding, roofing, etc. is difficult and time-intensive using the tools we have worked with thus far in this chapter. We have had a sneak peak into how the **Layer>New>Layer via Copy** feature can be used as a repair tool, when we were first introduced to it for covering a few of the disfigured bricks in the Brick building.psd file. Let's explore this command in depth now, and how it can be used to repair damaged areas that would be difficult, if not impossible, to repair, using any other tools, combination of tools, or commands. Many areas of the Fire truck photograph can be quickly repaired by employing this command, including unique damage such as repairing the letter "O" and number "3" in the sign above the door, and some of the damage around the rim of the tires. Let's repair a couple of them now to learn how the Layer via Copy command can be a great "tool" for easy and effective repairs that would otherwise be challenging, time consuming, and in some cases impossible to achieve professional results any other way.

7.5.1 Using the Layer via Copy Command When a Repair Requires Distortion

When repairing the bricks in the brick building photograph in Chapter Four, the repair bricks, when moved into position, fit perfectly over the damaged bricks. However, sometimes when using the Layer via Copy command, the content must be scaled, rotated, and/or distorted to perfectly cover the damaged area it is being used for. First, let's magnify in to the number 3. When we do, we can see that the *top* half of the number is in good shape, it is the lower half that is damaged. However, because we will use the top half to repair the lower half, let's repair the damaged area *around* the lower half of the number first by cloning over its damage using the Clone Stamp tool. Once that has been done, let's now select the top half of the number with the bottom edge of the selection ending exactly at its midpoint as shown in Figure 7.16, and then apply a feather radius of 2 pixels.

We will apply the Layer via Copy command, then with its layer still selected, choose **Edit>Transform>Flip Vertical**. When moved into place, the damage is now covered, however, the angle of the number does not match the rest of the letters in the sign. To solve this, let's now choose **Edit>Transform>Distort**. With the

FIGURE 7.16 Bottom area of the number 3 cloned, and a selection made of the top half to be used to cover the bottom half.

distort handles active, we can pull the lower left handle as needed to align the bottom edge of the number with the angle of the bottom of the rest of the letters of the word "Hose." When satisfied with its angle, the transformation is applied.

When aligning layer content being used for repair (such as the flipped number 3 content with the rest of the letters of the sign), it will oftentimes be helpful to lower the opacity of the repair layer to assist in aligning it with the content you are covering, combined with pressing the up, down, left, and right arrow keys on the keyboard when the Move tool is chosen, to help accurately place the repair content.

When you are satisfied with your number 3, if you chose to lower the opacity of the layer to help align it, be sure to return its opacity to 100%, and then merge the layer down to permanently "glue" it on top of the damaged number. Your resulting restoration of this area of the photograph should resemble the sample shown in Figure 7.17.

FIGURE 7.17 Repaired number 3 using the Layer via Copy command.

7.5.2 Using the Layer via Copy Command For Repairing Curved Content

Now let's use this command to repair some curved content.

Note

We have learned that the Clone Source panel allows us to rotate a clone source, however the Layer via Copy method is sometimes easier due to its ability to manually rotate the source content.

We will begin by making a generous selection (intentionally larger than needed) of the "good" area of the front tire to the left of the damaged area we plan to cover, as shown in Figure 7.18.

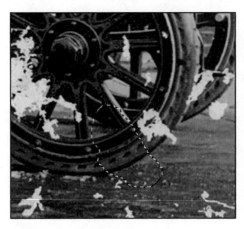

FIGURE 7.18 Tire repair selection.

Once the selection has been made, let's apply a small feather radius, and then choose the Layer via Copy command. With the new layer selected, this time we will choose **Edit>Transform> Rotate**, and then drag the layer to cover the damaged area to the right of it. When it is in position, drag the rotation handles as needed, then *generally* position the repair layer to match the surrounding content as shown in Figure 7.19.

Once it has been rotated to the angle required for the repair, the transformation is applied. Now using

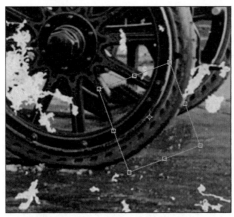

FIGURE 7.19 Repair layer rotated and positioned over the damaged area.

the Move tool, the position of the repair content can be fine tuned by temporarily lowering its opacity, and/or turning its visibility off and on, and tweaking its location using the arrow keys. For this type of repair however, once you are satisfied with its positioning, do *not* choose to merge the layer as yet: when extra content is included in the original repair selection, it should be erased *prior* to merging the layer.

7.5.3 Using the Eraser Tool With the Layer via Copy Command

Sometimes it is easier when borrowing content to use to repair to intentionally select an area larger than you will need, such as in the tire repair content we just applied. When this has been done, the excess repair content typically needs to be removed once it has been positioned over the damage you are covering, by using the Eraser tool.

The Eraser tool is the eleventh tool down from the top of the Tools panel, and is grouped with a couple of other types of eraser tools that we will not be using in our work as shown in Figure 7.20.

When we now choose the regular Eraser tool from the group, its options become active in the Options bar. As you can see, its choices contain some of the features we have already gained expertise with from other tools which utilize a brush in their application, such as assigning a brush size,

FIGURE 7.20 Choosing the Eraser tool in the Tools panel.

hardness, and opacity as shown in Figure 7.21.

FIGURE 7.21 Options bar when the Eraser tool is selected.

Notice however, that in addition to these features, the eraser has three working modes: Brush, Pencil, and Block, with the default mode being Brush. This is the mode that is applicable to our work, and the one that should be chosen at all times. It also contains an Erase to History option that is currently grayed out, and will not be used in our type of work.

When removing excess content on a layer created by the Layer via Copy command for restoration repairs such as the tire repair we are currently working on, we will want to use a soft brush with a Hardness of 0%, and an

FIGURE 7.22 Tire damage covered using the Layer via Copy command with excess removed using the Eraser tool.

Opacity setting of 80% most of the time versus 100% to provide a little fudge factor in our work.

When the tire repair layer's visibility is turned off and then back on, we can see that it contains additional content in some areas that is covering "good" content below it, that should be erased. Choosing a brush size applicable to the task, let's carefully erase the extra content of the repair layer that is not needed, periodically turning its visibility off and on, until all of the extra content has been removed as shown in Figure 7.22. Once we have done that, let's merge the repair layer down, then save and close this file for now.

When using the Layer via Copy command for repairs, an alternative to making a larger selection, then using the eraser tool to remove the excess repair content from it, is to use an appropriate selection tool to trace the area you need to cover first, apply a suitable feather, then move this selection over to the content you want to borrow, and apply the Layer via Copy command. When this new repair layer is now moved back into the original position, it will already be the exact size needed to cover the damaged area below it.

Demonstrating the Layer via Copy Command

Included in the book's "Video Demonstrations" folder is a video clip titled: *"Repairing Using The Layer via Copy Command"*. This video will demonstrate the number 3 and tire repairs detailed in this chapter and using the Eraser tool in conjunction with the Layer via Copy command, as well as how this command can be used to repair door trim, shingles, and other types of damage. Feel free to stop and watch it now, or at any time as a refresher.

7.6 Handling Color Mismatches When Using the Layer Via Copy Command

Sometimes when you use the Layer via Copy command, the repair *content* will match the destination area perfectly, however its color or values, may *not* match perfectly, based on a slight lighting variation in the area of the photograph you used as the clone source versus its destination. Because the content is on its own layer, its color or values can be easily and accurately adjusted to match the Background layer below it. Once we have learned color correction in Chapter Nine, you will have the expertise required to fix these types of mismatch discrepancies. Until then, when working on a restoration, if you are using a repair layer that matches in every way except that its color or values are *slightly* off, once it has been positioned, do not merge it with the Background layer: keep it as an active layer for now, so that its color adjustments can be made later.

If you have multiple repair layers that you are not merging because they need minor color adjustments to perfectly match their destination, as you work on a restoration, you can create a layer group in the file, and move all of these repair layers into the group, then close the group for convenience.

7.7 Choosing the Best Method to Repair a Damaged Area

In Chapter Eight, we will learn more cloning tools and surface repair techniques: some of which will produce results similar to those we have learned here, while in other circumstances they will help us achieve more effective and efficient results, depending on the type of damage they are applied to. At this stage, we have al-

ready developed a solid foundation in restoration, and gained the knowledge and experience required to repair a variety of surface damage. When practicing these new skills, it will be helpful to sometimes try more than one repair tool or technique on a damaged area, by applying it, then backing up in the History panel, to the state before it was applied, then trying a different method, especially in situations when you are not especially pleased with how the area is repaired the first time. This procedure will be more time-intensive for sure, however, the experience it will provide you will be invaluable, and will help further your understanding of the unique benefits and drawbacks of each repair method we have learned in this chapter. Let's reinforce our skills now on the projects provided, before learning more tools and methods for surface damage in the next chapter.

Test Your Knowledge

1. When the Patch tool is selected in the Tools panel, which patch usage method will be chosen by default in the Options bar?

2. Which mode should you select in the Options bar when using the Eraser tool for restoration?

3. What is the difference between the two Clone Stamp tool sampling methods?

4. When using the Patch tool, what is the name of the patch usage method in which a repair selection is made first, and then dragged over a damaged area to repair it?

5. How many source areas can you save in the Clone Source panel?

6. When using the Patch tool in its Normal mode, what option do you need to check in the Options bar, to sample texture only?

7. After choosing the Clone Stamp tool in the Tools panel, and assigning settings for it in the Options bar, what do you need to do first, before you will be able to paint a repair with it?

8. What command can you apply to soften the edges of a Patch tool selection?

9. What is meant by a "clone stamp pattern"?

10. What is the Reset Transform option of the Clone Source panel menu used for?

Try It Yourself

Project 1

Reopen your Firetruck_restored.psd file.

1. It will be helpful to first print a copy of the photograph at this stage of its repair for reference.

2. Study the printed copy carefully to determine the best repair solutions for its many damaged areas, and mark how you plan to repair them if you'd like.

3. Using the techniques you have learned in this chapter, complete the rest of the repairs needed to restore the surface damage on this photograph.

4. When using the Layer via Copy command, create a group to store any repair layers that are lighter or darker than their destination.

5. When the damage in the photograph has been repaired, save and close the file for now. In Chapter Nine, we will not only learn how to adjust the tonal quality of its repair layers to blend seamlessly with the surrounding content, but also how to convert its discoloration into a true black and white photograph.

 Project 2

Open your House_restored.psd photograph that we last worked on in Chapter Five.

1. When opening the photograph, click to convert the document's colors to the working space as shown in Figure 7.23, unless you chose to uncheck the mismatch warning when we were assigning our color settings. The last time we worked on this file, it was before we assigned the Adobe RGB (1998) working space for our RGB color settings.

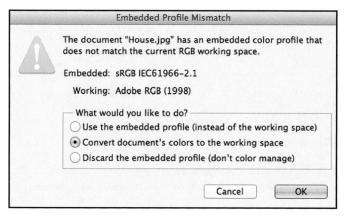

FIGURE 7.23 Assigning the Adobe RGB (1998) color space to the House_restored.psd file.

2. Using any combination of the tools and methods you have learned, repair the house and ground area, however do *not* repair the sky: we will use a special technique for it later.

3. Figure 7.24 is provided to suggest some areas that would benefit from the Layer via Copy command for their repair, with the red arrows providing effective repair source content to cover the corresponding area indicated by the black arrow.

4. When repairing the severe damage to the detail at the top of the third column, content can be borrowed from the lesser-damaged column to its left. Without borrow-

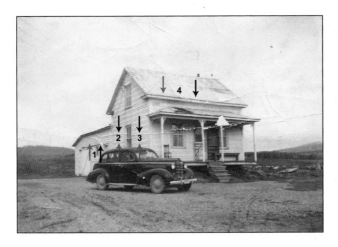

FIGURE 7.24 House_restored.psd with suggested areas to apply the Layer via Copy command.

ing content, this area would be very difficult to repair. The rest of the column on the left could be repaired first, prior to borrowing its top, or at any time. Once the repair layer is moved into place, its extra content is erased. A sample repair selection and its resulting repair application are shown in Figure 7.25.

FIGURE 7.25 Using column detail to repair another column.

5. If when using the Layer via Copy command, some of the resulting layers are lighter or darker than their destination, choose not to flatten them, and create a group to store them in for now. This file will be converted to a black and white photograph later in our work, and you will be able to adjust the values of your repair layers and then merge them at that time.

6. Save and close the file for now.

 Project 3

on the **DVD** Open the Wedding1.jpg file provided in the Chapter 7 Files folder. This photograph needs both surface damage repairs and color correction. We will repair its surface damage for now.

1. Save the file first as Wedding1_original.psd, and as a working copy named Wedding1_restored.psd into your Photoshop practice folder.

2. Most of its damage can be repaired using the Clone Stamp tool and the Patch tool.

3. For the damage to the roses, the Layer via Copy command will be helpful, although not required. If used, good sections of the damaged roses can be duplicated, then rotated and scaled as needed to repair the damaged areas. In Figure 7.26, the repair layers used are outlined in red.

FIGURE 7.26 Detail of repair layers that can be used to cover some of the damaged areas of the roses.

4. When you are satisfied with your repairs, save and close the file for now: we will color correct it as part of our learning in Chapter Nine.

Project 4

Open your Restaurant Kitchen_restored.psd file that we last worked on in Chapter Four. At that time, we duplicated its Background layer.

1. Working on the duplicated layer, begin by repairing the areas identified in Figure 7.27.

FIGURE 7.27 Restaurant Kitchen_restored.psd file with some damaged areas identified.

2. While magnified in to repair these areas, you will discover additional small areas that should be repaired as well.

3. Once you have repaired the circled areas, as well as the rest of the damage in this photograph, click the visibility of the working duplicated layer off and on to admire your work, or reopen your Restaurant Kitchen_original.psd file, arrange to view both documents simultaneously, and enjoy the fruits of your labor, then save and close the file for now. We will use its saved alpha channel as part of its tonal adjustment in Chapter Nine.

8

REPAIRING MINOR SURFACE FLAWS

In this chapter, we will first learn to how to determine what actually needs to be repaired before beginning every restoration project, followed by a focus on minor damage, which can oftentimes be repaired using either the Healing Brush tool or the Spot Healing Brush tool. We will also work with minor widespread surface damage, which may be more effectively and efficiently repaired by applying one of a variety of filter commands to the damaged area, and be introduced to how the Smudge and Blur tools can help in restoration.

8.1 Types of Damage

We began our restoration learning in Chapter Seven with the types of damage that usually required completely covering or reconstructing the area to remove its damage by using either the Clone Stamp tool or the Layer via Copy command. However, we also saw that, at times, the Patch tool was able to "blend" the source content with the destination area, and successfully repair it as well. Rather than have to *cover* damage, or use *large* patches to blend, many minute types of photograph damage can be repaired using tools, commands, and filters that intuitively utilize surrounding content to successfully restore the blemished area. Some damaged areas may be so minute, they will not even show up when the photograph is printed. Let's explore minor flaws compared to major ones, beginning with how to determine whether an area actually needs to be repaired or not.

8.2 Defining the Job First

Although we did not do this with all of the introductory projects covered in Chapter Seven, when beginning every restoration project, it will be helpful to always *first* determine what actually *needs* to be repaired. This determination is a two-stage process: the photograph is first enlarged and/or cropped (if applicable) to its final size, and then printed at that size, *before* beginning to restore it, on the *same* quality paper that the completed restoration will be printed on. This is an important first step as sometimes damage may be removed automatically if your final print will require cropping, and sometimes while working on the restoration, damage visible when the photograph is studied at an enlarged view on

your monitor, will not be visible when the restoration is printed at its final output size.

8.2.1 Cropping Before Restoring

Although the dimensions of the original photograph shown in Figure 8.1 were 3.83″ × 2.96″, the client wanted the photograph enlarged to a 7″ × 5″ print. As indicated by the red lines at the top and bottom of the image, we can see that in order to have the correct proportions for this enlargement, it required some cropping once it was enlarged. The photograph when proportionately enlarged as needed to produce the desired width of 7″ resulted in a corresponding height of 5.407″.

A copy of each figure shown in this chapter can be viewed on the companion DVD included with this book.

As indicated by the red arrow in the top left corner of Figure 8.1, this damaged area, detailed in Figure 8.2, will be removed automatically when the crop is com-

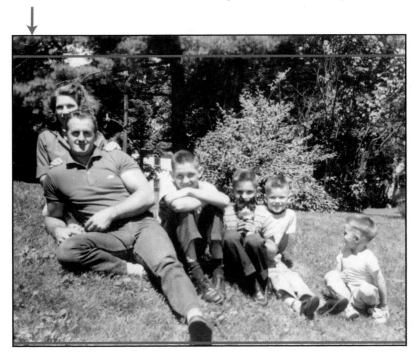

FIGURE 8.1 Final print size prior to cropping and repairing.

FIGURE 8.2 Enlargement showing damage that will be removed when the crop is completed.

pleted. If a photograph will require any cropping, by cropping the image to its final size prior to beginning its restoration, you will not be repairing damaged areas that may eventually be removed in the final print size.

8.2.2 Printing Before Restoring

Sometimes a photograph when scanned and viewed at a high magnification in Photoshop appears to need repairs in some areas, when in fact those damaged areas will not be visible when the restoration is printed. Best practice is to begin *every* restoration project by enlarging and/or cropping, if needed, then printing a copy of the photograph at its final output size. If the final size is too large for your printer to print in its entirety, print it in sections at actual size. This is detailed in tip number five of the "Ten Tips to Maximize Print Quality While Minimizing Cost and Waste" section in Chapter Six. Figure 8.3 details the left half of the resulting cropped 7″ × 5″ photograph at actual size with its *visible* flaws encircled in red.

FIGURE 8.3 Actual size illustration of the left side of the 7″ x 5″ print with visible damage identified.

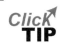

It will be beneficial in your own work to use a pen or marker to indicate in an identifiable color every spot you can see that needs to be restored directly on a "reference guide" actual size print you make prior to beginning to repair the photograph.

Because this photograph was printed at actual size, these are the *only* areas that require repair. Printing a "reference guide" proof first is critical because we have been taught to magnify in when restoring a photograph for accuracy. If the damage you are viewing on your monitor screen will not be visible in the final print, there is no need to fix it. With these identified damaged areas repaired, now let's look at part of this same half of the photograph at the enlarged view shown in Figure 8.4.

FIGURE 8.4 Enlargement of the repaired photograph showing damage that is not visible in the final print.

Notice when enlarged that there are scratches, spots, and other types of surface damage still visible in this photograph. However, as outlined in red in Figure 8.5, when this same area of the left half of the completed restoration is viewed at the final output size of 7″ × 5″, these blemishes are not visible.

Note

When comparing Figure 8.3 with Figure 8.5, notice that above the woman's head the white "patch" was removed. In the original image: was it actually sky, or was it damage to the surface of the photograph? What do you do when this happens in your own work? Because every photograph is unique, when a "leave in versus take out" restoration content decision is required, unless you know for sure what it should be, "when in doubt, take it out" if it appears odd, looks like a flaw, or detracts from the focus of the photograph.

FIGURE 8.5 Left side of the final 7″ x 5″ restoration at actual size detailing the area shown in Figure 8.4.

8.3 Using the Healing Brush Tool

The Healing Brush tool combines the *operation* of the Clone Stamp tool with the *blending* feature of the Patch tool, and is particularly effective for repairing small blemishes containing distinct textures. It is also an excellent tool for enhancements, such as removing facial wrinkles, which will be covered in Chapter Eleven. In this chapter, we will focus on its application to restoration.

You may have already noticed that it is one of the tools grouped with the

FIGURE 8.6 Choosing the Healing Brush tool in the Tools panel.

Patch tool, as shown in Figure 8.6, with its icon representing a "bandage" to symbolize its "healing" capability.

> ### Note
>
> The Healing Brush tool is also grouped with the Spot Healing Brush tool which is displayed as the default tool in this "healing" collection of tools when the preferences have been reset to the default settings. The Spot Healing Brush tool icon can be confusingly similar to the Healing Brush tool icon, as it contains the *same* bandage design, except that it additionally includes a dotted semi-circle on its left side. Be sure to select the Healing Brush tool for now, the second tool in the group. We will learn about the Spot Healing Brush tool later in this chapter.

Once the Healing Brush tool is chosen, its options display in the Options bar, as shown in Figure 8.7. When this tool is active, we can see in the Options bar that there are some similarities to the Options bar when the Clone Stamp tool is selected, with some new features: Brush Spacing, Mode Replace, and Source options of Sampled and Pattern.

When using the Healing Brush tool, its Brush Spacing is identical to the Spacing option if you choose to create a custom brush versus a standard size and hardness when using the Brush tool. What does it do? As illus-

FIGURE 8.7 Healing Brush tool features in the Options bar.

trated in Figure 8.8, it defines how often the brush tip is applied to the page with 25% being the default. When compared with the 100% setting, we can

FIGURE 8.8 Understanding Brush Spacing settings.

see that what the "100%" is actually representing is that when the brush is dragged across the page, the tip will not be reapplied until the previous tip has completely (or 100%) displayed versus overlapping by 75% when the 25% setting is chosen. The "continual flow" appearance of the tool is created by the 25% default, and the setting where we will keep any tool which utilizes a brush for its application.

The Size pop-up menu below the Spacing option provides options when using a pressure-sensitive tablet, and is only applicable when one is in use.

The Replace setting of the Mode option is designed to preserve textures at the edges of the brush strokes with the default being Normal. Let's keep the Mode at its default Normal option. Although its Hardness default setting is 100%, at times when using this tool, if the outer edge of its brush application appears too sharp, this setting can be reduced to a lower percentage.

Lastly, its default Source option of Sampled will allow us to Alt/Option click to define our repair source within the image, and will be the option we will always want to use in our work.

Let's learn how to use this tool and how it compares to tools we have previously learned, by opening a photograph provided in the Chapter 8 Files folder named C-portrait.jpg. As we have learned, save this file first as C-portrait_original.psd, and as a working copy named C-portrait_restored.psd into your Photoshop practice folder, optionally choosing to duplicate its Background layer to create a working layer. Notice in Figure 8.9, that it is missing a substantial amount of content on its right side, and some at its top edge. For now, our focus

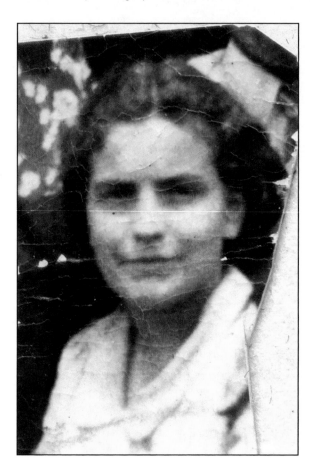

FIGURE 8.9 Photograph prior to repair using the Healing Brush tool.

will be on the surface cracks on the woman's skin and hair areas.

When we study this photograph closely, regardless of the visible surface cracks it has acquired though the years, we can see that the original photograph was lacking in clarity. Knowing that, our focus will be on repairing the damage, and restoring the quality back to that original state.

This photograph's many fine crack lines, combined with its overall textural surface quality, make it a great candidate for the Healing Brush tool.

For this photograph, while the Clone Stamp tool will be able to accurately cover the fine crack lines, because it will be "covering the texture with more texture," it

will be difficult to repair this type of damage without resulting in the type of clone stamp pattern we learned about in Chapter Seven. Instead of covering the damage, while the Patch tool will be able to repair it by mixing the source content with its destination, it will be challenging at times to draw patches small enough and accurate enough to cover only the areas that need to be repaired. In contrast to these, the Healing Brush tool will be able to repair these cracks by mixing the source content with its destination content using the accuracy of the Clone Stamp tool's method of application. As we can see in the sample provided in Figure 8.10, compared to the Clone Stamp tool or the Clone Stamp tool combined with the Patch tool, the Healing Brush tool was able to repair the damage and maintain the original photograph texture of the neck area at the same time.

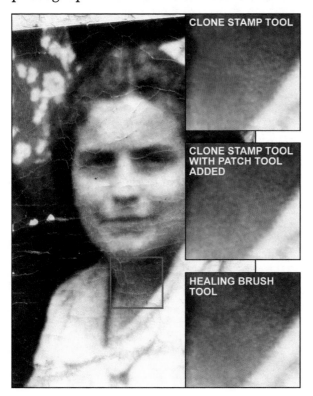

FIGURE 8.10 Comparing the Healing Brush tool repair to the Clone Stamp tool combined with the Patch tool.

FIGURE 8.11 Spot Healing Brush tool warning to choose the Healing Brush tool.

Let's learn to how to repair these cracks using the Healing Brush tool. Once the tool has been selected from the healing collection of tools in the Tools panel, single-click on the photograph. Notice the familiar message? This tool works its magic using the same operational format as that of the Clone Stamp tool: requiring the user to Alt/Option click first to define the source point with which to repair the image. If you accidentally choose the Spot Healing Brush tool instead of the Healing Brush tool and Alt/Option click on the photograph, you will get the message shown in Figure 8.11. Photoshop will politely remind you that you have chosen the wrong tool.

With the Healing Brush tool chosen, let's magnify in to the woman's forehead area using a view approximately the same as the one shown in Figure 8.12. Choose a

FIGURE 8.12 Enlargement showing surface damage.

FIGURE 8.13 Dragging the Healing Brush tool across a damaged area.

brush Size comparable to the size outlined in red, assign a Hardness setting of 65%, keep the Aligned option unchecked, and then Alt/Option click in the location indicated by the red circle.

Now, let's move the Healing Brush tool up and to the left slightly and drag across the crack line above it from

left to right. This tool is defined as a "brush" tool because it repairs by blending selected source content with the values and textures of the destination when dragged or "painted" across the area you want to restore as shown in Figure 8.13.

> ## Note
>
> Although for this cloning tool its Aligned option is not chosen by default, when checked, it will sample in the same manner as the Aligned option does when using the Clone Stamp tool. Furthermore, because of the painting operation of this tool, when selecting source content, be sure to not choose content directly behind the area you want to repair. You may end up simply "dragging" the damage from one area to another.

In addition to dragging with the Healing Brush tool over a damaged area, you can alternatively Alt/Option click to define the source content, then single-click over a blemish as well to remove it, such as the red spot below the woman's eye. As shown by the Clone Source panel icon in the Options bar when the Healing Brush tool is chosen (if your version of Photoshop contains the Clone Source panel's Show Overlay and Clipped options and they have been activated), notice that before you apply the tool, this feature allows you to preview the repair content before using it, just as the Clone Stamp tool did.

It will be helpful to choose a brush size slightly larger than the area you need to cover. A brush size too small may not be able to provide source content large enough to be able to blend realistically with the destination surrounding content to hide the damage effectively, and one overly large will blend too broad of an area beyond what you need to cover, oftentimes creating an unexpected result even if you are vigilant in sampling frequently close to your repair destination.

With just a few clicks and drags, the woman's forehead will be successfully repaired as shown in Figure 8.14.

FIGURE 8.14 Forehead repaired using the Healing Brush tool.

Now that we have a little experience with the Healing Brush tool, let's repair the rest of the woman's head and neck areas only, adjusting its brush size and opacity when needed depending on the area and texture of the damage, and dragging or single-clicking with the tool as needed to repair the cracks. When completed, the resulting repairs should resemble those shown in Figure 8.15.

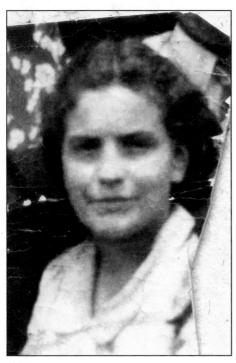

FIGURE 8.15 Head and neck area repaired using the Healing Brush tool.

With the woman's head and neck repaired, feel free to repair the rest of the photograph using the Clone Stamp tool and the Layer via Copy command, or simply save and close the file as is.

8.4 Using the Spot Healing Brush Tool

As we have learned, the Spot Healing Brush tool is also part of the "healing" collection of tools, and will be the visible tool in the group by default when the preferences are reset. This tool is very effective on scratches and small damaged areas. Let's select the tool that resembles the Healing Brush tool with a dotted semi-circle on its left side, and examine the Options bar settings shown in Figure 8.16 when this tool is active.

FIGURE 8.16 Options bar when the Spot Healing Brush tool is chosen.

When we press and hold on each of them, we can see that its Brush and Mode menu options are identical to those available when the Healing Brush tool is selected. When checked, its Sample All Layers option allows you to sample from all layers of the file, versus only the current layer which is a slight variation from both the Healing Brush tool and the Clone Stamp tool that additionally provide the option of Current and Below, if desired. However, what is distinctively different from the Healing Brush tool is the Spot Healing Brush tool's method of choosing repair content. Rather than Alt/Option clicking to select a source for the tool to use, we select how to let the *tool* determine the source through its Type options of: Proximity Match, Create Texture, and Content-Aware. This tool intuitively chooses surrounding content to repair with based on the "type" or "method" selected. If your version of Photoshop contains the Type option of Content-Aware, it will be chosen by default, and should be left at that setting. If your version of Photoshop does

not include this feature, the Proximity Match option will be preselected, and should be kept at that default setting. Although the Proximity Match and Content-Aware options perform similar actions of repairing with surrounding content and will oftentimes yield the same visual result, its Content-Aware option is sometimes more intuitive and therefore more successful in its choices of the image replacement content. The Create Texture option generates a texture based on the selected pixels, and is not typically used in restoration work.

8.4.1 Applying the Spot Healing Brush Tool to Scratches

on the **DVD** Let's learn how this tool works on scratches by opening the Bermuda scratches.jpg file provided in the Chapter 8 Files folder. Save it first as Bermuda scatches_original.psd, and as a working copy named Bermuda scratches_restored.psd into your Photoshop practice folder. As we can see in Figure 8.17, this photograph sustained some nasty scratches that would be extremely difficult to repair using the methods you have learned thus far because of the ocean spray underneath the scratches.

FIGURE 8.17 Bermuda photograph with scratches.

Let's begin by magnifying in to the left starting point of the scratch identified by the arrow in Figure 8.17 to a view comparable to that shown in Figure 8.18. Once we have done that, let's select a brush size that resembles the width in this example. Like its counterpart the Healing Brush tool, the Spot Healing Brush tool Hardness setting defaults to 100%. Feel free to leave it at that setting, or lower the Hardness percentage a little such as to 80%. If your version of the Spot Healing Brush tool contains the Type option of Content-Aware, keep it selected, otherwise keep the Type option of Proximity selected. As demonstrated in Figure 8.18, beginning with the end of the scratch centered underneath the brush, let's drag to the right and up, following over the damaged area as we drag. The area will be temporarily covered in black while dragging, and until Photoshop finishes adjusting the pixels.

FIGURE 8.18 Demonstrating the use of the Spot Healing Brush tool.

When dragging, it is not necessary to complete the covering of the entire scratch end to end in one drag. We can stop and start at any time. Occasionally it may also take a second swipe in an area to naturally cover it, however when done, this scratch will be realistically removed with its original location identified by the red enclosure shown in Figure 8.19.

FIGURE 8.19 First scratch repaired using the Spot Healing Brush tool.

Continuing to adjust the size of the brush depending on the view, let's repair the rest of the scratches now. It will be helpful to follow the example shown in Figure 8.18 as a reference for the size brush that will best repair based on your magnification: one too small will not cover well, and one too large may replicate unwanted content, such as another nearby scratch.

When repairing the scratch on the rock in this photograph, the Spot Healing Brush tool may "mix" or "spray" image content into the abutting water area, a side affect similar to the one you have learned can sometimes happen when using the Patch tool. This effect can be minimized when using either the Spot Healing Brush tool or the Healing Brush tool by making a selection first that will help to "constrain" the mixing or spraying to within the selected area. It will be beneficial to practice using either the Spot Healing Brush tool or the Healing Brush tool on the area shown in Figure 8.20 with and without making a selection before applying the tool, to better understand how restricting the effects of the tool by creating a selection first can be helpful.

FIGURE 8.20 Using a selection to constrain the effect of the Spot Healing Brush tool.

When you have completed the restoration of this photograph, save and close the file.

Note

Just as the Healing Brush tool can be used to single-click over damage to repair it without the need to drag to cover damage, the Spot Healing Brush tool can be effective at times when used in the same manner. Remember the blue "spots" in the sky of the Big Ben photograph we worked with in Chapter Seven? Although we were able to effectively cover them using the Clone Stamp tool, if you reopen the original copy of that file now, and use the Spot Healing Brush tool on those blemishes, you will be able to more easily and effectively cover them with a single-click on each one.

8.4.2 Applying the Spot Healing Brush Tool to Small Areas of Surface Damage

When a restoration project contains small tears and/or surface chips, the Spot Healing Brush tool can be used to quickly and effectively remove them.

Let's open another photograph in the Chapter 8 Files folder named Group photograph.jpg. Save it first as Group photograph_original.psd, and as a working copy named Group photograph_restored.psd. As shown in Figure 8.21, although this photograph has some larger damage that would best be repaired by using one or more of the restoration methods you have already learned, this

FIGURE 8.21 Group photograph with a variety of types of damage.

photograph has many small chips that can be easily and effectively removed using the Spot Healing Brush tool. The circles indicate an appropriate brush size, and a few of the many areas that can be repaired with a single-click, while the directional arrows indicate a few of the areas that can be repaired by using the same brush size, but dragged across the chips and scratches instead.

As we can see, except for a few areas of more severe damage, the Spot Healing Brush tool will be able to effectively remove most of the visible blemishes in this photograph. However, if we magnify in to the same area indicated by the red arrows after repairing those chips, we can see that many more tiny spots are still visible. And yes, in this case, if printed at actual size, they will still show up. This is when a restoration can

benefit from one of the Photoshop filter commands that remove damage by modifying pixels through balancing their colors. Let's save and close this file for now, and work with a different photograph to be introduced to the first of three filters that employ varying methods of mixing pixels to repair blemishes.

8.5 Repairing Using the Dust and Scratches Filter

Let's open the Damaged sky.jpg file provided in the Chapter 8 Files folder, and save it first as Damaged sky_original.psd, then as a working copy named Damaged sky_restored.psd into your Photoshop practice folder. Notice that this photograph has many fine speckles of damage in its sky area, with some of the more prominent damage visible in the enlargement included in Figure 8.22.

FIGURE 8.22 Damaged sky photograph with surface damage enlargement.

The Dust and Scratches filter will be able to remove most of this type of damage by altering its pixels with-

FIGURE 8.23 Selecting an area which to apply the Dust and Scratches filter.

out the need to laboriously repair each flaw individually. However, because we will only want to affect the area that contains the damage, it will be important to begin with a selection of just the sky. Using any selection method or combination of selection methods you have learned, select the sky area leaving some "breathing space" between your selection and the trees which we do not want to affect, then apply a small feather radius to the selection as shown in Figure 8.23. Because this filter will affect all pixels contained within a selected area, it will be easier to later fix the few flaws that will not become included in this more general selection.

Once we have done that, the Dust and Scratches dialog box is accessible under the Filter menu by choosing **Filter>Noise>Dust & Scratches** as shown in Figure 8.24. This filter is one of five noise command options

FIGURE 8.24 Choosing the Dust and Scratches filter command from the Filter menu.

that affect images in different ways, but the only one that we will use for surface damage repair.

Once the Dust and Scratches dialog box opens, we can see that it contains two adjustments: Radius (Pixels) and Threshold (Levels), with default settings of "1" and "0" respectively. While Radius determines how broad an area of pixels you want the filter to search for color differentiation, Threshold assigns how different those pixels must be before they will be affected. With Preview checked, when in this dialog box, it will be important to always start with the default settings of Radius: "1," and Threshold: "0," then slowly drag the Radius slider to the right until the damage is effectively removed in the image. Choose a setting that is high enough to remove the damage, but not higher than needed. The small "plus" and "minus" signs below the preview window allow you to adjust the magnification of the area you are looking at, to help you determine the Radius setting you need to apply. When the damage has been successfully removed (Radius 6), you can slowly drag the Threshold slider to the right, as high as possible, before the damage returns, or sometimes you may want to simply leave its default setting of "0", as shown in Figure 8.25.

FIGURE 8.25 Dust and Scratches dialog box settings.

Once you click OK to apply the settings, there will be only a few defects left near the edges of the trees that can quickly and effectively be removed using the Spot Healing Brush tool.

8.5.1 Combining the Dust and Scratches Filter With the Erase to Repair Technique

Before learning to repair surface damage by employing a blur command, let's learn another way to apply a repair that will at times be applicable to our future work as well, referred to in this book as the "erase to repair" technique. Let's begin by either backing up in the History panel to the original state of the train file, or by simply reopening the Damaged sky_original.psd file and saving it instead as Damaged sky_restored2.psd. This time, let's begin by duplicating its Background layer. Once we have done that, we will apply the same Dust and Scratches settings that we just used in the previous repair, this time to the *entire* duplicated layer without making any selection first. Although the sky will be repaired, the rest of the photograph will become blurred as well. Now, with the *duplicated* Background layer still active, let's select the

FIGURE 8.26 Duplicated layer with content erased that should not be affected by the Dust and Scratches filter.

Eraser tool, and assign a Hardness setting of 0, and an Opacity setting of 100%. With a brush size appropriate to your view, erase all the content that should not be included in the effects of the Dust and Scratches filter exposing the original content below it, using a larger brush for the main area, and a smaller one to carefully remove the content around the tops of the trees against the sky. It will be helpful once the content has been erased to temporarily hide the original Background layer to double check that all the content has been removed as shown in Figure 8.26.

When repair content has been completely isolated on a duplicated layer with all content that should not be affected by the filter erased, if desired, an additional Dust and Scratches setting can be applied or conversely, the layer's opacity can be lowered to subdue the effects of the filter, before it is merged with the original Background layer below.

Once all the content that should not be affected by the Dust and Scratches filter has been removed, let's turn the original Background layer back on, and then merge the two layers.

Just as in the selection method, there will most likely still be a small amount of damage around the edges of the trees that will require one of the other repair methods you have learned (such as the Spot Healing Brush tool), based on the amount of repair still remaining, which will depend on the time, accuracy, and brush size applied when erasing the blurred content around the tops of the trees. Which repair method is the "correct" one to use when applying this filter? The one you like the most, and feel works the best for you. With the photograph successfully repaired, let's save and close all of your Damaged sky files.

8.6 Repairing Using a Blur Filter

While the Dust and Scratches filter works great for small visible damage, a Blur filter will be able to more

effectively repair more significant widespread blemish-
es. Under the Filter menu, when the Blur command is
chosen, a variety of Blur filters become available from
its submenu, as shown in Figure 8.27.

FIGURE 8.27 Selecting a Blur filter from the Blur command submenu.

The two we will focus on for restoring this type of
damage, will be the Gaussian Blur filter and the Sur-
face Blur filter.

8.6.1 Using the Gaussian Blur Filter

Definition

Gaussian Blur: The Gaussian Blur filter creates a blur by averag-
ing selected pixels with the extent of the blur effect based on a
Radius value entered in its dialog box.

Let's open the K-Portrait.jpg photograph provided in the Chapter 8 Files folder, and save it first as K-Portrait_ original.psd, and a working copy named K-Portrait_re- storedG.psd ("G" for Gaussian) into you Photoshop prac- tice folder. Let's begin by printing a copy at its full 8" x 10" size first, so that we will be able to accurately deter- mine which blemishes are visible at the final output size, and which ones are not. Once we have done that, besides our printed copy, let's keep the K-Portrait_original.psd file also visible, as we will want to be able to easily com- pare the amount of blur applied to the restored file. When we examine the photograph closely, we can see that the background area of the original photograph was inten- tionally blurred. However, as we can also see in the en- largement included in Figure 8.28, this photograph is covered with speckles of damage.

FIGURE 8.28 K-portrait photograph with an area of its surface damage enlarged.

Although the worst of the damage is around the out-side of the woman, some of it is also visible on her hair, face, and neck. We will repair the background area first. Because of the strands of hair which protrude out be-yond the perimeter of the figure, let's begin by making a selection of the background area leaving a space be-tween our background selection and the woman. Then assign a feather radius such as 10 pixels, so that our blur will fade as it approaches the figure. Once the selection is made, before applying the Blur filter, let's save this selection into an alpha channel. Once the selection has been saved, let's apply a blur to this selection by choos-ing **Filter>Blur>Gaussian Blur.** When its dialog box opens, it provides a Radius slider to assign the degree of intensity of the blurring effect we want to apply. With the Pixels slider starting at 1.0 by default, let's slow-ly drag the slider until the damage is gone, while the blurred detail of the background still resembles that of the original photograph, with a suggested setting of Radius 28 shown in Figure 8.29. Once the blur has been applied, let's stop and save this document.

FIGURE 8.29 Photograph with the Gaussian Blur filter applied to a selection of the background.

8.6.2 Using the Surface Blur Filter

Although capable of recognizing the "surface" it is applied to and intuitively adjusting its application accordingly, the Surface Blur filter can also be used to produce a blurred appearance very similar to that of a Gaussian Blur. With this document saved, let's back up in the History panel to the state just before we applied the Gaussian Blur, choose Save As, and rename this file K-Portrait_restoredS.psd ("S" for Surface). Let's now reopen our Gaussian Blur copy, then use the arrange feature to display three files simultaneously: the original copy, the Gaussian Blur copy, and the current document that will become our Surface Blur copy. With our Portrait_restoredS.psd file active and its alpha channel selection loaded, let's choose **Filter>Blur>Surface Blur.** Once this dialog box opens, we can see that it provides both a Radius slider (Pixels) to assign the size of the sampling area and a Threshold slider (Levels) to assign the degree of tonal variation that surrounding pixels must have to be included in the blur. Experiment with a variety of combinations of these two sliders, and then choose one that retains a degree of clarity comparable to both the original and to your Gaussian Blur copy, with suggested settings of Radius 48, Threshold 96 as shown in Figure 8.30.

Once the blur has been applied, deselect the background area if it is still selected, then choose to save and keep either one of the restored versions open, and close the other two open files.

At this point, when magnified in, the area between

FIGURE 8.30 Assigning Surface Blur Radius and Threshold settings to a selection.

the blurred repair and the figure still contains the speckled appearance. With the Patch tool Mode set to Normal, and its Source option assigned, selections around the outer edge of the figure can be made, and then dragged out and released on top of appropriate blurred source content to quickly and effectively remove the speckles around the outer edge of the figure (or alternatively the Content-Aware Mode can be used if applicable). Let's do that now, being careful however, to not get too close to any of the curls which extend out beyond the general area of the woman's hair. We will correct those using the Smudge tool.

8.6.2.1 Understanding the Difference Between the Gaussian Blur Filter and the Surface Blur Filter

When viewed side by side, the blurs we created in the Gaussian Blur and Surface Blur versions appear virtually identical. What is the difference between them? Great question, and in our current application, there is virtually no difference in the end result, and in future applications similar to this the choice can be purely a matter of personal preference. The difference becomes apparent when surface *edges* are included in the application area, and how each filter handles (or doesn't), those edges. Although we will be using a more appropriate technique to remove the blemishes from the woman's face, Figure 8.31 contrasts the nose/mouth area of it with the Gauss-

FIGURE 8.31 Gaussian Blur filter compared to the Surface Blur filter when applied to edge details.

ian Blur filter applied to the same area with a comparable amount of blur applied using the Surface Blur filter. Even though the area *around* the facial features in each of the two dialog boxes is very close in its degree of blur, the Surface Blur filter was able to retain more of the *edge* details of the nose and mouth.

8.7 Repairing With the Smudge Tool

The speckles along the outer edge of the woman's hair provide a great opportunity to learn how the Smudge tool can help in restoration.

The Smudge tool is grouped with the Blur and Sharpen tools in the Tools panel, as shown in Figure 8.32.

FIGURE 8.32 Choosing the Smudge tool in the Tools panel.

The Smudge tool utilizes a brush to move source color in the direction you drag which can be used to effectively return the beautiful wispy curls along the outer edge of the woman's hair.

Once the tool is chosen, its options become available in the Options bar as shown in Figure 8.33.

FIGURE 8.33 Options bar when the Smudge tool is chosen.

We can see that the Options bar contains brush Size and Hardness settings for the Smudge tool, as well as the option to Sample All Layers. Although its Mode setting defaults to Normal and will be a great place to start, when using this tool, selecting either the Darken or Lighten option from its Mode pop-up menu may also be helpful at times, based on the content to which it is being applied.

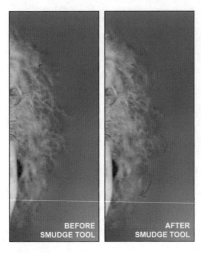

FIGURE 8.34 Using the Smudge tool to return the natural appearance to the outer edge of the woman's hair.

Its additional Strength setting can be thought of as a pressure setting: such as how "hard" you want to "press" to smudge the area. Its Finger Painting option uses the current foreground color in the Tools panel as the source content to smudge with, and will not be applicable to our work. To return the natural edge to the woman's hair with the Mode kept at its default setting of Normal and its Sample All Layers and Finger Painting settings off, let's choose a small brush, similar to the width of the curls, but large enough to "push" the colors in the direction we drag. Assign a Hardness setting of 100% and a Strength setting of 50%. By applying short strokes in the direction of the curls, the natural appearance of the hair is returned as shown in the before and after samples provided in Figure 8.34. The additional red arrows in the completed sample indicate the direction the source content was dragged with the Smudge tool.

> **Note**
>
> When used sparingly, the Smudge tool can also be used to repair small blemishes, such as some of the small speckles located inside the woman's hair. Be careful, however, to make short drags in the direction of the natural appearance of the hair. Many of the speckles within the woman's hair on the right in Figure 8.34 were also removed using the Smudge tool.

8.7.1 Repairing With the Blur Tool

In the same group of tools in the Tools panel as the Smudge tool, and the one that will display by default

when the preferences are re-set is the Blur tool as shown in Figure 8.35.

Once the tool is selected, its options display in the Options bar with some familiar settings as shown in Figure

FIGURE 8.35 Choosing the Blur tool in the Tools panel.

8.36. Like the Smudge tool, with its Mode setting kept at Normal, sometimes assigning either the Darken or Lighten Mode option may be more appropriate for the particular area to which you are applying the tool.

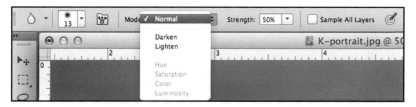

FIGURE 8.36 Options bar when the Blur tool is chosen.

This tool will blur based on the brush Size, Mode, and Strength settings assigned, and is effective for *small* areas where a blur is desired, without the need to create a selection and apply a blur filter. Figure 8.37 illustrates its application to the area below one of the woman's eyes, using the settings shown in Figure 8.36 (Strength 50%). Feel free to try this yourself, experimenting with the variation in the resulting effect when Lighten or Darken is chosen versus Normal from the Mode pop-up menu.

FIGURE 8.37 Before and after the Blur tool has been applied below the woman's eye.

8.8 Using Layers to Manage Blurs

Although we can see that the Blur tool will be convenient and helpful for small quick applications, it will not be a practical or effective method of repairing the majority of the blemishes on the woman's face and neck. These areas will best be repaired using a Blur filter but with its opacity reduced. As we will see, lowering the opacity of a blur layer is not the same as simply assigning a lower Radius or Threshold setting to the filter. Let's repair the left cheek in the photograph (the woman's right cheek) using the four-step method detailed in Figure 8.38.

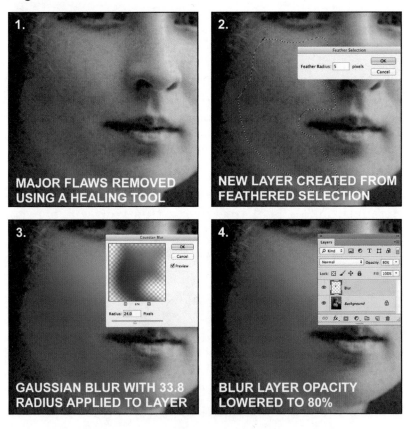

FIGURE 8.38 Four-step process to reduce the effect of a Blur filter.

First, let's begin by removing the major imperfections in the cheek area first using one of the healing tools, such as the Spot Healing Brush tool. This will allow us to keep its setting(s) lower when the Blur filter is applied, and still achieve the desired blending effect. Now let's make a selection, keeping the edge of the selection slightly away from the hair and features of the woman (to avoid the effect visible in Figure 8.31). Apply a small feather radius to it, and then convert the selection to a layer using the Layer via Copy command. For the third step, let's apply either a Gaussian Blur or a Surface Blur to this new layer, assigning enough blur to remove the blemishes, such as the Gaussian Blur Radius setting of 24.0 to 33.8 Pixels as shown in Figure 8.38. Although we have done that and the damage has now been removed, the setting we had to assign was so high, the woman's skin now has a fake "china doll" appearance to it. The critical fourth step in this repair method is to now *lower* the opacity of the blur layer, as low as we can go, while still hiding most of the original damage, such as the 80% opacity shown in the sample. Once satisfied with the results, the layer can be merged down. Feel free to now complete this restoration by repeating this process with the rest of the damaged areas of the woman's head and neck. Each blur layer should be treated individually. The amount of opacity reduction that is appropriate in one area may be too much or not enough in another. When the restoration is complete, merge its layers, and then save and close the file.

8.9 Combining Tools, Commands, and Techniques for Professional Restorations

Through Chapters Seven and Eight, we have now experienced a multiplicity of types and severities of restoration projects, and learned a variety of tools, com-

mands, and techniques that can be employed to repair them. We have also learned that these tools, commands, and techniques can, and oftentimes *should*, be combined to achieve the most effective and efficient results. The projects provided at the end of this chapter will require you to make experienced decisions regarding which tool and/or combination of tools, commands, and techniques should be employed to repair the specific types of damage each project contains, and reinforce your experience using them. Sometimes more than one tool or repair method can successfully achieve the same restoration result, allowing you to employ your favorite method, while others will be more specific. However, in completing them, you will be building a solid foundation in the restoration process, and gaining a wealth of experience that you will be able to apply to the challenges you will face in your own future work.

When completing restoration work that requires you to frequently switch between the Clone Stamp tool and one of its healing tool counterparts, the following keyboard shortcuts can improve your efficiency. Pressing the "S" key on the keyboard will automatically select the Clone Stamp tool, and pressing the "J" key on the keyboard will engage the last used healing tool from the healing collection of tools.

Test Your Knowledge

1. Under which Filter command submenu is the Dust and Scratches filter option found?

2. Which tool combines the operation of the Clone Stamp tool with the blending feature of the Patch tool?

3. How does the Surface Blur filter differ from the Gaussian Blur filter?

4. What is the purpose of creating a "reference guide" print before beginning a restoration?

5. When using either the Healing Brush tool or the Spot Healing Brush tool, why can it be beneficial at times to create a selection first before applying the tool?

6. How can the Smudge tool be used in restoration?

7. Which tool incorporates nearby image content when repairing?

8. Why should you crop first before beginning a restoration, if one is required?

9. How does the Spot Healing Brush tool icon differ from the Healing Brush tool icon?

10. What is "image noise"?

Try It Yourself

Project 1

Reopen your Group photograph_restored.psd file.

1. Begin by printing this photograph at actual size to evaluate what damage still needs to be repaired.

2. Use the Spot Healing Brush tool for the rest of the chips in this photograph.

3. To cover the tiny specs of damage, after making appropriate selections and feathering them, the Dust and Scratches filter settings of Radius 3, Threshold 15 can be applied as shown in Figure 8.39.

4. To repair the woman's blouse, be sure to magnify in large enough to work, and adjust your brush size as needed. Some of its repairs may need the Clone Stamp tool instead of the Spot Healing Brush tool or the Healing Brush tool.

5. The Healing Brush tool will be helpful on the textural pattern of the woman's skirt.

FIGURE 8.39 Dust and Scratches filter applied to the background area of the group photograph.

6. When repairing the boy's hair, after using the Clone Stamp tool to fill it in with content, the texture can be added by borrowing a selection from the mother's hair as shown in Figure 8.40.

7. When the damage in the photograph has been repaired, save and close the file.

Project 2

 Open the J-Restaurant.jpg file provided in the Chapter 8 Files folder and save it first as J-Restaurant_original.psd, then as a working copy named J-Restaurant_restored.psd into your Photoshop practice folder.

1. Choose the Crop tool, assign a Width of 10″ and Height of 8″ for it with no resolution entered, and then crop to remove the border around the photograph.

FIGURE 8.40 Borrowing hair texture for repair.

2. Now print a reference guide copy of the photograph at actual size to evaluate and identify its visible damage.

3. Although much of this photograph can be repaired using the Spot Healing Brush tool, feel free to use the tool(s) of your choice for most of its damage.

4. A few areas, such as the damage to the cash register keys, will be best served by the application of the Layer via Copy command.

5. When you are done repairing its damage, save and close the file. We will learn to repair discolored photographs such as this one in Chapter Nine.

Project 3

Open the Shoe store.jpg file provided in the Chapter 8 Files folder.

1. Save the file first as Shoe store_original.psd, and as a working copy named Shoe store_restored.psd into your Photoshop practice folder.

2. Choose **Image>Image Size** and with the Resample option unchecked and being sure that Constrain Proportions *is* checked, change the Resolution to 300 ppi which will convert the Document Size fields of the photograph to a Width of 11.133 and a corresponding Height of 8.04.

3. Now choose the Crop tool and assign a Width of 10″, a Height of 8″, and Resolution of 300 ppi.

4. As you will see, based on the dimensions we have assigned, when including the full height of the photograph, some of the width will need to be removed. Choose to center it, or align with the right side, or you will notice if you align the crop with the left side of the photograph, the tear of the shoe in the top right will be removed as shown in Figure 8.41. (The crop has been outlined in red for easy identification.)

FIGURE 8.41 Cropping the Shoe store_restored photograph to 10″ x 8″.

5. Now as you have learned, print a reference guide copy of the file at this 10″ × 8″ size before beginning its restoration to evaluate and identify its visible damage at this final output size.

6. When examining the print, you will see that the chairs and floor show chips and small damage that will benefit by selecting small areas, applying a feather to them, and then applying the Dust and Scratches filter, with suggested settings of Radius 6, Threshold 0, as shown in Figure 8.42.

FIGURE 8.42 Applying the Dust and Scratches filter to minor floor damage in the Shoe store_restored.psd photograph.

7. Complete the rest of the restoration of this photograph, referring to your reference guide print as you work, so that you will not be repairing damage that will not be visible when the restoration is printed.

8. When you are done, print the restoration at actual size, and compare it with your reference guide copy. If all of its visible damage has been removed, save and close the file.

Project 4

Open the April 1942_restored.psd file that was saved into your Photoshop practice folder in Chapter Three, converting it to the Adobe RGB (1998) color space if you have chosen to be prompted when opening. As you may recall, at that time we simply practiced selection with it, but did not save any of the selections that we made.

1. Begin by choosing the Crop tool, assign a Width of 4″ and Height of 6″ with no resolution entered, then crop starting at the upper left corner of the image area, and dragging diagonally down to the lower right as shown in Figure 8.43.

2. As you have learned, print a reference guide copy at this final output size before beginning its restoration to evaluate and identify its visible damage.

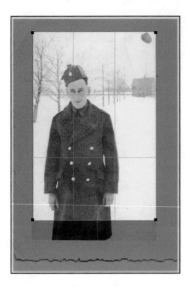

FIGURE 8.43 4″ x 6″ crop defined for the April 1942_restored.psd photograph.

3. Using the tools and techniques you have learned, repair the damage to the photograph except for the building in the distance.

4. For the building, although it has sustained a considerable amount of damage, the remaining restoration steps and their suggested sequence have been identified in Figure 8.44 as shown.

FIGURE 8.44 Repairs to house identified.

5. To repair the building, start with its roof. The left side provides a good patch that can be selected, then copied (each time any of these steps suggest copying selected content, it will always be using the Layer via Copy command). Now Alt/Option drag this repair layer to duplicate it as many times as needed to cover the rest of the roof. Once the roof is complete, all of its repair layers can be merged together.

6. The bottom half of this window is usable. By selecting it, then copying it, the copy can be flipped vertically then horizontally (**Edit>Transform**), and then positioned above it. When satisfied with its location, this layer can be merged down.

7. Now the entire window can be selected, copied, and then moved to the opposite side of the building to the suggested location indicated in red.

8. The light patch shown as #8 in Figure 8.44 can be extended using the Clone Stamp tool, and then selected, copied and flipped horizontally to create the other half of the door.

9. A rectangular selection can be made of the roof (once it has been repaired and all its repair layers merged), copied, and then moved above the roof to cover where the original chimney was. If desired, the opacity of this layer can then be lowered a little to blend in more naturally, such as 80%.

10. Although it appears that the tree, which is slightly visible, may have been in front of the house, a selection of the upper portion of some of the trees to the left can be made, copied, and then moved above the house with its extra content erased, and the layer opacity lowered, if desired.

11. The house area of this photograph should now *resemble* the sample shown in Figure 8.45.

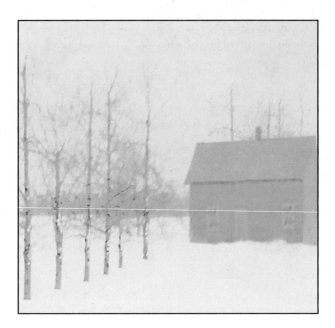

FIGURE 8.45 Suggested appearance of restored house.

12. When satisfied with your restoration, merge all of
the layers you have created, and then save and close
the file. What about its color? In Chapter Nine, we
will learn to restore this black and white photograph
back to its original beauty.

9

CORRECTING LIGHTING, CONTRAST, AND DISCOLORATION

After learning to transform photographs scanned in color to black and white images, we will focus on their enhancement through a variety of methods of adjusting their lighting and contrast. When working with color photographs, in addition to their lighting and contrast, we will learn multiple ways to correct a color cast, adjust saturation, and even explore altering the color of content within a photograph to enhance its overall aesthetic appearance.

9.1 Before We Begin

Some of the files we worked on in previous chapters still need correction whether they were color photographs that suffered from lighting issues, were faded and/or discolored, or were yellowed and/or faded black and white (herein referred to in this book as grayscale) photographs. This chapter is dedicated exclusively to learning a variety of Photoshop tonal and color adjustment commands and tools from simple to complex for correcting typical photograph lighting, contrast, and discoloration challenges. While exploring, we will discover that frequently the same result can be successfully achieved using any one of several different correction techniques, ranging in their degree of complexity. Sometimes a basic adjustment command will yield a satisfactory result equal to one achieved using a more complex method. Because of this while some corrections can only be achieved using a specific command, oftentimes a photograph will be used as an example to teach a new correction technique, which may also be satisfactorily corrected using a method you have previously learned in the chapter. Later on in your own work, when this type of scenario arises, you will have the expertise and flexibility to incorporate your favorite enhancement method. Additionally, when an adjustment command is multifaceted, containing options for correcting a variety of image color maladies, we will reexamine it multiple times, each time focusing specifically on the features it provides that are applicable to the particular correction challenge being explored. Let's get started. After an introduction to Adjustment layers, we will begin by working with grayscale photographs.

9.2 Using Adjustment Layers

Adjustment layers have been mentioned briefly in previous chapters, when the ability to affect or not af-

fect them has been a selectable feature in the Options bar with some of the tools we have learned so far. Before beginning to learn adjustment commands, it is important to understand the flexibility and "reverse-ability" advantage of applying corrections as adjustment layers versus menu commands. An adjustment layer can be thought of as a colored sheet of "cellophane" that affects how an image is "seen" through it. Most of the correction commands we will use will be available from the Image menu as well as available as adjustment layers. When a correction command is applied as an adjustment layer, the effect is "nondestructive." This means it can be repeatedly edited, as well as hidden or deleted at any time *until* it is merged down to permanently apply its adjustment to the image. In contrast, a correction command chosen from the Image menu is a permanent alteration *as soon as* it is applied. It is reversible *only* while the document is open, through the Undo command or the History panel. When a correction command is available both as an adjustment layer and as a command from the Image menu, our work will take advantage of the flexibility of the nondestructive benefits of applying it as an adjustment layer, versus the permanence of applying it as a command chosen from the Image menu.

An adjustment layer can be created using the Adjustments panel (**Window>Adjustments**) by single-clicking on one of the panel's adjustment command icons, by choosing one from its panel menu, by selecting an adjustment command from the menu that appears by either pressing and holding on the Create a new fill or adjustment layer icon at the bottom of the Layers panel, or by choosing **Layer>New Adjustment Layer**. We will apply adjustment layers from each of these locations so that in your own work, you will be able to decide which location works best for you.

Once an adjustment layer has been created, the following convenience icons shown in Figure 9.1 allow you to choose options for the adjustment in the Properties

panel of CS6, or in CS5, they appear at the bottom of the Adjustments panel:

Back: the ability to return to the main list (CS5)

Expanded view: toggle the size of the open panel (CS5)

Clip to layer: choose to affect only the layer directly below it rather than all layers below it

Show/Hide: toggle the visibility of the adjustment

View previous state: temporarily view the previous adjustment

Reset: reset to default before any changes were applied

Delete: delete the adjustment

FIGURE 9.1 Adjustment layer options in CS5 and CS6.

 A copy of each figure shown in this chapter can be viewed on the companion DVD included with this book.

Note

Adjustment command options will be applied hereafter in the Properties panel, if your version does not contain the Properties panel, these options will be applied in the Adjustment panel instead.

When a tonal or color correction command is applied as an adjustment layer, the new adjustment layer will appear above the currently selected layer in the Layers panel, with a mask automatically applied to it. If an active selection exists when an adjustment layer is added, the mask will reflect the selection, otherwise it will

FIGURE 9.2 Adjustment layer with mask.

encompass the entire layer as shown in Figure 9.2.

> **Note**
>
> If you prefer to not have a mask preapplied when using adjustment layers, uncheck the Add Mask by Default option available from the Adjustments panel menu before selecting an adjustment command. To remove one after it has been added, Right/Control click the mask icon in the adjustment layer, and choose Delete Layer Mask from the context-sensitive menu that appears. Also, you can select just the mask icon in the adjustment layer of the Layers panel, then click the Delete layer icon in the Layers panel (or drag it down and release it on top of the Delete layer icon), or with the adjustment layer selected, choose **Layer>Layer Mask>Delete**. When using any one of these methods, the removal does not delete the adjustment layer, only its masking capability.

If the options for an adjustment layer are not visible anytime an adjustment layer has already been added to an image, double-click directly on the adjustment icon of its adjustment layer in the Layers panel to reopen the options for it.

9.3 Converting Color Photographs to Grayscale Photographs

As we learned in Chapter One, it is best to scan a faded or discolored grayscale photograph in RGB color.

We have also learned that in contrast to a grayscale image which has only one channel (gray), RGB images contain four channels: a composite RGB channel, and three additional channels: Red, Green, and Blue which can provide more flexibility in the conversion to grayscale when needed. We will explore three ways to convert our images to grayscale. The first is by simply applying the **Image>Mode>Grayscale** command, the second is by choosing the Black/White command first, *then* applying the **Image>Mode>Grayscale** command, and the third is by choosing the Channel Mixer command first, *then* applying the **Image>Mode>Grayscale** command.

9.3.1 Converting to Grayscale Using the Image>Mode>Grayscale Command

This command will convert an RGB color image to grayscale in one click. Let's reopen our April_restored. psd file now from our practice work in Chapter Eight to learn to convert it from its Adobe RGB (1998) color space to a grayscale photograph by applying this command. As you may remember, we worked to repair its damage, but the photograph itself was badly discolored. Once the file is open, let's choose **Image>Mode>Grayscale.** The dialog box shown in Figure 9.3 appears, requiring a confirmation that we want to discard the color information from the image, with a suggestion that we may want to keep its color mode in RGB, and use the Black & White command first, to have more control over the conversion before permanently removing its color.

FIGURE 9.3 Discard color information dialog box.

*When the Discard color information dialog box is open, it contains a Don't show again checkbox you can select to not have it warn you each time you choose the **Image>Mode>Grayscale** command.*

However, the appearance of this dialog box will return when the Photoshop preferences are reset to their default settings.

As soon as we click the Discard button, the photograph is converted to grayscale, and its file size significantly reduced. Once it has been converted, we can see that it lacks some contrast. Although we can apply additional commands to correct that, let's back up in the History panel to before the image was converted, and apply the suggestion offered in the Discard dialog box instead: the Black & White command.

9.3.2 Applying the Black & White Command Before Converting a Photograph to Grayscale

This is the first of several correction commands that can be applied either from the **Image>Adjustments** submenu, or as an adjustment layer: we will apply it as an adjustment layer, through the Adjustments panel (**Window>Adjustments**).

Let's choose to apply this adjustment layer by either clicking its respective icon outlined in red in Figure 9.4, or by selecting it from the Adjustments panel menu as shown.

Once we have done that, the adjustment layer appears above the current selected layer (the Background layer) in the Layers panel. Simultaneously, the Properties panel updates to reflect the chosen command with default settings applied, with an Auto adjustment button, as well as a Presets pop-up menu of grayscale conver-

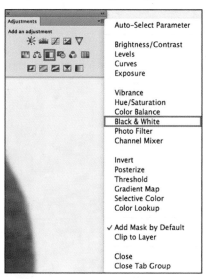

FIGURE 9.4 Choosing to create a Black & White adjustment layer through the Adjustments panel.

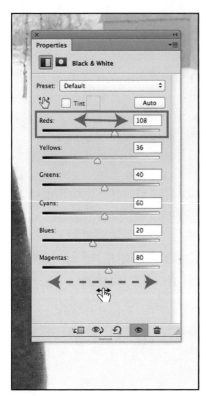

FIGURE 9.5 Dragging the hand icon to adjust the color sliders of the Black & White command.

sion options to choose from, and sliders for a customized conversion. This command is one of a variety of commands which also include the On-image adjustment tool, hereafter referred to as its "hand icon" which when dragged left or right over an area in the image, updates its color sliders with positive or negative settings relative to the direction and location of the drag, as illustrated in Figure 9.5. When the Black & White command is applied from the **Image>Adjustments** submenu, the hand icon is accessible by holding down the Control/Command key as you drag on the image.

Let's scroll through and try each of the available black and white presets from its Preset pop-up menu to see how they alternatively affect the contrast in the photograph. Also, let's try selecting its hand icon and dragging left to right within the image, and watching how the image updates as the color sliders move to reflect the changes, to better understand how this color modifier can be helpful as well. Once an acceptable balance of contrast has been achieved, before the permanent conversion to grayscale is applied, the "cellophane" adjustment layer's effects must be permanently applied by merging this adjustment layer down. Once this is done, the image is converted to grayscale by choosing **Image>Mode>Grayscale**. However, instead of applying the mode conversion just yet, let's back up in the History panel to the opening state one more time, to learn

about the Channel Mixer command, before making the final permanent mode conversion from RGB to Grayscale.

9.3.3 Applying the Channel Mixer Command Before Converting a Photograph to Grayscale

This feature is also available as both a permanent command by choosing **Image>Adjustments** and selecting it from its submenu, or as a nondestructive adjustment layer. Let's apply it as an adjustment layer, this time by pressing and holding on the Create a new fill or adjustment layer icon at the bottom of the Layers panel that we learned about in Chapter Four, and selecting Channel Mixer from the menu that appears. Unlike choosing the Black & White command, we will see no change in the photograph until the Monochrome option is checked in the Properties panel. Once checked, we can see that this command also provides a Preset pop-up menu of grayscale conversion options as shown in Figure 9.6.

As we scroll through the options in its Preset pop-up menu, notice that no matter which preset we select, the Total percent shown below its color sliders always equals "+100%". The sliders can be manually adjusted as well, being mindful to adjust individual channel percents as needed, to keep the total at exactly "+100%" to maximize the effectiveness

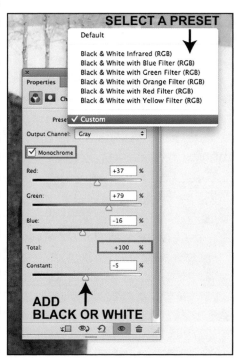

FIGURE 9.6 Applying Channel Mixer adjustment layer settings.

of this command. The Constant slider will add more black or white, if desired, depending on the direction its slider is dragged. When using this method of grayscale conversion, once the Channel Mixer settings have been assigned, the adjustment layer must be merged down, followed by choosing the **Image>Mode>Grayscale** command to complete the process.

9.3.4 Choosing the Most Effective Grayscale Conversion Method

Should you use either the Black & White command or the Channel Mixer command first, or just choose **Image>Mode>Grayscale** and have the image converted to grayscale with one click? The answer will depend on the particular photograph you are working with, as well as your personal preference. Sometimes depending on the image, there will be minimal difference in the end result, and the choice will be yours. Other times, the tones and contrast of a photograph may be more significantly improved by the intermediate application of one particular correction command over another. When working on a correction project where maximum contrast and tonal range are important, it will be helpful to try all three methods we have learned first, before making the conversion to grayscale permanent.

*Want to be able to easily compare the effects of all three conversion methods on the same photograph before permanently changing its color mode to grayscale? The Duplicate command located under the Image menu creates a copy of the active file. Once a duplicate copy has been made, when the arrange option of 2-up Vertical is chosen, the **Image>Mode>Grayscale** command can be applied to the duplicate copy. Then using the original file, two separate adjustment layers can be created, one using the Black & White command, and one using the Channel Mixer command, with their effects compared by clicking the visibility icon for each adjustment layer on and off one at a time, to preview its particular effect. Once a decision has*

*been made, the duplicate copy of the file is deleted, and the chosen adjustment layer is merged down, with the unused one deleted (if applicable), then the permanent conversion to grayscale is completed by choosing the **Image>Mode>Grayscale** command.*

After comparing the results of each conversion process, turn this photograph into a grayscale one using your favorite method. Once the conversion has been made, let's save this file and close it for now.

9.4 Applying Tonal Adjustments to Grayscale Photographs

We have learned how to convert a color photograph to grayscale, including how we can improve the lighting and contrast of the resulting grayscale image, by employing either the Black & White command or the Channel Mixer command prior to its conversion. Oftentimes, however, once converted, a grayscale photograph may be further enhanced by the application of one or more additional tonal adjustment commands. Let's learn how the Auto Tone, Auto Contrast, Brightness/Contrast, Levels, and Curves commands can be used to improve the lighting and contrast of grayscale photographs, and how we can monitor our adjustments in the Histogram panel, beginning with the Auto Tone and Auto Contrast commands.

9.4.1 Applying the Auto Tone/Auto Contrast Commands to Grayscale Photographs

Anytime an "auto" command is chosen, Photoshop makes decisions *for* you, rather than you evaluating the particular photograph and controlling its correction by applying customized adjustment settings for the image. However, these one step commands are easy to apply, always worth trying, and sometimes produce amazing results. Although we will also discover the availability of auto settings within some of the other correction com-

mands which will be accessible as both adjustment layers and permanent adjustment commands, these two auto options are only available as permanent applications by choosing **Image>Auto Tone** and **Image>Auto Contrast**. While the Auto Tone command reassigns the black and white points in the image and the Auto Contrast reassigns the image contrast range, the results are oftentimes similar, and surprisingly effective.

> ### Note
>
> In version CS3 and earlier, the Auto Contrast command is selected from the **Image>Adjustments** submenu. When the Auto Tone command was added in CS4, both of these commands were moved to the Image main menu.

on the DVD Let's try each of them now, one at a time, on the photograph named Mountains.jpg provided in the Chapter 9 Files folder. Let's select the **Image>Auto Tone** command first which significantly improves the image with one click. Now let's back up in the History panel to before it was applied, and this time select **Image>Auto Contrast**. The image is once again, significantly improved, as shown in Figure 9.7.

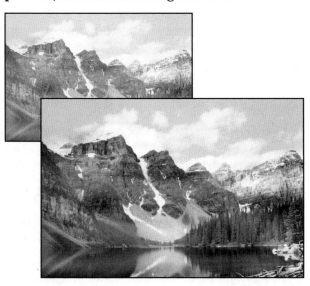

FIGURE 9.7 Before and after applying the Auto Contrast command.

When applying commands such as Auto Tone or Auto Contrast, which are not available as adjustment layers, it will be helpful to first duplicate the Background layer, then apply the correction to the copied layer. It will then be easy to turn the adjusted layer off and on to compare its improvement against the original, as well as delete the layer if needed to start over, or to apply a different correction method instead. When satisfied, the layer can be merged down.

Click **TIP**

For many photographs, once they have been converted to grayscale, these one-click adjustments may satisfactorily complete the correction process. However, let's close this file without saving the changes, and instead reopen our April_restored.psd file. Let's apply each of these auto correction commands to it, reverting back in the History panel in between their applications, to observe how they positively affect the photograph. Now let's back up in the History panel one more time to its opening state, and begin to learn a variety of correction commands which offer varying degrees of customization and *user input* in their application, beginning with the Brightness/Contrast command.

9.4.2 Applying the Brightness/Contrast Command to Grayscale Photographs

The Brightness/Contrast command is easy to use, and is available under the **Image>Adjustments** submenu, or as a flexible, nondestructive adjustment layer. Let's learn to apply it as an adjustment layer, by choosing to apply it from the Layers menu, by selecting **Layer>New Adjustment Layer>Brightness/Contrast**. We can see when we press and hold on the New Adjustment Layer command to select Brightness/Contrast from its submenu, that some of the adjustment commands are grayed out. The unavailable commands are applicable to color images, and our active file is grayscale.

Once the Brightness/Contrast command is selected from the New Adjustment Layer submenu, the New

FIGURE 9.8 New Adjustment layer dialog box.

Layer dialog box opens as shown in Figure 9.8, which did not appear when we applied an adjustment layer using any of the other methods.

Although this dialog box appears when an adjustment layer has been added, it is basically the same as the New Layer dialog box that appears when the New Layer command is chosen from the Layer menu, except that the adjustment layer is named by default according to the command that has been selected, with the number "1" added automatically to its name, as multiple adjustment layers of the same type can be added to a file if desired.

Once we click OK to create the new adjustment layer, the Properties panel updates with two sliders: one to adjust brightness and one to adjust contrast. By dragging each slider to the right then left, we can see how this easy-to-use command affects the overall tonal quality of the image. When the Brightness slider is moved to the right, the photograph is uniformly lightened or "brightened." Alternatively, when the same slider is dragged to the left, the lights are

FIGURE 9.9 Applying the Brightness/Contrast command as an adjustment layer.

decreased, and the image is uniformly darkened. As the Contrast slider is dragged, the overall *range* of the image's tones is increased when dragged to the right, and decreased when dragged to the left. Your settings may differ slightly depending which method you used to first convert the photograph to grayscale, however with little effort, the photograph is significantly improved with settings of Brightness –15 and Contrast 63, as shown in Figure 9.9.

Note

If your version of Photoshop contains the Use Legacy option, you will want to keep this option unchecked. This command's method of correction was improved in CS3: assigning its legacy option would assign correction using its previous technology.

When this adjustment layer is hidden, we can compare its improvement, as well as double-click on its icon in the Layers panel to readjust its settings at any time. Once you are satisfied with your brightness and contrast improvements, save and close the file.

9.4.3 Understanding the Histogram Panel

Let's examine the standalone Histogram panel before exploring the Levels and Curves commands. Because both of these commands include a histogram in their panels, it will be helpful to secure a general understanding of the information the Histogram panel provides first.

This panel provides a graph that maps the tonal distribution of the active image as shown in Figure 9.10.

FIGURE 9.10 Photograph with the Histogram panel open.

Histogram Panel: In Photoshop, the Histogram panel provides a visual representation of the pixel distribution of the shadows (left side), midtones (middle), and highlights (right) of an image mapped using a histogram. When a photograph contains a full range of tones, it will display vertical bars distributed across the entire histogram graph, with the height of a vertical bar corresponding to the amount of brightness at that particular tonal range. Gaps existing between the bars of a histogram indicate missing color bit data, with wider gaps indicative of major color bit loss, with this loss simultaneously visible in the image as a posterized appearance.

The Histogram panel shown in Figure 9.10 is a visual indicator that this photograph contains a good range of shadows, midtones, and highlights, because it displays vertical bars that span across almost its entire width. Although for this particular photograph, that can also be easily confirmed by simply looking at the photograph directly, the Histogram panel can be helpful in determining how an image needs to be corrected, as well as helpful in monitoring color bit loss after a correction has been applied.

Let's reopen the Miner_restored.psd file we saved with an alpha channel in Chapter Three. Once the photograph is open, and its "miner car" alpha channel is active, let's first choose to select everything except the mining car selection (**Select>Inverse**). Now let's open the Histogram panel (**Window>Histogram**) and notice how it differs from the lake sample shown in Figure 9.10. Compared to the lake sample, notice in Figure 9.11, that the red arrows added on the left (shadows) and right (highlights) sides of the graph, illustrate that no vertical bars exist in these locations, indicating that its tonal range currently lacks bit data in these areas of the histogram, making the image appear somewhat "washed out."

We will explore another correction method for adjusting the tones in this photograph. For now, let's temporarily add a Brightness/Contrast adjustment layer to this file to examine how the Histogram panel works. In the Properties panel, leaving its Brightness slider at zero, while moving its Contrast slider to the right, watch how the histogram's vertical bars automatically update by spanning more of the width of the graph, as the tonal range is adjusted in the photograph. However, if you click on its Uncached data warning triangle, or its Uncached Refresh icon (identified in Figure 9.11) to update the histogram, the update will show "gaps" between some of the vertical bars. Once you have compared the tonal adjustment in the photograph with that of the histogram while moving the Contrast slider to the right, delete the Brightness/Contrast adjustment layer so that we can examine what "gaps" in a histogram mean.

FIGURE 9.11 Miner_restored.psd with Histogram panel graph content identified.

Note

By default, the Histogram panel will be in Compact View which will display only the histogram, and its Uncached data warning triangle. For the Uncached Refresh icon (two curved arrows) to be visible in addition to the Uncached data warning triangle, the Histogram panel must be in Expanded View, chosen from its panel menu.

9.4.3.1 Comparing the Histogram of a 16 Bits/Channel Versus a 8 Bits/Channel Grayscale Photograph

In Chapter One, we were introduced to scanning at 16 bit versus 8 bit. The Histogram panel can be helpful in understanding when and why scanning an image at 16 bits/channel versus 8 bits/channel can have its advantages. When experimenting with the Brightness/Contrast adjustment layer added to the Miner_restored.psd file, as the Histogram panel updated while you dragged the Contrast slider to the right, gaps appeared between the vertical bars of its histogram.

The cat shown in Figure 9.12 was scanned twice from a black and white negative, once at 16 bits/channel and once at 8 bits/channel. We can see that the histograms of the two original photographs on the left are almost identical. However, once the images have been enhanced with the *exact same* adjustment settings, and their histograms refreshed, although it appears to the naked eye to show no visible quality loss, the 8 bits/channel image displays *some* gaps in the vertical bars of its histogram, compared to the 16 bits/channel image histogram which still contains *no* gaps.

What does this mean? Depending on the photograph you are working with, and the amount of adjustments you apply to it, usually there will be no visible quality degradation after the correction, even though some narrow gaps will result in the vertical bars of the histogram. However, if *extensive* adjustments need to be

ORIGINAL 16 BIT

ADJUSTED 16 BIT

ORIGINAL 8 BIT

ADJUSTED 8 BIT

FIGURE 9.12 Comparing a16 bits/channel image with a 8 bits/channel image after tonal adjustments have been applied.

made, wider gaps in the histogram will be visible, and will also be visible in the image as blotchy flat areas of color, often referred to as "posterization." The additional bits provided by 16 bits/channel versus 8 bits/channel can help minimize these gaps in the histogram, allowing more extreme tonal adjustments to be made *before* gaps begin to appear. By keeping the Histogram panel open at all times, you will be able to click on its Uncached data warning triangle or its Uncached Refresh

icon if in Expanded View to update its graph, and monitor the effects of your adjustments as you make them.

9.4.4 Applying the Levels Command to Grayscale Photographs

For many photographs, simply applying the Auto Tone, Auto Contrast, or the Brightness/Contrast command to them will significantly and satisfactorily improve them. However, the Levels command provides more specific tonal adjustments when needed. When the Histogram panel displays "empty" areas at either end of it such as those detailed in red in Figure 9.11, it may be worth applying the Levels command to remap or "reassign" the shadows (black) and highlights (white) in the photograph. If your Miner_restored.psd file is not still open, reopen it now, and reactivate its alpha channel, then again choose **Select>Inverse** to select everything except the miner car. The Levels command is available from the **Image>Adjustments** submenu as a permanent command, and as a nondestructive adjustment layer when chosen from the Adjustments panel.

Let's choose to add one as an adjustment layer by either clicking its icon or by selecting it from the Adjustments panel menu as shown in Figure 9.13.

Once the Levels adjustment layer is applied, in the Properties panel, we can immediately see that it provides more choices than the Brightness/Contrast command does. With our new knowledge of the Histogram panel, we can also see that the Levels command contains its own

FIGURE 9.13 Choosing to apply a Levels adjustment layer from the Adjustments panel.

histogram built in, and that for the Miner_restored.psd file, it shows that the tonal range does not span edge to edge of its histogram. We can see that the Levels command also contains some presets that can be selected from its Preset pop-up menu at the top of the Properties panel shown in Figure 9.14.

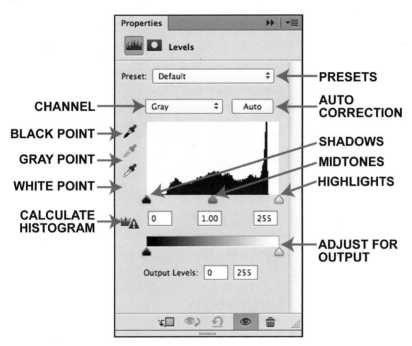

FIGURE 9.14 Properties panel when the Levels command is applied as an adjustment layer.

To help understand how this command works, let's select its Increase Contrast 2 preset, watching both how the image contrast improves, and how its histogram updates. Now, let's choose its Increase Contrast 3 preset, and notice that instead of moving *closer* to the activity of the graph as the Increase Contrast 2 preset did, it moves the shadows and highlight triangles almost right *to its edges:* just what we want. Notice that simultaneously, the photograph has now been significantly improved.

Let's click the Revert icon at the bottom of the Properties panel, and instead choose to correct the image by manually selecting the shadows triangle below the Lev-

FIGURE 9.15 Manually assigning Levels adjustments.

els histogram and dragging it to the right, to the beginning of the vertical bars of the graph, then selecting the highlights triangle and dragging it left to align with the end of the vertical bars of the graph. Once we have done that, let's drag the midtones triangle as needed, to reassign the midtones once the rest of the tonal range has been redefined as suggested in Figure 9.15: Shadows 29, Midtones 1.09, Highlights 236.

> **Note**
>
> The Levels Calculate Histogram icon shown in Figure 9.14 will recalculate the histogram and update its display of the bit data. When it is visible, this warning icon indicates that the current histogram may not be the most accurate bit data display. When you single-click on it, the histogram is updated, and the warning icon disappears. Additionally, when an image is printed (output), if its highlights or shadows seem to have been lost, the Levels Output slider will allow you to reduce the gamma range to accommodate your printer if needed. These output sliders should *only* be adjusted after a test print clearly indicates that the image's highlights and/or shadows are out of gamma for your printer.

Alternatively, its black point and white point eyedroppers can be used, if desired, to click within the photograph itself to reset the "darkest" spot (black point: click on what should be black in the image) and "lightest" spot (white point: click on what should be white in the image), to reassign the parameters of its histogram (its gray point eyedropper will be unavailable until we are working with a color photograph).

When exploring the Levels command, it will be important to try each of its methods of remapping the contrast of a photograph. Although one particular procedure will quickly become your favorite, you will be able

to try employing a different option, or a combination of options, when your favorite method alone may not yield the best results.

*The Levels command also provides an Auto button, whether chosen from the **Image>Adjustments** submenu, or as an adjustment layer (in earlier versions it may be listed as Auto Levels under the Image main menu). Like the Auto Tone and Auto Contrast commands, when clicked, Photoshop will assign the levels correction "automatically." However, when the result is not perfect, this feature can be a great first step that can be followed by further manual Levels adjustments, if more customization is required.*

Once you are satisfied with the contrast adjustments you have made, the Levels adjustment layer can be merged down. The alpha channel can also be deleted, and the file saved and closed. However, want to perfect it first? When examined closely, we can see that the Miner_restored.psd file has a few surface blemishes. Feel free to use your repair expertise to remove them before saving and closing the file, being sure that you select its Background layer to begin its repairs.

9.4.5 Applying the Curves Command to Grayscale Photographs

Let's open the Currier.jpg photograph provided in the Chapter 9 Files folder to learn to use the Curves command. In continuing to reinforce good work habits, save it first as Currier_original.psd, then as a working copy named Currier_enhanced.psd into your Photoshop practice folder. The Curves command can also be chosen either from the **Image>Adjustments** submenu as a permanent alteration, or as an adjustment layer accessible either from the Adjustments panel by selecting its icon, or by choosing it from the Adjustments panel menu as shown in Figure 9.16, or by clicking on the Create a new fill or adjustment layer icon at the bottom of

FIGURE 9.16 Choosing to apply a Curves adjustment layer.

the Layers panel, or from the Layers menu by selecting New Adjustment Layer. Before choosing it however, let's study its icon in the Adjustments panel, outlined in red in Figure 9.16. Notice that its shape resembles the letter "S," which reflects a typical adjustment "curve" often applied using the Curves command to improve the tones in a photograph. Always wanting the flexibility and "forgive-ability" of adjustment layers, we will choose to add the Curves command also as one, using any one of the methods you have learned.

When the Curves adjustment layer Properties panel opens, its diagonal line contains no points on it, and no change appears in the photograph, until points are added on its line and moved to create a "curve." In Figure 9.17, we can see that its graph displays a black triangle representing shadows, and a white triangle to represent highlights, just as the Levels command does.

> **Note**
>
> By default, when working in grayscale, the Curves command displays its white triangle on the left, and black triangle on the right. To make its appearance echo what we have just learned when using the Levels command, Curves Display Options can be chosen in the Curves command dialog box by clicking on its Options button if chosen from the **Image>Adjustments** submenu, or from the Properties panel menu once a Curves adjustment layer has been applied. Once this dialog box is open, when Light (0-255) is selected from its Show Amount of option, the graph will convert to match the sample shown in Figure 9.17.

FIGURE 9.17 Curves adjustment layer Properties panel and Curves Display Options dialog box.

When the Curves adjustment layer is active, we can see that some of its available options replicate those of the Levels command: black, gray, and white eyedroppers; a variety of presets; its own histogram; and an Auto option. However, unlike the Levels command, which allows adjustments only to its shadows, midtones, and highlights, the Curves command allows the assignment of up to 16 possible individual tonal adjustment points. We can see that it also provides a hand icon similar to the one provided when using the Black & White command. Adjustment points are added to the graph by either clicking directly on the graph with the mouse, or if the hand icon is selected first, when clicked within the image, a corresponding point will be added within the graph.

Note

In addition to its hand icon, the Curves command additionally provides the ability to draw a custom tonal curve, or modify an existing curve by clicking and dragging within its graph using its "pencil" icon.

In the Properties panel, once points have been added to a Curves graph, they can be individually selected to move each one up/down/left/right within the graph, adjusting the tones relative to the direction dragged.

 In addition to clicking within the image to add points to the graph, the hand icon can also be used to drag within the image to adjust points on its graph. However, when using either the hand icon, its pencil icon, or manually dragging a point, caution must be used when moving existing points on a Curves command graph: slight adjustments in its curve can quickly become major changes in the photograph. When a point in a Curves graph is selected, it may be more helpful to adjust it by pressing the left/right/up/down corresponding arrow keys on the keyboard to make the adjustment with more precision and better control.

To delete an existing point, select the point, and then click the Backspace/Delete key. When first learning, it will be helpful to begin by selecting a preset (such as Medium Contrast), and watching how the graph updates. Notice once this is chosen that the graph's curve now resembles the letter "S." However, let's increase its contrast even more now by further customizing this Curves adjustment. In addition to manually moving existing points, when a particular point has been selected, it can also be adjusted by highlighting and changing its Input and Output values as shown in Figure 9.18. When adjusting one of the points, note whether you are changing its Input or its Output value. In CS6, the Input field has been switched and now displays on the left below the graph.

Let's choose to enter the values shown in Figure 9.18 by first selecting the lower left point and changing its Input value from 73 to 76 and its Output value from 56 to 41. Now let's select the remaining point and change its Input value from 163 to 169 and its Output value from 164 to 174. Once these values have been entered and the changes in the photograph observed, let's save and close this file for now.

FIGURE 9.18 Customizing the curve of a Curves preset adjustment.

9.4.5.1 Adjusting the Midtone Range of a Grayscale Photograph Using the Curves Command

Many times a photograph's contrast can be significantly improved using a simple one point midtone Curves adjustment. Let's reopen the Restaurant Kitchen_restored.psd file that we created an alpha channel for in Chapter Three, duplicated its Background layer in Chapter Four, and repaired its damage in Chapter Seven. With this photograph's duplicated repaired Background layer active, let's choose to load its alpha channel, then select everything except the floor (**Select>Inverse**). Once we have done that, let's now apply a Curves adjustment layer. Once applied, in the Properties panel, press directly on the point where the diagonal of the curve intersects the center of the grid, then slowly drag down, following the intersection of the grid lines, until the contrast has been satisfactorily improved: a quick, easy fix, and oftentimes very effective, as detailed in Figure 9.19.

When you are satisfied with your contrast adjustment, save and close the file.

> **Note**
>
> To drag *down* to increase the midtone contrast when using the Curves command as shown in Figure 9.17, the Curves Display Options must be set to Light (0–255). If it is set to Pigment Ink % instead, you will need to drag diagonally *up* following the graph to achieve the same type of contrast adjustment results. Whenever settings are assigned for the Curves command in this text, they will be assigned with the Curves Display Options set to Light (0–255).

9.5 Applying Adjustment Layers When Using the Layer via Copy Command

In Chapter Seven, we learned that one way to repair severe damage to a photograph was to use the Layer via Copy command. When using this command to repair areas of the Fire truck_restored.psd photograph, some of the copied layers may have been slightly lighter or darker than the area around them, once they were moved over the damage they were created to cover. At that time, any layers that were not a perfect color match were saved into a group with the file, instead of being merged down. Let's reopen the file now and delete the group (folder only by choosing Group Only when deleting). Any extra layers saved with the file can now be adjusted to match their surrounding content using one of the methods we have learned, oftentimes requiring only a simple midtones Curves adjustment similar to the one shown in Figure 9.19. However, before adjusting these layers, the photograph should be converted to grayscale by either choosing **Image>Mode>Grayscale** (without flattening), or by adding a Black & White or Channel Mixer adjustment layer *above all* of its existing repair layers and choosing *not* to merge it down until all individual layer corrections are made, as shown in the left sample of Figure 9.20. By default, adjustment layers affect all

layers below them. To be sure an adjustment layer affects *only* the specific repair layer it is intended to correct, the adjustment layer must be "clipped." To do this, once an adjustment layer is added directly above the specific layer it is intended to affect, before assigning any settings to it, the Clip to layer icon is clicked at the bottom of the Properties panel. Once this has been done, the adjustment layer's icon becomes indented, and an arrow appears pointing to the layer directly below it in the Lay-

FIGURE 9.19 Applying a simple Curves midpoint adjustment.

ers panel, indicating that the adjustment will affect *only* that layer, not *all* of the layers below it.

The Clip to layer feature can also be easily applied by holding down the Alt/Option key while clicking between the adjustment layer and the layer directly below it that you want it clipped to affect.

In Figure 9.20, its sample on the right details the additional application of two Curves adjustment layers, with the Clip to layer option applied to each one to restrict its adjustment to affect only the layer directly below it. Once any existing mismatched layers of your Fire truck_restored.psd image have been adjusted, all layers should be merged, and its mode converted to grayscale, if you chose not to convert it before adjusting the tones of the individual repair layers. Once the file has been flattened, before saving and closing the file, it can be optionally further enhanced by adding a basic

Curves midtone adjustment (such as an Input setting of 142 and an Output setting of 114) to improve the overall tonal quality of the photograph.

 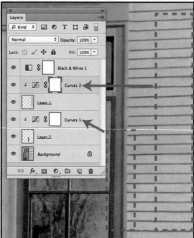

FIGURE 9.20 Applying the Clip to layer option to restrict the effects of an adjustment layer.

> **Note**
>
> Multiple adjustment layers can be applied to the entire image, or clipped to apply them to only specific layers whether they are all of the same type, or a variety of *different* types. If the effect of a particular adjustment layer requires a selection so that its correction will not affect the entire layer below it, the selection must be made prior to the application of the adjustment layer.

9.6 Eliminating Stains and Isolated Discoloration in Grayscale Photographs

In Chapter Eight, we repaired the damage to a photograph named J-Restaurant_restored.psd. At that time, we observed that it contained some stained areas in addition to its overall yellowed appearance. Many times, these types of correction challenges will be resolved automatically when the image is converted to

grayscale as shown in Figure 9.21 which compares a section of the original image after its damage had been repaired and the exact same area once it had been converted to grayscale. As we can see, with no additional tonal adjustments required, the stains became indistinguishable once the conversion to grayscale was applied.

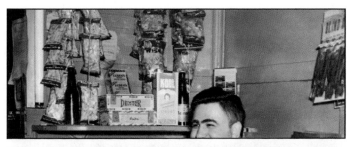

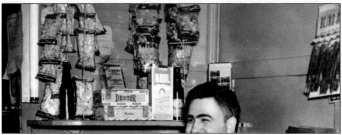

FIGURE 9.21 Stained photograph before and after its conversion to grayscale.

If once converted to grayscale, a photograph still contains a discolored area that does not become indistinguishable after its conversion, a selection can be made of the area and a small feather applied to the selection or a new layer made of the selection, and then the area can be corrected independently of the rest of the photo using any of the techniques learned. It will seamlessly blend it in with its surrounding content, just as the repair layers shown in Figure 9.20 were adjusted.

9.7 Applying Tonal Adjustments to Color Photographs

Now with a solid foundation in the use of the Auto Tone, Auto Contrast, Brightness/Contrast, Levels, and

Curves commands on grayscale images, let's learn how to apply these same commands, as well as additional ones both independently and in combination, to correct lighting, contrast, and discoloration in color photographs.

9.7.1 Applying the Auto Tone/Auto Contrast Commands to Color Photographs

We have learned that the Auto Tone and Auto Contrast commands located under the Image menu (in version CS3 and earlier under the **Image>Adjustments** submenu) can be helpful when applying a quick tonal adjustment to a grayscale photograph. These commands can also be helpful at times with color images as well.

on the DVD
Open the Sailboat.jpg image provided in the Chapter 9 Files folder, and save it first as Sailboat_original. psd then as a working copy named Sailboat_auto.psd into your Photoshop practice folder. Let's begin by selecting the Auto Tone command, to significantly improve the image with a single click. Now let's revert back in the History panel to the opening state, and instead apply the Auto Contrast command. As we can see, using either command, the image is substantially improved. Let's save this Auto Contrast version, and then close this file for now. We will return to it and compare these results with a lightness adjustment applied through a different command later.

9.7.2 Applying the Brightness/Contrast Command to Color Photographs

Let's open the Butterfly.jpg file provided in the Chapter 9 Files folder which contains an overall dark appearance: perfect for the Brightness/Contrast command. Choose to save it first as Butterfly_original.psd, then as a working copy named Butterfly_enhanced.psd into your Photoshop practice folder. We have already learned that this command can be applied from the **Image>Adjustments** submenu, or as a nondestruc-

tive adjustment layer which is what we want. Once the Brightness/Contrast adjustment layer has been added, in the Properties panel, let's adjust its Brightness slider to the right to lighten the photograph. Now, experiment by dragging its Contrast slider first to the left to reduce the contrast, and then to the right to add more contrast along with the brightness. Sometimes a photograph needs either only brightness or only contrast, but oftentimes will benefit by the application of both. With little work, this photo is now significantly more appealing after the application of a Brightness setting of 79 and a Contrast setting of 29, as shown in Figure 9.22.

FIGURE 9.22 Applying the Brightness/Contrast command to a color photograph.

Let's save and close this file, and move on to adjusting lighting and contrast in color photographs using the Levels command.

9.7.3 Applying the Levels Command to Color Photographs

Although the Sailboat_auto.psd photograph we worked with earlier became significantly improved by applying either the Auto Tone or Auto Contrast commands, let's re-open our Sailboat_original.psd file to instead improve this photograph using the Levels command. Once it is open, let's rename the file Sailboat_levels.psd. When we add a Levels adjustment layer to this file, in the Properties panel, we can immediately recognize in its histogram that its white point needs to be reassigned. Just as we learned when working with grayscale photographs, this can be done by either using its white point eyedropper and selecting a white area such as one of its clouds, or by manually dragging its highlights triangle to the left to where the activity of the graph ends, as shown in Figure 9.23.

FIGURE 9.23 Manually adjusting the Levels histogram to correct lighting in a color photograph.

Before saving and closing this file, let's reopen our Sailboat_auto.psd file, and arrange these documents to compare the two correction results. As we can see in Figure 9.24, by manually applying the Levels command versus applying the Auto Contrast command, the photograph's contrast is more noticeably improved. Once we have done that, let's save and close both copies of this file.

FIGURE 9.24 Comparing lighting adjusted using the Auto Contrast command versus manually applied using the Levels command.

Is the improvement achieved using the Levels command significant enough to *never* use either the Auto Tone or the Auto Contrast commands when working with color images? Every photograph will be different. In your own work, you may find that the one click application of the Auto Tone or Auto Contrast command is worth trying first as it is often times quite effective, and when not, a more customizable color correction command can be applied instead, or in addition to the auto option.

Note

Although preset for an average correction, the default auto setting used in the Levels command, the Curves command, as well as the Auto Tone, Auto Contrast, and Auto Color commands can be changed. When either a Levels or Curves adjustment layer is active, if Auto Options is selected from the Properties panel menu or Options is selected in the dialog box when the command is chosen from the **Image>Adjustment** submenu, a higher or lower percentage than the 0.10% default setting can be chosen to define how the shadows and highlights will be adjusted when its auto option is assigned. If a change to these settings is desired, the setting should be limited to between 0.0% and 1%. If one is made, and the Save as defaults button is then checked, the new settings will apply to all commands that provide an "auto" option (Levels, Curves, Auto Tone, Auto Contrast, and Auto Color). However, if the Photoshop preferences are reset, these settings will revert back to the defaults of Shadows: 0.10% and Highlights: 0.10%.

9.7.3.1 *Applying the Levels Command to Selections*

In Chapter Three, we saved two selections as alpha channels in the Covered Bridge_enhanced.psd file: the entrance to the bridge and the stone support beneath the bridge. These channels were saved to allow us to independently improve the lighting in these areas, as the rest of the photograph contains great color and contrast, except for its guardrails, which we painted in Chapter Six to give them a more rustic appearance. Let's reopen this file now, and select its Background layer, not

its painted rails layer. Once the Background layer is selected, let's make the "bridge entrance" alpha channel active, and then choose to add a Levels adjustment layer. The entrance is currently so dark that we cannot see any of its interior structural details. However, if this area is lightened too much, it will no longer appear natural. As we can see in Figure 9.25, by dragging only its highlight triangle to the left to a setting of 144, more interior details are exposed yet the entrance still looks natural.

FIGURE 9.25 Applying a Levels adjustment layer to the bridge entrance selection.

Once satisfied with the entrance, let's now load the alpha channel of the stone area below the bridge to make its selection active, and then apply another Levels adjustment layer. This area should be lightened just enough to allow more of the details of the rocks to be visible, yet still darker than the rocks to the right of it that are not under the bridge, so that the shadow created by the bridge above it will still appear natural. To achieve that effect, let's drag its highlight triangle to the left to a setting of 182 as shown in Figure 9.26.

FIGURE 9.26 Adjusting the Levels of the stone area selection.

Note

Even though the stone area Levels adjustment layer (Levels 2) was placed above the Levels adjustment layer used to correct the entrance (Levels 1) as shown in Figure 9.26, we can see that its adjustment does not also further affect the entrance adjustment layer below it. When an adjustment layer is linked to a mask (by selecting an area to modify first with the default setting of Add Mask by Default active), only the selection is affected.

9.7.4 Applying the Curves Command to Color Photographs

Just as we saw that the effects of the Curves command were similar to those achieved with the Levels command for lighting and contrast when working in grayscale, we will oftentimes achieve similar results when using the Curves command versus the Levels command when working in color. If the Sailboat_original.

psd file is reopened, and this time a Curves adjustment layer is applied to it, in the Properties panel when its white eyedropper is single-clicked on one of its clouds, the photograph is corrected with results comparable to those achieved using the Levels command.

DVD Sometimes however, because of the flexibility of choosing *where* on a Curves graph you want to make adjustment(s), the Curves command may better serve the specific tonal correction range needed within an image. Let's explore this additional Curves flexibility by opening the Light rocks.jpg image provided in the Chapter 9 Files folder. As usual, save it first as Light rocks_original.psd, then as a working copy named Light rocks_enhanced.psd into your Photoshop practice folder. When either the Auto Tone or Auto Contrast command is applied to it, little improvement appears in the photograph. When we study the Histogram panel, we can see that it lacks intensity of bit data in its shadows. Therefore, if a Levels adjustment layer is applied, and its shadows adjusted, the image is improved. However, let's choose to adjust it instead using a Curves adjustment layer, which will allow us to target a more specific area of its midtones.

> **Note**
>
> When working in color, the Histogram panel provides additional pop-up menu options when in Expanded View, and from its panel menu, for viewing its channels both singularly and collectively, and for displaying them in color rather than in black and white.

Once a Curves adjustment layer has been applied to this photograph, let's select its hand icon, and click on the approximate area of the rocks shown in Figure 9.27.

With the point added to the graph in the Properties panel, click again on the hand icon to deselect it, then reselect the point added to the graph. It will be help-

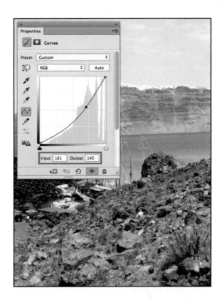

FIGURE 9.27 Using the Curves On-image hand tool to select an area within the photograph for adjustment.

FIGURE 9.28 Reassigning a selected Curves adjustment point in the Properties panel.

ful to use the up/down/left/right arrow keys on the keyboard to move the point in various directions, and observe how the image gradually changes with the point's movement. Once you have experimented with it, choose your own setting, or one similar to the sample shown in Figure 9.28, or highlight the Input setting and change it to 181, then highlight the Output setting and change it to 140.

When any type of adjustment layer is applied, its layer Opacity setting can be reduced in the Layers panel, providing even more flexibility to its adjustment capabilities. This can be particularly useful when working with the Curves command due to the sensitivity of its adjustment points. In the sample shown in Figure 9.29, the image has been overly adjusted, however, it still appears effective because its Curves adjustment layer's Opacity setting has been reduced to 77%.

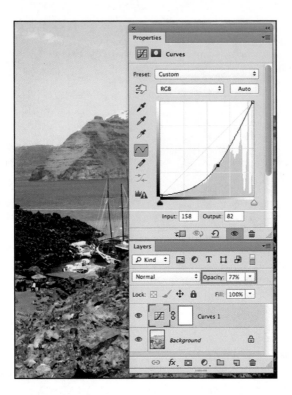

FIGURE 9.29 Lowering the opacity of an adjustment layer.

9.8 Adjusting Shadows and Highlights

Sometimes a photograph contains either excessively dark shadows, washed out highlights, or both, and would therefore not benefit as well from any of the correction commands we have learned thus far. Although we will apply the Shadows/Highlights command to a color photograph, it works equally well with grayscale images. In Chapter Three, we saved a file we named Egyptian Columns_enhanced.psd, with its columns saved as a selection into an alpha channel, isolating the columns from the sky in the photograph, as the sky did not need any correction. Let's reopen this file now, and load its selection. (Remember to click OK to convert its color profile to the Adobe RGB (1998) color space if you have chosen to be asked.) When we study this photo-

graph closely, we can see that its shadows are so dark that all detail is lost, and that its column details have been almost completely washed out in the bright sun areas. These types of lighting issues are ideally suited for correction using the Shadows/Highlights command, one of the correction commands available only from the **Image>Adjustments** submenu. Because this command is not also available as an adjustment layer, let's duplicate this photograph's Background layer first, before making any changes to the image. Once we have done that, with its duplicated layer and its selection active, let's choose **Image>Adjustments>Shadows/Highlights.** We can see when its dialog box opens, that it provides individual sliders to adjust the image's shadows, highlights, or both. Let's drag its Shadows slider to the right, while observing the shadows on the left side of the image. As its amount is increased, the overly dark shadows are lessened, allowing more of the columns' details to be visible. Now, let's drag its Highlights slider to the right, noting that as its amount slider is increased, its excessive "washed out" appearance becomes reduced, once again allowing more of the details on the columns to display. This dialog box also includes a Show More Options alternative, which when checked provides additional sliders for further customization. When we deselect our selection and hide its duplicated layer with this adjustment applied and then make it visible again, we can see that even when using only its standard options and assigning Shadows 45% and Highlights 32% as shown in Figure 9.30, the details on its columns are significantly more dis-tinguishable. When satis-

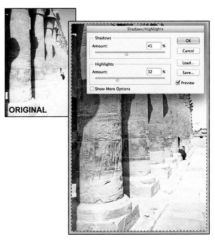

FIGURE 9.30 Egyptian columns photograph with shadows and highlights improved.

fied with the adjustments made to the duplicated layer, the layer should be merged down.

> ### Note
>
> Because we duplicated the Background layer prior to adding this adjustment command, we can delete its effect if necessary, as well as show/hide it to analyze its efficacy, but once its settings are applied, we cannot readjust them, as we are able to do when using commands applied as adjustment layers. However, if the layer that the Shadows/Highlights command will be applied to is converted to a Smart Object first, when the adjustment command is chosen, it will instead be applied automatically as a Smart Filter, allowing us to return to its *original* dialog box to readjust it at any time. Any layer (including a Background layer) can be converted to a Smart Object by Right/Control clicking the layer and choosing Convert to Smart Object from the context-sensitive menu that appears, or by selecting the layer, then choosing Convert to Smart Object from the Layers panel menu, or by choosing **Layer>Smart Objects>Convert to Smart Object.** Figure 9.31 details the conversion of this image's Background layer into a Smart Object (identified by the small "page" icon added to its layer thumbnail), with the Shadows/Highlights command applied as a Smart Filter. As a Smart Filter, when the Shadows/Highlights Smart Filter name is double-clicked in the Layers panel, the Shadows/Highlights dialog box reopens allowing its settings to be adjusted as needed.
>
> Smart Filter adjustments become permanently applied when a Smart Object is converted back to a regular layer by Right/Control clicking the layer and choosing Rasterize Layer from the context-sensitive menu that appears, or by choosing **Layer>Rasterize>Smart Object,** or by choosing **Layer>Smart Objects>Rasterize**.

Feel free to back up in the History panel and apply this correction as a Smart Filter instead, then save and close the file.

9.9 Correcting an Overall Color Cast

In our work with lighting and contrast, we explored an assortment of correction commands ranging from ba-

FIGURE 9.31 Background layer converted to a Smart Object with the Shadows/Highlights command applied as a Smart Filter.

sic to more complex. When learning color cast removal, we will also examine a variety of color correction commands with varying degrees of complexity (Auto Color, Color Balance, how the Levels and Curves commands can also be used for color cast removal, and learn how to combine commands when necessary to further improve a photograph's color).

Definition

Color Cast: When an image is dominated by an overall tint of one color that negatively shifts all the rest of its colors towards it, the photograph is described as having a color cast.

9.9.1 Correcting a Color Cast Using the Auto Color Command

Let's begin our color cast correction by opening the Sidney.jpg file provided in the Chapter 9 Files folder. As usual, save it first as Sidney_original.psd, then as a

on the DVD

FIGURE 9.32 Applying the Auto Color command.

working copy named Sidney_enhanced.psd into your Photoshop practice folder. When this image opens, although the entire image contains an overall reddish tint, it is most noticeable on the side of the Opera House, and in the reflection of it in the water. Let's learn to correct this photograph first using the Auto Color command. Like the Auto Tone and Auto Contrast commands, the Auto Color command is only available from the Image menu by choosing **Image>Auto Color** (in version CS3 and earlier from the **Image>Adjustments** submenu). When chosen, it applies default correction settings that can also be changed in the Levels or Curves command dialog boxes, just as the Auto Tone and Auto Contrast commands can. When applied to this photo using the default preference settings, its color is improved as shown in Figure 9.32. However, when examined closely, it appears to have "over-corrected," as the photograph now contains a slight, but still visible color cast, this time of green.

How was the Sidney_enhanced.psd photograph corrected using the Auto Color adjustment? Why does it now have a slight green color cast? Let's save and close this file for now, and learn a little color theory that will help us to better understand how to correct a color cast in our work.

9.9.2 Color Theory Basics

In a traditional 12 hue color wheel used for pigments, when a color is combined with its opposite or comple-

ment (the color directly across from it on the wheel such as red to green), the two colors neutralize each other. When working with RGB colors defined as "additive" colors, the concept is similar. When a particular color dominates an image, or a selection within an image, if some of its "opposite" or "complement" color is added,

FIGURE 9.33 Comparing a traditional color wheel with one displaying the RGB additive colors.

the effect of the dominant color is reduced. In Figure 9.33, a traditional color wheel is compared to the relationship of the RGB additive colors' "wheel," with one of its complementary color sets (red/green) further outlined in white.

If the original Sydney photograph is reopened and examined more closely, we can see that its color cast is actually a magenta hue rather than a red one: to correct it, green is used (its "additive color complement") to adjust or "neutralize" its magenta cast.

Note

If your version of Photoshop contains the Variations Command located under its **Image>Adjustments** submenu, this easy to use dialog box will provide a sample of the open photograph with each of the available RGB colors shown in Figure 9.33 individually applied to it. In version CS5, when working in Mac OS this command is only available in 32 bit mode, and has been deleted from both platform versions in CS6. If your version of Photoshop contains it, to apply it, simply click the preview of the desired improved color. When you do that, its Current Pick preview updates to show how the color you selected will improve the photograph. If you are using this command, it will be helpful to lower the amount of application each click will provide by dragging its Fine/Coarse slider one notch to the left of its default center location.

9.9.3 Correcting a Color Cast Using the Color Balance Command

Now that we have a solid understanding of how a color's complement or opposite can help neutralize its color cast, the Color Balance command will be easy to understand and easy to use.

on the DVD　Let's open the Koala.jpg file provided in the Chapter 9 Files folder, saving it first as Koala_original.psd, then as a working copy named Koala_enhanced.psd into your Photoshop practice folder. We can see when this image opens that unlike the magenta color cast of the Sydney.jpg file, this photograph's color cast is distinctly more red. Let's learn to remove it using the Color Balance command. Available as both a permanent command from the **Image>Adjustments** submenu, and as a flexible nondestructive adjustment layer, let's select its icon in the Adjustments panel or from its panel menu, as shown in Figure 9.34.

FIGURE 9.34 Choosing to apply a Color Balance adjustment layer from the Adjustments panel.

When the Color Balance adjustment layer Properties panel opens, we can see that its sliders echo the complementary color relationships illustrated in Figure 9.33: Cyan/Red, Magenta/Green, and Yellow/Blue, with each of these sliders centered between its respective colors with an initial setting of "0," signifying "no adjustment." We can also see that it provides a Tone pop-up menu to select to affect either the image's Shadows, Midtones, or its Highlights, with its Midtones option chosen by default. When using the Color Balance command, although more than one of its sliders can be adjusted,

for this photograph, let's keep the default Tones setting of Midtones and drag its Cyan/Red slider to the left approximately −38 with its Magenta/Green and Yellow/Blue settings kept at 0. This adjustment shifts its colors from red towards cyan, effectively removing the cast as shown in Figure 9.35. However, before permanently assigning this adjustment setting, it will be helpful to move each slider in both directions to better understand the power of this command for color correction. Once you have done

FIGURE 9.35 Applying the Color Balance command to remove a color cast.

that, return the Magenta/Green and Yellow/Blue slider settings back to 0, and drag the Cyan/Red slider back to −38 (or enter the value in its setting box) to remove the cast, then save and close the file.

Now that we have learned to use the Color Balance command, let's reopen our Syndey_enhanced.psd file, and remove its slight green color cast. By adjusting its Magenta/Green slider as little as −8 and keeping its Cyan/Red and Yellow/Blue sliders set to 0, the green cast is removed, as shown in Figure 9.36. Feel free to adjust its Magenta/Green slider to −10 and to −6 to decide what works best for you, and to better understand how a *small* color balance adjustment can often times have a *major* impact on color cast correction.

When removing a color cast using the Color Balance command, how do you know when "enough is enough"? If any white or gray is visible in the photograph, watch as you drag one of its sliders, and stop when it becomes a "true white," or "true gray," not tinted slightly by either color of the slider being adjusted.

FIGURE 9.36 Correcting a slight green color cast.

9.9.4 Correcting a Color Cast Using the Levels Command

on the **DVD** We have already learned how powerful the Levels command can be for lighting and contrast. Let's now explore its options for removing a color cast by opening another photograph in the Chapter 9 Files folder named Market.jpg. As usual, save it first as Market_original. psd, then as a working copy named Market_enhanced. psd into your Photoshop practice folder. We can see when this photograph opens that it contains a strong red color cast. Let's begin by adding a Levels adjustment layer. When working with grayscale images, we learned that we could click the Levels' black and/or white point eyedroppers within the image to redefine its shadows and/or highlights respectively. We also learned that its gray point eyedropper is only accessible when working with a color photograph. The Levels command's gray point eyedropper can oftentimes be a quick, easy, and very effective one-click way to "neutralize" or "redefine" true gray in a color photograph. Let's try it. The trick to success is to find a spot within the photograph that definitely should be *true* gray, so that when it is redefined with the gray point eyedropper, all other colors will be shifted accordingly.

FIGURE 9.37 Using the gray point eyedropper to redefine true gray using the Levels command.

Let's select the gray point eyedropper in the Properties panel, then single-click on the gray umbrella on the location identified in Figure 9.37. With one click, the colors of the photograph are "reset" to match the new "true gray." The results of this technique are often amazingly successful, and many times produce a quick and accurate color cast removal. However, if desired, the image can also be further enhanced with the Levels command by adjusting its individual channels. When we press on its RGB pop-up menu, in addition to its RGB option, we can select each individual channel and tweak its histogram to further refine the color cast adjustment as shown in Figure 9.38. As indicated by the red arrows added to this figure, when the left slider of a specific channel is dragged to the beginning of the activity in its histogram, its excessive color is removed or "clipped" and the image color is improved.

Whether you stop once you have applied the gray point eyedropper to reset its gray point, or continue to refine its individual channels using its histogram, when you are satisfied with your correction of this photograph, save and close the file.

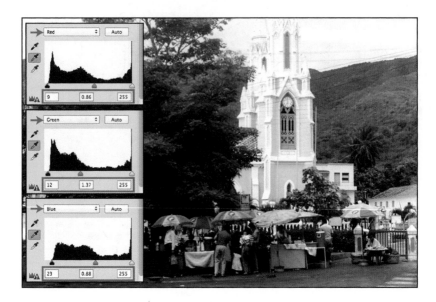

FIGURE 9.38 Adjusting individual channels using the Levels command.

9.9.5 Correcting a Color Cast Using the Curves Command

Just as we have learned that the Curves command has its own black, gray, and white point eyedroppers, when working in color, its gray point eyedropper can also be used to neutralize a color cast. In Chapter Three, we saved a photo as Rushmore_enhanced.psd with an alpha channel selection of its sky. Let's reopen this file being sure that its color profile is converted to the Adobe RGB (1998) color space when opening. Although its sky is washed out and will be separately enhanced in Chapter Eleven, the rest of the image suffers from a yellow color cast that we will correct using the Curves command. Because our work in this chapter will focus on its color cast not its sky for now, it will not be necessary to activate its alpha channel. With our knowledge of complementary colors, we have learned that in photographs such as this one, its yellow cast can be neutralized with blue. Let's apply a Curves adjustment layer to this file to learn how one can be used to remove a color cast. In the Properties panel this time, let's select its gray point eyedropper, to

choose to redefine its "true gray" just as we were able to do when using the Levels command. We will begin by selecting the approximate area identified in Figure 9.39.

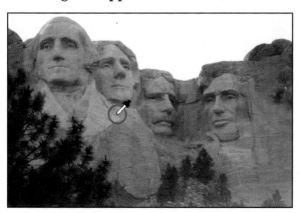

FIGURE 9.39 Using the gray point eyedropper to redefine true gray using the Curves command.

When using the gray point eyedropper of either the Levels or Curves command to adjust a color cast, it will be helpful to test a few gray areas and observe how the image changes. For example, if you experiment with the Curves eyedropper on the Rushmore_enhanced. psd image, you will see the cast of the new gray will shift more or less towards its complement depending on the particular location you click. In your own work, if the first point you select using the Levels or Curves' eyedropper does not accurately neutralize its color cast, try clicking it on another gray area instead.

Once the major yellow cast has been removed, the image now suffers from a slight blue cast. Like the Levels command, the Curves command also provides the option to select and adjust the curve of each·channel individually in addition to its RGB channel. When its Blue channel is selected and its curve point activated, the point can be carefully moved using the arrow keys to further tweak the color of the rocks, or its Input and Output point values reassigned with suggested settings of Input 104 and Output 115 as shown in Figure 9.40.

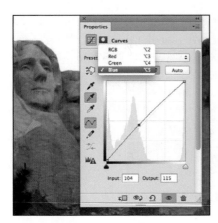

FIGURE 9.40 Adjusting the color of an individual channel when using the Curves command.

Once this correction has been made, let's choose to merge this adjustment layer down. The color cast should now be successfully removed, except for the bottom edge of the photograph, adjacent to the large tree on the left. Let's save and close this image for now, we will learn how to apply a tool to correct a small area such as this later in this chapter.

Sometimes a quick color cast fix can be made using the Curves command by selecting the particular channel that is causing the cast in the Curves dialog box, and simply dragging its top right end point of the graph straight down slightly to remove some of its color within the image. Figure 9.41 exemplifies this click tip applied to the Koala.jpg file using a Curves adjustment layer instead of using the Color Balance command.

FIGURE 9.41 Manually adjusting the end point of a channel when using the Curves command to remove a color cast.

9.10 Correcting Saturation in a Color Photograph

Sometimes a photograph may have great color balance but may have been taken on a hazy or sunless day, resulting in colors that appear dull and lack vibrancy. Sometimes an image's colors are true, but are *overly* saturated appearing almost cartoon-like in their brilliance. Both of these photograph maladies can be easily enhanced by employing the Hue/Saturation command.

Let's open the Saturation.jpg photograph provided **DVD** in the Chapter 9 Files folder to learn how to adjust the saturation of a photograph. Begin by saving it first as Saturation_original.psd then as a working copy named Saturation_enhanced.psd into your Photoshop practice folder.

The Hue/Saturation command can be applied both as a permanent command located under the **Image>Adjustments** submenu, or as a flexible, non-destructive adjustment layer, which is what we want. Let's choose to add a Hue/Saturation adjustment layer by choosing its icon in the Adjustments panel, or from its panel menu as shown in Figure 9.42.

When the Hue/Saturation Properties panel opens, we can see that this command contains three adjustments. At this time, we will work with its Saturation option. When this slider is dragged to the left, or a negative value is typed in its setting box, the image's saturation is decreased versus when the slider is moved to the

FIGURE 9.42 Choosing to apply a Hue/Saturation adjustment layer.

right, or a positive value is assigned, its saturation is increased. Let's take the "fluorescent" appearance out of the colors in this photograph by adjusting its Saturation slider to −46 and keeping its Hue and Lightness settings at 0 as shown in Figure 9.43.

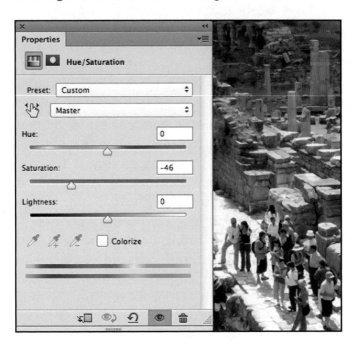

FIGURE 9.43 Adjusting the saturation of an image using the Hue/Saturation command.

How much saturation do you need to subtract when an image appears "over-saturated"? If there are people in the image, study their skin color and adjust as needed until their skin appears normal. If there are no people, look for a subject within the photograph that you recognize as clearly oversaturated, and then use that as your benchmark. Oftentimes beginning with a setting of Saturation −20, followed by subtracting or adding to that initial value as needed, will work great. Always be mindful however, that if too much saturation is removed, the image's colors will begin to loose their hue and start to turn gray. When the saturation slider is dragged to its left endpoint, indicated by a value of −100, all color is removed from the image.

9.11 Replacing Color

Sometimes a photograph may not contain an overall color cast, it simply has an area of color that you would like to change or enhance. Depending on the size and degree of change required, it can be adjusted by using the Replace Color command, the Hue/Saturation command, or the Color Replacement tool.

9.11.1 Replacing Color Using the Replace Color Command

In Chapter Four, we saved a file named Two gondolas_enhanced.psd in which we added a second copy of the gondola to improve its composition and interest. Let's re-open this image and this time, study its color. Remember that it will need to be converted to the Adobe RGB (1998) color space when opening it. Once it is open, we can see that overall, its colors are great except that the water in the canal of the Background layer appears more yellow than blue which gives us a false impression that the canal is dirty and/or polluted. Let's choose to enhance this photograph by adjusting this color using the Replace Color command. This command is only available as a permanent application by choosing **Image>Adjustments>Replace Color.** Because of that, let's choose first to duplicate its Background layer, not its single gondola layer, to correct its water area, yet have the flexibility to delete the layer and start over later, if needed. With its duplicated Background layer active, before applying this command, let's select just the water within the photograph using any method(s) of your choice. When a selection is made first, the Replace Color command will be restricted to affect colors only within the selection area, rather than the entire photograph. With this selection active, let's choose **Image>Adjustments>Replace Color** to open its dialog box. When it opens, in its Selection category, its Selection preview radio button will be chosen by default. In

FIGURE 9.44 Adjusting color using the Replace Color command.

this mode, when its eyedropper is clicked either within its preview area of the dialog box, or clicked within the photograph, the selected area becomes highlighted. Let's choose its Image radio button instead, so that this preview will echo the image area when clicked. When its eyedropper is clicked either within this preview window, or clicked in the corresponding area of the actual photograph, its Color box reflects the selected color we want to change. It's Fuzziness setting can be thought of as a "fussiness" setting, as it will determine the range of pixel color variation from the selected color you want to effect. The higher the number, the "less fussy," or broader color range will be affected. In its Replacement category, Hue, Saturation, and Lightness sliders are provided, with its Hue slider allowing you to drag across its "color wheel" to select the desired replacement color. After using its eyedropper to select the color to adjust in the Image box first and assigning Fuzziness 187, feel free to experiment with a variety of settings, as well as try those shown in Figure 9.44 of Hue +166, Saturation −21, and Lightness −10.

Note

Because of this command's Fuzziness setting that defines the range of its application, it is not critical to have an exact selection of the area to affect, as long as the colors in the areas also included in the selection are different enough to not be recognized by its Fuzziness slider setting. As we can see in the sample provided in Figure 9.44, its selection encompasses part of the dock area, as well as part of the gondola on the selected layer, however because of the distinct difference in the colors in these areas compared to the color selected to replace, when the command is applied, these areas are not affected by it.

9.11.2 Replacing Color Using the Hue/Saturation Command

In addition to modifying saturation, the Hue/Saturation command can also be used to replace a color within an image with an alternate color. Let's choose to delete the duplicated Background layer of our Two gondolas_enhanced.psd file to instead improve the water's appearance using this command. Like the Replace Color command, when using the Hue/Saturation command for color replacement, when a selection is made first the color change will be limited to the selected area rather than the entire image. Let's select this photograph's canal water again, this time being careful to create an accurate selection of just the water area, so that it will be the only area of the image affected by our settings, and then choose to add a Hue/Saturation adjustment layer. As we can see in Figure 9.45, in the Properties panel, with its pop-up menu set to the default option of Master, when the Hue slider is dragged to the left or right from its original "0 change" center location, the selected area's color is altered, as shown in the color bar at the bottom of the panel. Notice that when using the Hue/Saturation command for color replacement, its saturation and lightness can also be adjusted as needed.

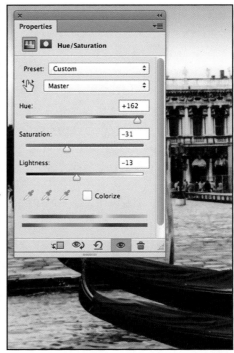

FIGURE 9.45 Using the Hue/Saturation command to replace color.

Feel free to experiment by creating a variety of combinations

of the Hue/Saturation/Lightness settings to your water selection first before assigning the ones shown in Figure 9.45 of Hue +162, Saturation −31, and Lightness −13, then save and close this file.

9.11.2.1 Using the Hue/Saturation Eyedroppers to Select an Area to Affect

The Hue/Saturation command can also be applied to an area selected by a sensitivity setting rather than by a marquee selection.

Let's open the Cactus.jpg image provided in the Chapter 9 Files folder to learn how this option of the Hue/Saturation command works. Once the file is open and a Hue/Saturation adjustment layer is applied to it, we can see that this command also contains a hand icon that can be used to click an area within the image to define the color to affect. Alternatively, a specific color can be chosen to affect from its Master pop-up menu, or by clicking its left eyedropper after any color other than the default Master option is selected from its pop-up menu first. When this is done prior to dragging the Hue slider left or right, there is no need to isolate an area of the photograph as a selection, the adjustment will be limited to the prechosen color, based on a sensitivity range predetermined by its plus and minus eyedroppers. Prior to dragging the hue slider, if its *plus* eyedropper is selected and dragged across an area in the photograph, its color bar at the bottom of the panel simultaneously widens, signifying that a broader range of colors will be affected by the hue adjustment. Conversely, when its *minus* eyedropper is selected and dragged within the desired color area in the image, the color bar at the bottom of the panel updates once again, this time becoming narrower to indicate that the area that will be affected by the color adjustment will be reduced. When the hue slider is then dragged left or right to shift the selected color, more or less of the image will

be affected by the range defined first by the plus or minus eyedropper as shown in Figure 9.46.

ORIGINAL RANGE RANGE EXPANDED RANGE REDUCED

FIGURE 9.46 Using the Hue/Saturation command eyedroppers to define a range for hue adjustment.

When dragging the plus or minus eyedroppers to reassign the color range to affect, if the dark gray range bar between the two color spectrums at the bottom of the panel does not expand or reduce as much as desired, its width can be manually adjusted as needed. After applying either the plus or minus eyedropper, before dragging the Hue slider, place the mouse on the lighter gray bars located to the left and right of the dark gray range bar, then press and drag them individually to further shrink or expand the width of area to affect as needed. Its small white squares (triangles in CS5) can be dragged to customize the transition of the adjusted color to a color not affected by it.

Let's explore various Hue/Saturation color and range settings using the Cactus.jpg file such as the settings shown in Figure 9.46, noticing the width of the slider relative to the amount of color shift when the same −123 Hue adjustment is made in the Range Expanded versus Range Reduced samples, then close this file without saving the changes.

9.12 Using Tools to Correct Lighting and Discoloration

When small areas of a photograph require lighting or discoloration adjustments, or areas that may be difficult to isolate with a selection, sometimes the correction may be achieved more easily by using a tool, rather than a command. Four tools in the Tools panel (the Color Replacement tool, the Dodge tool, the Burn tool, and the Sponge tool) all allow us to "paint" enhancements directly on the image, without having to apply these types of adjustments as commands.

9.12.1 Replacing Color Using the Color Replacement Tool

In Chapter Six, using the Stonehenge photograph, we learned that we could create a new layer, and use a brush to paint over the grass to hide some of its burnt out areas. It was important when painting for us to set the opacity of the brush at a low percentage, so that as the color was applied, the textural quality of the grass remained in tact. Rather than painting on a separate layer, the Color Replacement tool brushes color directly onto the layer you want to affect, converting the color you paint over to the color you paint with while *retaining* the textural details of the area being covered.

Let's reopen the Stonehenge_enhanced.psd file we saved in Chapter Six, remembering to convert its profile to the Adobe RGB (1998) color space when opening it. Once it is open, when we examine its stones, we can see that they contain a blue cast in some areas. Because the cast is not over the entire photograph, and not

FIGURE 9.47 Choosing the Color Replacement tool from the Tools panel.

even over *all* areas of the stones, this image is an ideal candidate for the Color Replacement tool. The Color Replacement tool is grouped with the Brush tool in the Tools panel, as shown in Figure 9.47.

Once it has been selected, the Options bar updates to reflect its features. In addition to brush settings of Size and Hardness, it provides four Mode settings, with Color chosen as the default option. Let's keep this default Color Mode setting in our work, as shown in Figure 9.48.

FIGURE 9.48 Choosing options for the Color Replacement tool.

The three sampling icons next to its Mode setting allow us to choose how we want the tool to pick the color to use: Continuous, Once, or Background. We will once again select its default sampling option of Continuous, allowing us to continually sample colors to replace as we brush on the photograph. Its Limits pop-up menu provides three options: Contiguous, Discontiguous, and Find Edges. As also shown in Figure 9.48, let's choose its Find Edges option, which will help to preserve the edges of the areas as we paint. The sensitivity of this tool is also affected by its Tolerance setting, a term we have become familiar with from its application to other tools we have learned to use. Here, a low setting will increase the sensitivity of the tool, limiting its affect to color pixels only closely matching those we sample versus a high tolerance setting will affect a broader range of pixel color variation. For its Anti-alias setting, we have learned that anti-alias is our friend, and a setting we will never want to uncheck.

Because this tool will use the current foreground color to replace colors we brush over, let's select a neutral gray to use such as R:191, G:191, and B:191. Once we have done that, let's select a soft, large brush (approximately half the width of one of the larger stones based

on your view), then assign the rest of its options as shown in Figure 9.48: Mode Color, Contiguous, Limits Find Edges, and Tolerance 16%. With the Background layer active in the Layers panel, brush over the areas that contain a blue cast.

Don't see any change in the photograph? Be sure that you were working on the Background layer, not the grass layer. If you were working on the correct layer, click in the History panel back to the state prior to your application of this tool, and study a particularly "bluish" area, then click back to the most recent history state. You will be pleasantly surprised at how the textural quality and natural green moss has been kept in tact, while the blue cast has been easily removed.

9.12.2 Using the Dodge Tool to Lighten Areas of a Photograph

Now that the color cast has been successfully removed from this photograph, we can see that some of its stones still have overly dark areas on them. Although we have learned a variety of commands that can correct this, these types of areas can also be selectively lightened using the Dodge tool. Although we will use it to enhance this color photograph, the Dodge tool is equally effective on grayscale images. With its icon resembling a small "wand," the Dodge tool is grouped with the Burn and Sponge tools as shown in Figure 9.49.

When the Dodge tool is selected, its features become active in the Options bar. In addition to choosing settings of brush Size and Hardness, the range of its effect is assigned through its Range pop-up menu options of Shadows, Midtones, or Highlights, with the default setting chosen

FIGURE 9.49 Selecting the Dodge tool in the Tools panel.

of Midtones, which usually works well. Its Exposure, or "pressure" setting defaults to 50%, however lowering its percentage to one such as 20%, provides better control. If your version of Photoshop contains the Protect Tones option, it defaults to being checked, which will help keep the original colors while lighting the area it is applied to, and should always be kept on. Once we have selected a soft large brush (you will always want to select the largest brush you can control for this type of correction: in this image, approximately half the width of one of the large stones based on your view), let's set the remaining options for the Dodge tool as shown in Figure 9.50: Range Midtones, Exposure 20%, Protect Tones checked.

FIGURE 9.50 Choosing options for the Dodge tool.

Once we have done that, let's apply this tool to all of the stones' shadowed areas. By choosing an Exposure setting of only 20%, brushed over, they become lightened, yet still appear as shadows, which is what we want. Because of the low exposure setting we have assigned, some areas may need to be brushed over more than once.

> **Note**
>
> Although the Dodge tool's Midtones range setting will be very effective in most applications, when attempting to lighten *excessively* dark shadows, such as the sides of the small stones on the far right of the Stonehenge photograph, it may be helpful to temporarily select the Shadows range in the Options bar instead. Additionally, sometimes as an area is lightened, it may also begin to shift in its hue, creating a new color cast. Once the rocks have been lightened, the Color Replacement tool can be reapplied in some areas, if needed. In your own work however, when both of these tools are required, if the Dodge tool is applied first *before* the Color Replacement tool, this extra step will be eliminated.

With the grass repaired in Chapter Six, and the stones now lightened and their blue cast removed, we have significantly enhanced this photograph. Let's stop and save it now. Although your results may vary slightly, let's compare this completed enhancement to the original Stonehenge.jpg file from the Chapter 6 Files folder as shown in Figure 9.51.

ORIGINAL

GRASS PAINTED, BLUE CAST REMOVED, AND DODGE TOOL APPLIED TO ROCKS

FIGURE 9.51 Comparing the original Stonehenge photograph with its completed enhancement.

9.12.3 Using the Burn Tool to Darken Areas of a Photograph

Grouped with the Dodge tool, the Burn tool effectively darkens an area, and is also controlled by brush Size, Hardness, Range, Exposure (pressure), and Protect Tones settings. Let's reopen the Currier_enhanced. psd file we worked on earlier in this chapter. Once we have done that, let's select the Burn tool. When we do, its features become active in the Options bar. We can see that its options are identical to those of its counterpart, the Dodge tool, except that its Protect Tones

feature is grayed out because we are currently working with a grayscale image. This tool, like the Dodge tool, can be applied to both color and grayscale images. When working with color, its Protect Tones option provides the same "color protection" as the Dodge tool's Protect Tones feature and should be checked.

As we study the Currier_enhanced.psd file more closely, we can see that its name over the entrance and the carved details on either side of it are still so light, they are difficult to distinguish. A quick and easy way to improve these areas is to apply the Burn tool to them. Like the Dodge tool, when using the Burn tool, usually its default Range setting of Midtones will work well combined with a low Exposure setting such as 20% rather than its default setting of 50% for more control, as shown in Figure 9.52 (this figure displays the Protect Tones option available and checked, to exemplify its application when working with a color photograph).

FIGURE 9.52 Assigning options for the Burn tool in the Options bar.

With the Background layer selected, let's apply a few strokes (with our brush tilted slightly to echo the angle of the building) onto the sign area above the door, making it much more readable. It will be important not to darken the area significantly more than the rest of the wall, so that it will still appear natural. Want to carry it a step further and enhance the wall so that its bricks are more distinct too? It would be difficult to make an accurate selection to affect only the wall, without also affecting the shrubs, etc. around it. By using the Burn tool instead, and applying just a few strokes that also echo the angle of the brick wall, its detail becomes significantly more visible. Having fun? Feel free to also apply the Burn tool to a few areas around its fountain area if you like. Although your results may vary, your Currier_enhanced.psd file should now resemble the sample shown in Figure 9.53.

FIGURE 9.53 Applying the Burn tool.

When you are satisfied with your improvements, merge the Curves adjustment layer down, then save and close the file.

 To achieve natural results and minimize streaking when using either the Burn tool or the Dodge tool, always apply the fewest strokes possible, using the largest brush size possible based on the area you want to cover.

9.12.4 Using the Sponge Tool to Saturate or Desaturate Areas of a Photograph

Also grouped with the Dodge and Burn tools is the Sponge tool. This tool will allow us to increase or decrease saturation using a brush for its alteration. When the tool is chosen, and its features become active in the Options bar, we can see that in addition to assigning its brush Size and Hardness, a Mode pop-up menu which toggles between two options: Desaturate and Saturate, and a Flow option providing a "pressure" or "sensitivity" setting, similar to the Exposure setting available with the other two tools it is grouped with. As we can

see in Figure 9.54, changing the Flow default setting of 50% to a lower percentage such as 20% will once again provide more control when applying the tool. If your version also contains its Vibrance checkbox, this option defaults to being preassigned, and will help to retain more of the natural color as it is altered just as the Protect Tones option does for the Dodge and Burn tools.

FIGURE 9.54 Assigning options for the Sponge tool in the Options bar.

This tool is quick and easy to use for enhancing small areas of a photograph that need to be either "brightened" or "dulled down," without requiring the application of an adjustment command. Let's reopen the Rushmore_enhanced.psd file we worked with earlier in this chapter. This image's color has been corrected, except for its lower right area, which still contains a blue cast, that we will be able to easily "neutralize" or "dull down" using the Sponge tool. With the tool chosen, let's select a brush with a Hardness setting of 0%, a Size as large as possible while still able to control its application based on our view, set its Mode to Desaturate, its Flow to 20%, and keep its Vibrance option checked, then brush over the color cast areas illustrated in Figure 9.55. By limiting the tool's application to only

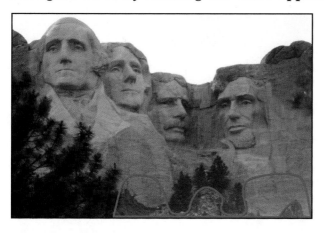

FIGURE 9.55 Applying the Sponge tool.

the areas that still contain a bluish hue (indicated within the red area), with a minimum of brush strokes, the cast is quickly and easily removed. When satisfied with your image, save and close the file.

Test Your Knowledge

1. What is a color cast?

2. What does the Histogram panel display?

3. Where can the default settings for the Auto Tone, Auto Contrast, and Auto Color be changed?

4. When working with additive colors, what color will neutralize red?

5. What does the Dodge tool do?

6. What does the Fuzziness setting control when using the Replace Color command?

7. What is the advantage of applying a command as an adjustment layer versus through the **Image>Adjustments** submenu?

8. Can an image have multiple different types of adjustment layers applied to it?

9. Does the Burn tool require that a selection be created, or an adjustment layer applied first, in order to work?

10. How can the Shadows/Highlights command be applied, to be able to edit its settings later on?

Try It Yourself

Project 1

Reopen your House_restored.psd file that you last worked on in Chapter Seven.

1. Convert this photograph to grayscale by choosing the **Image>Mode>Grayscale** command, and choose to

discard the color information when prompted. Be sure to choose the Don't Flatten option rather than the default option of Flatten if the dialog box shown in Figure 9.56 appears when the **Image>Mode>Grayscale** command is chosen.

FIGURE 9.56 Flatten image before mode change dialog box.

2. If your file contains tonal mismatched repair layers that were saved into a group, delete the group (folder only by choosing Group Only when deleting), then add a Curves adjustment layer to each one to adjust its tones to match the content around it, clipped to affect only the layer it is created for.

3. When all extra layers blend seamlessly with the content around them, merge them down.

4. Now apply a Levels adjustment layer dragging its shadows triangle to 38, and its highlights triangle to 238 as shown in Figure 9.57.

FIGURE 9.57 Applying a Levels adjustment layer to the House_restored.psd grayscale photograph.

5. Save and close the file for now. We will repair its sky in Chapter Eleven.

Project 2

Reopen the photograph of your own from Chapter Three that had "an area or two distinctly lighter or darker than it should be," with those areas saved into alpha channels. Be sure to convert the photograph's profile to the Adobe RGB (1998) color space when opening it.

1. Following the steps we applied to the Covered bridge_ enhanced.psd file, activate one of your own photograph's selections, and then add an appropriate correction command such as a Brightness/Contrast, Levels, or Curves adjustment layer to correct its lighting.

2. Repeat step one for any additional selections you may have already saved with the file.

3. Select the Background layer, then create additional selections for any areas that you did not create in Chapter Three, which you realize now could be further enhanced using an adjustment layer.

4. Repeat step one for all new selections you may have added to the file in step three.

5. Select the Background layer and convert it to a Smart Object.

6. Select the adjustment layer directly above the Smart Object, and delete it, returning this area back to its original overly light or dark state.

7. Now reselect the Smart Object layer, and activate the selection that had been used for the adjustment layer deleted in step six.

8. Apply the Shadows/Highlights command to the layer, and adjust the lighting of the selected area only through this command. (These steps are demonstrated by their application to a new version of the Covered bridge_enhanced.psd file shown in Figure 9.58.)

FIGURE 9.58 Applying a Smart Filter and a separate adjustment command to a Background layer converted to a Smart Object.

9. When you are satisfied with your improvements to your photograph, choose to flatten, save and close the file.

Project 3

Reopen the "Wedding1_restored.psd" file you repaired as Project 3 in the "Try It Yourself" section of Chapter Seven. At that time, its damage was repaired. You will now remove its color cast.

1. Apply the Auto Color command to the entire photograph.

2. Select only the bride's hair, and apply a small feather such as 2 pixels, then apply a Color Balance adjustment layer with settings of Cyan/Red 0, Magenta/Green 0, Yellow/Blue −30.

3. Select the Background layer again, make a new selection of all of the skin areas in the photograph: the bride's face, the groom's face, and the groom's hand (hold Shift when selecting, so that all areas will be part of the same selection), then apply a small feather to this selection, such as 2 pixels.

4. Apply a new Color Balance adjustment layer to this selection, and assign the settings shown in Figure 9.59 of Cyan/Red +23, Magenta/Green 0, Yellow/Blue −22.

FIGURE 9.59 Applying multiple Color Balance settings to skin.

5. Reselect the Background layer, and then select all of the white in the photograph: the bride's dress and veil, the groom's shirt and shirt sleeve, and the bride's flowers (it will not be necessary to select the white areas of every leaf).

6. Apply a Hue/Saturation adjustment layer, adjusting its Saturation slider to −38 keeping its Hue and Lightness settings both at 0, to eliminate the yellow cast without causing the whites to appear fake.

7. Reselect the Background layer, then select the Sponge tool, and with its Mode set to Saturate, a Flow setting of 20%, and its Vibrance option checked, brush over the green areas of the leaves, using an appropriate brush size with a Hardness of 0%, to enhance their green appearance.

8. Change its Mode setting only from Saturate to Desaturate, then brush over any discoloration areas visible on the wall above the couple, and any streaks of yellow cast that may be left on the bride's dress.

9. Reselect the Background layer and convert it to a Smart Object.

10. Create a selection on the Background layer of the roses only, apply a small feather to the selection, then apply the Shadows/Highlights command as a Smart Filter with a Shadows setting of 0%, and Highlights setting of 19%, to enhance the details of the petals.

11. Your Wedding1_restored.psd file should now resemble the sample shown in Figure 9.60. Tweak any of your adjustment settings if desired, then choose to flatten, save, and close the file.

FIGURE 9.60 Wedding1_restored.psd file with multiple color corrections applied.

Project 4

Open the Egypt.jpg file provided in the Chapter 9 Files folder.

1. Save the file first as Egypt_original.psd, then as a working copy named Egypt_enhanced.psd into your Photoshop practice folder.

2. Begin by removing all of the people from this photograph using any combination of tools and techniques you have learned.

3. Select its sky only, then apply a Surface Blur with a Radius setting of 5, and Threshold setting of 15, to remove its textural quality.

4. Select Inverse, and then save this selection into an alpha channel.

5. With the selection active, apply a Color Balance adjustment layer, with settings of Cyan/Red +53, Magenta/Green 0, and Yellow/Blue –50, and then deselect the selection.

6. With the Background layer chosen, select just the ground area of the photograph.

7. Apply a Levels adjustment layer to this selection, adjusting its shadows triangle only to 63.

8. Select the Color Balance adjustment layer, and then choose to add a Hue/Saturation adjustment layer, so that it will be *above* all the other layers to affect the *entire* image with settings of Saturation –20, Hue 0, Lightness 0.

9. With the Hue/Saturation adjustment layer still active, apply a Curves adjustment layer, so that it will affect all layers below it. Click on the center of its graph, and use the arrow keys to adjust it slightly to universally darken the image by applying a setting such as Input 131, Output 118.

10. Your Egypt_enhanced.psd photograph should now resemble the sample shown in Figure 9.61.

11. Merge all of its layers. Once you have done that, feel free to apply the Sponge tool to any areas that may still have a slight cyan color cast, or appear too rich and unnatural using a brush with a Hardness setting of 0%, a Size relative to your view, with its

FIGURE 9.61 Egypt_enhanced.psd file with multiple color corrections applied.

Mode set to Desaturate, Flow 10%, and Vibrance checked.

12. Save and close this file. We are ready to have some fun adding and deleting subjects from photographs in Chapter Ten.

10 ENHANCING PHOTOGRAPHS

BY ADDING, DELETING, REPLACING, AND BLURRING CONTENT

With our skills in repairing a photograph, combined with our experience in correcting its color, we are ready to learn how these talents can be integrated and expanded to improve the actual subject matter of the photograph. After working with resampling, we will explore how the Content-Aware command, the Gradient tool, the Lens Blur filter, along with the tools and techniques we have learned to use for repair work, can all be used to enhance photographs by either adding or deleting of some of their content, or by defining or redefining their point of interest.

10.1 Adjusting Resolution When Adding Content to a Photograph

In Chapter One, we were introduced to resolution, and examined how important it was when combining images, their resolutions should be the same whenever possible. In Chapter Five, we practiced combining images, and learned how to scale imported content proportionately, by adding the Gull.psd image into our Shore_enhanced.psd destination file. Because the resolutions of the two images were the same and required no resampling, it was slick and easy to enhance the shore photograph by inserting some interesting additional content. In the same chapter, we also learned that an interpolation method can be assigned when an image *does* need to be resampled, with the promise that in Chapter Ten, we would examine how to minimize the ramifications of resampling when it is inevitable. Let's begin this chapter by importing content from another image to enhance a photograph, when the two original file resolutions are mismatched, by learning how to resample each image *prior* to its integration.

on the DVD Let's open the Monument Valley.jpg file provided in the Chapter 10 Files folder. This will be our destination file, so save it as Monument Valley_enhanced.psd into your Photoshop practice folder. Now when we open the Image Size dialog box (**Image>Image Size**), we can see that its resolution is 72 ppi. Let's click the Cancel button in this dialog box for now, and then close the file temporarily. Now let's open our Tourist.psd file that we used the Refine Radius tool to select the tourist's hair in Chapter Three, and saved it at that time into your Photoshop practice folder. Remember to click OK to convert its color profile to the Adobe RGB (1998) color space if you have chosen to be asked. (If you are not working in CS5 or higher, because you do not already have a copy of this file, open the copy provided in the Chapter 10 Files folder.) When we open the Image

Size dialog box this time, in contrast to the Monument Valley photograph, this image's resolution is 300 ppi. We learned in Chapter One that when an image is imported into another, its resolution becomes converted to the destination file. When a low resolution image is imported into a high resolution one, it becomes physically much smaller, and that contrastingly when a high resolution image is imported into a low resolution one, its physical dimensions become substantially larger. How can we combine these images together without resulting in drastic resolution or size alterations to either one? Because both images are only 4″ × 6″ prints, 150 ppi is an acceptable median resolution between our two image resolutions. By resampling our Monument Valley photograph to 150 ppi ("upsampling"), and resampling our Tourist.psd image down to 150 ppi ("downsampling"), when we combine them, their sizes will remain rel-ative to their original states resulting in a mini-mal negative impact from resampling. In the Image Size dialog box of our Tourist.psd file, the first thing we will need to do is be sure that the Resample Image box is *checked* (we have always wanted it to be unchecked in our previ-

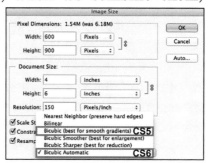

FIGURE 10.1 Downsampling 300 ppi to 150 ppi.

ous work, as we have been taught "best practice" to never resample), and that its Constrain Proportions box is also checked. Once we have done that, we can highlight its current resolution and choose to downs-ample it to 150 ppi, and keep its default interpolation method set to Bicubic Automatic (CS6), or Bicubic (CS5) as shown in Figure 10.1.

A copy of each figure shown in this chapter can be viewed on the companion DVD included with this book. **on the DVD**

> **Note**
>
> We learned in Chapter Five that Bicubic Smoother was best for enlarging an image, and that Bicubic Sharper was best when an image needed to be reduced. So… for all versions of Photoshop except CS6, why assign Bicubic now? We also learned in Chapter Five that Bicubic is a median between Bicubic Smoother and Bicubic Sharper. Because we are not attempting to make severe resampling adjustments, the median setting for both will be easy and adequate. If you are working in CS6, feel free to leave it at the default setting of Bicubic Automatic, and let Photoshop determine the best interpolation method for you, or create one copy using Bicubic Automatic, and a second version in which you select Bicubic, and compare the results of each, determining at that point which interpolation method works best in this instance for you.

Let's stop and save this file for now, then leave it open while we resample our Monument Valley_enhanced. psd photograph. Once we have reopened the Monument Valley image, and reopened the Image Size dialog box for it, with the Resample Image and Constrain Proportions boxes checked, let's choose to upsample this file's resolution from 72 ppi to 150 ppi, choosing the Bicubic interpolation method again, or in CS6, choosing Bicu-

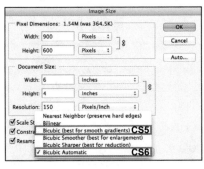

FIGURE 10.2 Upsampling 72 ppi to 150 ppi.

bic Automatic as shown in Figure 10.2, then save the file.

Because we will be moving content from our Tourist.psd file into our Monument Valley_enhanced.psd file, let's choose to arrange our documents as 2-up Vertical to be able to conveniently access both open files simultaneously. With the Tourist.psd file active, let's now load its saved selection, and then drag this selection into the Monument Valley_enhanced.psd file, centering it between the two famous rock formations in the destination photograph.

> **Note**
>
> When working with a small document size such as 6″ x 4″, upsampling it from 72 ppi to 150 ppi will minimize the negative impact of resampling, and produce an acceptable quality photograph when printed at actual size. In your own work, remember to always rescan images with resolutions lower than 300 ppi whenever possible.

10.2 Adjusting Sizes, Tonal Ranges, and Lighting When Combining Images

When images are used to create a composite photograph, even if their resolutions are in sync, often times they will still require scaling, color, and lighting adjustments to appear realistic when combined together.

10.2.1 Adjusting Sizes and Tones When Combining Images

Because both the Monument Valley and Tourist photographs were resampled to the same resolution before they were combined, the only scaling that will be required is to resize the tourist as desired so that she appears to be naturally posed in front of the rock formations. We have learned to proportionately resize by choosing **Edit>Transform>Scale**, and resizing with the Shift key held down while dragging diagonally using a corner selection handle (her size will depend upon how close or far away you want her to appear to be from you, the "photographer"). Once we have done that however, our tourist still does not look natural in the Monument Valley photograph, as she is noticeably darker than the image she is imported into. To have imported images appear as though they are part of the photograph they are brought into, usually their color will need to be manipulated in some manner, such as adjusting skin tones to match existing skin tones in the destination

file. By applying one or more adjustment layers clipped to affect only the imported image, it can be lightened or darkened, and its colors adjusted as needed for realism, without affecting the destination file. Let's do that to our tourist now. She can use some lightening, and some hue adjustment. Apply your expertise to her using adjustment layers until she appears similar in her tonal range to the destination file as shown in Figure 10.3.

FIGURE 10.3 Matching the colors and tones of an imported image to the destination file.

10.2.2 Matching Light Sources When Combining Images

In addition to achieving a comparable tonal range between all photographs that are part of a composite image, being cognizant of the *direction* of the main light source in each photograph, (from the sun, from a lamp, etc.), and adjusting it as needed so that it is relatively the same in each photograph, is critical for a composite image to appear realistic. In the two photos used in the Monument Valley_enhanced.psd file, the light source in both photographs is coming from the left. However, when mismatch lighting occurs between files, if selec-

tions are made with small feathers applied to them, adjustment commands can be applied to modify the lighting in these selected areas, as well as the Dodge and Burn tools can be strategically applied to lighten and darken areas respectively as needed. Just as with tonal adjustments, when adjusting light sources, a median can be struck by making adjustments to *both* the imported file(s), and the destination file, to ensure a clear, consistent light source between all photographs used in the composite image.

If there is no text of any kind visible in an image (sign, license plate, etc.), sometimes it will make no difference whether an image is reversed when imported into the destination file. When this is the case and the two images have distinct but opposite lighting, try choosing **Image>Image Rotation>Flip Canvas Horizontal** *if it is before the file is imported, or* **Edit>Transform>Flip Horizontal** *to its layer after it is imported. Its lighting will then match the destination file.*

Our tourist now appears to be standing in Monument Valley, however what about the reflection in her eyeglasses? We will remove it in Chapter Eleven while learning how to correct a variety of flash reflection maladies. Let's save and close the Monument Valley_enhanced.psd file for now, then close the Tourist.psd file, optionally choosing to save it when prompted.

10.3 Enhancing a Photograph by Removing Distracting Content

Sometimes enhancing a photograph means removing some of its content. At times this can be achieved using the Content-Aware command, or by manually covering the unwanted element(s), using the Clone Stamp tool, the Healing Brush tools, the Patch tool, and/or the Layer via Copy command. Although we have learned to use for them for repairs, in this chapter we

will learn how these options singly and in combination can also be used to enhance a photograph by removing content within it. However, when no logical, viable content exists to cover an unwanted area, applying a neutral gradient background to cover the distracting content may be the best alternative. Let's explore each of these "enhancement by removal" options, beginning with the Content-Aware command.

10.3.1 Removing Distractions Using the Content-Aware Command

Sometimes a photograph is great, except that it contains some type of distracting content such as an unwanted person, telephone pole, sign, etc. Photoshop contains a command that "intelligently" fills a selected area for you, by borrowing the surrounding content, and replacing the active selection with it. Let's begin our enhancement by removal work, by learning how this command, available in CS5 and higher, works.

 Let's open the Alaska.jpg file provided in the Chapter 10 Files folder. Save this file first as Alaska_original.psd, then as a working copy named Alaska_enhanced.psd into your Photoshop practice folder. We can see when this photograph opens that it has a construction crane in its top right corner, and a pole extending above its entrance sign. Let's learn how the Content-Aware command can be used to remove these types of distractions/disfigurements. Let's make a general selection around the construction crane, then choose **Edit>Fill**, and from its **Contents>Use** pop-up menu, select Content-Aware. When we click OK, the crane is magically removed as shown in Figure 10.4.

Click **TIP** *In addition to applying the Content-Aware command by choosing* **Edit>Fill,** *when you are working on a Background layer anytime a selection has been created, if the Backspace/Delete key is pressed, the Fill dialog box opens with the option to fill the deleted area with Content-Aware.*

**ORIGINAL
SELECTION**

**RESULTING
CONTENT-AWARE FILL**

FIGURE 10.4 General selection with the Content-Aware command applied.

In this first scenario, there is enough surrounding similar content to make the resulting removal simple, easy, and effective, and with clouds that can be difficult to replicate, this crane is a great candidate for the Content-Aware command. However, because this command uses surrounding content to perform its magic, its accuracy is based on what *type* of content surrounds the area you want to remove, and how *close* that content is. Oftentimes the degree of accuracy applied to the selection of the content to be removed will affect the accuracy of the Content-Aware command results. To better understand this, let's now make a general selection around the pole that extends above the sign, such as the sample shown in Figure 10.5, and then apply the Content-Aware command.

Once we click OK, and the command is applied, notice that in contrast to how effective the application of the Content-Aware command was in removing the crane from the sky, our results this time, are similar to the sample shown in Figure 10.6. The selected content has been removed, however the

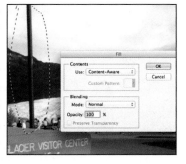

FIGURE 10.5 When the surrounding content is more complex, selecting a general area with which to apply the Content-Aware command.

FIGURE 10.6 Content-Aware command applied with mismatched resulting fill.

replacement content most likely looks worse than the original content did.

Let's back up in the History panel to before we made our general pole selection, and this time create a more accurate selection of the pole using a tool such as the Magic Wand. Because the Content-Aware command searches for surrounding content to fill with, once we have accurately selected the pole, we will still need to include a small amount of surrounding content in our selection. However, to minimize the inclusion of content we don't want, let's control the accuracy of how we expand this initial selection, by using the **Select>Modify>Expand** dialog box and assigning 10 pixels for its Expand By value. When the Content-Aware command is applied this time, the results are significantly improved, except for the small area of duplicated content identified in Figure 10.7.

> **Note**
>
> When assigning a pixel value in the Expand Selection dialog box to enlarge a selection to be used for the Content-Aware command, the value required is relative to the resolution of the image. A low resolution image will necessitate a significantly smaller pixel value to be effective then one required by a high resolution image, such as our Alaska photograph.

Let's examine the resulting fill. The glacial texture, in particular, would have been very difficult to cover realistically using any of the previous techniques we have learned, even if we had used the Layer via Copy command. Although a small area of "doubled" content re-

**ORIGINAL SELECTION
BEFORE EXPAND SELECTION
APPLIED**

**RESULTING FILL
WITH SMALL REMAINING
MISMATCHED CONTENT
AREA IDENTIFIED**

FIGURE 10.7 Selection created, with the selection expanded by 10 pixels, and the resulting fill after the Content-Aware command has been applied.

mains to be removed using one or more of the tools we have learned in our repair work, the rest of the pole has been quickly, and effectively eliminated.

Alternatively, if you prefer to make quick, loose selections instead of accurate ones, and still want to remove content using the Content-Aware command, it will work effectively if it is applied multiple times to smaller selections created one at a time, instead of applying it once to a larger, single selection which encompasses the entire content you want to replace.

Note

In CS6, an additional Content-Aware tool was added: the Content-Aware Move tool, which is grouped with the rest of the healing collection of tools (see Figure 8.6). Using the same innovative technology as the Content-Aware mode of the Patch tool, this tool allows you to make a selection, then move the selection to a new spot (rather than delete it), and after you do, Photoshop will intuitively fill in the area where the content used to be, as well as blend the moved selection into its new surroundings. In Figure 10.8, the original photograph is shown with one of the Canada geese at the far left with a moving dotted outline around it. The photograph would be enhanced if the goose was moved to the right. By selecting it using the Content-Aware Move tool (or any selection tool), it can then be dragged with the Content-Aware Move tool to the new location. As we can see in the sample on the right, the goose has been repositioned, balancing the composition much better. Like the Content-Aware mode of the Patch tool, when using the Content-Aware Move tool, the Adaptation pop-up menu in the Options bar provides five "pattern mixing settings" ranging from Very Loose to Very Strict with its Medium setting pre-chosen by default. For the sample shown, the Very Loose option was selected, based on the pattern texture of the grass area the goose was moved to. When the goose was moved to the new location using the Content-Aware Move tool, the area where the goose was originally located is perfectly filled in, and the goose blends in naturally into his new surroundings.

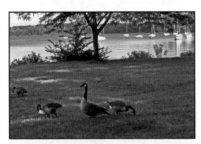

FIGURE 10.8 Using the Content-Aware Move tool to enhance a photograph.

10.3.2 Removing Distractions Using Duplicated Content

Although the Content-Aware command can be great for some removal enhancements, oftentimes for distracting content in a photograph to be eliminated, it will require you, the professional, to choose exactly what content will be used to manually cover/remove it.

Let's take a look at Figure 10.9. In this original sample, the desired final crop area is outlined in red. Although a simple crop will eliminate most of the distracting content, to create a photograph of just the husband and wife, the head of the third person (the gentleman with his arm outstretched) will need to be removed from the photograph.

FIGURE 10.9 Original image with cropped enlargement identified in red.

Typically when working on a project such as this, the photograph should be cropped to its final size before beginning the enhancement by removal process. However, before applying the crop, a study of the entire photograph should be performed first, to evaluate whether any content that will be required to cover the area to be removed, exists beyond the desired crop area. If it does, the content removal enhancement will need to be completed *before* the crop is applied. This particular photograph can be cropped first, as we can see that there will be sufficient content that can be used within the confines of the final crop area. It will entail using content from the shed behind the couple, and parts of the man's suit.

Let's open a copy of this file that has already been cropped to the final size, ready for the content removal enhancement, named Content removal.jpg provided in the Chapter 10 Files folder. As usual, save it first as Content removal_original.psd, then as a working copy named Content removal_enhanced.psd into your Photoshop practice folder. To begin, we can use the board in the top

left corner of the image to cover content in the lower right. Let's select a section of it comparable to the sample shown in Figure 10.10, and then apply a small feather to the selection, followed by the Layer via Copy command.

FIGURE 10.10 Making a selection to use to cover/remove content within the same photograph.

Once we have done that, this layer content can be moved into the location needed to naturally cover the distraction. Aligning the top of this board with the top of the existing board edge will work well. Using the Eraser tool, we can now erase any areas of this layer we do not need, such as its content that now covers the man's hat as shown in Figure 10.11 (the layer is identified by a solid red outline, with the content already erased indicated by a dotted line).

COPIED LAYER

ERASED CONTENT

FIGURE 10.11 Erasing unwanted content from a layer used to cover/remove content.

Just as we learned when working with copies of layers in repair work, lowering layer opacity, and turning working layers off and on is helpful with enhancements as well. Temporarily lowering the Opacity setting of the layer before beginning to erase its content, to an opacity low enough to be able to see both the layer you are working on and the content of the layer below it, and periodically turning the active layer on/off as you work to compare your results, will significantly improve the accuracy of your erasure.

We can see at this point, that although we have successfully covered some of the unwanted content, we will need additional image content to further cover our distraction. Let's now borrow content from the dark area in the top *right* of the photograph, and repeat the process of selecting it, copying it, moving it into position, and erasing where it covers content we need to keep visible in the original Background layer. Once we have done that, the two cover layers can be merged together (but not yet merged with the original Background layer).

Note

For convenience in your future work, multiple cover layers can be merged as long as they are not merged with the Background layer, until you are sure they will no longer need any individual manipulation, or until the project is completed.

Once the two cover layers are merged, they may not abut as a "seamless" match. Anytime this happens in your own work, the problem can be quickly and easily eliminated with the Patch tool, by making selections from either side of the seam (using its Destination method), then dragging and releasing them over the seam area where the layers meet. The edges will be blended together, and the seam magically removed. This same Patch tool blending technique can be handy if canvas has been added to an image, and its color does not perfectly match the image content abutting it, such as in the Train_enhanced.psd file we worked with in Chapter Five. After eliminating the seam using the Patch tool on this man's suit coat, feel free to reopen your Train_enhanced.psd file (remembering to convert its profile to the Adobe RGB (1998) color space when opening it), and remove any visible seams created where its sky abuts the added canvas if you would like to further reinforce the process and value of this Patch tool enhancement tip.

The balance of the content removal in this project will require reconstruction of the suit coat using the Clone Stamp tool, the Dodge tool, and the Burn tool. We can see by the light area of the man's suit coat lapel, that when we reconstruct the rest of the coat, the light will need to be along the top edge of the man's shoulder. Once content from the suit coat is cloned to fill the area in the shape of the shoulder, the Dodge and Burn tools can be applied as needed to create the 3-dimensional quality shown in the duplicated layer outlined in red in Figure 10.12.

When reconstruction is required in an enhancement project such as the suit coat in this photograph, by first making a selection around the area to reconstruct on the Background layer and choosing the Layer via Copy command, a removable "canvas" to "paint" on will be created to work on, providing the flexibility of its disposal, as well as the ability to temporarily hide it as needed.

It may be helpful at times when using the Clone Stamp tool in this project, to uncheck its Aligned option, to be able to repeatedly select source content from the

FIGURE 10.12 Duplicated layer identified in red with Dodge and Burn tool accents applied to it.

same existing suit coat area. Once the man's shoulder has been successfully reconstructed, we can see that this photograph also contains a few blemishes which will require our restoration expertise to repair them. Once the file resembles the completed sample shown in

FIGURE 10.13 Completed photograph enhancement with content removed.

Figure 10.13, all layers can be merged, and the file saved and closed.

Having trouble knowing how to create the highlights, shadows, and folds required for the reconstructed suit coat to appear realistic? In your own work, when reconstructing an area of a photograph, use a resource to work from. In an instance such as this suit coat for example, a flyer from a clothing store will most likely contain a photograph of a male model posing in a suit that you will be able to use as a lighting reference for studying the highlights, shadows, and folds you may need to recreate.

10.3.3 Removing Distractions by Applying a Gradient

Sometimes a photograph may have unwanted or distracting content that is best removed by applying a gradient *behind* the desired content in the image, effectively covering the *distracting* content, and resulting in a final appearance similar to that of a studio portrait.

Let's take a look at Figure 10.14, which contains the area to be isolated and enlarged outlined in red. Unlike the previous photograph we enhanced, when we examine this image closely, we can see that there is no clear-cut content to logically use to cover/remove with, either within the confines of the final image area, or anywhere else in the photograph. Scenarios such as this one in your own work are great candidates for extracting the desired content from its negative surroundings, and moving it above a neutral gradient that covers the distraction(s), comprised of colors selected within the original photograph.

FIGURE 10.14 Photograph with area to be isolated and enlarged outlined in red.

Let's learn how to enhance a photograph using this extraction removal technique, by opening the cropped version of the image shown in Figure 10.14 named Gradient couple.jpg provided in the Chapter 10 Files folder, and saving it first as Gradient couple_original.psd, then as a working copy named Gradient couple_enhanced. psd into your Photoshop practice folder. When this image opens, we can see that the cropped version still contains a hand resting on the man's shoulder that will need to be removed, using the same removal techniques we applied in the previous exercise. Because the man is not facing us exactly straight on, simply copying the entire shoulder on the right and flipping it horizontally will not work, however parts of it can be used, combining them as needed, using the Clone Stamp tool.

> ### Note
>
> In your own work, before extracting any content to place it above a gradient background, carefully evaluate its perimeter first, and remove/cover any distracting, unwanted content that negatively affects it. Although this can always be done later to the extricated layer, or to the final flattened image, it will be easiest if it is done first, whenever possible.

Once the man's shoulder has been reconstructed, let's make a general selection around the couple we are going to extract from the background as shown in Figure 10.15.

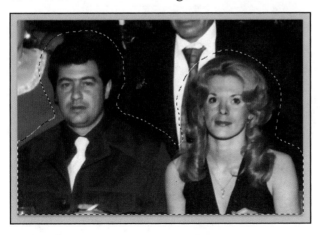

FIGURE 10.15 General selection of area to extract.

With the selection active, let's apply the Layer via Copy command, then select the Background layer and turn its visibility off. With the copied layer of the couple active, let's apply a Layer Mask to refine its selection.

> **Note**
>
> Although this project extricates the couple using a Layer Mask, any selection method that will result in an accurate selection can be used to isolate them. If an alternative selection method is used, once it has been created, in the Refine Edge dialog box, the New Layer with Layer Mask output option can be applied.

With an appropriate brush size based on our view, let's paint away all of the excess content around the outside of the couple. At any time while refining the Layer Mask, the Background layer's visibility can be activated as needed to double check the content that is included or may have accidentally been excluded when fine tuning the selection. Although we learned how the Refine Radius tool can help preserve individual strands of hair in a selection, when using a Layer Mask to paint around the woman's hair, it will not be necessary to select all of the individual strands of hair visible in the original photograph. As we can see in the detail provided in Figure 10.16, a general mask will be

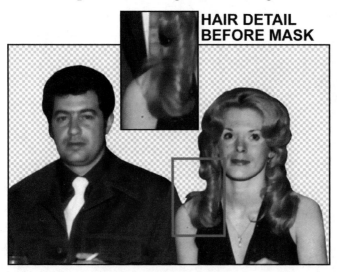

FIGURE 10.16 Couple isolated from the background using a Layer Mask.

sufficient. We will "add" strands of hair back to the image later.

When all image content outside of the couple has been removed, the mask is applied by either Right/ Control clicking on the mask icon in the Layers panel and choosing the Apply Layer Mask command from the context-sensitive menu that appears, or by choosing **Layer>Layer Mask>Apply**. To further assure that the resulting pixel content has been completely and accurately isolated from its background and that its edges appear soft and natural, using a tool such as the Magic Wand, select all the negative space around the isolated content, then expand this selection by one or two pixels, apply a feather with a radius setting of 1 pixel to this expanded selection, then delete it.

If you are not sure that you are done with the mask, before applying it (which will permanently remove it), the masked layer can be duplicated first before applying the mask to it. This tip allows you to keep a saved layer below it with the mask still editable to return to if needed.

10.3.3.1 *Creating a Gradient Background Layer*

When a custom gradient is created, it will always be comprised of whatever the current foreground and background colors in the Tools panel are at the time it is generated. Because of this characteristic of the tool, it is usually easier to assign the default colors in the Tools panel first, with black as the foreground color, and white as the background color prior to selecting the Gradient tool in the Tools panel. The Gradient tool is located between the Eraser tool and the Blur, Sharpen, and Smudge tool group in the Tools panel, as shown in Figure 10.17.

FIGURE 10.17 Choosing the Gradient tool in the Tools panel.

As we can see, it is grouped with the Paint Bucket tool, and in CS6, the 3-D Material Drop tool, both of which we will not be using in our work.

Once the tool is chosen, its features become active in the Options bar. We will want to keep all the default settings as shown in Figure 10.18, then single-click on the gradient sample *not* the down arrow on its right side, to open the Gradient Editor dialog box to create a custom gradient. (The gradient sample bar will display a black to white gradient if the default colors in the Tools panel have been assigned before the tool is chosen.)

**SINGLE-CLICK TO
CREATE A CUSTOM GRADIENT**

FIGURE 10.18 Options bar when the Gradient tool is chosen.

When the Gradient Editor opens, it displays a variety of premade gradients, with a gradient bar below them to create a custom gradient. The color stops (squares with triangles pointing to the gradient bar) which appear *above* the bar, customize opacity, the ones *below* customize color. When the left color stop below the gradient bar is clicked, it will reflect the current foreground color of black, which is what we want. When the right color stop below the gradient bar is clicked, rather than using white, its eyedropper can be dragged outside the editor and clicked to choose a color within the photo-

FIGURE 10.19 Choosing a custom color for a gradient from within a photograph.

graph such as the color selected in Figure 10.19.

Once we have selected a color in the area shown in Figure 10.19, we can click OK to exit the Gradient Editor. Because we have learned best practice to always have the flexibility whenever possible to delete layers to redo them

if necessary, let's create a new layer *above* the Background layer, and below our isolated content layer before applying the Gradient tool. With the new layer active and the Gradient tool selected, let's drag a "line" from the lower center between the couple, to the center top of the layer to fill it with our custom gradient as shown in Figure 10.20.

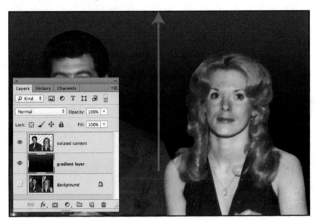

FIGURE 10.20 Gradient background layer added below isolated content.

Note

When the Gradient tool is not dragged from edge to edge of a photograph, any area within the photograph that exists beyond either end of the line drawn with the tool, will be automatically filled with the respective left (starting) or right (ending) color stop hue.

When adding a horizontal or vertical gradient to an image, if the Shift key is held down when dragging the Gradient tool to define the direction of the gradient, it will constrain the motion of the tool, assuring that the resulting gradient will be parallel with the sides of the photograph.

To add detail to some of the edges of the woman's hair, let's use the Smudge tool, with a small brush chosen based on our view, Hardness 100%, Mode Normal, and a Strength setting such as 70%, just as we learned to

do in Chapter Eight. With the isolated content layer active, when we drag in the direction of the strands of hair, the content will be softened and stretched, giving the appearance of strands of hair as shown in Figure 10.21.

FIGURE 10.21 Smudge tool applied to create individual strands of hair.

What else can be done to this photograph to improve it? When studying it closely, we can see some blemishes on the photograph that should be fixed. Feel free to repair them before saving and closing this image for now. We will learn how to add some "sparkle" to the couple's eyes in Chapter Eleven.

10.4 Enhancing a Photograph by Replacing Content

Instead of hiding part of an image by covering it with content from another area of the same photograph, sometimes a photograph can be enhanced by replacing some of its content with content from another photograph, referred to in this book as "borrowing power."

Let's open the Rider.jpg file provided in the Chapter 10 Files folder, and save it first as Rider_original.psd, then as a working copy named Rider_enhanced.psd into your Photoshop practice folder. What a great photograph...except that the rider is not looking at the camera, and also does not look particularly happy. How can we have her facing the camera and smiling? Borrowing power: replacing the rider's head with one from another photograph taken at the same event. Let's now open the photograph named Rider head.jpg. Although this image does not also show the rider *on* the horse, its head area can still be used to replace the one in our Rider_enhanced.psd file as shown in Figure 10.22.

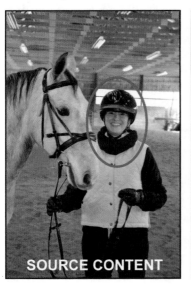
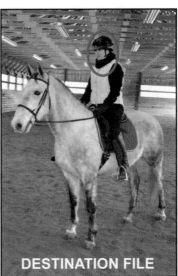

FIGURE 10.22 Source content earmarked to replace content identified in the destination file.

With both images arranged 2-up Vertical let's make an oval selection similar in the one shown in the left image of Figure 10.22, and move it into our Rider_enhanced.psd file, then close the Rider head.jpg file, without saving any changes. We can see when the content is added to the destination file, that the head will need to be reduced in size. How can we know how much to reduce it? Let's place the source content directly over

the corresponding area of the destination file, and then reduce the layer opacity of the head layer to 50%. Once we do that, we can see both heads, and be able to scale the replacement head down to correspond to the size of the head of the rider below it as shown in Figure 10.23.

FIGURE 10.23 Head layer with 50% opacity, scaled to match the destination file.

When we hide our replacement layer and study the original image, we can see that we will not want any of the neck area from the imported head, just its head and helmet, to have our rider facing the camera. Let's do that by reselecting the head layer, and applying a Layer Mask to it, so that we can remove its excess content safely. When erasing, we can even cut into part of the top area of the helmet, and reveal some of the original content below it, if we have aligned and scaled the replacement head to fit exactly on top of the original image. Once we have done that, the only two problem areas that remain, are the brim and the back

FIGURE 10.24 Areas outlined in red requiring coverage in the Background layer.

of the helmet on the Background layer that extend out beyond the replacement head shown outlined in red in Figure 10.24.

After we apply our expertise in the use of the Clone Stamp tool and the Layer via Copy command to these areas of the Background layer (and any additional cloning tools if needed), thanks to borrowing power, the resulting file is now a great photograph ready for framing, as shown in Figure 10.25. Once satisfied with the resulting photograph, the layers can be merged, and the file saved and closed.

FIGURE 10.25 Completed enhancement of the Rider photograph with an enlargement of the replacement head area.

> **Note**
>
> The images used in this project were digital photographs shot one directly after the other in the exact same lighting conditions. In your own work, you may be able to locate a photograph that has great replacement content in it, however, in addition to scaling, replacement content may require additional transformations such as rotation and/or distortion, and color adjustments to better match the destination file. Study any skin, sky, clothing, etc. in the replacement content, for cues regarding what adjustments may need to be made to its color, in order for it to appear natural in the destination file.

10.5 Adjusting an Image's Focal Point

Sometimes you may not need or want to completely cover or replace an area of a photograph, you would just like to make it less noticeable, so that the emphasis in the photograph can be shifted away from the distraction and towards your desired focal point.

> ### Definition
>
> **Focal Point:** The focal point in a photograph is the area within it that the viewer's eyes are drawn to, due to its color, size, or sharpness compared to the rest of the content in the image.

A blur filter can be used to either improve the focal point of an image by minimizing the negative impact of distracting content it may contain, or to completely redefine a photograph's depth of field. Let's explore applying a blur to each of these types of focal point adjustments, beginning with minimizing a distraction by applying a localized blur command.

10.5.1 Adjusting an Image's Focal Point by Minimizing Distraction

When the Surface Blur filter is applied to a selected area of distracting content, its detail will become less distinct, allowing the focus of the image to be redirected to another more desirable point of interest in the photograph.

on the **DVD** Let's open the Window.jpg photograph provided in the Chapter 10 Files folder, and save it first as Window_original.psd, then as a working copy named Window_enhanced.psd into your Photoshop practice folder. When the image opens, we can see that it contains a

large window with ornaments hanging on it, light reflections in it, and outdoor content seen through it, which all pull the focus away from the subject of the photograph, the little dog. Let's create an accurate selection of just the window area, and then select the Surface Blur filter (**Filter>Blur> Surface Blur**). In its dialog box, let's begin by assigning the settings shown in Figure 10.26 of Radius 36, Threshold 84.

FIGURE 10.26 Surface Blur settings to eliminate distracting content.

Once we click OK and exit the Surface Blur dialog box, we can see that instead of the window dominating the photograph, it becomes a great backdrop to refocus our attention on the little dog. If desired, this concept can be carried even further by making additional individual selections of the flag reflection and ornament hangers that are still slightly visible in the window, and applying a feather radius to them, and then a localized Gaussian Blur. The original image is compared to both of these solutions in Figure 10.27. Feel free to apply only the Surface Blur, or an additional Gaussian Blur afterwards if you wish, then save and close the file.

ORIGINAL

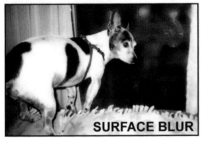

SURFACE BLUR

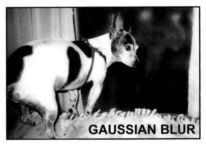

GAUSSIAN BLUR

FIGURE 10.27 Window photograph shown as original, and with Surface Blur and Gaussian Blur filters applied.

10.5.2 Adjusting an Image's Focal Point by Redefining Its Depth of Field

The Lens Blur filter can be used to redefine the depth of field in a photograph to shift its focal point.

Definition

Depth of Field: Depth of field refers to the distance or content within a photograph that is in focus. When both foreground and background content are sharp within an image, the photograph is described as containing a large or wide depth of field. Conversely, an image in which only a small area of either its foreground or background area is sharp and clear with the rest of its content out of focus, is one which contains a narrow or shallow depth of field.

DVD
on the

Let's open the Las Vegas.jpg photograph provided in the Chapter 10 Files folder, and save it first as Las Vegas_original.psd, then as a working copy named Las Vegas_enhanced.psd into your Photoshop practice folder. We can see when this image opens that it contains a large depth of field. In addition to the Venetian tower in the foreground being sharp and clear, even the name on a hotel several blocks behind it is legible. To reduce its depth of field to redirect its focal point to the Venetian tower in its foreground, we will apply a Lens Blur to it.

Let's begin by assigning the default colors in the Tools panel, with black as the foreground color. Once we have done that, let's turn on the Quick Mask Mode. In Chapter Three, we learned to use the Quick Mask Mode to refine an existing selection. Here we will use it to create a mask for the Lens Blur filter. Choosing an appropriate size based on our view, with settings of Hardness 50%, and Opacity 100%, let's accurately paint over the tower and surrounding foreground content as shown in Figure 10.28.

Now the creative fun begins. Let's increase the brush size (approximately double its size based on your view), change its Hardness to 0%, and lower the Opacity setting in the Options bar. When painting now, we are controlling the "depth transition" we want to create between the full focus of the tower, and the area which will be out of focus behind it. The sample

FIGURE 10.28 Tower and foreground painted using the Quick Mask Mode.

shown in Figure 10.29 illustrates a suggested Quick Mask Mode brush Opacity setting of 32% and identifies the area it has been applied to, which will allow it to be clearer than the area beyond it when the Lens

Blur filter is applied. When the opacity of an area of a mask is lowered, the resulting blur effect when the Lens Blur filter is applied will be correspondingly reduced, increasing its depth of field relative to the settings of the Brush tool.

Just before entering the Lens Blur filter dialog box, with the Quick Mask Mode icon still *on* in the Tools panel, the Channels panel must be opened

FIGURE 10.29 Lowering the opacity of the mask to adjust the depth of field.

(**Window>Channels**) to be sure that the RGB composite channel is both *visible and highlighted* (when the RGB channel is clicked, the Red, Green, and Blue channels will become highlighted automatically as well), and the visibility of the Quick Mask alpha channel is turned *off* as shown in Figure 10.30. We are now ready to enter the Lens Blur filter dialog box to redefine our depth of field by choosing **Filter>Blur>Lens Blur**.

FIGURE 10.30 Quick Mask Mode turned on in the Tools panel with its visibility in the Channels panel turned off.

> **Note**
>
> Besides the Lens Blur option for adjusting depth of field, CS6 includes three additional depth of field blur filters also located under the Blur category of the Filter menu: Field, Iris, and Tilt-Shift. While each of these blur filters allow the customization of the location of the focal point, the strength of the blur effect, and the radius of the resulting depth of field without requiring a mask to be created first, these filters do not offer the specific type of customization demonstrated here with the Lens Blur filter, and will not be covered in this text.

As identified in Figure 10.31, three of the Lens Blur dialog box settings are critical for our depth of field adjustment to work, while its additional setting options are fun to experiment with on your own.

- Preview: The "Faster" option is adequate and easier on memory.
- Depth Map: Source: This is where the Quick Mask selection must be chosen from its pop-up menu.
- Iris: Radius: This assigns the blur intensity.

FIGURE 10.31 Assigning the Preview, Source, and Radius of a Lens Blur.

With assigned settings of Preview Faster, Depth Map Quick Mask, Radius 35, Threshold 255, and all other settings left at 0 as shown in Figure 10.31, when we exit the Lens Blur dialog box, our Las Vegas photograph has a new, clear focal point: its Venetian tower as shown in Figure 10.32.

ORIGINAL

LENS BLUR APPLIED

FIGURE 10.32 Before and after the Lens Blur has been applied to the Las Vegas photograph.

Note

The actual transition area from focused to blurred may vary in your file from the end sample provided based on the brush size, opacity, and amount of "depth transition" masking you applied. Additionally, the Radius setting shown in Figure 10.31 is only a suggested value. Also, instead of the very shallow depth of field created in this sample, you can create a more realistic, gradual depth of field, by additionally painting the midpoint area (the Rialto bridge, and the area of the Venetian hotel to the left of it) in the Quick Mask Mode at a percentage such as 50–70%, allowing it to appear less sharp than the tower, but sharper than the hotels with the full blur applied to them in the distance. Feel free in your own work to increase the blur intensity based on the subject of the photograph, and your personal preference: use your creativity and have fun.

In this chapter, we have learned a variety of ways to enhance photographs by adding, deleting, covering, and blurring their content. Let's move on to Chapter Eleven and learn a potpourri of tricks and trade secrets that will further enhance your special photographs.

Test Your Knowledge

1. In what dialog box do you create a custom gradient?

2. What does the **Fill>Content-Aware** command do?

3. Where is the focal point in a photograph?

4. What is depth of field?

5. Under what category of the Lens Blur dialog box do you assign the source for the blur?

6. What is a color stop?

7. How do you assign the direction of a gradient?

8. When choosing to downsample in the Image Size dialog box, the Resample option must be turned _____?

9. What is upsampling?

10. How can you constrain the motion of the Gradient tool when drawing with it?

Try It Yourself

Project 1

Open the barn.jpg file provided in the Chapter 10 Files folder. Save it first as Barn_original.psd, then as a working copy named Barn_enhanced.psd into your Photoshop practice folder. This project is designed to employ the Content-Aware command. If your version of Photoshop does not have this feature, the project can still be completed using the Clone Stamp tool, the healing tools, and the Layer via Copy command.

1. Remove the five distractions in this photograph outlined in red in Figure 10.33 using the Content-Aware command, leaving only the couple in the foreground. For the people in the distance, the command will perform more accurately if it is applied a couple of times to smaller sections of each person, rather than a single selection of each person in his/her entirety.

FIGURE 10.33 Content identified to be removed using the Content-Aware command.

2. Once its distractions have been removed, zoom in to study the areas in which the Content-Aware command has been applied. This photograph was specifically selected for this exercise, as the areas that were easily removed using the Content-Aware command, would have been considerably more difficult to remove using other methods we have learned.

3. When your completed enhancement resembles Figure 10.34 (it will most likely not match the sample provided exactly, as each resulting Content-Aware fill is

FIGURE 10.34 Barn photograph with Content-Aware command used to remove its distractions.

based on the size of the original selection made), save and close the file.

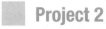

Project 2

Open the Little girl.jpg file provided in the Chapter 10 Files folder, saving it first as Little girl_original.psd, then as a working copy named Little girl_enhanced.psd into your Photoshop practice folder. You may recognize this photograph from Chapter One. However, if you return to Chapter One, and study Figures 1.11 and 1.12 closely compared to Figure 1.13, you will see that her hand is blurred in the first two figures, but corrected in the third one. You will use the arm from another photograph to cover the blurred one.

1. Open the file named Little girl's hand.jpg. In this photograph, the little girl is not looking at the camera, but her hand rests nicely on her dress. With the files arranged 2-up Vertical, select the area defined by the guides provided, and move it into your Little girl_enhanced.psd file, then close this file and do not save the changes.

2. Position the hand as shown in the detail provided in Figure 10.35.

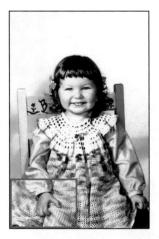

FIGURE 10.35 Imported hand content positioned to cover the blurred hand of the original image.

3. Select the new hand layer, and with its opacity lowered as needed, use the Eraser tool to remove all unnecessary content in it.

4. Apply a Levels adjustment layer clipped to affect just the hand layer, dragging its shadows triangle until its tones match those of the Background layer.

5. Merge the layers, and then use the Clone Stamp tool and/or the Layer via Copy command to adjust the folds in the sleeve and the texture of the dress as shown in Figure 10.36. Once you have done that, if any new layers have been created while adjusting the folds and texture of the dress, merge them down, then save and close this file for now. The texture of the dress in the area of the imported layer will not be as distinct as the texture of the rest of the dress in the photograph. We will reopen this file and learn how to sharpen this area in Chapter Eleven.

FIGURE 10.36 Little girl photograph with hand replaced.

Project 3

Open the Germany.jpg file provided in the Chapter 10 Files folder and save it first as Germany_original.psd, then as a working copy named Germany_enhanced.psd into your Photoshop practice folder. This photograph contains a wing of the building in which much of its exterior tudor detail is hidden by foliage, that can be replaced with the same part of the building from another photograph taken from a slightly different angle which exposes more of the detail on its facade. The guides have been added to this photograph to help align the imported content at critical intersections within it.

1. With the Germany_enhanced.psd file still open, open the Germany wing.jpg, and arrange the files 2-up Vertical. Because this shot was not taken at exactly the same angle, part of this image can be used to effectively cover the foliage of your Germany_enhanced.psd photograph, but will require some transformations and color adjustments applied to it. Create a selection of the area defined by the guides provided, move it into your Germany_enhanced.psd file, then close the Germany wing.jpg file without saving any changes.

2. With the wing layer selected and a lower opacity assigned to it, use the Scale and Distort transformation commands to align the roof peak and bottom corner of the wing to the guides provided, and where the bridge connects to the building, align this content as shown in Figure 10.37.

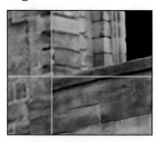

FIGURE 10.37 Aligning the corner of the building in the imported wing layer with the edge of the bridge in the Background layer.

3. To match the color of the bricks on the wall of the wing layer with those of the Background layer, apply a Curves adjustment layer clipped so that it will affect only the wing layer.

4. When the key areas have been aligned, all nonessential content from the wing layer can be erased. When erasing around the peak and side of its roof, it will be helpful to make selections using the Polygon Lasso tool to delete the content as shown in Figure 10.38.

FIGURE 10.38 Deleting content around the roof of the wing layer using the Polygon Lasso tool.

5. To match the water of the wing layer to that of the Background layer, apply the Burn tool.

6. Merge the layers, and then apply the Clone Stamp and Patch tools to cover any remaining unwanted foliage on the building or in the water.

7. Your completed Germany_enhanced.psd replace-ment project should resemble the sample shown in Figure 10.39. When you are satisfied with your re-sults, save and close the file.

FIGURE 10.39 Sample of completed Germany_enhanced.psd project.

 Project 4

Reopen your Church_enhanced.psd file from Chapter Five and convert its color profile to the Adobe RGB (1998) color space.

1. Use the Content-Aware fill command to cover the white areas in the sky (the white canvas areas can be selected using the Rectangular Marquee tool).

2. Once the Content-Aware command has been ap-plied, a "larger than normal" center cross may ap-pear. Create a much tighter selection around the area to remove, and then apply the Content-Aware command one more time.

3. Your completed Church_enhanced.psd file should now resemble the sample shown in Figure 10.40.

FIGURE 10.40 Church_enhanced.psd file with Content-Aware fill applied to cover its added canvas.

11

TRICKS
AND
TRADE SECRETS

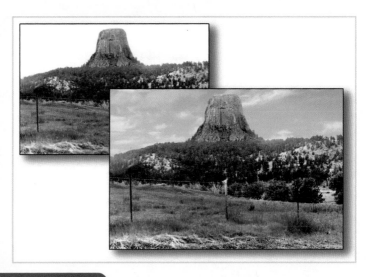

This chapter is chock-full of tricks to boost the professionalism of your work, including creative cropping, removing "a few extra pounds" with the Liquify filter, adding a sepia tone to a photograph, and so much more.

11.1 Enriching Your Restorations and Enhancements With Tricks and Trade Secrets

We have learned to repair photographs, learned to enhance their colors and tones, and learned techniques for removing and replacing photograph content, employing a wide assortment of tools and commands. So now what? This chapter is dedicated to learning some tricks and trade secrets that will utilize some of those same tools, commands, and techniques in less traditional roles as well as combine them with some new ones, which will take the quality and professionalism of your work to the next level. Let's get started.

11.2 Enhancing Photographs Using Artistic Cropping

In Chapter Five, we learned the mechanics of cropping a photograph. Let's learn now how cropping can be used to artistically enhance a photograph, and transform it from ordinary to extraordinary.

How do you "crop artistically" if you are not an "artist"? When using the Crop tool in version CS5, a Rule of Thirds grid was added to help, and in CS6, this was expanded to include additional grids including one called the Golden Spiral. Whether your version of Photoshop contains one or more of these options, you *can* learn to improve the composition of your photographs.

Definition

Composition: In photography, composition refers to the positioning of the content within the photograph so that its focal point is both visually balanced and aesthetically pleasing.

Let's open the photograph named Sunset.jpg provid- **DVD**
ed in the Chapter 11 Files folder. Save it first as Sun-
set_original.psd, then as a working copy named Sun-
set_enhanced.psd into your Photoshop practice folder.
We can see when this file opens, that its horizon line
and its focal point (the sun) are both approximately in
the center of the photograph. Creating a focal point that
is both visually balanced and aesthetically pleasing can
oftentimes be achieved by simply cropping to off-set the
focal point within the photograph, so that it is no longer
"dead center." When using the Crop tool, the Rule of
Thirds grid overlay in CS5 and all of the additional
overlay options added in CS6 can guide you through
this task. However, whether your version of Photoshop
contains any of these overlays or not, the concept re-
mains the same. Shifting the focal point to an area off-
center and shifting the horizon line either up or down
from the center will improve your photograph. In Fig-
ure 11.1, the original photograph is shown with three
cropped versions of it. We can see that the "rule of
thirds" simply splits the image into 9 equal sections to
give you "guide points and lines" to help you shift the
point of interest. The concept behind the Golden Spiral
overlay is to use elements within the image to draw the
eyes of the viewer to the focal point. In its sample pro-
vided, we can see that the rays of the sun on the hills
seem to aid in "pulling" our eyes up to the focal point
(the sun) in the photograph. Let's try this now by as-
signing a crop size of 6″ × 4″ and a resolution of 300 ppi.
If your version of Photoshop contains any grid overlays,
when the Crop tool is chosen, they will become active to
select in the Options bar. However, with or without
them, crop to shift the sun (the focal point) left or right,
and shift the horizon to take it from the horizontal cen-
ter to approximately "one third" of the height of the fi-
nal image area.

FIGURE 11.1 Cropping to move the focal point and horizon line of a photograph to increase its aesthetic appeal.

 A copy of each figure shown in this chapter can be viewed on the companion DVD included with this book.

Click **TIP** *If your version of Photoshop does not contain any crop overlay guides, all versions of Photoshop contain the option to show a non-printing grid by choosing* **View>Show>Grid,** *with its grid size customizable under the Guides, Grids, and Slices category of the Preferences dialog box. Although it may not provide an exact "rule of thirds" grid, turning on its visibility can be helpful in guiding you through the repositioning of the focal point and horizon line when cropping your photographs. To hide it when no longer needed, simply select* **View>Show>Grid** *again to toggle its visibility off.*

When you are satisfied with your cropped photograph, save and close the file.

11.3 Correcting Keystone Perspective Distortion

Photoshop provides multiple techniques for correcting perspective distortion caused by the keystone effect,

depending on the severity of the distortion: the Perspective option of the Crop tool (except CS6), the Perspective Crop tool (CS6 only), the Lens Correction filter, and correcting the distortion manually using the **Transform>Distort** command.

Let's open the Keystone1.jpg photograph provided in the Chapter 11 Files folder. Save it first as Keystone1_original.psd, then as a working copy named Keystone1_crop.psd into your Photoshop practice folder. We can see when this photograph opens, that its sides appear to angle in, as though they could eventually "meet" if extended. While sometimes this effect is welcomed, more often, it is the disappointing result of having to stand at ground level and shoot up to include the entire building.

11.3.1 Using the Perspective Option of the Crop Tool (Except CS6)

Let's select the Crop tool, and with no size or resolution defined, simply drag from the upper left corner of the image to the lower right corner to include the entire photograph in the crop preview. Once this has been done, the Perspective feature becomes available for selection in the Options bar. When checked, the top left and right corner handles of the crop preview can be dragged inward until they echo the sides of the building as shown in Figure 11.2. Once the command is completed, and the photograph has been straightened, let's save and close this file for now.

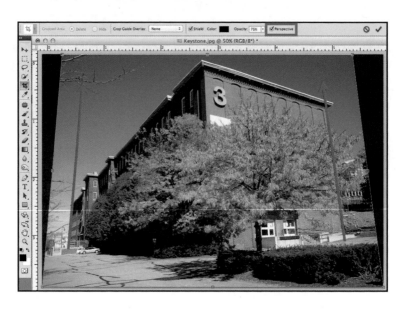

FIGURE 11.2 Applying the Perspective feature of the Crop tool (except CS6).

11.3.2 Using the Perspective Crop Tool (CS6)

If you are working in CS6, let's learn how the Perspective Crop tool performs this same function. The Perspective Crop tool is grouped with the regular Crop tool, as shown in Figure 11.3.

Once the tool is chosen, with no width or height assigned in the Options bar, a crop is drawn from the upper left corner to the lower right corner of the photograph. Once the preview area has been defined, a grid appears to assist in the correction. However, other than this initial step, the perspective is corrected using the same process shown in Figure 11.2. The top left and right selection handles are dragged inward to align parallel to the sides of the building (with the help of the grid provided). Once the crop has been applied and the building has been straightened, let's save and close this file for now.

FIGURE 11.3 Choosing the Perspective Crop tool in the Tools panel (CS6 only).

11.3.3 Using the Lens Correction Filter

The Lens Correction filter is designed to improve a variety of distortions, one being that of vertical distortion caused by the keystone effect. To try this filter, re-open your Keystone1_original.psd file, and save it this time as Keystone1_lens.psd into your Photoshop practice folder.

When the Lens Correction filter is selected from the Filter menu, its dialog box opens. Once its Custom tab is selected, let's assign the settings of: Geometric Distortion −11, Vertical Perspective −19, Angle 3.00, and Scale 77% with a suggested sequence of their application detailed in Figure 11.4.

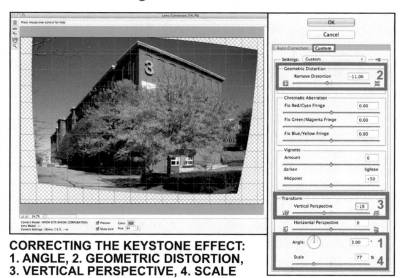

CORRECTING THE KEYSTONE EFFECT:
1. ANGLE, 2. GEOMETRIC DISTORTION,
3. VERTICAL PERSPECTIVE, 4. SCALE

FIGURE 11.4 Applying the Lens Correction filter to correct the keystone effect.

To best learn how this dialog box works, test various settings, and record their effect on the image. If the Background layer of the file is converted to a Smart Object before the dialog box is opened, the filter will be applied instead as a Smart Filter allowing you to double-click on it in the Layers panel to reopen its dialog box as often as needed to readjust its settings after it has been initially assigned.

Click
TIP

FIGURE 11.5 Cropping a photograph corrected using the Lens Correction filter, and its transparent areas filled using the Content-Aware command.

Once these settings are applied, a decision must be made to either further crop the image to eliminate its transparent areas, or fill them in, if the entire building is to be included in the final crop. Figure 11.5 illustrates a suggested crop preview area to best include the entire building, with its transparent areas shown as filled using the Content-Aware command once the crop was completed.

Once all areas of the image area have been filled, the file can be flattened, saved, and closed for now.

11.3.4 Using the Transform>Distort Command

Open your Keystone1_original.psd file one more time, and save it as Keystone1_distort.psd into your Photoshop practice folder. As we have learned, the Distort command only applies to regular layers. To be able to use the Distort command to correct the keystone effect in this photograph, one option would be to convert the Background layer into a layer, however let's choose to duplicate the Background layer, and apply the correction to the duplicated layer instead which will allow us to easily turn its visibility off and on to compare its perspective correction to the original image. With the duplicated Background active, let's choose **Edit>Transform>Distort**. To assist in the correction, let's choose **View>Show>Grid** to help us determine when the sides of the building have been accurately straightened (the grid shown in Figure 11.6 was set to a 2″ grid in the Guides, Grids, and Slices category of

the Preferences dialog box). We have learned that the Distort command allows us to manipulate each handle individually, and return to a specific handle more than once as needed to balance the corrections. With adjustments required to only its two top corner handles, the duplicated Background layer is straightened, as shown in Figure 11.6.

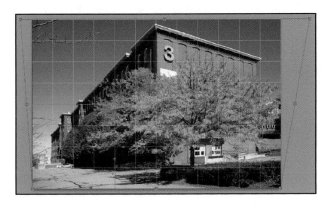

FIGURE 11.6 Correcting the keystone effect using the Distort command.

It will be fun to now temporarily hide this layer to compare the original image to our distortion correction. When you are satisfied with your results, flatten the file, save it, and leave it open.

Now reopen your Keystone1_original.psd file, as well as your Keystone1_crop.psd, and Keystone1_lens. psd files, then choose to view all four at the same time. Study each correction method compared to the original image, and how each crop method affected the final appearance of its resulting image. Which keystone correction method is best? For this type of photograph, it is purely a matter of personal preference. Simply the technique that works the best for you.

11.3.4.1 Adjusting Height When a Perspective Crop Has Been Applied

For the Keystone1 file, each of these methods effectively corrected the keystone effect visible in the original

image. However, let's learn a little trick that can be applied if a perspective correction appears to "compress" the resulting photograph by opening the Keystone2.jpg file provided in the Chapter 11 Files folder. Save it first as Keystone2_original.psd, then as a working copy named Keystone2_enhanced.psd into your Photoshop practice folder. We can see when we study this image that although its large columns in the foreground angle inward slightly, the buildings in the background display even more noticeable distortion. Using whichever perspective crop method you have available to you based on your version of Photoshop, begin by correcting the perspective within the image as you have just learned to do. Once you have done that, your results will most likely resemble the sample shown on the right of Figure 11.7. We can see that the keystone effect has been corrected however the image now appears to be compressed, loosing some of its lofty beauty.

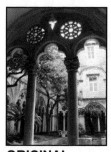

ORIGINAL

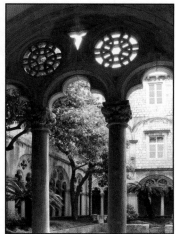

AFTER PERPSECTIVE CROP APPLIED

FIGURE 11.7 Comparing the distortion results of a perspective crop.

The loftiness can be returned to this photograph by adding canvas, and scaling the image back up. To do this, the Background layer must be first converted to a regular layer. Once we have done that, we can add some canvas to the image by changing the height from 17.067″ to 19″, with the Anchor setting of bottom center assigned as shown in Figure 11.8.

Once this has been done, let's choose **Edit>Transform>Scale**. We have always learned best practice to hold the Shift key down when scaling to constrain the transformation and maintain its proportions. However, in this instance, we do *not* want to employ the Shift key, let's simply drag the top *center*

FIGURE 11.8 Adding canvas to improve the appearance of a photograph which had a perspective crop applied.

handle upward until it aligns with the top edge of the document. We can now complete the transformation, flatten the document, and crop the image (if desired) to 4″ × 6″ with a resolution of 300 ppi. Figure 11.9 compares the original photograph on the left with our perspective plus scaling corrected version on the right. We can see when this sample is compared to the one on the right in Figure 11.7, that through the application of this additional step, the correction more naturally reflects the proportions of the original photograph. When you are satisfied with your corrected Keystone2_enhanced.psd file, save and close it.

ORIGINAL

PERPSECTIVE CROP, SCALING, AND FINAL SIZE CROP APPLIED

FIGURE 11.9 Applying scaling to a perspective distortion correction.

> **Note**
>
> Although discussed here relative to a distortion correction made using the Crop tool or Perspective Crop tool, this trick can be applied to a keystone effect correction made using any one of the methods you have learned, anytime the resulting correction appears "compressed."

11.4 Applying the Unsharp Mask Filter

Although the name of this filter is Unsharp Mask, it can be used to sharpen areas of a photograph that lack definition as well as be used as a slick trick to enhance the effects of aerial perspective in a photograph.

> **Definition**
>
> **Aerial Perspective:** also referred to as "atmospheric perspective," aerial perspective is the term given to the effect that occurs when the details of a subject being viewed become less defined and its colors become muted as the distance between the viewer and the subject increases.

11.4.1 Using the Unsharp Mask Filter to Improve Definition

In Chapter Ten, you saved a file named Little girl_enhanced.psd into your Photoshop practice folder, with the girl's blurred hand replaced. We noticed at that time, that the crochet detail of the dress in the replacement hand photograph was not as sharp as the crochet detail in the original photograph. Let's reopen that file now, and learn how the Unsharp Mask filter can help enhance the detail in this area of the little girl's dress.

> **Note**
>
> Although the Unsharp Mask filter can be applied to an entire regular layer or a Background layer, when only a specific area of a photograph requires sharpening, it will be important to select only that area to apply the filter to, and not to apply it over the entire image, as areas which do not require it will become over-sharpened and begin to appear fake and "outlined."

Let's create a selection of just the area of the dress we want to affect, and then apply a small feather radius so that when the filter is applied, its outer edges will blend naturally with the sharper existing details of the rest of the dress as shown in Figure 11.10.

FIGURE 11.10 Applying a feather to a selection to be used for the Unsharp Mask filter.

Now to select the filter, let's choose **Filter> Sharpen>Unsharp Mask**. Once we have done that, the Unsharp Mask dialog box opens, providing three sliders: Amount, Radius, and Threshold, and a preview window as shown in Figure 11.11.

Although this filter cannot literally "sharpen" a photograph, it creates the "illusion" of sharpening, by increasing the contrast of adjacent pixels. After assigning an amount of sharpening, the Radius slider determines the "spread" of the effect, meaning how many pixels away from an edge that you want Photoshop to apply the amount to, with the Threshold slider allowing you to define the degree of contrast the pixels require *before*

FIGURE 11.11 Choosing settings for the Unsharp Mask filter.

they will be affected by the filter effect, with a default value of 0 indicating that all pixels will be affected. Before assigning the settings shown in Figure 11.11 of: Amount 95%, Radius 4.5, and Threshold 0, it will be helpful to drag each slider until the effects are extreme to understand both how this filter works, and the "halo" effect that appears around edges that have been over-sharpened.

Note

Assigning a pixel value for the Radius slider is relative to the resolution of the image. When applying the Unsharp Mask filter to a low resolution photograph, a lower radius will be required to have the same effect that a higher value with have on a high resolution photograph.

Once the detail of the little girl's dress has been enhanced, let's save and close this file.

11.4.2 Using the Unsharp Mask Filter to Enhance the Effects of Aerial Perspective

In Chapter Ten, we learned how to use the Lens Blur filter to adjust the depth of field in a photograph. At times we may not need or want to adjust the depth of field in a photograph, we would just like the details in the *foreground* to appear a little sharper, making them appear to come forward, which in doing so, will enhance the aerial perspective that already exists in the image.

Let's open the Unsharp mask.jpg photograph provid- ed in the Chapter 11 Files folder. Save it first as Unsharp mask_original.psd, then as a working copy named Unsharp mask_enhanced.psd into your Photoshop practice folder. Our goal is to have the foliage in the foreground

area appear closer to us by sharpening its details. Because we will not want to sharpen any other area of the photograph except the foliage, we will need to isolate the effect of the filter by creating a selection first as shown in Figure 11.12. Although

FIGURE 11.12 Creating a selection to isolate the effects of the Unsharp Mask filter for aerial perspective.

the selection will not require the accuracy of the Quick Mask Mode around each blade of grass, it will be important to include the flowers that appear in front of the water on the far right to maximize the effect we will be creating with this filter.

Once the selection is made, a small feather radius such as 5 pixels is applied. When the Unsharp Mask filter dialog box is opened, our goal is to sharpen the reeds and wild flowers as much as possible before they begin to appear outlined and fake. Experiment with the Amount and Radius settings, keeping the Threshold setting at 0, with suggested values of: Amount 126, and Radius 3.7. Figure 11.13 details the flowers on the far right before and after the filter has been applied appearing closer for us to pick them.

Once the initial selection of the area to apply the Unsharp Mask filter to has been defined, if the Layer via Copy command is applied to it, the new layer can be converted to a Smart Object which will apply the Unsharp Mask filter as a Smart Filter, allowing you to double-click on it in the Layers panel, to reassign its settings as many times as desired until you are satisfied with its results and the file is flattened.

Click↗
TIP

FIGURE 11.13 Detail of the flowers on the right side of the photograph before and after the Unsharp Mask filter has been applied.

11.5 Improving Washed Out Skies

Ever had the "perfect photograph" except that its sky was washed out? Let's learn a couple of tricks for fixing this malady: replacing it with a gradient and replacing it with a sky from another photograph. We will begin by creating a sky replacement gradient, similar to the one that was provided for you when learning about layers in Chapter Four.

11.5.1 Improving a Sky Using a Gradient

Open your Rushmore_enhanced.psd file that you saved with a selection of its sky in Chapter Three, and corrected its color cast in Chapter Nine. It's time now to breathe new life into its washed out sky. Before we do that, let's examine the effect we are going to reproduce. When you look outside, you will see that the blue of the

sky will always appear somewhat lighter closer to the horizon, the phenomenon we will be replicating when we create our custom gradient. Let's begin by loading this file's saved selection of its sky area. Once we have done that, when applying a gradient in Chapter Ten, we learned that by creating it on its own separate layer, it provided the flexibility to redo it as many times as needed. A great habit to embrace when working with gradients. Let's create a new layer in the Layers panel and name it "Sky". We have learned that a color can be sampled from the image once the Gradient Editor has been opened. However, before we open the Gradient Editor, let's instead click the foreground color in the Tools panel first, and assign R: 163, G: 188, and B: 241. Now with the Sky layer active, let's select the Gradient tool in the Tools panel which will make its gradient sample bar become active in the Options bar. When we single-click on it to open the Gradient Editor, notice that the editor displays our current foreground color fading to whatever your current background color is, as the first gradient shown in the Presets area, with the second box displaying our selected foreground color fading to transparency. Perfect, just what we want. When we single-click on this Preset box, the gradient bar updates to reflect our chosen foreground color fading to transparency as shown in Figure 11.14.

With our Sky layer selected, our sky channel loaded, and our new gradient created, we are ready to enhance the Rushmore sky. Let's apply the gradient, by holding the Shift key down while we press and drag from the top of the

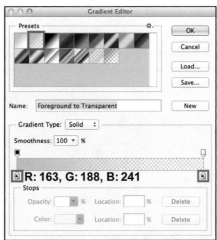

FIGURE 11.14 Creating a custom gradient for a sky.

photograph, down to approximately the middle of Roosevelt's nose as shown in Figure 11.15.

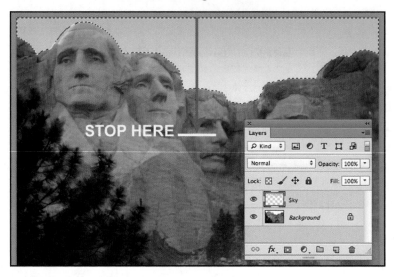

FIGURE 11.15 Applying a gradient to the sky selection of the Rushmore photograph.

> **Note**
>
> We have created a gradient that transformed the foreground color to transparency, because the existing sky contained an acceptable "white" sky to fade the gradient into. At times you may want to assign a lighter blue color for the right color stop, rather than selecting the foreground to transparent preset option.

In your own work, how will you know what color blue to use when creating a sky gradient, so that it will appear to "belong" with the photograph you are applying it to? If the photograph contains any blue already, such as water, mountains in the background, etc., when in the color picker, move the eyedropper out and select that color first. Although you will most likely need to then adjust it slightly (lighter/darker/brighter/duller) within the options area of the Color Picker, your resulting sky color will "match" its destination, and appear natural.

Before merging the Sky layer down, feel free use the Gradient tool to further experiment with this con-

cept, by applying a variety of different length gradients, always holding the Shift key each time, but stopping each one either higher and lower than the suggested distance shown in Figure 11.15. When you are satisfied with your results, save and close this file.

11.5.2 Replacing a Washed Out Sky With a Sky From Another Photograph

Using gradients for skies work, as oftentimes we have days when "there's not a cloud in the sky." However, what if you *want* clouds to be in the sky? To create that effect and have it appear natural, a sky must be imported. Let's open the House_restored.psd file saved in your Photoshop practice folder that you have previously repaired and converted to grayscale. We will be deleting its current sky to replace it with one containing clouds. We have previously straightened this photograph and cropped off the border surrounding it. However, if we check its image size, we can see that this photograph is not a typical frame size. To standardized its dimensions as well as reduce some of our sky selection work, let's begin by assigning a crop of 10″ × 8″ at 300 ppi. Once we have done this, we will need to convert its Background layer to a regular layer in order to be able to replace its sky. If your copy of this file still contains the Levels adjustment layer we used to improve its contrast, be sure to merge that layer down first. With the new Layer 0 active, its existing sky must be *precisely* selected to delete it. Care should be taken to use your favorite accurate selection method to trace around the house, tree line, etc., applying a

FIGURE 11.16 House_restored.psd file cropped and original sky eliminated.

feather of one pixel to the selection, and expanding it by one pixel prior to deleting it, or use the Refine Edge dialog box to adjust its edge to eliminate any existing halo effect. If you prefer, delete the content using a layer mask, then apply the layer mask when you have satisfactorily eliminated the sky only from the photograph. With the image cropped and its sky deleted using your favorite technique, the House_restored.psd file should now resemble Figure 11.16.

 We are ready to add a sky to this image. Where do we find one to use? You can use any photograph you have available to you, however, a folder named Sky photographs has been provided in the Chapter 11 Files folder. Let's open the Sky2.jpg file. Although we could convert this color image to grayscale prior to importing it, an imported source image's color mode is always converted to the destination file. With our two files arranged to view them both simultaneously, let's drag the Sky2.jpg photograph into the House_restored.psd file. As soon as it reaches the destination file, its color information is discarded automatically. We can now close the Sky2.jpg file without saving any changes if prompted.

Click **TIP** *None of the sky photographs provided in the Sky photographs folder contain any power lines, however each of the original images had one or more power lines in it. When using your own photographs, the Spot Healing Brush tool is a great tool for quickly and effectively removing any power lines they may have in them. Figure 11.17 shows the original sky photograph saved as the Sky2.jpg image with all its existing power lines.*

Once the sky photograph layer is dragged below the house layer (Layer 0), it can be scaled as needed to hide any details it contains (such as its trees) that we do not want visible in our final image. When scaling, it will not be necessary to hold the Shift key down while dragging, as there is nothing that will be visible that will appear "distorted" if it is not proportionately enlarged.

FIGURE 11.17 Original Sky2.jpg file prior to the application of the Spot Healing Brush tool to eliminate its power lines.

Although we could at this point flatten and close the file, let's improve its realism with one more step. The imported new sky is rather dark and overpowering, and therefore doesn't match the destination file as well as it should. One way we could improve that would be to apply an adjustment layer to it. However, let's learn another trick. Let's add a new layer, and move it to the bottom of the stacking order in the Layers panel. Once we have done that, let's choose to fill this new layer with white. Now when we select the sky layer, and assign this layer an Opacity setting such as to 65%, it allows some of the white of the layer below it to peak through and soften its effect as shown in Figure 11.18.

Feel free to assign a different percentage of opacity to your sky layer. Once you are satisfied with your results, flatten the file or leave it with its layers intact for future reference, then save and close the file.

Note

All of the sky photographs provided in the Sky photographs folder have some trees in them. While this project did not use them, they can often be left visible within the destination file, to blend naturally with any the file they are added into may have, or can be used to replace damaged ones that exist in a photograph being restored.

FIGURE 11.18 House_restored.psd file shown with its sky layer's Opacity setting changed to 65%, and a white filled layer added below it.

11.6 Learning the Weight Reduction Trick

The Liquify filter can be a great tool for eliminating a few pounds off the loved ones in your photographs.

DVD Let's open the Weight trick1.jpg file provided in the Chapter 11 Files folder. Save it first as Weight trick1_original.psd, then as a working copy named Weight trick1_enhanced.psd into your Photoshop practice folder. Now let's choose **Filter>Liquify** to open the Liquify filter dialog box. Although this dialog box contains a variety of tools and options, we will simplify its use by focusing on its key settings shown in Figure 11.19, which will effectively apply an "instant weight reduction" to the person shown in this photograph.

The Liquify filter provides a variety of expand/contract/shift tools on the left side of its dialog box, with its Forward Warp tool chosen by default, which is the one we will use for our weight reduction magic. On the right side of this dialog box, an option to show its Advanced Mode can be clicked to access its additional settings. Rather than using the default brush size, we will instead assign a larger one such as 900. Using a larger brush will help to minimize the "lumpy" effect when

FIGURE 11.19 Assigning key settings and options in the Liquify filter dialog box.

the tool is applied. Let's also assign a low brush pressure setting of 20, which will "slow down" the effect of the filter for better control. Optionally, the Show Backdrop feature will allow you to set an opacity visibility so that you can watch the "before and after" effects of your "weight reduction surgery," without having to exit this dialog box to see its miraculous results.

> **Note**
>
> The size of the brush when using the Liquify filter is relative to the resolution of the image. A low resolution image will require a significantly smaller brush to achieve the same degree of control as the 900 size recommended for a high resolution file.

To apply the Forward Warp tool, align its center crosshairs with the edge of the person's stomach, then drag the tool with short strokes to the left as shown in Figure 11.19, to achieve the "tummy tuck" effect. Many

small applications will usually work much more effectively than trying to correct an area with one long drag with the tool.

Click
TIP

While in this dialog box, holding the Alt/Option key while clicking the Cancel button will convert the Cancel button to a Reset button. However when clicked, this will reset everything in this dialog box, including the brush settings and the mode setting. If you hold down the Alt/Option key while pressing on the image area of the dialog box instead, it will dynamically reverse the steps you have applied. Alternatively, pressing Control/Command + Z will reverse only the last drag of the tool so that you can redo it, leaving all previous applications intact.

With a few drags to the left with the Forward Warp tool, and a couple dragged up to lift the waist band area of his pants, our subject looks great, as shown in Figure 11.20. When you are satisfied with your results, save and close the file.

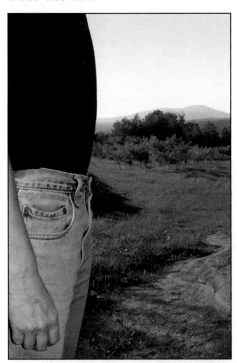

FIGURE 11.20 Completed Liquify filter application to the Weight trick1_enhanced.psd file.

11.6.1 Moving Content to Its Own Layer Before Applying the Liquify Filter

Although the Liquify filter dialog box additionally provides masking tools and options that can be applied to help isolate areas to affect/protect when needed, oftentimes it may be easier and offer more control to move the content you want to affect to its own layer instead, which will be the focus of this book. You may have noticed that in order to perform its magic, the Liquify filter had to shift some of the adjacent landscape content of the Weight trick1_enhanced.psd file to achieve the desired outcome. While in this photograph it had minimal negative affect, sometimes it can be much more disappointing, as shown in Figure 11. 21.

In this sample, the mast of the sailboat behind the person *also* became "liquified" when the Liquify filter was applied to his stomach area. This is when the masking options

FIGURE 11.21 Liquify applied with resulting warped sailboat mast.

provided in the Liquify dialog box can be helpful, or alternatively depending on the content in your photograph, if the subject is selected and moved to a separate layer using the Layer via Copy command *prior* to the application of the Liquify filter, two additional straightforward solutions become available. To employ the first alternative, once the liquify filter has been applied to the copied layer, the original content on the layer beneath it (the subject's protruding stomach), can be covered using the Clone Stamp tool and/or the Layer via

Copy command. In the second alternative, depending on the photograph it is applied to, the corrected liquified layer can be moved to cover over the original content, with the photograph then re-cropped to reflect the original 6″ × 4″ image size. Figure 11.22 compares the original image to both of these solutions.

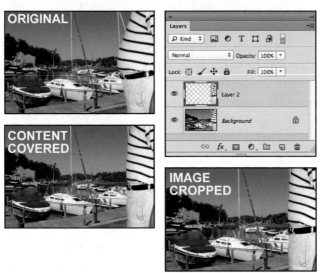

FIGURE 11.22 Repair solutions when using the Liquify tool on content isolated on its layer.

This photograph is also provided in the Chapter 11 Files folder named Weight trick2.jpg, if you would like to try this yourself. The same brush settings that were applied to our Weight1_enhanced.psd project were used for the sample shown in Figure 11.22.

Demonstrating the Application of the Liquify Filter

Because it is easy to "overdose" with the Liquify filter, included in the book's "Video Demonstrations" folder, is a video clip titled: *"Applying The Liquify Filter For Weight Reduction"*. Feel free to stop and watch it now, or at any time as a refresher.

11.7 Applying a Transitional Tonal Correction to a Photograph

In Chapter Nine, we learned a variety of ways to adjust the tonal quality of a photograph, whether it was in color or in grayscale. However, when a photograph contains a section of it that is considerably lighter or darker than the rest of the image, achieving a seamless transition between the area corrected and the original content requires a selection with a unique type of feathered edge to allow its corrections to morph seamlessly into the adjacent uncorrected content. Let's learn a couple of different ways to achieve this: by creating a selection that combines feathering with transformation, and by creating one that utilizes a gradient quick mask.

Let's open the Faded.jpg photograph provided in the Chapter 11 Files folder. Save it first as Faded_original.psd, then as a working copy named Faded_feather.psd into your Photoshop practice folder. We can see when this photograph opens that its restoration will require a variety of corrections, however, for this project, we will focus our attention on the left half of the photograph which is distinctly lighter that the right half.

11.7.1 Creating a Seamless Tonal Integration Using a Feathered and Transformed Selection

Let's begin by creating a selection of the left half of the image, as shown in Figure 11.23. Before the correction is applied, a large feather must be applied to the right side of the selection, so that its affects will transition seamlessly into the unaltered content of the image. However, when a feather is applied, it typically transitions the edges of all *four* of its sides, not just its right side. The trick is to apply a transformation to the selection, by choosing **Select>Transform Selection**, and extending its selection handles out beyond the document area on the sides you do not want affected by the

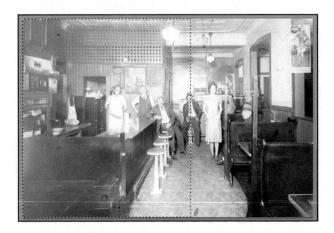

FIGURE 11.23 Selecting half of an image to apply a tonal correction to it.

feather a distance relative to the feather radius you as-
sign to the selection as shown in Figure 11.24.

Once the transformation has been applied, we are
ready to add a large feather. We have learned that the
amount of feather required to create a gradual pixel
change is relative to the resolution of the image. Be-
cause we will want a smooth tonal adjustment transi-
tion, and this image's resolution is 300 ppi, let's assign
a feather radius of 80 pixels. With the selection made,
transformed, and feathered, the image is ready for its
tonal adjustment, such as applying a Levels adjustment
with its shadows triangle set to 70. This adjustment now
equalizes the majority
of the tones in the pho-
tograph, in prepara-
tion for its repair. As
we can see in Figure
11.25, because of the
combination of a large
feather coupled with
the selection transfor-
mation, the transition
from the Levels ad-
justment to the area
not affected by it is
seamless.

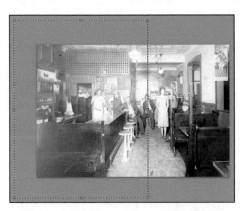

FIGURE 11.24 Extending the selection handles of a
feather to limit its application.

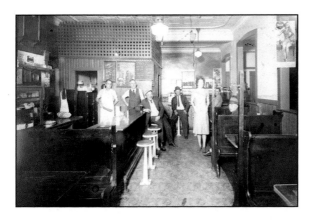

FIGURE 11.25 Using a transformed feather to control the affect of a correction.

Note

Although in this example, the transformation of the selection was made prior to the application of the feather, alternatively, this type of selection transformation can be added after a feather radius is applied, as long as it is prior to the application of the tonal correction. If you are not sure how far to extend its handles, overextend them. You cannot extend them too far, you can only extend them not far enough.

Once the tonal correction has been applied, save and close the file.

11.7.2 Creating a Seamless Tonal Integration Using a Gradient Quick Mask Selection

The Gradient tool in conjunction with the Quick Mask Mode can also be used to create a selection which will morph seamlessly from fully selected content to un-affected content for this type of tonal correction challenge. Let's explore this selection alternative. Open your Faded_original.psd file, and this time save it as Faded_gradient.psd into your Photoshop practice folder. We will begin by turning the Quick Mask Mode on with the default colors of black as the foreground color and white as the background color selected in the Tools panel. Now let's select the Gradient tool being sure that it is in its default Linear setting. Once we have done that, because the Quick Mask Mode *protects* an area from being select-

FIGURE 11.26 Creating a selection by combining the Quick Mask Mode with the Gradient tool.

ed, with the Shift key held down to keep the gradient straight as we draw, let's press and drag from the *right* side of the image towards the left, releasing the mouse approximately in the middle of the gentleman on the left in the photograph, as shown in Figure 11.26.

Once we exit the Quick Mask Mode, we are ready to assign the same Levels adjustment (moving its shadows triangle to 70) to complete the tonal correction. This file can now be saved and closed, or feel free to continue to develop and refine your repair talents by completing the rest of its tonal and surface restoration.

Note

The Faded.jpg file has been used to demonstrate two correction tricks that can be employed to unify the general tones in a photograph. In addition to its surface damage, this photograph still requires more "area specific" tonal corrections, such as the small light patch that remains on the booth in the left side of the photograph, and the faces of the people in it, which can all be satisfactorily corrected by applying the Burn tool as seen in the completed restoration shown in Figure 11.27.

FIGURE 11.27 Faded.jpg photograph fully restored: tones and surface damage.

11.8 Applying a Sepia Tone to a Photograph

The original Fire truck photograph that we have corrected and converted to a grayscale image may or may not have originally contained a sepia tone. Sometimes the sepia tone in a photograph shifts with age, and sometimes a grayscale simply yellows with age. When a sepia tone is desired, it is best to first convert the photograph you want to apply it to into a grayscale image while making all of its corrections, then apply the sepia tone to the completed restoration. Let's reopen our completed Fire truck_restored.psd file one more time, and learn how to add a sepia tone to it.

Once it is open, save a new working copy named Fire truck_sepia.psd into your Photoshop practice folder.

> **Note**
>
> When applying a sepia tone to a photograph, a variety of Photoshop methods exist which provide similar end results. The specific technique that will be introduced in this book creates realistic sepia tone results that are both easy to apply and to customize, as needed.

To make our adjustment, we will need to access the Hue/Saturation command, which is currently grayed out, as it is only applicable to color photographs. Let's begin by choosing **Image>Mode>RGB Color** to now convert this copy of the fire truck photograph into a color image. Notice once we do that, its original coloring does not return, as we chose to permanently discard its color information when our original Fire truck_restored.psd file was converted to grayscale in Chapter Nine. With this copy now in the RGB color mode, let's apply the Hue/Saturation command as an adjustment layer, so that we will be able to take advantage of its flexibility when applied nondestructively. When the properties for the Hue/Saturation adjustment layer become available, its Colorize option must be selected first. Once this has been checked, let's enter the values of: Hue 42, Satu-

ration 17, Lightness 0 to create a great sepia tone as shown in Figure 11.28.

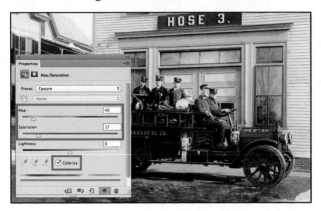

FIGURE 11.28 Choosing Hue/Saturation settings to create a sepia tone.

However, as a nondestructive layer, feel free to return to the Properties panel and readjust its Hue and Saturation settings slightly higher or lower individually, with the resulting sepia tone becoming either richer or more subtle depending on the changes you assign. When you are satisfied with the sepia tone you have applied, save and close this file.

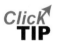

If your Fire truck_sepia.psd file is saved with its Hue/Saturation adjustment layer rather than flattened, the next time you have a photograph that you want to apply a sepia tone to, once the new image has been converted to an RGB image, your Fire truck_sepia.psd file can be opened and its adjustment layer dragged into the document you want to apply a sepia tone to. The new photograph will have your saved sepia tone settings applied automatically to it.

11.9 Adding Highlights to the Eyes of People and Pets

This simple trick is one that can make a portrait of either a person or a pet appear to come to life. Adding highlight spots to eyes, if none are visible, can turn

a nice portrait photograph into an awesome one. Let's learn how to apply highlights to the eyes of both people and pets beginning with applying them to people.

11.9.1 Adding Highlight Spots to People's Eyes

In Chapter Ten, we last worked with the Gradient couple_enhanced.psd file. Let's reopen this file now. When we study it closely, we can see that the eyes of the two people in the photograph do not contain white highlight spots in them. Let's learn to add them now. Typically a person's highlight spot will be in the same location in each eye, and will also typically be located on the pupil, near its top. It will be helpful once again when adding content to first create a new layer, so that it can be deleted, or have its opacity reduced, if desired. With a new layer created and selected, let's magnify in to the woman's eyes. Select the Brush tool with a small Size setting assigned (choose one that corresponds to the size of the highlight spots relative to the magnification shown in Figure 11.29) with Hardness 50%, Opacity 100%, using white as the foreground color, single-click to apply the highlight spot

FIGURE 11.29 Adding white highlight spots to people's eyes.

to one of her eyes. Feel free to back up in the History panel to redo it, or simply delete the layer and create a new one, if you are not happy with your "first shot." Although this is a quick and simple trick once you are used to applying it, initially there is typically a learning curve in mastering the location, and brush size required to create a natural and realistic highlight. Once you are satisfied, you can add a second layer for the woman's other eye highlight, or simply move to the other eye and repeat the process to apply a corresponding highlight spot on the same layer. Depending on the photograph, sometimes after the highlight spots are applied, they may seem too stark in their appearance. Because they

have been created on their own layer(s), their opacity can be lowered as needed. In the sample shown in Figure 11.29, the highlight layer's Opacity setting was reduced to 80%.

Once you are satisfied with the placement, size, and opacity of the woman's highlights, create a new layer or layers, then repeat the steps you have just learned to create highlight spots on the man's eyes. When you are satisfied with your results, before flattening the file, turn the visibility of the highlight layers off and then back on. As you will see, this simple little trick can have a significant impact on the final appearance of a photograph.

11.9.2 Adding Highlight Spots to Pets' Eyes

Let's open the White dog_enhanced.psd photograph that you saved in Chapter Two. Before we work on the dog's eyes, notice that the image can use some tonal adjustments that you may want to apply first. The sample shown in Figure 11.30 was corrected using three adjustment layers: Levels (lighten the image), Color Balance (remove the slight green cast when magnified in to the head area), and Hue/Saturation (lower the saturation slightly for more natural fur coloring).

Adding highlights to pets' eyes follow the same steps as those of humans. With a new layer created, and a small brush size chosen with: Hardness 100%, Opacity 100%, using white as the foreground color, let's single-click to apply highlights that favor the top left area of each eye in this photograph as shown in Figure 11.30. As we can see in this sample, when adding the highlight layer, it should be added directly above the Background layer, and below any adjustment layers you may have added to correct the image's color. Although this sample kept the highlight layer's Opacity setting at 100%, depending on the photograph you are adding highlights to, just as with people, sometimes you may want to lower the opacity of their application.

FIGURE 11.30 Adding highlights to pets' eyes.

Just for fun, with the Background layer selected, apply the Unsharp Mask filter to this entire photograph, with settings: Amount 71, Radius 2.2, Threshold 0, and watch the dog's hair, especially on his ears, pop off the page: animal fur is a great candidate for the Unsharp Mask filter in your future work.

When you are satisfied with your results, merged its layers if desired, then save and close this file.

Note

Why was a brush Hardness setting of 50% applied to the couple's eyes, and a brush Hardness setting of 100% applied to the dog's eyes? When adding highlights to eyes, you will want to assign a brush hardness based on the clarity of the photograph they are being applied to.

11.10 Correcting Flash Reflection

Reflection caused by a camera's flash can oftentimes negatively impact an otherwise great photograph. Let's learn how we can correct some of its most common adverse effects: "red-eye" in people, color and details in pets' eyes, and reflections in eyeglasses.

11.10.1 Eliminating Red-Eye

When red-eye exists in a portrait photograph, it can be eliminated by using either the Red Eye tool, or by combining an application of the Sponge tool with the Burn tool. Let's learn each of these methods, beginning with the elimination of red-eye in a photograph by applying the Red Eye tool.

11.10.1.1 *Eliminating Red-Eye Using the Red Eye Tool*

on the **DVD** Let's open the photograph named Red-eye.jpg provided in the Chapter 11 Files folder. Save it first as Red-eye_original.psd, then as a working copy named Red-eye_enhanced.psd into your Photoshop practice folder.

The Red Eye tool is grouped with the rest of the healing collection of tools we have already learned to use, as shown in Figure 11.31. Once the tool is chosen, its

two features, Pupil Size and Darken Amount, become active in the Options bar, with both of them at default settings of 50% as shown in Figure 11.32. These default settings usually work well, but can be adjust-

FIGURE 11.31 Choosing the Red Eye tool in the Tools panel.

ed lower if the tool's affect overpowers the red area of the eye it is applied to.

FIGURE 11.32 Options for the Red Eye tool.

Let's apply this tool to the left eye only of our Red-eye_enhanced.psd image (the person's right eye) using its default settings, by single-clicking on the pupil, just below the white highlight spot in the eye as shown in Figure 11.33.

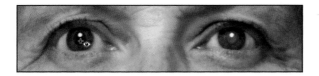

FIGURE 11.33 Applying the Red Eye tool.

11.10.1.2 *Eliminating Red-Eye by Applying the Sponge and Burn Tools*

As we have just seen, the Red Eye tool can oftentimes work great, correcting red-eye by converting a red pupil to a black one with a single click. However, depending on the photograph and the person's eye color, even with the ability to lower the darkening amount of the Red Eye tool's application, a more natural look may be achieved by applying the Sponge tool, or a combination of the Sponge tool and the Burn tool. Let's use the same photograph, but apply this technique instead to remove the red-eye from the person's other eye.

It will be important to begin by being zoomed in to a view similar to the one shown in Figure 11.34. Once we have done that, let's select the Sponge tool, and then in the Options bar, choose Desaturate from its Mode pop-up menu. Keep its Flow option at its default setting of 50% (even though for most applications of this tool, we have learned to lower its flow to 20%) and keep its Vibrance option checked, if applicable. It will be important to choose a brush size that is exactly the *same* diameter as the pupil to be covered with a Hardness setting of 0%. With the brush centered directly over the pupil, apply consecutive clicks without moving the mouse, until the red has been neutralized as shown in the left sample of Figure 11.34.

We learned in Chapter Two about increasing the default number of 20 states in the History panel to a suggested number of 200 states. Applying the same tool consecutively such as in this application of the Sponge tool, exemplifies how handy additional states can be. If

you chose not to increase the number of history states from the default of 20, and now decide to return to the first state, you will most likely discover that in actuality it is not the first state. Every mouse click is a state, and in order to neutralize the red-eye, you probably had to apply more than 20 mouse clicks. To increase history states if you still need to, choose the Performance category once the Preferences dialog box has been opened.

Sometimes at this point the red-eye has been naturally removed, and the correction is done. However, if desired, the Burn tool can be applied on top, in the same manner and location as the Sponge tool was to further darken its appearance using a brush again the same size as the pupil, with settings: Hardness 0%, Range Midtones, Exposure 20%, and its Protect Tones option checked if applicable, with this additional effect shown applied to the sample on the right in Figure 11.34.

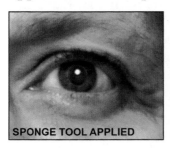 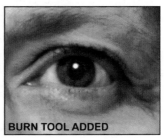

FIGURE 11.34 Sponge and Burn tools applied to eliminate red-eye.

When you are satisfied with your corrections of both eyes, save and close this file for now.

Demonstrating Red-Eye Correction

The application of these two techniques are demonstrated in a video clip included in the book's "Video Demonstrations" folder, titled: *"Demonstrating Red Eye Removal Using The Red Eye Tool, The Sponge Tool, And The Burn Tool"*. Feel free to stop and watch it now, or at any time as a refresher.

11.10.2 Eliminating Flash Reflection in Pets' Eyes

When photographing a dog or cat, if his/her eyes are affected by a camera's flash, it can be so disappointing, especially if the resulting shot, except for the eyes, happens to be a priceless one. Let's learn how we can fix this when it happens.

Open the Dog eyes.jpg file provided in the Chapter 11 Files folder, and save it first as Dog eyes_original.psd, then as a working copy named Dog eyes_enhanced.psd into your Photoshop practice folder.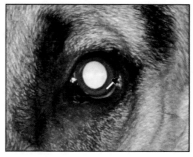

Let's begin by adding a layer above the Background layer and naming it eye color. We will need to use the Eyedropper tool to sample the existing brown color that surrounds the area affected by the flash. It will be helpful to magnify in to the eye to sample its color, as shown in Figure 11.35.

Once we have done that, a color such as R: 106, G: 76, B: 52 should now be the current foreground color in the Tools panel. With the eye color layer selected, let's use the Brush tool with Hard-

FIGURE 11.35 Sampling the brown color in the dog's eye.

ness 0%, Opacity 100% to paint over the flash reflection area. Now let's temporarily lower the opacity of this layer to 50%, and add another layer above it named "pupil". Working on the pupil layer, and using a brush size that is approximately the size of the reflection area (visible because the eye color layer opacity has been lowered), with black as the foreground color, and a Hardness setting of 50%, let's click once or twice to cover the flash reflection. Once this has been done, the opacity of the eye color layer can be returned to 100%. To complete this eye, the final step is one we have already learned, adding a highlight spot to it. Choosing a small brush size with Hardness and Opacity settings of 100%, let's add

another layer named "highlight" above the pupil layer, and with white as the foreground color, click once to add a highlight spot to this eye, placing it approximately at the top center of the pupil. Your Dog eyes_enhanced.psd image at this point should resemble the sample shown in Figure 11.36.

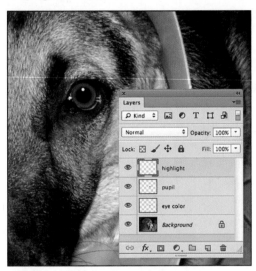

FIGURE 11.36 Sample of layers used to correct flash reflection in a dog's eye.

Following these same steps, the other eye will now be enhanced.

To complete the other eye, as an alternative to building it from scratch, you can select the eye color layer, the pupil layer, and the highlight layer used for the first eye and create a group from them, duplicate the group, move it into place, and then adjust each layer's size and position as needed based on the angle of the dog's head.

Once both eyes have been corrected, your Dog eyes_enhanced.psd image should now resemble the completed sample shown in Figure 11.37. When you are satisfied with your enhancements to this file, save and close it, optionally choosing to keep its layers in tact for future reference.

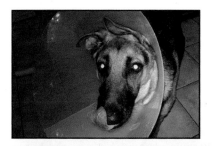

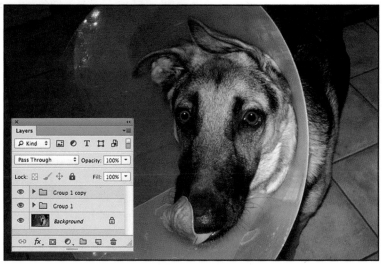

FIGURE 11.37 Before and after the dog's eyes have been enhanced.

11.10.3 Minimizing Flash Reflection in Eyeglasses

You may be curious why the title of this section is "Minimizing Flash Reflection in Eyeglasses" not "Eliminating Flash Reflection in Eyeglasses." Once you know how to reduce this malady, you can choose to completely eliminate its effects if you want to, however a little reflection is acceptable, and makes the person's eyeglasses appear natural. It is when the reflection overpowers the photograph that it should be addressed, and will be the focus of this correction technique.

Let's reopen our Monument Valley_enhanced.psd file we worked on in Chapter Ten, so that we can fix the flash reflection in the eyeglasses of our tourist. When the file opens, it most likely still contains multiple lay-

ers, the Background layer, our tourist layer, plus a variety of adjustment layers that were added to improve her tonal quality. Before beginning her eyeglass corrections, make any additional color corrections first, if you wish (sometimes when a file is reopened, you see more corrections you'd like to make), then merge all of its layers. Once it has been flattened, let's zoom in to a close up magnification that includes both eyes, so that we can study her eyeglasses. Notice that the left eye (her right), shows a slight amount of flash reflection which is not offensive, and looks natural. That will be our reference for the corrections we will apply to the right eye (her left). The corrections are made using the Clone Stamp tool, however, the trick is the Options bar settings. We can see in Figure 11.38 that the brush size we will want to select for this type of correction should only be slightly larger than the area we want to cover. For the Opacity setting, let's choose only 20%. Although at this opacity some of the areas will require more than a single click, we will have more control when cloning, as the changes with each click will be subtle. Once the reflections on the right have been corrected, a couple of clicks can also be added to minimize (not remove) the reflections on the frame only on the left side. When done, the

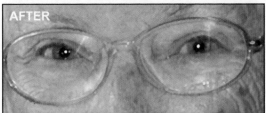

FIGURE 11.38 Minimizing eyeglass reflection.

eyeglasses of your tourist should resemble the sample shown in Figure 11.38. With the reflections reduced but not eliminated, they remain realistic. Once you are satisfied with your corrections, save and close the file.

11.11 Learning the Age Reduction Trick

Let's reopen our Red-eye_enhanced.psd file, so that we can now learn to remove "crows' feet" and reduce wrinkles, shaving some years off of the person in the photograph. We will use the Healing Brush tool for this type of enhancement, with Hardness 58%, and a brush Size setting comparable to the sample shown in Figure 11.39, based on your view. We have learned how to use the Healing Brush tool in Chapter Eight with the promise at that time that we would explore its "plastic surgery" capabilities.

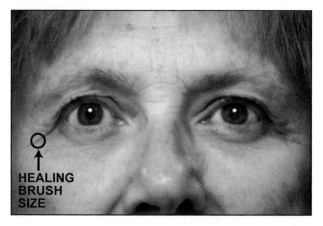

FIGURE 11.39 Choosing a brush size for the Healing Brush tool for wrinkles.

The trick that makes this particularly effective is to work on a separate layer when removing wrinkles, allowing the flexibility to not only delete the layer and start over if needed, but more importantly to lower the *opacity* (and therefore the effects) of the layer, literally controlling the "age" you reduce the person to. To do this, let's assign one more feature in the Option bar,

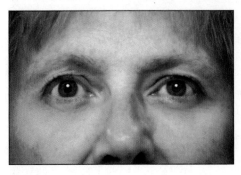

FIGURE 11.40 Wrinkles removed from the Red-eye_enhanced.psd file.

choosing Sample: All Layers, or alternatively: Current and Below. Now by sampling close to the area to enhance, the Healing Brush tool will remove the crows' feet and any other wrinkles you choose to apply it to. Once we have done that, the repair layer's opacity can be reduced, "adding some years back," to control just how much younger we want to make the person appear in the photograph. Feel free to reduce the Opacity setting of the Healing Brush layer, or keep it at 100% as shown in Figure 11.40.

Note

There is no limit to the number of Healing Brush layers you can add, with its Sample setting assigned to All Layers. In Figure 11.40, an additional layer was created for the area below the eye on the right, so that its Opacity setting could be lowered independently of the rest of the enhancements, to only 37%, as shown in Figure 11.41.

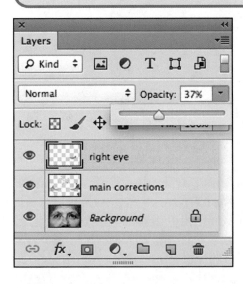

FIGURE 11.41 Adding multiple Healing Brush layers to adjust their opacity independently as needed.

11.12 Learning the Teeth Whitening Trick

Sometimes a great portrait photograph would be even better if the person's teeth were just a little bit whiter. Here's an easy trick to achieve that appearance.

Let's open the Teeth.jpg file provided in the Chapter 11 Files folder, saving it first as Teeth_original.psd, then as a working copy named Teeth_enhanced.psd into your Photoshop practice folder. Although there is more than one way to correct this malady in a photograph, this book will use the Replace Color command. The first step is to isolate the teeth with a selection. As we have previously learned, because the Replace Color command utilizes a Fuzziness amount which determines how "fussy" we want the command to search for the color to affect, the selection does not have to be extremely accurate, as shown in Figure 11.42.

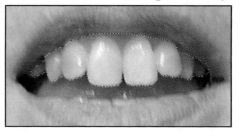

FIGURE 11.42 Selecting teeth to whiten them.

Before applying the adjustment however, it will be important to first apply a small feather radius, such as one or two pixels, to naturally fade the correction edges. Once we have done that, let's choose **Image>Adjustments>Replace Color**. In its dialog box, we will want to use the Image viewing mode instead of the default Selection mode. Now the eyedropper can be used to either select the color to correct in the preview window provided, or by moving its eyedropper out to sample an area within the image itself, with a suggested selection area shown in Figure 11.43.

How much do you whiten the teeth? Using the settings shown in Figure 11.43 of: Fuzziness 144, Hue 0, Saturation −74, Lightness +29, will whiten the teeth, but not drastically. Too white will draw the attention of the viewer directly to the teeth, as well as make them

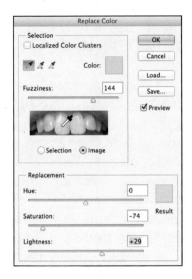

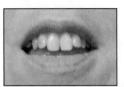

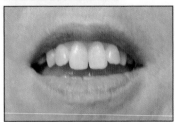

FIGURE 11.44 Whitening teeth using the Replace Color command.

FIGURE 11.43 Assigning settings to whiten teeth in the Replace Color dialog box.

appear fake and unnatural. With these settings applied, Figure 11.44 shows the teeth before the correction compared with their improvement using the Replace Color command.

Test Your Knowledge

1. What is aerial perspective?

2. What setting in the Liquify dialog box allows you to "slow down" the effect of the filter for better control?

3. What is the keystone effect?

4. The Unsharp Mask filter contains three settings: Amount, Radius, and _____?

5. What can the Quick Mask Mode applied as a gradient be used for?

6. As an alternative to using the Red Eye tool, what other two tools when used in tandem can also remove redeye in a portrait photograph?

7. What does the composition term "rule of thirds" mean?

8. To be able to apply a sepia tone to a grayscale photograph, what must you do to it first?

9. What does the Radius slider determine in the Unsharp Mask filter dialog box?

10. What collection of tools is the Red Eye tool a part of?

Try It Yourself

Project 1

Open the Cathdral.jpg file provided in the Chapter 11 Files folder. Save it first as Cathedral_original.psd, then as a working copy named Cathedral_enhanced.psd into your Photoshop practice folder.

1. Begin by applying the Shadows/Highlights command, leaving the Shadows slider at its default amount setting of 35%, and assigning its Highlights setting an amount of 40%.

2. Choose to display the Grid as well as the Rulers.

3. Convert the Background layer to a regular layer, and rename it "Cathedral".

4. Add a new layer and move it below the Cathedral layer.

5. With the Cathedral layer selected, choose **Edit>Transform>Distort**, and adjust its two top transformation handles to straighten the cathedral with the help of the grid, as shown in Figure 11.45.

6. Choose **Image>Canvas Size** and increase the canvas to a width of 4″, and height of 6″ with its Relative box left unchecked, and its Anchor setting assigned to center bottom.

7. With the Cathedral layer still selected, choose **Edit>Transform>Scale** and drag the top center

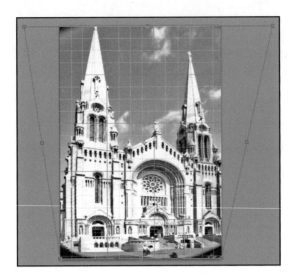

FIGURE 11.45 Using the Distort command to straighten the sides of the cathedral photograph.

transformation handle until it aligns with the ½″ mark in the vertical ruler, being sure to *not* hold the Shift key down when scaling the layer.

8. Once the transformation has been completed, use the Rectangular Marquee tool to select the cross and its base at the top of the right spire of the cathedral, including the sky above it as shown in Figure 11.46.

FIGURE 11.46 Selection of the cross at the top of the right spire and the sky above it.

9. Choose the Layer via Copy command, then move this new layer over to replace the cross at the top of the left spire which had been cut off in the original photograph.

10. Merge the cross and sky layer with the Cathedral layer, then fill all of the transparent areas in the sky, and remove the dark areas that were originally created by the camera's lens.

11. Recrop the photograph using a width of 4″ and a height of 6″ with a resolution of 300 ppi. The crop should include the spire on the left, and align with the existing right side of the photograph.

12. Fill the remaining transparent areas, using existing content as needed, then flatten and save the file. Your completed Cathedral_enhanced.psd image should now resemble the sample shown in Figure 11.47.

FIGURE 11.47 Before and after the cathedral distortion and content enhancements.

Project 2

Open the Creative crop.jpg file provided in the Chapter 11 Files folder.

1. As you have learned, save it first as Creative crop_original.psd, then as a working copy named Creative crop_enhanced.psd into your Photoshop practice folder.

2. Choose the Crop tool, and assign a width of 6″, height of 4″, with a resolution of 300 ppi.

3. Crop the photograph to enhance its aesthetic appeal focusing on the boat incorporating the principle of the rule of thirds.

4. When you are satisfied with your results, save and close the file.

Project 3

Open the Devils tower.jpg file provided in the Chapter 11 Files folder, saving it first as Devils tower_original.psd, then as a working copy named Devils tower_enhanced.psd into you Photoshop practice folder.

1. Convert the Background layer to a regular layer.

2. Use your favorite method to select its sky, then expand this selection by one pixel, apply a feather radius of one pixel to it, then delete the sky.

3. Open the Sky1.jpg file provided in the Sky photographs folder inside the Chapter 11 Files folder.

4. Arrange the two documents 2-up Vertical to drag the sky photograph into your Devils tower_enhanced.psd file, then close the Sky1.jpg file and do not save the changes if prompted.

5. Drag the sky layer below the Devils tower layer (Layer 0).

6. Without scaling it, reposition the sky photograph until its trees are just barely hidden behind the content of the Devils tower photograph as shown in Figure 11.48.

FIGURE 11.48 Devils tower with sky added and grass enhanced.

7. Choose Layer 0, then select just its yellow grass in the foreground area, and apply a feather radius of 5 pixels to the selection.

8. Apply the Unsharp Mask filter to this selection with settings: Amount 88, Radius 3.8, Threshold 0.

9. Flatten, save, and close the file.

Project 4

Take a look through some of your own photographs for one in which you want to either remove or reduce facial wrinkles, remove red-eye, improve the appearance of the eyes of a pet, or melt away a few pounds from a loved one.

1. Following our learning, save it first as (name)_original.psd, then as a working copy with the same name plus _enhanced.psd into your Photoshop practice folder.

2. Employ the techniques you have learned in this chapter to enhance the photograph.

3. Add extra layers when applicable to assist in your corrections.

4. Compare your completed enhancement to your original photograph. If you are satisfied with your results, choose to flatten any layers you created, or choose to save the file with the layers, to have the flexibility to further enhance it in the future, or to use it as a reference in your future work.

12 CONQUERING SPECIAL CHALLENGES

In order to be able to restore and enhance over-sized artwork, the creation of a composite file of multiple scanned sections will be examined, as well as how to photograph large artwork when scanning is not an option. Additional topics include how to redo only a section of a restoration without having to redo it in its entirety, how to brainstorm solutions to nontraditional restoration projects, and a recapitulation of the top ten tips you have learned in this book.

12.1 Digitizing Challenges

In our restoration and enhancement work thus far, we have learned to scan photographs, negatives, and slides, and we have learned to adjust the resolution of photographs downloaded from a digital camera. But what do you do when a picture is too large to fit on the bed of your scanner? And what do you do if a picture can't be removed from its frame, or is stuck to the frame's glass? Let's learn some techniques to address these types of challenges, beginning with how to scan a picture that is larger than your scanner's bed.

on the **DVD** A copy of each figure shown in this chapter can be viewed on the companion DVD included with this book.

12.1.1 Scanning Photographs Larger Than the Scanner Bed

When the entire picture you want to scan (photograph, drawing, painting, etc.) is too large to fit on your scanner's bed, one digitizing solution to this quandary is to scan the artwork in pieces, then combine them in Photoshop. By following a few important guidelines, this process can be done with minimal difficulty, resulting in a seamless composite image in Photoshop.

12.1.1.1 *Create a Significant Content Overlap Between the Sections Scanned*

When placing content on the scanner bed each time, it will be helpful to overlap the content contained in each specific section scan by a few inches. This will provide a tonal adjustment and placement alignment fudge factor when the scans are combined into a composite file later in Photoshop.

12.1.1.2 Place Each Section of the Artwork on the Scanner as Straight as Possible Using the Guides Provided on Your Scanner

It will be helpful to take the extra time required to assure that each time the content to be scanned is placed on the scanner's bed, that it is aligned with the scanner's edge guides as accurately as possible. The slightest shift in the positioning of a scanned section will require straightening later on in Photoshop, in order to properly align with the rest of the sections of the composite file.

12.1.1.3 Name the Scanned Sections According to Their Future Placement in the Composite File

Depending on the number of sections required to digitize the artwork, when saving each section file, name each one numerically such as #1, #2, etc. starting with the upper left corner, or assign them names such as "left half" and "right half" to make the assembly in Photoshop easier.

12.1.2 Assembling a Composite Image in Photoshop

Once multiple scans have been created of a picture, let's learn how to assemble them in Photoshop.

We will be using three files that were created from a pastel drawing that was larger than the scanner bed, and one that could not be removed from its glass and wood frame.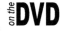

> **Note**
>
> When removing artwork from a frame is not possible, simply scan it still within the frame with the frame lying flat on the surface of the scanner's bed, and leave its lid up.

FIGURE 12.1 Assigning dimensions, resolution, color mode, and background color for a new document in the New dialog box in Photoshop.

To begin this process, we will need to create our composite canvas where we will add the scanned sections. With Photoshop open, let's choose **File>New**, something we have never needed to do before, as we have always opened existing files in our work. Once we have done that the New dialog box opens. Although we can see that the file can be named here, we will instead choose **File>Save As** once we have exited this dialog box. As shown in Figure 12.1, let's assign settings of: Width 12″, Height 22″, Resolution 300 ppi, Color Mode RGB, and in the Background Contents section, select White from its pop-up menu to define the color of the canvas.

When determining how large a canvas to create, calculate the size you will need based on the original picture size with a few additional inches added in both dimensions. This will provide flexibility when positioning the sections with the excess cropped away once the sections have been assembled and aligned.

Note

In the New dialog box, the Resolution and Color Mode settings should always be assigned to match the files that will be imported into it. For its Background color, although white is a suggested color, because any excess canvas will be cropped away and the files merged down once the scanned sections have been assembled, any one of its Background Contents options can be selected.

With the new canvas created, choose **File>Save As**, and name this file Pastel_composite.psd, saving it into your Photoshop practice folder.

The three scanned files that we will use to create this composite image are located in the Pastel scans folder provided in the Chapter 12 Files folder. With our composite canvas still open, let's choose **File>Open** and navigate to this folder. Once it is open, we can see that its three files are named: Top.psd, Middle.psd, and Bottom.psd. Let's open all three of these files so that we can import them into our Pastel_composite.psd file. Once they are all opened, it will be helpful to arrange them to view all four files simultaneously. We can see that each of the scanned sections will need to be rotated in order to align properly in the composite file, which can be done either before or after their importation. Using the Move tool, let's choose to import each section into the composite file first, and then rotate its layer as needed. As soon as a copy of each scan has been added to the composite, the originals can be closed without saving any changes, if prompted. Although not required, it will be helpful to rename each layer as they are imported according to their content. When all three files have been added to the composite, roughly position them according to their name and content as shown in Figure 12.2.

To accurately position each section, let's first select the Middle layer, and lower its Opacity setting to a percentage such as 67%. By turning this layer off and on while moving it using the

FIGURE 12.2 Three section scans rotated, named, and roughly positioned in the Pastel_composite.psd file.

arrow keys, we will be able to see the point where it is perfectly aligned with the Top layer. Once this has been achieved, this procedure can be repeated with the Bottom layer. With all three sections placed accurately, your composite file at this stage should resemble Figure 12.3.

FIGURE 12.3 Composite file with the content of the Middle and Bottom layers accurately aligned with the Top layer.

12.1.2.1 Adjusting Color Variations When Creating a Composite Image

When scanning a section of an oversized piece, sometimes an edge will scan darker than the rest, or an entire section may scan lighter or darker than the rest of the sections of the picture.

With our Pastel_composite.psd file, the content has been aligned, but a dark shadow is visible along the bottom edge of both the Top and Middle layers. By originally scanning with a generous overlap, when the appropriate layer is active and a selection of just the darkened edge is made and deleted, this problem is corrected. In

Figure 12.4, the shadow on the Top layer has already been selected and deleted, with the dark shadow on the Middle layer selected and ready to be deleted as well. Following this example, let's select and delete the dark edges of these two layers.

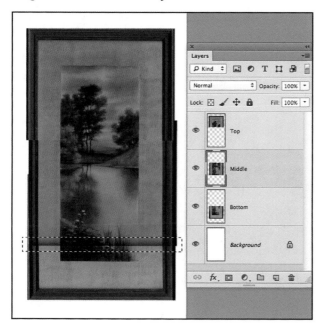

FIGURE 12.4 Deleting the darkened edge of overlapped layer content in a composite file.

Before cropping and flattening this file, we can also see that the Bottom layer requires an overall tonal adjustment to match the tonal quality of the other two content layers, such as a Levels adjustment layer with its Shadows triangle set to 32.

Note

When this happens in your own work, applying either a simple Levels or Curves adjustment layer to the mismatched section(s) will usually unify the tonal quality across all layers. If isolated tonal mismatches *still* remain on individual layers after an overall tonal adjustment has been applied, feathered selections can have adjustment layers applied to them, or the Dodge or Burn tool can be employed to further unify the tonal quality across all sections of all scans of a composite image depending on whether an area is too light or too dark.

When you are satisfied with both the positioning and tonal matching of the three sections of the pastel file, the file can be cropped and its layers merged. The file as shown in Figure 12.5 is now ready for the restoration and tonal correction it requires. Save and close the file, or feel free to complete its restoration now or at any time in the future.

FIGURE 12.5 Composite file cropped and flattened.

In your own work, once you have aligned and color adjusted all of the scanned sections of a composite file, it will be helpful to print a test copy scaled to fit, to carefully examine the color and positioning of each section for any final adjustments that should be corrected before the file is cropped and flattened.

12.1.3 Scanning a Photograph Stuck to Glass

When a photograph is stuck to glass, attempting to detach it by soaking, etc. has its risks. As an alternative, a photograph can be scanned while still stuck to its

frame's glass as shown in Figure 12.6. In this example, the smaller original is shown clearly stuck to its frame's glass in multiple areas, as evident by its reflections. The larger version is the same photograph scanned with its glass attached, and then converted to grayscale in Photoshop. In this example, shown before any restoration work has begun, we can see that no flash reflection, or any other indication that the glass was scanned along with the photograph, is visible in it, except for the fold lines that existed in the original photograph because it was larger than the frame it was placed in.

PHOTOGRAPH TAKEN OF ORIGINAL WITH EDGES OF GLASS VISIBLE

PHOTOGRAPH AFTER SCANNING AND GRAYSCALE CONVERSION

FIGURE 12.6 Before and after a photograph stuck to glass has been scanned.

12.1.4 Photographing a Picture That Can Not Be Scanned

Sometimes you may have a picture hanging on a wall that you cannot easily scan in pieces, but still want a digital copy of it. Whether it is a print or any other type of artwork, if its frame contains glass, photographing the artwork can be challenging to minimize the light

reflections that will appear in the glass. Some typical solutions include move the artwork outdoors to photograph it, apply a polarizing filter to your camera, or use specially positioned additional lighting. However, this book will examine two additional solutions you have available to you because of your expertise in Photoshop. Photograph the artwork with your camera's flash off, or photograph the artwork at an angle.

12.1.4.1 Photographing the Artwork With Your Camera's Flash Off

By turning off the flash on your camera, you will eliminate most of the reflection in the glass when the photograph is taken. Because your camera's flash will be off, a tripod can help eliminate blur, or alternatively, anything you can rest your camera on to stabilize it when taking the photograph. Without using a flash, the resulting photograph will oftentimes be dark, and still contain some minor reflections as shown in Figure 12.7.

FIGURE 12.7 Photograph of a painting taken with a camera's flash off.

Click TIP

When photographing artwork to digitize it, it will be helpful to take multiple shots, some closer, some slightly further back, etc. By opening them later in Bridge, you will be able to easily compare them, and choose the best one to enhance.

Once you have opened the file in Photoshop, before adjusting its tonal quality, or any remaining flash reflections, crop the photograph to eliminate its frame and/ or mat, as these can affect your color adjustment settings. As shown in Figure 12.8, once cropped, with only the Auto Color command applied, the original painting shown in Figure 12.7 is already substantially improved with only three minor reflections remaining to remove, identified by the red arrows.

FIGURE 12.8 Digitized painting with Auto Color command applied and reflections identified.

Using some of the tools and techniques you have learned, selecting an area, feathering it, adding a color adjustment to it, and sparingly applying the Patch and Burn tools, these reflections which appear as patches of lighter content can all be eliminated.

With all of the light areas removed, to more closely match the colors of the original painting, the Color Balance command was applied, along with the Curves command to further lighten the overall tone of the painting. Once all of these techniques and adjustments were applied, the resulting digitized painting is shown in Figure 12.9.

FIGURE 12.9 Digitized painting with all reflections eliminated, and final color and tonal adjustments applied.

In your own work, once you think you have accurately matched your digital copy's colors to the original artwork you photographed, it will be helpful to print a copy of your digital image before merging any color adjustment layers you may have added to the file. This will allow you to compare the colors in the print against the original, just in case its adjustment layers require further modifications to more precisely match the original artwork you have digitized.

12.1.4.2 *Photographing the Artwork at an Angle*

Using this method, the camera's flash can be turned on. How much of an angle you will need to stand at relative to the artwork will depend on the size of the artwork, so multiple shots taken from the right and left at slightly different angles will be helpful, with the resulting images again reviewed in Bridge. In Figure 12.10, we can see that the flash reflection of the chosen photograph appears on the mat area, just outside the content area of the artwork.

The next step is to straighten the distortion. Although we have learned other distortion correction techniques, the application of the Distort command is particularly effective for this type of adjustment. In

FIGURE 12.10 Photographing artwork under glass from an angle.

FIGURE 12.11
Edit>Transform>Distort command applied to straighten artwork photographed at an angle.

Figure 12.11, the four corner transformation handles are adjusted as needed with the help of the guides added, so that the proportions of the resulting corrections are kept relative to the shape of the original artwork.

Once this command has been applied, the image can be cropped to eliminate the frame, and the color adjustments can begin. As we can see in Figure 12.12, after the initial application of the Auto Color command, in this version of the painting, virtually *no* reflections are visible, except for a slightly lighter edge near where the flash

FIGURE 12.12 Straightened artwork cropped and the Auto Color command applied.

had been, that can easily be corrected with the Burn tool, followed by any additional respective color adjustments as may be required to match the original piece.

12.2 The Selective Redo Technique: How to Redo Without Starting Over

You will find in your work that it will be important to reopen a restoration a day or two after you "think" you are finished. You'll be surprised when you do how often you will see things you want to change, that you didn't notice when you worked on it previously for multiple consecutive hours at a time. Sometimes the changes or additions are easy, and are no problem to further perfect your work. However, other times there will be areas you will want to do over. But because you have reopened a previously closed file, and therefore can't go back to an earlier History state, do you want to start the entire restoration over, especially if what you have done for the *most* part, is great? There are two better solutions, depending on your workflow.

12.2.1 Using Content from the Background Layer if It Was Duplicated

on the DVD Let's open the Pahls1.psd file provided in the Chapter 12 Files folder, and save it first as Pahls1_original. psd, then as a working copy named Pahls1_redo.psd into your Photoshop practice folder.

As we can see when this file opens, the Background layer was duplicated first to create a working layer named Working. Let's learn how to redo the area of the Working layer outlined in red in Figure 12.13. Here the window's edge is not straight, and the stripes on the window awning to the right of it were poorly restored and look fake.

We have learned about duplicating a Background layer before beginning a restoration. While useful for

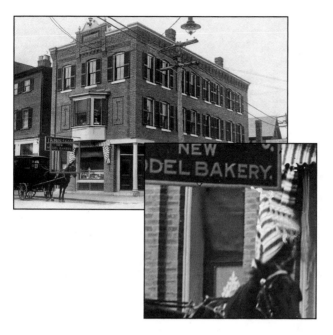

FIGURE 12.13 Area to redo identified in red.

a variety of reasons, it will be particularly handy when this type of scenario arises. If you begin a restoration project by duplicating its Background layer to create a working layer, and need to redo part of it later on, the process will be quick and easy. Let's learn it now. We will begin by temporarily hiding the visibility of the Working layer, choosing the Background layer, and creating a selection of just the area that we want to replace on the Working layer (selecting the content to redo when in your *own* work). When selecting it, we will want to be generous in the size of the selection, and to apply a small feather radius such as 5 pixels to it, then choose the Layer via Copy command, as shown in Figure 12.14.

FIGURE 12.14 Selection of an area on the Background layer to replace the corresponding area on the Working Layer.

We can now turn the visibility of the Working layer back on, and this copied content layer can be moved *above* the Working layer, but *below* the Adjustment layer, that the Working layer already has applied to it. Once we do that, we can see that this copied content layer needs its own adjustment layer in order to match the Working layer. Let's apply a Levels adjustment layer clipped to affect only the copied content layer, with its Shadows triangle set to 39, and then merge this adjustment layer down onto the copied content layer. Once we have done that, any unnecessary content can be erased from the copied content layer, and then it should be merged down onto the Working layer, to begin redoing the area that was not done satisfactorily the first time. Now feel free to restore this replaced area, or simply save and close the file.

12.2.2 Using Content from the Original File

In your own work, if you have a restoration that you are done or near done with, that you did *not* duplicate its Background layer first before you started its repairs, and want to redo an area of it without starting over, there is another solution.

on the DVD Let's open the Pahls2.psd file provided in the Chapter 12 Files folder and save it first as Pahls2_original. psd, then as a working copy named Pahls2_replace.psd into your Photoshop practice folder. We can see that this restoration contains the same area requiring replacement as the one we just worked on, except that all of its repairs have been applied directly onto its Background layer. In our work throughout this book, we have learned to always save an original .psd version of every project before beginning to restore or enhance a copy of it. Let's now also open the original copy of this file named Pahls_original.jpg provided in the Chapter 12 Files folder, and then arrange the original and working documents to be able to easily access both of them simultaneously. We can see that our Pahls2_

replace.psd file contains an adjustment layer used to add its sepia tone, which we will choose to temporarily hide before adding content from the Pahls_original.jpg file. With the Pahls_original.jpg file active, let's make a generous selection of the same general area as we did in the last project, and also apply a small feather radius of 5 pixels to it. Now using the Move tool, let's drag this selection into our Pahls2_replace.psd file, and then close the Pahls_original.jpg file without saving any changes.

Once the selection has been added to the working file, let's move it approximately into its desired position, above the Background layer, but below its adjustment layer. To position the replacement content over the area we want to redo, let's zoom in to be able to accurately view and work on the area. Once we have done that, we will want to lower the opacity of the repair layer enough to see both layers to apply the up/down/left/right arrow keys to move it into its exact position. When the

repair layer can be turned off and on with its Opacity setting at 100% with no visible shift in its position, the repair layer is perfectly aligned with the original content below it as shown in Figure 12.15.

Once the existing adjustment layer is turned back on, we can see that this repair layer needs a separate adjustment layer clipped to affect only its content, such as

FIGURE 12.15 Positioning the repair layer over the area to be redone.

a Levels adjustment with its Shadows triangle set to 70. Once this adjustment layer matches the tonal quality of the repair layer to the Background layer, let's merge it down onto the repair layer. Just as before, we will now want to erase all unnecessary extra content on the repair layer that is not required to redo the area below it on

FIGURE 12.16 Repair layer merged down onto the Background layer ready to be redone.

the Background layer. When the repair layer appears to blend seamlessly in its positioning and tonal quality with the working layer below it, and all of its excess is removed, it should be merged down as shown in Figure 12.16. When you are satisfied, save and close this file, or choose to finish its restoration if you would like.

Demonstrating the Selective Redo Technique

These two redo techniques are demonstrated in a video clip included in the book's "Video Demonstrations" folder titled: *"Demonstrating The Selective Redo Technique"*. Feel free to stop and watch it now, or at any time as a refresher.

12.3 Thinking Outside the Box: Solving Nontraditional Challenges

When you encounter a nontraditional restoration challenge, it presents the perfect opportunity to use your professional expertise to "think outside the box" for a repair solution. It will be helpful to start by asking yourself the following questions:

- Does the photograph contain any content I can copy and reuse somewhere else?
- Do I have another photograph I can borrow content from to replace damaged content in the restoration?

- What filters have I learned to apply that might be helpful on this photograph?
- Would it be better to photograph the original, scan it, or try both?
- What will be the most effective and efficient application sequence of the repair techniques I need to employ?

Let's take a look at a couple of unique restoration projects that will help jump-start this thought process in your own work.

12.3.1 Repairing a Photograph Applied to Metal

In the sample shown in Figure 12.17, the original photograph consisted of a metal surface that over the years had separated from its backing. Rather than attempt to reseal the lifted areas of the photograph, to preserve this precious memory before it sustained further damage, it was scanned instead so that it could be repaired and reproduced digitally.

METAL SURFACE HAS LIFTED FROM ITS BACKING

FIGURE 12.17 Original photograph shown with surface lifted from its backing.

During the scanning process, additional pressure was applied to the lid of the scanner to push the lifted sections back down flush with the rest of the photograph's surface area with the resulting scan shown in Figure 12.18.

In examining the original, although its border contained a "honeycomb" pattern that was badly damaged in some

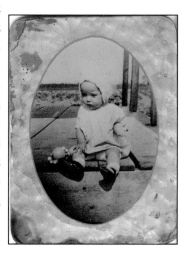

FIGURE 12.18 Scanned original with lifted areas flattened.

areas, most of the actual photograph area of this piece remained in tact. Further study showed that the honey-comb pattern was random, not requiring precision rep-lication, with a section shown in Figure 12.19.

FIGURE 12.19 Section of the random honeycomb pattern outside the image area of the photograph.

Because of this, feathered selections from other areas of the pattern could be copied, scaled, rotated,

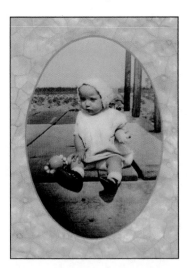

distorted, etc., varying each one's size and origin, using the Layer via Copy command combined with the applica-tion of the Clone Stamp tool and some of the other healing tools, to create new pattern areas to replace its various damaged ones. Its corners were also squared off, allow-ing the resulting restoration to fit properly in a standard frame, with the resulting restoration shown in Figure 12.20.

FIGURE 12.20 Completed digitized restoration of a photograph whose metal surface had been damaged.

12.3.2 Repairing Missing Text

Another application of the Layer via Copy command can be to add/repair/replace text in a restoration. In the project shown in Figure 12.21, in addition to its overall restoration, some of the ancestral information contained in this family tree was incorrect, for which the owner of the document had tried to correct on his own.

FIGURE 12.21 Original family tree with enlarged area whited out.

Although the area on the left was information that needed to be removed, the area on the right needed some names added to replace the incorrect ones that had been covered over with correction fluid. Replacement letters and lines were copied from other parts of the tree, then scaled and rotated as needed, as well as the style and placement of the letters in the names, were copied from surrounding names as shown in Figure 12.22.

FIGURE 12.22 Before and after the corrected names have been added to the family tree.

This technique was also used to replace some of the letters in existing names in other areas of the document that were filled in and hard to read, such as the name "George" in the upper right corner of each of the samples in Figure 12.22. To complete the project, the small shield shown to the right of the tree was filled in with the family colors, by creating selections of its sections and moving them onto separate layers, and then applying fills to them as shown in Figure 12.23.

FIGURE 12.23 Completed family tree.

12.4 Top Ten Best Practices for Your Future Professional Restoration and Enhancement Work

The following ten tips are ones from various chapters in the book that will increase your efficiency, your proficiency, and your professionalism. Let's recap them now:

1. Always save an original version, then create a working copy to restore or enhance.

2. Zoom in when restoring a photograph to maximize your accuracy.

3. Always apply color and tonal corrections as adjustment layers whenever possible.

4. Apply a small feather radius to a selection when using the Layer via Copy command.

5. Always match resolutions when combining images.

6. Apply Filters as Smart Filters whenever possible.

7. Create separate layers for gradients and fills.

8. Crop and print a copy of the original photograph at the final size and paper quality before beginning each restoration.

9. Leave the project and come back to it. You may notice things to add or change that you missed the first time.

10. Remember to *have fun*.

Test Your Knowledge

1. When photographing a photograph, how can you minimize glare?

2. How large a canvas should you create for a composite image?

3. How can you verify that a "redo" piece of an original photograph has been added exactly over the area you want to replace?

4. What tonal side effect can sometimes occur as a result of scanning a picture in sections due to its size?

5. What should you always do when scanning a picture in sections, to help in the alignment process when the composite image is assembled in Photoshop?

6. Once a "redo" piece has been verified as being exactly over the area you want to replace, what should you do before continuing with the restoration/enhancement?

7. What background color should you select when creating a new canvas to import scanned sections into?

8. What dialog box do you need to access to create a new canvas to build a composite image on in Photoshop?

9. When an original repair section is added to a completed restoration, where should it be added in the Layers panel?

10. How do you scan a photograph that cannot be removed from its frame?

Try It Yourself

Project 1

on the DVD

Open the Scanned composite.psd file provided in the Chapter 12 Files folder. Save it first as Scanned composite_original.psd, then as a working copy named Scanned composite_ready.psd into your Photoshop practice folder.

1. Begin by turning each layer off and back on to understand what content on each layer is visible in the composite file.

2. Apply individual Levels adjustment layers to begin to unify the tonal quality of the composite, with each one clipped to affect only the layer it is added to correct, as shown in Figure 12.24.

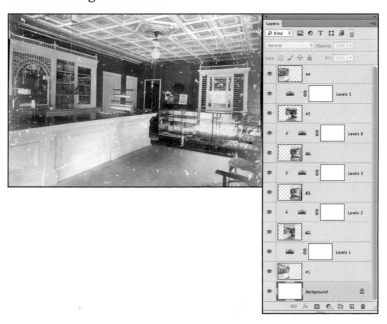

FIGURE 12.24 Levels applied as adjustment layers clipped to correct each layer individually as needed.

3. Once all of the layers contain *generally* similar levels, apply the Dodge tool with a large, brush, and settings of: Hardness 0%, Range Midtones with its Exposure set to a low percentage such as 17% to spot lighten the edges of some of the layers as needed to blend them in.

4. Conversely, apply the Burn tool also with a large brush, and settings of: Hardness 0%, Range Midtones, with its Exposure set to a low percentage such as 17%, to spot darken the edges of some of the layers as needed to blend them in.

5. When the tonal quality across all of the composite layers is *generally* unified, flatten the file.

6. If needed, create feathered selections using the Lasso tool, and apply Levels adjustment commands to any remaining spot areas of the photograph, to further unify the tonal quality of the photograph, and then merge these additional adjustment layers down.

7. Once all tones in the file have been unified, apply a final Levels adjustment layer to the entire flattened file to increase its contrast, if desired.

8. Crop the file to a width of 12″, a height of 8″ with a resolution of 200 ppi (the original file is 200 ppi rather than 300 ppi, intentionally assigned as such to allow its file size to be more manageable for this book project), to remove the white areas around the outside of some of the scans, or choose to fill them in with image content, with your file at this stage resembling Figure 12.25.

FIGURE 12.25 Composite file ready for its restoration.

9. Save the file, then restore it now if you would like, or at any time on your own to further practice and sharpen your restoration skills.

Project 2

Select a photograph or piece of artwork of your own that is too large for your scanner's bed, requiring it to be scanned in two or more sections.

1. When scanning, scan each section at a resolution of 300 ppi, and name each one appropriately relative to its location within the original file.

2. Create a new blank document with a resolution of 300 ppi with a minimum of two inches added to each dimension of its canvas beyond the dimensions required for the original artwork, saving the document as My composite_practice.psd.

3. Open all of your scanned sections, and drag them into your composite file, then close the original scanned files without saving any changes.

4. Assemble your scans, rotating them if needed, then delete any dark edges that overlap the duplicated content below them.

5. Adjust each layer's tonal quality using individual adjustment layers clipped to affect only the layer they are designed for if needed, to unify the composite file.

6. When all of this file's layers are perfectly aligned with their position verified by turning them off and on individually in the Layers panel, and their tones have been matched, save this project with its layers for future reference into your Photoshop practice folder.

Project 3

Open your completed Fire truck_sepia.psd file from your Photoshop practice folder, which should be saved with a Hue/Saturation adjustment layer, and save a new working copy of it as Fire truck_redo.psd into your Photoshop practice folder.

1. Open the *original* Fire truck.jpg file provided in the Chapter 7 Files folder, and select an area similar to the sample shown in Figure 12.26, and apply a feather radius of 5 pixels to this selection.

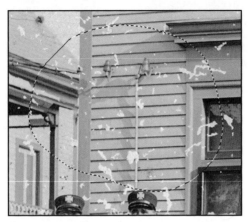

FIGURE 12.26 Selection of the original Fire truck.jpg file.

2. Arrange the two documents to conveniently drag this selection into your Fire truck_redo.psd file, positioning it below the existing Hue/Saturation adjustment layer in the Layers panel.

3. Apply a Levels adjustment layer clipped to affect only this new layer, to match its tones with the Background layer, such as adjusting only its Highlights triangle setting to 200.

4. Adjust its placement so that when turned off and on, it blends seamlessly with the original file as shown in Figure 12.27.

5. Save and close the file with all of its layers for future reference.

Project 4

Use your digital camera to photograph a piece of artwork under glass. When photographing it, turn your camera's flash off to minimize flash reflection, or shoot

FIGURE 12.27 Fire truck_redo.psd with replacement content aligned and Levels adjustment applied.

your photographs at an angle, and take multiple shots at varying distances from the artwork.

1. Download the photographs, and then open them in Bridge to select the one you want to work on in Photoshop.

2. In Photoshop, begin by straightening the image if applicable, using one of the methods you have learned, and then crop the photograph to remove its mat and/or frame if it is visible in the image.

3. Begin by applying a general tonal adjustment to the photograph.

4. Create feathered selections with adjustment layers applied to them, to remove any reflection areas your photograph may contain.

5. Additionally, apply spot adjustments as needed, using the Burn tool with a soft brush and low exposure setting to further eliminate any small reflection areas that may remain, and/or apply small Patch tool corrections to remove the appearance of any seams that may remain along the edges of reflections that have been corrected.

6. Print a copy of the photograph to compare its tones with those of the original artwork.

7. Apply any additional adjustment layer(s) *above* any clipped layers you may have created, as may be needed, to further adjust the *overall* tonal quality of your photograph to match it to the original artwork, then print a second color proof of the file.

8. When you are satisfied with your results, save the file with its layers for reference, or choose to merge them, and then close the file.

PUTTING IT ALL TOGETHER:
APPLYING YOUR SKILLS TO COMPLEX RESTORATION AND ENHANCEMENT PROJECTS

In This Chapter

- Correct an extreme color cast
- Repair surface damage combined with folds and tears
- Artistically crop and enhance the lighting and depth of a photograph
- Assemble and repair a composite image

In your own projects, while some of them will require the application of a particular tool or technique to complete them, more commonly they will require a multiplicity of tools, filters, commands, and techniques to fully restore and/or enhance them. In preparation for that, each project in this chapter has been specifically selected to provide a variety of challenges designed to facilitate the refinement and perfection of your skills as a professional.

13.1 Choosing to Follow the Step-By-Step Project Completion Format

This final chapter is comprised of four hands-on projects, which are a culmination of our learning. In some instances, although one method will be shown, more than one solution will provide similar satisfactory results. When applicable, feel free to tap your expertise, by choosing an alternate method that you prefer instead. Each project will begin with a before and after sample, and a general list of the tools and techniques that will be required to restore/enhance it. Feel free to then follow the step-by-step instructions provided to guide you through the project, or challenge yourself to locate its working file(s) and complete the restoration/enhancement project on your own.

on the **DVD** A copy of each figure shown in this chapter can be viewed on the companion DVD included with this book.

Project 1

FIGURE 13.1 Before and after the Black dog photograph enhancement.

13.1.1 Black Dog Photograph Enhancement Step-By-Step

Tools, Commands, and Techniques

- Alpha channels
- Dust and Scratches filter
- Auto Color command
- Adjustment layers
- Sponge tool
- Eyedropper tool
- Eye color, pupil, and pupil highlight layers
- Brush tool
- Color Picker
- Spot Healing Brush tool

Open the Black dog.jpg file provided in the Chapter 13 Files folder, and save an original .psd version and a working copy with the name of your choice (optionally choosing to duplicate the Background layer to create a working layer) into your Photoshop practice files folder.

1. When examining the photograph closely, we can see that the dog's fur contains a slight digital texture to it. By applying the Dust and Scratches filter with a small pixel radius, this textural quality can be reduced. To do this, we will need to create an accurate selection of the dog, and apply a small feather radius to the selection, such as 5 pixels. Once the selection has been created, let's choose to save the selection into an Alpha channel, so that we will be able to reuse it again later.

2. With the selection active, in the Dust and Scratches dialog box, let's assign settings of: Radius 1, Threshold 0, as shown in Figure 13.2, and then deselect the selection.

FIGURE 13.2 Dust and Scratches filter settings for the black dog.

Note

Although applying the Dust and Scratches filter with only a 1 pixel radius will reduce but not completely remove the digital texture on the dog, if a larger radius is applied, the fur texture will be removed as well. In your own work when using the Dust and Scratches filter, study the preview area of its dialog box closely as you adjust its Radius and Threshold settings to determine at what point its effectiveness is maxed out based on the original texture within the photograph.

3. To begin correcting the color in the photograph, we can start with the application of the Auto Color command.

4. Although this improves the color, we can see that more correction is required. Let's now apply a Color Balance adjustment layer to the entire photograph with settings of: Cyan/Red 0, Magenta/Green 0, Yellow/Blue –16. At this point we are not simply adjusting the dog's color, we are also adjusting the floor tile color.

5. Because the tile color now looks natural, let's reactivate the alpha channel we previously created of the dog, so that our next color adjustment will only affect it. With this selection active, let's apply a Hue/Saturation adjustment layer, changing its Saturation setting to –65, keeping both its Hue and Lightness settings at 0.

6. A small blue cast still remains now only between the dog's legs that can be removed with the Sponge tool using a large brush with a Hardness setting of 0%, its Mode set to Desaturate, with a Flow setting of 20%, and its Vibrance feature checked.

7. For the dog's eyes, let's create a new layer first above the adjustment layers, and sample the existing brown area of one of its eyes with the Eyedropper tool, then darken this color slightly in the Color Picker by changing it to R: 96, G: 80, B: 51. Using the Brush tool and a corresponding brush size with a Hardness setting of 0% and an Opacity setting of 100%, we will paint over the brown area in each eye.

> **Note**
>
> You have learned that when adding an enhancement to a pair of eyes, an effect can be applied on the same layer or to separate layers for each eye depending on your work preference. These directions assume that for each of the three layers required to reconstruct the dog's eyes in this project, each effect will be created for both eyes on the same layer.

8. Let's choose to temporarily lower the Opacity setting of this eye layer for now, to approximately 50%.

9. As we have previously learned, for the dog's pupils, we will want to add another new layer above the eye layer. With black as the foreground color, and the Brush tool chosen, select a brush size slightly larger than the existing pupil, with a Hardness setting of 50% and an Opacity setting of 100%. Center the brush over the pupil and click once to add the black pupil, and then return the opacity of the eye layer back to 100%.

10. For the pupils' highlights, let's add another new layer above the pupil layer. With white as the foreground color and the Brush tool chosen, select a small brush size with both a Hardness setting and Opacity set-

ting of 100%, and click to center the highlight above the middle of the pupil. If you have created one layer for both eyes when adding each effect, your Layers panel should now resemble Figure 13.3.

FIGURE 13.3 Layers panel with adjustment layers and eye enhancement layers added.

11. With the Background layer selected, the remaining minimal surface damage on the photograph can be removed easily using the Spot Healing Brush tool.

12. The alpha channel can now be deleted, and the file flattened prior to saving and closing it, or alternatively saved with its layers and channels for future reference.

Project 2

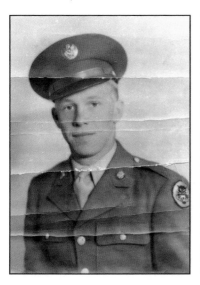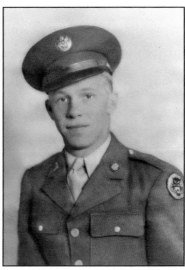

FIGURE 13.4 Before and after the Soldier photograph restoration.

13.1.2 Soldier Photograph Restoration Step-By-Step

Tools, Commands, and Techniques

- Healing tools
- Adjustment layers
- Eraser tool
- Eyedropper tool
- Layer via Copy command
- Surface Blur filter
- Gaussian Blur filter
- Replace Color command
- Brush tool
- Transformation commands

Open the Soldier.jpg file provided in the Chapter 13 Files folder, and save an original .psd version and a working copy with the name of your choice into your Photoshop practice folder.

1. Before beginning this restoration, to more clearly understand the specific repair instructions detailed

in these steps, as well as identify additional repairs you will need to apply to it, begin by printing a copy of the file at its final output size of 5" × 7".

2. Due to the extensive repair work this file will require, let's duplicate its Background layer and rename this new layer Working, and then lock the position of this layer.

3. We will start its restoration by repairing just the tears in the photograph using the Clone Stamp tool and/or the Healing Brush tool and the Patch tool. In the sample shown in Figure 13.5, both the Clone Stamp and Healing Brush tool were alternately applied in random order to demonstrate that for this *type* of repair, they can be used interchangeably based on your personal preference.

FIGURE 13.5 Folds repaired in the Soldier photograph.

4. When we study this soldier's face, we can see that in addition to its textural quality, it has some larger spots identified in Figure 13.6. Let's remove just

these larger blemishes quickly and easily using the Spot Healing Brush tool.

FIGURE 13.6 Before and after the large blemishes have been removed from the soldier's face.

5. Let's select the soldier's head and neck (selecting his skin only, not his hair or hat), using an accurate selection method, and apply a feather radius of 5 pixels to this selection, and then save it into an alpha channel.

6. With this head selection active, we will apply two adjustment layers to improve the color of the skin: a Color Balance adjustment layer with settings of: Cyan/Red 0, Magenta/Green −7, and Yellow/Blue −21, then add a Hue/Saturation adjustment layer, setting its Saturation slider at −25, with both its Hue and Lightness settings kept at 0, being sure that each of these adjustment layers affect only the head selection as shown in the Layers panel in Figure 13.7.

7. With the large spots repaired on the soldier's head and neck, let's minimize its remaining textural quality. With its alpha channel loaded, we will want to choose the Layer via Copy command to create a copy of this selection on its own layer, being sure that this new layer is below the two adjustment layers in the Layers panel.

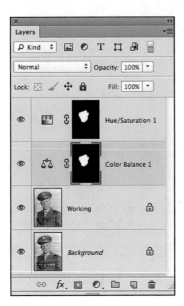

FIGURE 13.7 Adjustment layers added to the face selection only.

8. With this layer active, let's apply a Surface Blur filter with settings of: Radius 8, and Threshold 7, then lower the Opacity setting of this layer to 80%. This will eliminate most of the textural quality on the skin without having it appear fake as shown in Figure 13.8.

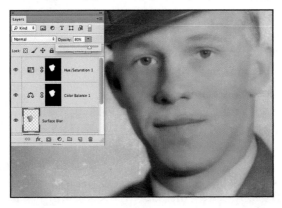

FIGURE 13.8 Surface Blur applied to a separate layer with its opacity lowered to 80%.

9. Once this blur has been applied and its layer opacity lowered, this blur layer, as well as the two adjustment layers created for the facial tones, should all be merged down onto the Working layer.

10. To unify the background texture of this photograph, let's create an accurate selection around the outside of the soldier, to apply another Surface Blur filter, choosing to expand this selection assigning an Expand By setting of 1 pixel, and a feather radius setting of 1 pixel assigned to it as well.

11. With this selection active, due to the severity of the background's damage, our Surface Blur filter settings will need to be higher than those used for his skin, with suggested values of Radius 16 and Threshold 30 as shown in Figure 13.9.

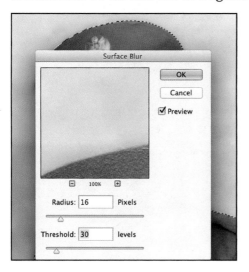

FIGURE 13.9 Surface Blur filter applied to a selection of the background.

12. Once this filter has been added, any remaining background coloring anomalies can be eliminated by applying the Gaussian Blur filter with a suggested Radius setting of 20 to area selections created with a soft feather radius assigned to them first, such as a setting of 10 pixels.

13. It is time to refine the repairs previously made to the soldier's uniform. Although the tears in the photograph may be gone, many of its details, such as pocket stitching, etc. may be gone as well, and its resulting repair coloring uneven. For its details,

we can utilize the Layer via Copy command. Although the sample shown in Figure 13.10 typifies just one example of borrowing some of the jacket's pocket stitching, examine your work closely for areas where its details are lost, but can be copied and reused from another area where the same detail is clear, always remembering that sometimes once a repair layer is created, it may be more effective with its opacity reduced.

POCKET STITCHING SELECTION MADE, FEATHERED AND COPIED

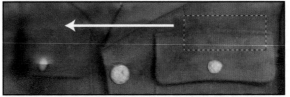

POCKET LAYER WITH EXCESS ERASED, AND LAYER OPACITY REDUCED

FIGURE 13.10 Pocket detail copied and reused with its excess erased and its opacity reduced.

14. For some of the edge details of the jacket, we can use the Eyedropper tool to select an appropriate color to paint its edges back in using the Brush tool, assigning a small brush size, and applying the color on its own separate layer, so that its opacity can be reduced. One of the areas that may benefit from this is shown in Figure 13.11 with the opacity of the layer then reduced.

15. With transformations applied, we can use the Layer via Copy command to repair the pin on the jacket lapel as shown in Figure 13.12.

**POCKET DETAIL
PAINTED
ON ITS OWN
LAYER**

**LAYER OPACITY REDUCED AS
NEEDED TO MELD**

FIGURE 13.11 Using the Brush tool to redefine edge details.

FIGURE 13.12 Lower half of the pin copied and transformed to repair its damaged top half.

16. This same concept can be used to improve the jacket's buttons, by borrowing the details from the clearest one, such as the one on the right pocket. Once the button is copied, it can be distorted as needed to replace the other pocket button, as well as copied and scaled to cover the larger buttons which lack the detail that it contains.

17. To unify any spotty or unevenly colored areas of the jacket, we can effectively minimize them by using the Patch tool, and selecting comparable areas for each application.

18. To adjust the overall coloring of the left half of the jacket that appears slightly darker than that of the right, let's apply a Curves adjustment layer to it. We will need to select it and apply a feather radius of 5 pixels to the selection. Although we could apply the adjustment command directly to this selection, let's choose this time to select the Layer via Copy command first, and then apply a Curves adjustment layer clipped to affect only the copied layer with settings such as Input 121 and Output 139, as shown in Figure 13.13. Once this has been done, both of these layers can be merged down onto the Working layer.

FIGURE 13.13 Curves applied to unify the tonal quality of the jacket.

19. Let's whiten up the soldier's shirt and tie using the Replace Color command. We will need to select the area to affect first, and apply a feather with a small radius setting such as 2 pixels, then in the Replace Color dialog box, with its Fuzziness slider set to 70, let's click on the shirt in the approximate location

shown in Figure 13.14, then assign settings of: Saturation −49, Lightness +16, Hue 0.

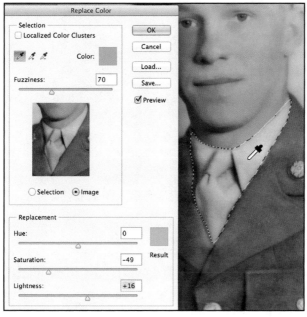

FIGURE 13.14 Whitening the shirt and tie using the Replace Color command.

It will be important not to be tempted to adjust the Saturation and Lightness settings until the shirt becomes pure white, as it will then no longer look natural. In your own work, the secret is to whiten an area, but keep its tonal quality relative to the overall tonal quality of the rest of the photograph.

20. Let's add some life to the soldier's eyes by enhancing the whites and the highlights in them. For the whites, we will want to create a selection of the eyes first, then again use the Replace Color command. In its dialog box, the eyedropper should be clicked on the white area of one of the soldier's eyes, with settings of: Fuzziness 40, Lightness +20, Hue 0 and Saturation 0 as shown in Figure 13.15. For the pupil highlights, we will create a new layer (or two if you prefer) above the Working layer, then choose the

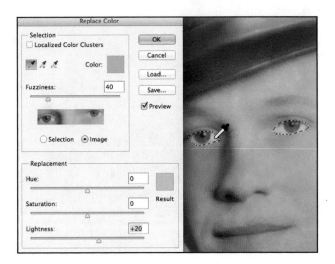

FIGURE 13.15 Using the Replace Color command for whitening eyes.

Brush tool with a small brush size comparable to the existing highlights, with its Mode set to Normal, its Opacity set to 100%, and white selected as the foreground color. With a single click over each existing pupil highlight, we will then want to lower the opacity of this layer a little, so that the new highlights will not overpower the photograph with a suggested layer setting of Opacity 80%, then merge this layer with the Working layer.

21. We are almost done with this restoration. This is the stage when a test proof at 100% size should be printed and compared to the original print made prior to the restoration process, to examine the photograph for areas which may still benefit from small applications of the Patch tool for color and/or texture blending, any details that need sharpening by painting or copying content, or any small blemishes that may have been missed, that the Spot Healing Brush tool can easily eliminate.

22. Once all of this photograph's damage has been repaired, we can see that it still contains a slight overall green color cast. Let's add the final touch to this project with a Color Balance adjustment layer as

shown in Figure 13.16, with slider settings of: Cyan/ Red 0, Magenta/Green −9, Yellow/Blue 0.

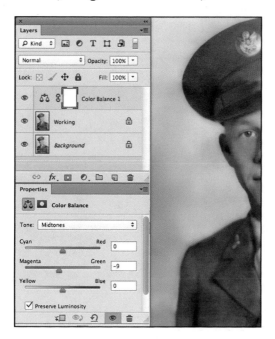

FIGURE 13.16 Applying a Color Balance adjustment layer to remove the green color cast from the Soldier photograph.

Note

When applying this Color Balance adjustment layer, if your file contains repair and/or adjustment layers in addition to the Working and Background layers, be sure it is added above all other layers in your Layers panel, to ensure that it will provide a universal color cast correction.

23. Once you have done that, in your own work, especially with an extensive restoration project such as this one, it will be important to save and close the file, then re-open it in a day or two to review it one more time for any final adjustments or changes you find you want to make. At that point, when you are satisfied with your work, any alpha channels the file may contain can be deleted, and the file flattened.

Project 3

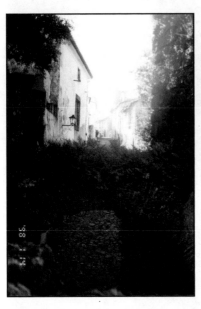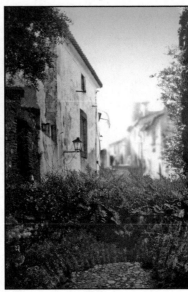

FIGURE 13.17 Before and after the Portugal photograph enhancement.

13.1.3 Portugal Photograph Enhancement Step-By-Step

Tools, Commands, and Techniques
- Shadow/Highlights command
- Unsharp Mask filter
- Artistic crop
- Lens Blur filter
- Refine Edge dialog box
- Custom gradient
- Ruler tool
- Adjustment layers
- Content-Aware command
- Color Replacement tool

DVD *on the*

Open the Portugal.jpg file provided in the Chapter 13 Files folder, and save an original .psd version and a working copy with the name of your choice (optionally

choosing to duplicate the Background layer to create a working layer) into your Photoshop practice folder.

1. We can see when this photograph opens, that it is slightly crooked. Let's select the Ruler tool, and drag up the edge of the building on the left to define the required straightening angle as shown in Figure 13.18 (the ruler line has been highlighted in red), then apply the Straighten option in the Options bar.

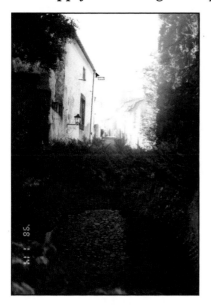

FIGURE 13.18 Ruler tool applied to straighten the Portugal photograph.

Note

If your version of Photoshop converted the Background to a regular layer in the straightening adjustment, choose to either lock the position of the layer, or optionally convert it back to the Background layer.

2. Before we make any color adjustments, let's crop the photograph for a more interesting composition. With the Rule of Thirds view overlay showing (if applicable) choose to crop the photograph with a size of Width: 4″, and Height: 6″ and no resolution assigned, to resemble the sample shown in Figure 13.19, with

the bottom left corner of the crop just above the date information visible in the original photograph.

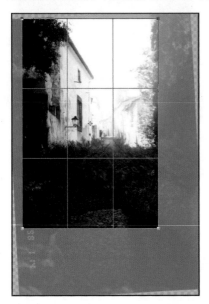

FIGURE 13.19 Suggested crop preview for the Portugal photograph.

3. With our photograph artistically cropped, we are ready to start correcting and enhancing it, beginning with the Shadows/Highlights command. Choose to apply the settings shown in Figure 13.20 of Shadows 42%, Highlights 41%, or optionally choose to assign them with the command applied as a Smart Filter.

FIGURE 13.20 Shadows/Highlights dialog box settings for the Portugal photograph.

4. Choosing the Sponge tool with a large brush size and Hardness of 0%, its Mode set to Saturate, its Flow set to 20%, and its Vibrance feature checked, let's brush across just the green ferns in the foreground a few times to brighten them up a little.

5. In addition to their saturation, let's create a rough selection with a feather radius of 5 pixels around the ferns to apply the Unsharp Mask filter with settings of: Amount 77%, Radius 2.6, and Threshold 0 as shown in Figure 13.21.

FIGURE 13.21 Applying the Unsharp Mask filter to the fern area of the Portugal photograph.

6. We can see that this photograph contains a blue color cast. Let's apply a Color Balance adjustment layer to it, with settings of: Cyan/Red 0, Magenta/Green 0, Yellow/Blue −19.

7. While the Color Balance adjustment layer has improved much of this photograph's color cast, the building on the left and the cobblestones on the street could still use some blue neutralization. Let's use the Sponge tool with the same settings we used in step

four, except that we will need to change its Mode setting to Desaturate. Once we have done that, a few passes over each of these areas will work well.

8. Let's make the buildings in the distance appear further away using the Lens Blur filter. To begin, we will need an accurate selection of them to isolate them from the foliage in the foreground. To do this, with a general selection created first, we can enter the Refine Edge dialog box to customize only the settings shown in Figure 13.22: Smart Radius checked, Radius 2 px, Contrast 20%. Notice that with its View Mode set to On Black, as the Refine Radius tool is applied in the preview area, we can easily see its affect on our selection.

FIGURE 13.22 Using the Refine Edge dialog box to improve a selection.

Note

If your version of Photoshop does not include the Refine Edge dialog box, each time this selection adjustment is recommended, the Magic Wand can be alternatively applied to the area, followed by the Layer via Copy command. If this copied layer is then moved *above* the content that the blur is applied to, the resulting effect will replicate that which can be achieved through the Refine Edge dialog box.

9. To apply the Lens Blur filter, with our selection active, let's first turn on the Quick Mask Mode, and then select the RGB composite channel in the Channels panel. Once the Lens Blur filter dialog box is open, with Quick Mask selected from the Depth Map Source pop-up menu, let's adjust only its Radius setting to 15.

10. We will now want to create a selection of the upper half only of the sky area to apply a gradient to it, using the Refine Edge dialog box again to improve the accuracy of our selection. The initial selection should include the edge of the foliage, so that in the Refine Edge dialog box we can apply the Refine Radius tool to tweak the selection customizing only the settings shown in Figure 13.23: Smart Radius checked, Radius 2 px, Contrast 20%. Once we have exited the Refine Edge dialog box, let's save this selection into an alpha channel.

FIGURE 13.23 Improving the accuracy of the sky selection in the Refine Edge dialog box.

11. Before choosing the Gradient tool, let's open the Color Picker and assign a foreground color of R: 129, G: 185, and B: 228. Once we have done that, when the Gradient tool is chosen, and the Gradient Editor is

opened, we will choose the Foreground to Transparent option.

12. To apply the Gradient tool, we will want to create a new layer above the Color Balance adjustment layer first, and then load our saved sky selection alpha channel. While holding the Shift key down, let's press and drag the Gradient tool starting at the top edge of the image, and releasing the mouse in the general location shown in Figure 13.24.

FIGURE 13.24 Applying a gradient to the sky in the Portugal photograph.

If any areas in the top left section of the photograph did not get filled in with the gradient, with the Background layer selected, a quick fix is to apply the Content-Aware command to replace any white areas it may contain with surrounding foliage.

13. We are almost done. With the Background layer active, let's use the Burn tool on the stone wall along the right edge the photograph, with the following settings: Hardness 0%, Range Shadows, Exposure 20%, and its Protect Tones feature checked.

14. As a final touch, let's green up some of the foliage on the left side of the photograph a little bit: the leaves at the top, and the left half of the ferns on the bridge using the Color Replacement tool. In the Options bar, with a Mode setting of Color, Sampling setting of Continuous, Limits setting of Find Edges, Tolerance setting of 10%, and Anti-alias checked, use a brush size relative to the example shown in Figure 13.25 based on your view, to apply just a few strokes in each of these two areas, so that their foliage will still retain the appearance of natural lights and darks.

FIGURE 13.25 Color Replacement tool brush size and its application to the foliage in the Portugal photograph.

15. Although this photograph now looks great, feel free to further adjust any of its colors, or choose to delete its alpha channel, flatten its layers, then save and close the file.

Project 4

FIGURE 13.26 Before and after the portrait painting restoration.

13.1.4 Portrait Painting Restoration Step-By-Step

Tools, Commands, and Techniques

- New document dialog box
- Assembling a composite file
- Nonaligned use of the Clone Stamp tool
- Adjustment layers
- Assigning a Clone Sample Mode and separate layer when cloning
- Reusing repair layers
- Dodge tool
- Burn tool
- Smudge tool
- Replace Color command

Two scanned sections of a damaged painting have been provided for this project, each with approximate dimensions of width 10″ and height 8-1/2″. To begin this project, we will need to create a new document to assemble this composite file in.

1. As shown in Figure 13.27, let's choose **File>New** then assign: Width 14″, Height 20″, Resolution 300 ppi, Color Mode RGB, and a Background Contents setting of White then click OK. Instead of naming the file in the New dialog box, we will name and save the file once it has been created.

FIGURE 13.27 New dialog box to assign dimensions for the composite portrait canvas.

2. Choose **File>Save As** and name this file Portrait_original.psd. We will choose to create our working copy once the composite has been assembled and cropped.

3. The files that we will use to create this composite portrait are located in the Portrait scans folder provided in the Chapter 13 Files folder. Once they have been opened, with the files arranged to view all three simultaneously, drag the scanned sections into the Portrait_original.psd file, and then close them without saving any changes, if prompted.

4. Once these files have been added, it will be helpful to also name their layers relative to their content, with the files added to the composite and their names of Top and Bottom assigned in the Layers panel as shown in Figure 13.28.

5. After lowering the opacity of the Top layer, let's adjust its positioning using the up/down/left/right arrow keys, until its visibility can be turned off and

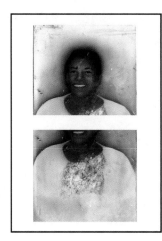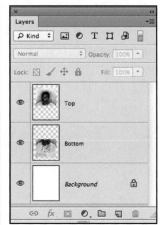

FIGURE 13.28 Composite canvas and corresponding Layers panel with layer names applied.

back on again, with no visible shift detected, confirms that it is perfectly aligned with the content of the Bottom layer, then return its opacity to 100%.

6. We can see that there is a slight color differentiation between the Bottom and Top sections of the woman's dress. To correct that, a Color Balance adjustment layer can be added, with settings: Cyan/Red +33, Magenta/Green 0, Yellow/Blue +33, being sure that this layer is added between the Bottom and Top layers, so that its effects will be applied only to the Bottom layer.

7. We can see that although this adjustment layer now matches the *color* of the dress, it still remains *darker* than the Top layer. To correct this, let's now add a Curves adjustment layer that also affects only the Bottom layer, with settings of Input 127 and Output 157.

8. The file is now ready to be flattened, then cropped. When cropping it, we will want to assign a width of 11″, and a height of 14″, with a resolution of 300 ppi, using the default interpolation method preassigned in your version of Photoshop. The crop should eliminate all of the extra white area of the canvas, as well

as adjust its image area comparable to the crop preview shown in Figure 13.29.

FIGURE 13.29 Suggested crop preview for the portrait painting restoration.

9. Let's stop and save these changes to this Portrait_original.psd file. Once we have done that, we can now choose **File>Save As** to create our separate working copy of this file that we will restore with the name of your choice, then optionally choosing to duplicate its Background layer to create a working layer with its position locked before beginning the restoration process.

10. If any slight color mismatch remains where the two sections of the woman's dress meet, a few passes with the Patch tool will eliminate them.

11. Most of this portrait can be restored using the Clone Stamp tool in combination with the healing collection of tools as you have learned. Because of that, the rest of the steps provided here will focus on its special challenges.

12. When studying the dress's neckline, we can see that a small section of it on the left is still pretty much in tact that we can copy and reuse. Attempting to re-

pair this kind of detail using the Clone Stamp tool or any of the other healing tools would be much more difficult. In Figure 13.30, the original feathered selection is shown, along with its application to the damaged area on the right, which required its duplication, rotation, and distortion.

FIGURE 13.30 Initial dress neckline selection copied and transformed to cover a comparable damaged area.

13. Once we have done that, we can reuse this same layer content by transforming it two or three more times (depending on the size of your original selection) to cover the rest of the damaged areas of the dress's neckline as well, with all of these repair layers merged down onto the Background (or working layer if you created one) before continuing the restoration. Although this area will now still require repair work, the challenging part of repairing the curved neckline of the dress is done.

14. Let's now study the woman's necklace. Even though its right half is badly damaged, its left half can more easily be repaired, and then used to replace its right half. Let's begin by smoothing out its scratches using the Smudge tool. With a small brush, Hardness 0%, and Strength 50%, a few strokes following the curve of the necklace will work great. Once we have done that, its highlights and shadows can also be improved. The Dodge tool using a small brush with Hardness 0%, Range set to Midtones, Exposure 20%, and its Protect Tones checked, can be brushed down its center, to increase its 3-dimensional appearance. To redefine its

edges and further enhance its 3-dimensional quality, the Burn tool can then be applied along both sides of its outer edges using a small brush with Hardness 50%, Range set to Shadows, Exposure 20%, and its Protect Tones checked. Once these enhancements are made, it can be copied and flipped to repair the right half as shown in Figure 13.31. With additional copies transformed and erasures applied, this same content can also be used to fill the remaining necklace area between these two sections.

FIGURE 13.31 Left half of necklace repaired then used to replace its right half.

15. This same concept can be applied to the left shoulder. Once the right shoulder of the dress which has only minimal damage has been fully restored, it can be copied, transformed, and positioned to cover the more severely damaged left one.

16. To repair the light area of the background, we can use the Clone Stamp tool with its Align option *unchecked*. Although much of it is badly damaged, a useable source can be found in the upper left corner. Figure 13.32 shows suggested source content for the Clone Stamp tool, with its Aligned feature unchecked, and its resulting repair.

17. Once the white area of this painting has been repaired, its color can be improved using the Replace Color command. Let's select the background area,

FIGURE 13.32 Clone Stamp tool source defined with Align option unchecked, and its resulting application.

then in the Replace Color dialog box, click its eye-dropper in the white area, and adjust Fuzziness 40, Lightness +77, Hue 0, Saturation 0.

18. To soften the transition between repairs made to the blue area that abuts the white area, let's create a new blank layer first, before applying the Clone Stamp tool or Healing Brush tool with its Current and Below setting selected in the Options bar. Once the area has been cloned, its layer opacity can be lowered as needed to blend the two areas as shown in Figure 13.33.

FIGURE 13.33 Cloned layer opacity reduced to blend its content with the area below it.

19. To lighten the woman's face a little, once it has been selected, a Curves adjustment layer with Input 114 and Output 138 can be applied, and then merged down.

20. This woman's eyes can also benefit from highlight spots as we have learned to add them, with their layer Opacity setting lowered to 80%, to meld better with the existing content.

21. Once all of the rest of its damaged areas have been repaired, a proof can be printed to examine for any additional corrections it may need, followed by saving and closing this project, choosing to either keep its layers or flatten the file.

13.2 On Your Own

You are ready to work on your own. There is nothing like experience. The more restoration and enhancement projects you complete, the easier they will become, the more professional your results will be, and your workflow will become increasing more efficient as you invent a few new working tips of your own. Always approach each project with an open mind and be ready to "think outside the box" when necessary. Take the time to evaluate each one first: determining not only what it will take to restore or enhance it, but especially the most effective *order* of application of the tools, commands, and techniques required by the project. The reward and satisfaction of this profession lies in the fact that each project will inherently provide you with unique challenges. Good luck, and enjoy.

APPENDIX

Answers to Test Your Knowledge

Chapter 1

Chapter 2

Chapter 3

Chapter 4

Chapter 5

Chapter 6

Chapter 7

Chapter 8

Chapter 9

Chapter 10

Chapter 11

Chapter 12

Answers to Test Your Knowledge

Chapter 1

1. JPEG
3. Always have them the same whenever possible
5. 600
7. No matter how many times it is saved, no image data will ever be deleted
9. Define the area to scan

Chapter 2

1. Image Size
3. Bottom left of the document window
5. Control+Alt+Shift or Command+Option+Shift
7. Press and drag on its name tab to pull it away
9. Create your configuration of panels, then **Window>New Workspace**, Name it

Chapter 3

1. Magic Wand
3. Shift key
5. Apply a Feather
7. Frequency
9. Four

Chapter 4

1. Layer via Copy
3. Above the currently selected layer
5. Click its Eye icon
7. Layer groups also provide collapsible folders and individual manipulation within the group
9. All layers within the file become merged with its background layer

Chapter 5

1. Rectangular Marquee tool
3. Changes the pixel dimensions of an image through interpolation
5. Bicubic Automatic
7. Distort
9. Show Transform Controls

Chapter 6

1. Alt/Option
3. The conversion method that will be applied when colors in the color space of a destination device are out of the range of the color gamut of the source device
5. When the working space of the file you are opening does not match the working space assigned in Photoshop
7. Cyan-Magenta-Yellow-Black
9. Photoshop Manages Colors

Chapter 7

1. Source
3. Aligned: you determine the distance the source follows, Aligned unchecked: Tool will start from the same original point until a new source point is defined
5. Five
7. Press Alt/Option to define the source point
9. Cloned area begins to look fake due to its repetitive pattern appearance

Chapter 8

1. Noise
3. Detects the surface it is applied to and intuitively adjusts its application accordingly
5. To constrain its effect
7. Spot Healing Brush tool
9. It has a dotted half semi-circle on its left side

Chapter 9

1. When an image is dominated by an overall tint of one color that negatively shifts all the rest of the colors towards it
3. When either a Levels or Curves adjustment layer is active, and Auto Options is selected from the Properties panel menu, or by choosing Options in the Levels or Curves dialog box when the command is chosen from the Image menu
5. Lightens an area of a photograph
7. Nondestructive
9. No

Chapter 10

1. Gradient Editor
3. The area within a photograph that the viewer's eyes are drawn to, due to its color, size, or sharpness compared to the rest of the content in the image
5. Depth Map
7. Drag the Gradient tool
9. Resampling to raise the ppi of an image

Chapter 11

1. The effect that occurs when the details of a subject being viewed become less defined and its colors become muted as the distance between the viewer and the subject increases
3. When photographing a tall building, in order to include the entire structure, the photographer usually needs to tilt the camera, resulting in a photograph where the vertical sides of the building appear to angle inward from their base to their highest point
5. Seamless tonal integration between selected and nonselected content
7. Cropping to off-set the focal point within the photograph so that it is no longer dead center

9. Determines how many pixels away from an edge you want Photoshop to apply the Unsharp Mask filter to

Chapter 12

1. Shoot the photograph with the Flash off, or shoot with the Flash on at an angle
3. Turn its layer off and on in the Layers panel
5. Place each section of the artwork on the scanner as straight as possible using the guides provided on the scanner
7. Any one of its options because the canvas will not be visible
9. Above the working layer but below any adjustment layers that may be added

INDEX